Photographic Treasures from the Cincinnati Art Museum

Kristin L. Spangenberg

Photographic Treasures

from the

Cincinnati Art Museum

Cover: Ansel Adams, *Monolith, The Face of Half Dome, Yosemite National Park, California,* 1927, gelatin silver print, see pp. 122-23. *Frontispiece:* Jan Saudek, *Image #35 (Another Child, David is Born),* 1966, gelatin silver print, see pp. 186-87.

Photographic Treasures from the Cincinnati Art Museum

Kristin L. Spangenberg
Cincinnati Art Museum

Typography and design by Noel Martin
Typesetting by Cobb Typesetting, Inc.
Offset lithography and duotones by Young and Klein, Inc.
Copy photographs by Ron Forth, pp. 14, 16, 18, 20, 22, 23, 24, 26, 28, 32, 42, 70, 74-75, 182, 200, 204, 206, 208, 210, 212, 214

Library of Congress Catalog Card Number: 89-60290

Cataloging Notes:

Cincinnati Art Museum
 Photographic treasures from the Cincinnati Art Museum / /Kristin L. Spangenberg.
 Published on the occasion of the celebration of the 150th anniversary of the announcement of photography.
 Includes index.

1. Photography – Catalogs. 2. Photography, Artistic – Catalogs. 3. Cincinnati Art Museum – Photographic collections. I. Spangenberg, Kristin L., 1944- . II. Title.

TR 650 U6C5 1989
ISBN 0-931537-05-3

The Cincinnati Art Museum gratefully acknowledges operational support from the Cincinnati Fine Arts Fund and the Ohio Arts Council.

Contents

Foreword

It might be expected that Cincinnati, a relatively old and large American city in the nineteenth century, was involved from the earliest years in photography following its discovery. Indeed, this was the case, as text and illustrations in this publication attest. It might be expected that the Cincinnati Art Museum, founded in 1881, would have collected and exhibited photographs as *art* from an early date. Both of these assumptions are true.

Photographs made their initial appearance at the Cincinnati Art Museum in an exhibition in 1896 when a small group of daguerreotypes was lent by the noted Cincinnati painter, Israel Quick, and Cincinnati photographer, James M. Landy. This exhibition was *A Group of Portraits Exhibited in the Art Museum During the Summer of 1896.* In 1900, the Museum organized and presented *A Collection of Artistic Photographs by Mr. Clarence H. White of Newark, Ohio, and Others,* and stated in the catalogue's preface: "The present collection of photographs is important as showing an unusual attainment of artistic qualities by means of the camera and photographic print. In the choice of subjects for aesthetic interest and the manipulation of processes the collection possesses rare interest." Clarence White was relatively unknown then, but his fame and the acclaim given him today commend the Museum for this early recognition.

The Museum acquired its first photographs for the collection in 1899. These were daguerreotypes (accession numbers 1899.30-38) given by Mrs. James M. Landy in memory of her photographer husband. Collecting interest was spotty in the decades that followed, although from time to time an attractive photograph was acquired by purchase or gift. In 1974, reflecting a broader policy for collecting and exhibiting works on paper, the Department of Prints, Drawings and Photographs was formed and Kristin L. Spangenberg, formerly the Museum's assistant curator of prints, was named curator. The existing photography collection was inventoried, a list of significant photographic artists was compiled, exhibitions of high quality were sought or organized, and the Museum energetically pursued a purchase program for acquiring high-quality works and solicited donors of photographs. Thus, the Museum established clear goals and embarked under Kristin Spangenberg's curatorship to fulfill them.

In celebration of the 150th anniversary of the announcement of photography in 1989, this publication is intended to serve as a selective catalogue of masterpiece photographs in the Museum's collection. As a catalogue, it joins others devoted to the permanent collection in a series that began in the 1970s and now includes the following: Carolyn R. Shine and Mary L. Meyer, *Art of the First Americans,* (1976); Carol M. Macht and Deborah Long, *Cincinnati Landmarks* (1976); Millard F. Rogers, Jr., *Spanish Paintings in the Cincinnati Art Museum* (1978); Kristin L. Spangenberg, *French Drawings, Watercolors and Pastels 1800-1950* (1978); Denny T. Carter, *The Golden Age: Cincinnati Paintings of the Nineteenth Century Represented in the Cincinnati Art Museum* (1979); Ellen S. Smart and Daniel S. Walker, *Pride of the Princes: Indian Art of the Mughal Era in the Cincinnati Art Museum* (1985); Mary Ann Scott, *Dutch, Flemish, and German Paintings in the Cincinnati Art Museum* (1987); Otto Charles Thieme, *Simply Stunning: 200 Years of Fashion from the Cincinnati Art Museum* (1988).

The Museum is indebted to Curator Kristin L. Spangenberg for authoring this publication and for the research shared here with the catalogue's readers. Others who joined in the production of this publication, to whom appreciation is expressed, are recorded in the acknowledgments.

Millard F. Rogers, Jr.
Director

Acknowledgments

In November 1974, Millard F. Rogers, Jr., the director of the Cincinnati Art Museum, created the Department of Prints, Drawings and Photographs. The curator gathered together the Museum's scattered holdings in photographs, evaluated their importance, and drew up a desiderata to acquire important works by major photographers spanning the history of photography. This catalogue of selected works began as a publication to accompany the Museum's final centennial exhibition, "The Cincinnati Art Museum Photography Collection," in 1981. Its progress was interrupted by the award of an Institute of Museum Services grant to conduct a feasibility study for the renovation of the entire department. In 1986, work on the catalogue was resumed and its format was revamped to include recent acquisitions. Its publication was projected to coincide with the 150th anniversary of the announcement of photography in 1989.

After nearly a decade, it is difficult, if not impossible, to properly thank all those who have generously given of their time, knowledge, and support to this project. I would like to express my gratitude to Millard Rogers who saw the value of the collection and of this publication. Without his continuing patient encouragement to pursue this ambitious project and the allowance of time to research and write, this catalogue could not have been realized.

My sincere appreciation is extended to the photographers who responded to my enquiries regarding their images and aesthetics: Berenice Abbott, Richard Avedon, Ansel Adams, Lewis Baltz, Hilla Becher, Brassaï, Harry Callahan, Paul Caponigro, Marie Cosindas, Harold Edgerton, Alfred Eisenstaedt, Lee Friedlander, Yousuf Karsh, Vilem Kriz, Barbara Kruger, John Clarence Laughlin, Richard Long, Duane Michals, Barbara Morgan, Arnold Newman, Cindy Sherman, Aaron Siskind, Eve Sonneman, and Jerry Uelsmann.

Numerous curators, scholars, dealers, and collectors have unselfishly shared their knowledge and expertise, without which my research could not have been accomplished. Wherever possible I have tried to acknowledge their specific contributions. I would like to thank in particular Mary Street Alinder, James C. Anderson, Yeatman Anderson, Terry Ariano, Paul M. Bailey, Gordon Baldwin, Anne Baruch, Jacques Baruch, Linda Benbow, James Borcoman, Janet Borden, Janet Buerger, Peter Bunnell, Barbara Burger, Walt Burton, Richard Caldwell, Martha Chahroudi, Robert Chandler, Marella Consolini, W. H. Crain, Kenneth C. Cramer, Isobel Crombie, Carolyn A. Davis, William A. Deiss, Nancy Dengler, Ron Dengler, Evelyn Dietz, Kenneth W. Duckett, Françoise Dumas, Carol Ehlers, Kenneth Finkel, Paula Fleming, Stephen J. Fletcher, Roy Flukinger, Larry Fong, Bonnie J. Ford, Robert Fraenkel, Leila Francy, Deborah Frumkin, Marianne Fulton, Peter Galassi, Pascal Gauthier, Elizabeth Glassman, Sarah Greenough, Kathryn Hamilton, Ronald J. Hill, Wilbur T. Holmes, Marie Morris Hambourg, Edwynn Houk, André Jammes, Sidney Kaplan, Jerry L. Kearns, Robert Koch, Chris Muller Kreamer, R. E. Lassam, John H. Lawrence, Joseph Leach, Edward Lentz, Janet Lehr, Simon Lowinsky, Harry Lunn, Joanne Lukitsh, Barbara McCandless, Jerald C. Maddox, Bernard Marbot, Juliet Man Ray, Anthony Montoya, Anita Ventury Mozley, Weston J. Naef, Beaumont Newhall, Rina Niles, J. Robert Orton, Jr., Stanley W. Olsen, Richard Pare, Joan Pedzich, Marcuse Pfieffer, Steve Plattner, Mary K. Pozzi, Lester Pross, Gene Prakapas, Nils Ramstedt, Andrew Rasanen, Howard Read, Pamela Roberts, Sandra Roff, Grant Romer, Sally Robertson, Stephen T. Rose, Gerd Sander, Josiane Sartre, Larry J. Schaaf, Brigid Shields, Carl Solway, William Stapp, Miriam Stead, John Szarkowski, Joanne Steichen, Sean Thackrey, Ken Trapp, David Travis, John Wadel, David Walter, Carl Worswick, Daniel Wolf, and Loretta Yarlow.

The staff of the following libraries answered my queries and facilitated my use of the materials in their custody: Mary R. Schiff Library, Cincinnati Art Museum; Stieglitz Archives, Collection of American Literature, Beinecke Rare Book and Manuscript Library, Yale University; Boston Public Library; Cincinnati Historical Society; Ryerson Art Library, The Chicago Art Institute; Fine Arts Library and Pusey Library, Harvard University Libraries; Thomas J. Watson Library, Metropolitan Museum of Art; Public Library of Cincinnati and Hamilton County; Art and Architecture Library, Stanford University; University of Cincinnati Library.

I owe particular thanks to my readers. Robert A. Sobieszek, director of photographic collections for the International Museum of Photography at George Eastman House, read the artist entries and provided helpful suggestions for their accuracy and improvement. The first version of the glossary written in 1981 was a collaborative effort with Thomas W. Orth and was thoughtfully reviewed by Alice Swan. The expanded and revised glossary is my full responsibility. James M. Riley, director of the Image Permanence Institute at Rochester Institute of Technology, and John R. Thirtle, retired senior research associate to the director of the Color Photography Division, Kodak Research Laboratories, reviewed the glossary and clarified details on materials and procedures.

Jonathan Z. Kamholtz, a superb editor with whom I have had the good fortune to work before, through his perceptive suggestions and gentle criticism brought consistency and lucidity to the content and style of the manuscript.

All of the former and current staff and volunteers of the Department of Prints, Drawings and Photographs must be thanked for their patience and support throughout the duration of this project. I extend my special thanks to Dennis Kiel, associate curator, who ran the department study room, assumed various projects I was unable to undertake, and contributed two entries to the catalogue. Former department secretaries Lucy Woodworth, Lori Saylor, Teresa Cory, and Stephanie Stein worked on the manuscript as it evolved. The department secretary, Linda Pieper, expertly typed the final version of the lengthy and difficult manuscript and prepared the artist index.

Explanatory Notes

I owe my sincere appreciation to many Cincinnati Art Museum staff members who contributed in important ways to the success of this publication. Carol M. Schoellkopf, manager, Publications Production, deftly edited the manuscript and coordinated various phases of printing production. Beth DeWall, manager, and Joy Payton, assistant manager, Merchandising and Photographic Services, oversaw the photographic needs and distribution of the catalogue. Noel Martin gave this publication its elegant and sensitive design.

Finally, I will never be able to repay or fully express my profound gratitude to family and friends for their unfailing support and enduring interest. In particular, thanks is totally insufficient to John E. Gilmore whose suggestions and encouragement are a vital and natural part of a partner's support. I dedicate this manuscript to him for his constant understanding and patience during the final years of this book.

<div align="right">

Kristin L. Spangenberg
Curator
Prints, Drawings and Photographs

</div>

Entry order: Photographs are arranged in approximate chronological order by date of execution.

Titles: Descriptive titles have been used when there is no existing title. Foreign language titles have been translated into English.

Dates: Dates without parentheses appear on the work. Assigned dates appear in parentheses. *Ca. (circa)* precedes uncertain dates.

Medium: Every effort has been made to accurately describe in a consistent and systematic fashion the medium used. Descriptions of the photographic processes can be found in the glossary.

Measurements: Dimensions are listed in centimeters, height preceding width. Measurements represent the image area unless otherwise specified. A second set of measurements records the size of the support or mount.

Signatures and Inscriptions: Signatures and inscriptions have been transcribed as accurately as possible regardless of spelling or grammar. Virgules designate the beginning of another line. Right and left indicate the reader's right and left, except when referring to the human figure.

Credit line: The source of purchase funds or gift is noted. When preceded by *museum purchase* and followed by *by exchange,* the work was purchased with deaccession funds. Works transferred from another department are so indicated with the donor and original year of donation identified, when known.

Accession number: The year of acquisition is followed by the number of the object. For example, 1980.1 would be the first work acquired in 1980.

Provenance: All previous owners or dealers are listed chronologically. Information relating to auction sales and transfers of ownership follows the respective collector's name in parenthesis.

Exhibitions: All exhibitions significant for dating, scholarship, or ownership have been listed. The state in which an institution is located is not listed when it is well known and not subject to confusion. The city is not listed when it forms part of the institution name. English spelling is used for foreign cities unless the city forms part of the institution name. *Checklist* refers to a description of an object's vital statistics without additional commentary.

Bibliography: All early references, monographs, specialized studies, critical analyses, and commentaries pertaining to the specific piece owned by the museum have been included.

Footnotes: All letters cited are to Kristin Spangenberg (KS) unless otherwise indicated. The letters reside in the curatorial files of the Museum.

The two entries written by Dennis Kiel are signed with the initials D. K.

Catalogue

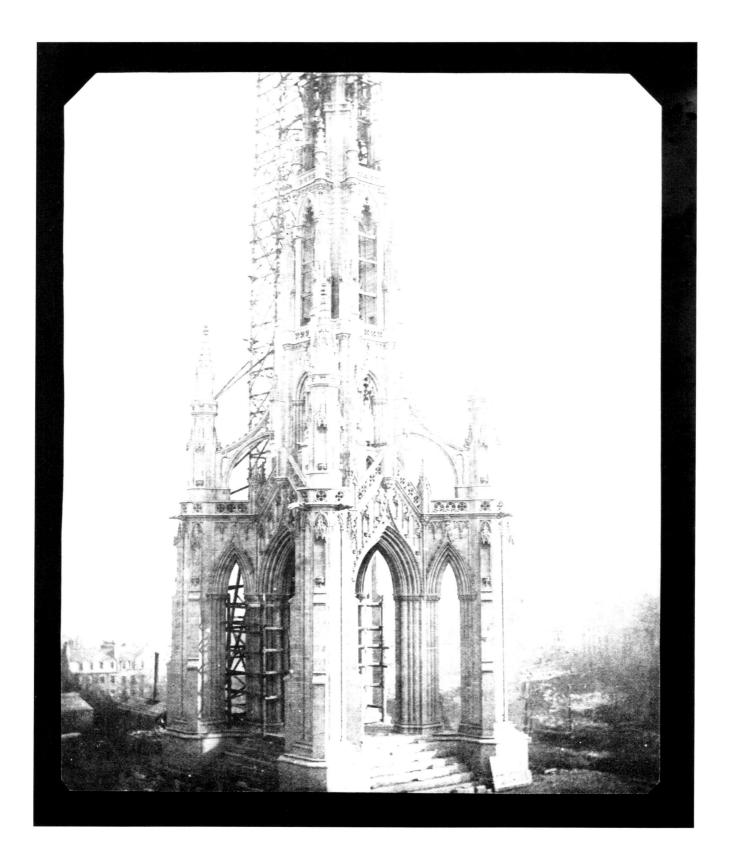

William Henry Fox Talbot

British, 1800-1877

The Scott Monument, Edinburgh, in the Course of Construction (1844). Salted-paper print from paper negative, 19.6 x 15.8 cm on 23.0 x 18.5 cm. Number with pen and black ink by another hand on verso: *LA26*.

The Albert P. Strietmann Collection, 1979.39.

Provenance: William Henry Fox Talbot, Lacock Abbey, Wiltshire, Great Britain; Thackrey and Robertson, San Francisco.

Exhibitions: Cincinnati Art Museum, *The Cincinnati Art Museum Photography Collection*, 1981-82.

> The great and unquestionable superiority of the Calotype pictures, however, is their power of multiplication. One Daguerreotype cannot be copied from another; and the person whose portrait is desired, must sit for every copy that he wishes. When a pleasing picture is obtained, another of the same character cannot be produced. . . .[1]

William Henry Fox Talbot was a well-to-do, learned Victorian country gentleman who seriously pursued various branches of scientific and classical knowledge. He made contributions in the fields of mathematics, astronomy, etymology, optics, and Assyriology. Except among a few contemporary scientists like Sir David Brewster,[2] the importance of Talbot's invention of the negative-positive process was overshadowed by the prior announcement of the invention of the daguerreotype. Yet during the twenty years of his pioneering work in photography, Talbot made the first fixed photographic negative, discovered the latent image on paper, and developed a halftone reproduction method.

Talbot was born in Melbury, Dorset, Britain, on February 11, 1800, the son of Lady Elisabeth Fox-Strangways and William Davenport Talbot, and died at his ancestral home, Lacock Abbey, Wiltshire, on September 17, 1877. An outstanding scholar, he graduated from Trinity College, Cambridge, in 1821 and received his master's degree from Cambridge University in 1825. In 1832 he became a Fellow of the Royal Society for his publications in the field of mathematics and in 1833-34 he sat as a Liberal member of the House of Commons.

It was during a tour of Italy in 1833, with his new wife Constance Mundy, that he conceived of the "idea" of photography after unsuccessful attempts to sketch with the aid of a camera lucida. Between January 1834 and the summer of the following year, he developed his photogenic drawing process. The earliest extant negative was taken of a diamond-paned window in the South Gallery of Lacock Abbey with a camera obscura in August 1835. This preceded by two years Daguerre's first successfully fixed direct positive.[3] After the summer of 1835, Talbot appeared to have set further experimentation aside until the announcement of Daguerre's discovery of the daguerreotype on January 7, 1839. Concerned lest the priority of his invention be lost, he showed his photogenic drawings at the Royal Institution on January 25 and a week later described the process to the Royal Society in a paper called "Some Account of the Art of Photogenic Drawing." During

the remainder of 1839 through the fall of 1840 he continued to improve his process. On September 22 and 23, 1840, he discovered that with the appropriate reducing agent he could chemically develop a latent image, thus reducing the necessary exposure time, so that for the first time, photographic portraits were possible with his process. He patented the calotype negative-positive process on February 8, 1841, with the hopes of benefiting from its commercial exploitation.

In an effort to promote the advantages of the calotype over the popular daguerreotype, Talbot opened a printing works in Reading in 1834 to mass produce prints for book illustration, under the direction of Nicolaas Henneman. In 1844 he issued the first of six parts of the *Pencil of Nature* in which he advanced the potential scientific and aesthetic applications of the calotype process. His second publication, *Sun Pictures in Scotland*, was issued during the summer of 1845. It contained twenty-three calotypes without text, and was the first photographically illustrated book devoted to a specific pictorial idea. As with other pictorial anthologies popular at the time, *Sun Pictures in Scotland* paid homage to the towering figure of British literary Romanticism, Sir Walter Scott (1771-1832). It focused on the landmarks and sites mentioned in Scott's works.

Talbot visited the Scott Monument designed by George Kemp (1795-1844), which stands in the heart of Edinburgh, in October 1844. The Museum's salted-paper print is an untrimmed proof of the subject which appeared as Plate 2 in *Sun Pictures in Scotland* titled "Sir Walter Scott's Monument, Edinburgh; as it appeared when nearly finished, in October 1844." The image records the scaffolded state of the memorial before the installation of the statue of Scott in the tower. Talbot placed the monument at the center, and used sunlight to describe the rich detail of one façade.

The soft definition of form and warm, full-bodied color made the calotype a natural medium for Romantic pictorialism. Unfortunately the inventor's promotional efforts came too late and the problems of fading were poorly understood. Talbot's vigorous enforcement of patent infringements stifled technological improvements in Britain through 1854, when the calotype was superseded by the wet-collodion process.

1. "Photogenic Drawing, or Drawing by the Agency of Light," *The Edinburgh Review*, 76, No. 154 (Jan. 1843), 333.

2. Karl Steinorth in *Camera*, 55, No. 9 (Sept. 1976), 24.

3. Helmut Gernsheim, *The Origins of Photography* (London: Thames and Hudson, 1982), p.43.

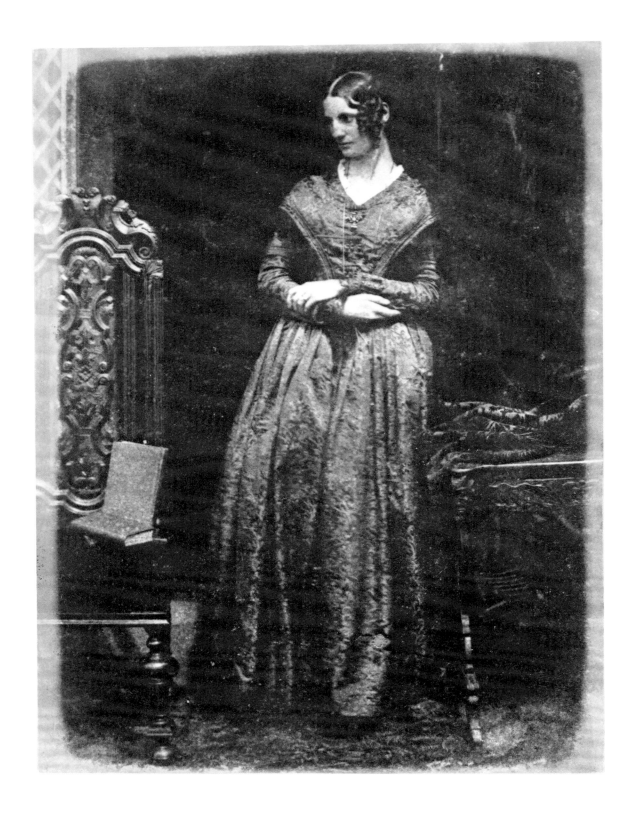

David Octavius Hill and
Robert Adamson

British, b. Scotland, 1802-1870 and 1821-1848

Mrs. Bell of Madras (ca. 1844). Salted-paper print from paper negative, 19.8 x 15.0 cm on gray album sheet 37.3 x 26.0 cm. Title with pencil on album sheet lower left: *Mrs. Bell, wife of Major Bell.*

The Albert P. Strietmann Collection, 1976.37.

Provenance: Private Collection, Great Britain; Thackrey and Robertson, San Francisco.

Exhibitions: Cincinnati Art Museum, *The Cincinnati Art Museum Photography Collection*, 1981-82.

The collaboration of D. O. Hill and Robert Adamson was among the first to successfully bring to perfection W. H. F. Talbot's early calotype process in Great Britain. This famous partnership between the artist Hill and photographer Adamson was originally undertaken to assist Hill in his painting

The calotype came to Scotland through the auspices of the physicist Sir David Brewster, who was in correspondence with Talbot. In May 1841, Dr. John Adamson made the first calotype in Scotland using instructions supplied to Brewster. On Brewster's advice that it would not be financially worthwhile, Talbot did not patent the calotype process in Scotland. He did, however, solicit Brewster's aid in finding someone to practice the process professionally. Robert Adamson, the brother of Dr. Adamson, was born in 1821 in Berunside and died in St. Andrew's in 1848. Poor health had forced him to abandon career aspirations to be an engineer. In the fall of 1842, Robert Adamson, trained by his brother, set up the first photographic studio at Rock House on Calton Hill, Edinburgh.

David Octavius Hill was born in Perth, Scotland, in 1802 and died in Newington in 1870. He began his career in the 1820s as a landscape painter and pioneer lithographic illustrator. He became a founding member and secretary of the Royal Scottish Academy in 1830. In May 1843, clergymen in the Church of Scotland resigned en masse, rejecting the patronage system of the established church. Hill conceived of a monumental painting commemorating the first gathering of the Free Church of Scotland at Tanfield, Edinburgh. At the suggestion of Sir David Brewster, he enlisted the aid of Robert Adamson to take portraits of the 474 participating clergy as preliminary studies for the painting. Although the painting was not completed until 1866, the collaboration of Hill and Adamson extended beyond the immediate needs of the project.

From 1843 until Adamson's death in 1848, they made over fifteen hundred negatives. Their reputations as portraitists brought eminent Victorian artists, scientists, and society figures to their studio. In addition, they made calotypes of architecture and monuments in Scotland, picturesque depictions of Newhaven fisherfolk, and friends posed in *tableaux vivants*. Their partnership was a skilled blend of artistic and technological expertise. Hill broke new ground by utilizing the calotype for artistic purposes. He arranged sitters while Adamson operated the camera and oversaw the chemical processing. Together their accomplishments exceeded Hill's individual photographic efforts.

Isabella Morrison Adamson, sister of Robert Adamson, married Colonel Oswald Bell of Madras in April 1847. She is posed as a vision of Victorian Womanhood. Her dress, with an inverted triangle surmounting a domed skirt trimmed in a restrained manner, emulates the fashionable silhouette of the 1840s. In keeping with styles of the period, her hair is parted in the middle with ironed ringlets cascading on either side of her face. Strong sunlight was needed to keep exposure times down to a minute. Hill posed Isabella out-of-doors amid furniture and props against the southwest wall of Rock House. The simple composition and dramatic chiaroscuro highlighting her face and hands, with little emphasis on the background, reflect the academic painting traditions of the 1840s. More than one negative would be taken at a sitting to insure a successful negative. Variant poses, probably taken at the same time, can be found in the collections of the Scottish National Portrait Gallery, Edinburgh, and the George Eastman House, Rochester.[1] The negatives were often retouched to remove unwanted spots or supports, or to reinforce the lines of drapery and hands. The coincidence of the qualities of the calotype with contemporary taste in painting led to comparisons to Rembrandt etchings and mezzotint engraving.

1. Sara Stevenson, *David Octavius Hill and Robert Adamson* (Edinburgh: National Galleries of Scotland, 1981), p. 132; the International Museum of Photography at George Eastman House, accession no. 77.502:1.

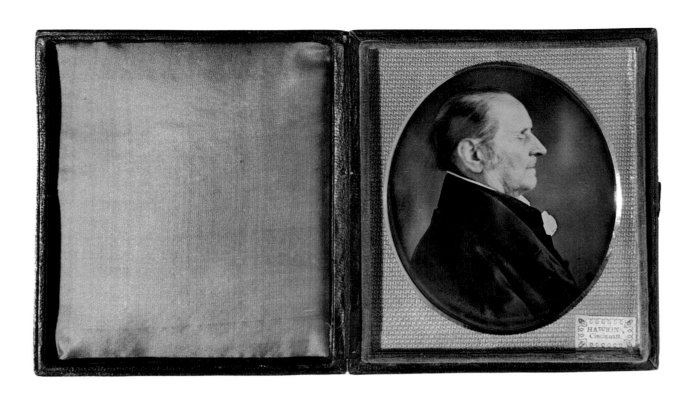

Ezekiel Cooper Hawkins

American, ca. 1808-ca. 1862

Ethan Stone (mid-1840s). Hand-colored daguerreotype, sixth-plate, in papier mâché case, plush-lined, 8.0 x 6.9 cm. Yellow label printed in black lower right corner in front of mat: HAWKINS / CINCINNATI.

Gift of Mrs. Alexander G. Cummins, 1939.129.

Exhibitions: Cincinnati Art Museum, *The Cincinnati Art Museum Photography Collection*, 1981-82.

Ezekiel Cooper Hawkins was Cincinnati's first documented commercial daguerreotypist. A portrait and landscape painter turned daguerreotypist, Hawkins was documented in Steubenville between 1811 and 1829 where he was a house and sign painter by trade.[1] He moved to Wheeling in 1829 where he pursued portraiture and probably learned the rudiments of daguerreotyping. On August 27, 1841, the *Cincinnati Daily Gazette* carried the following notice:

> DAGUERREOTYPE, OR PENCIL OF NATURE.
> MESSRS HAWKINS & TODD, have the honor to inform the ladies and gentleman [sic] of Cincinnati, that they have taken Rooms directly opposite the Post Office, (for a short time.) where they are prepared to furnish the most perfect PHOTOGRAPHIC PORTRAITS, in any weather, without the slightest inconvenience to the sitter. Hitherto it has been generally supposed that sunshine was indispensable to the production of these pictures, but this late improvement proves this a mistake. Persons wishing to perpetuate the true resemblance of themselves and friends, on an imperishable tablet, have now an opportunity of doing so, at a moderate expense. Those who have never enjoyed an opportunity of witnessing a specimen of Photography by this *improved Apparatus*, cannot form an adequate idea of their extreme perfection and beauty over former productions of the Daguerreotype. You are most respectfully invited to call and examine the Miniatures for yourselves.[2]

By October 11, Hawkins and Todd had relocated to Main and Fourth Streets over Mr. Luckey's store.[3] Although nothing is known about his partner Todd, Hawkins was active in Cincinnati from 1841 to about 1862.

Hawkins was probably the first daguerreotypist west of the Alleghenies. He was one of the earliest users of the negative-positive process in America. Unfortunately, his claims of priority for the use of collodion have not been substantiated.[4] Hawkins first advertised his "solographs" (his name for salted-paper prints from paper negatives) in the *Williams' Cincinnati Directory* in 1851-52.[5] His solographs were exhibited at the Mechanic's Fair, Cincinnati, in October 1852[6] and the Crystal Palace, New York, in 1853.[7] His earliest datable salt print is of *The Steamer Jacob Strader* under construction in 1853, which appeared in the *Western Art Journal* in 1855.[8]

Ethan Stone (1767-1852) was an early Cincinnati pioneer and philanthropist. He arrived in the city by covered wagon in 1802 and established a prosperous legal practice. He became president of the Bank of Cincinnati in 1814 and was one of the founders of Christ Church in 1817. By the early 1820s his failing eyesight forced him to retire. Around 1823 he aided Dr. John Locke in establishing a non-sectarian school for young ladies which was patronized by Cincinnati's prominent families. Hawkins's dignified profile portrayal of Stone followed in the tradition of miniature paintings and silhouettes. It does not call attention to Stone's blindness. The simple case and mat suggest a date of the mid-1840s. It would have to have been taken by Stone's death in 1852.

1. W. H. Hunter, "The Pathfinders of Jefferson County," *Ohio Archaeological and Historical Publications*, VI (1898), p. 300.
2. *Cincinnati Daily Gazette*, 27 Aug. 1841, p. 2, col. 7.
3. *Cincinnati Daily Gazette*, 11 Oct. 1941, p. 3, col. 4.
4. Charles A. Seely and J. Milton Sanders, "Who Made the First Collodion Picture?", *The American Journal of Photography*, NS I, No. 7 (1 Sept. 1858), 99-100.
5. *Williams' Cincinnati Directory*, 1851-52, p. 189.
6. *Cincinnati Daily Gazette*, 8 Oct. 1852, p. 2, col. 3.
7. *Cincinnati Daily Gazette*, 20 Aug. 1853, p. 2, col. 3.
8. *Western Art Journal* I, No. 1 (Jan. 1855), illus. opp. p. 14. There are two additional solographs: *Hughes High School*, illus. opp. p. 6, and *N. Longworth*, illus. opp. p. 10.

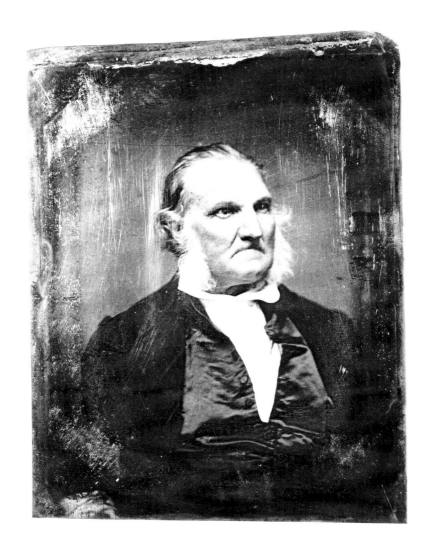

Mathew B. Brady

American, ca. 1823-1896

John James Audubon (ca. 1847-48). Daguerreotype, half-plate, 13.5 x 10.0 cm.

Centennial gift of Mr. and Mrs. Frank Shaffer, Jr., 1981.144, 1982.268.

Provenance: Ann Bakewell Gordon (sister of Lucy Bakewell Audubon, the painter's wife); Eliza Berthoud Grimshaw (daughter of Lucy Audubon's sister Eliza Bakewell Berthoud from Ann Gordon; lent to the U. S. National Museum, Washington, D. C., through John A. Clark, New Orleans, 1892-ca. 1894); Meta Grimshaw, New Orleans (daughter of Eliza Grimshaw); Susan Lewis Shaffer, Cincinnati (from Meta Grimshaw, her second cousin, with payment to Thomas Param, Meta Grimshaw's cousin, after her death in 1936); Mr. and Mrs. Frank H. Shaffer, Jr., Cincinnati (from the estate of his sister Susan Shaffer, 1976; withdrawn from sale at Christie's East, New York, May 15, 1980, lot 14).

Exhibitions: U. S. National Museum, Washington, D. C., 1892-ca. 1894 (lent by Eliza Grimshaw through John A. Clark, New Orleans; the Smithsonian Archives has no records to indicate whether loan was exhibited); Cincinnati Art Museum, *The Cincinnati Art Museum Photography Collection*, 1981-82; Cincinnati Museum of Natural History, *Audubon in Cincinnati*, 1985.

Bibliography: Shufeldt, R. W., and M. R. Audubon. "The Last Portrait of Audubon, together with a letter to his son." *The Auk*, XI, No. 4 (Oct. 1894), 309-11, illus. p. 308, pl. IX; Soucie, Gary. "Audubon by Brady." *Audubon*, 82, No. 3 (May 1980), 30, illus. color p. 31.

Although famous today for his collection of Civil War photographs, Mathew B. Brady was one of America's leading portraitists of the daguerrean era. During his career he photographed seventeen United States presidents from John Quincy Adams to William McKinley and recorded over one hundred images of Abraham Lincoln. An intuitive pictorial historian, he persuaded politicians, Union officers, actors, writers, and other celebrities to sit before his studio cameras. Around 1845 he conceived of *The Gallery of Illustrious Americans* modeled after James Longacre's *National Gallery of Distinguished Americans* issued between 1834 and 1839. Brady's *Gallery* was to feature a series of twenty-four biographical essays on eminent citizens by the art critic, Charles Edwards Lester, accompanied by lithographs after Brady's daguerreotypes made by New York's most prominent portrait lithographer, François D'Avignon. Although the *Gallery* received critical acclaim and brought national attention to Brady's work, public subscriptions to this ambitious business venture were disappointing; as a consequence, only twelve of the projected total were published in 1850. Among the individuals selected by Brady for his photographic coffee table book were Zachary Taylor, John C. Calhoun, Daniel Webster, Silas Wright, Henry Clay, John C. Frémont, John J. Audubon, William H. Prescott, Winfield Scott, Millard Fillmore, William E. Channing, and Lewis Cass.

Brady's daguerreotype of the naturalist and wildlife painter, John James Audubon (1785-1851), accompanied the seventh biographical essay by Lester in the *Gallery*. This is the only known photograph of the naturalist.

In 1839 the final volume of *Birds of America*, begun in 1830, was finally issued. Audubon immediately began work on *Quadrupeds of America* with his sons. By 1847, however, his powers had begun to fade. The uncompromising dramatic skylighting intensified the emotional impact of Audubon's toothless hawk-like visage, and suggested the former dynamism of the declining artist.

The details of Brady's early life and career are incomplete and inconsistent. He was born in 1823 or 1824 near Lake George, New York. He claimed to have learned daguerreotyping from S. F. B. Morse and John W. Draper. He opened his first New York studio in 1844 at 207 Broadway and established two opulent studios further up Broadway in 1853 and 1860. In 1858 he opened a studio in Washington D. C. under the direction of Alexander Gardner. Although myopic, Brady managed all aspects of the studio; he followed the standard practice of employing operators to prepare the plates and work the cameras, and assistants to do the processing. The daguerreotypes which carry his name have a consistency in style and quality. A portrait by Brady was a symbol of social arrival. In 1851 he received critical acclaim at the great Crystal Palace Exposition in London. His obsession to document the American Civil War ultimately led to financial ruin. In spite of the fact that the United States government finally purchased his negatives, he died penniless in New York in 1896.

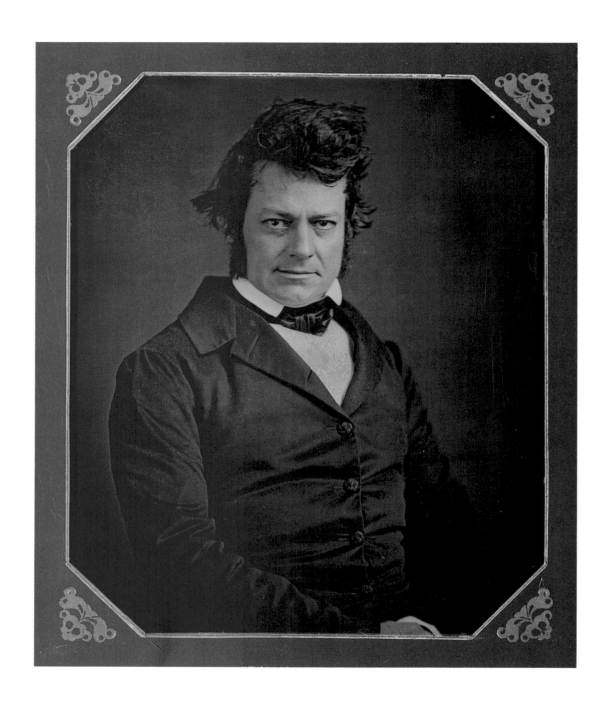

Unidentified Artist
American, 19th century

Edwin Forrest (1848). Daguerreotype, half-plate, 15.9 x 13.3 cm. Hallmark upper left: J. B. BINESSE & CO. N. Y. Protective backing inscribed with pencil: *Edwin Forrest / The Property of / James Landy / This picture was / presented to J. Landy / by his friend / S. S.* [Samuel Sherwood] *Smith Esq.;* / inscribed with pencil by Gustave von Groschwitz: *Probably French* (*B. N.* [Beaumont Newhall]) / *GvG*; label inscribed with pencil affixed to backing: *Edwin Forrest / 1848.*

Gift of Mrs. James M. Landy in memory of James M. Landy, 1899.32.

Provenance: S. S. Smith, Esq.; James M. Landy, Cincinnati, d. 1897; Mrs. James M. Landy, Cincinnati (from the estate of her husband, James M. Landy), 1897-99.

Exhibitions: Cincinnati Art Museum, *A Group of Portraits Exhibited in the Art Museum during the Summer of 1896,* p. 12, no. 574 [a], dated 1848; Cincinnati Art Museum, *The Cincinnati Art Museum Photography Collection,* 1981-82.

Edwin Forrest was America's first actor of international stature. Born in Philadelphia in 1806, at the age of seventeen he joined a strolling company in Pittsburgh and toured the river towns along the Ohio. According to the Cincinnati *Independent Press & Freedom Advocate,* on July 17, 1823, he played a Kentucky Negro, Cuffee, in one of the early black-face farces, *The Tailor in Distress, or a Yankee Trick.*[1] In 1823 Forrest made his New York debut in the role of Othello at the prestigious Park Theater. His mature style with its electrifying climaxes of passion was influenced by the British actor, Edmund Kean. The actor's bombastic speech and animal vigor in rendering Shakespearian tragedies, and his ardent interpretations of zealots struggling against tyranny, struck a responsive cord with theater-going audiences. In 1834, after establishing himself on the American stage, he took London by storm and captured the attention of Catherine Norton Sinclair (1818-1891), whom he married in 1837. His American homecoming brought further accolades as he continued to mesmerize audiences with his impassioned delineations of Lear, Richelieu, and Richard III.

While engaged at the National Theater in Cincinnati during the first two weeks of May 1848, an incident, as recorded in an affidavit, signaled the turning point in his domestic relations and culminated in a scandalous divorce three years later.

> When I entered my private parlor in the City Hotel, I preceded S. S. Smith, . . . who was with me, some yards, and found Mrs. Forrest standing between the knees of Mr. Jamieson, who was sitting on the sofa, with his hands upon her person. I was amazed and confounded, and asked what it meant. Mrs. Forrest replied, with considerable perturbation, that Mr. Jamieson had been pointing out her phrenological developments. Being of an unsuspicious nature, and anxious to believe that it was nothing more than an act of imprudence on her part, I was for a time quieted by this explanation.[2]

It was Forrest's discovery of a letter from George Jamieson written to her under the soubriquet of "Consuelo" in January 1849 that irrevocably shattered his confidence in his wife's fidelity and precipitated their separation. In December 1851 their sensational divorce trial, during which each party accused the other of flagrant infidelities, engrossed the attention of the civilized world. The trial's crowning blow was the verdict requiring alimony for his former spouse which he refused to pay.

In May 1849, shortly after his separation, Forrest's long smoldering feud with the "high brow" British actor William Macready erupted into a riot outside the Astor Place Opera House in New York, during Macready's farewell performance. The publicity from the professional and domestic crises packed the theaters. In his final years a partial paralysis slowed his strident gait as his fiery style was supplanted by a new generation of more genteel performers. Forrest died in 1872.

This half-plate daguerreotype was undoubtedly taken while the virile, vain, and fiercely independent actor was in his prime. Top and side lighting further accentuate his defiant gaze and spare smile. Of all the celebrity daguerreotypes owned by the Cincinnati photographer James M. Landy (1838-1897), this portrait in its distinctive black octagonal passe-partout mat with gold decorative corner embellishments, apparently never was reproduced as a mounted card. The plate carries the hallmark *J. B. Binsse & Co. N. Y.,* an American firm that was active between 1843 and 1847,[3] making Landy's date of 1848 credible.[4] The inscription suggests that the daguerreotype was once owned by the same S. S. Smith who testified on Forrest's behalf.

1. *Independent Press and Freedom Advocate,* 17 July 1823, p. 3, col. 3.
2. Richard Moody, *Edwin Forrest: First Star of the American Stage* (New York: Knopf, 1960), pp. 245-46.
3. Beaumont Newhall, *The Daguerreotype in America,* 3rd rev. ed. (New York: Dover, 1976), p. 119.
4. See Cincinnati Art Museum 1896 exhibition, no. 574 [a].

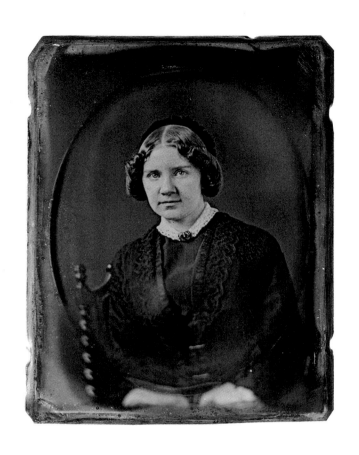

Thomas Faris

American, active 1841-1862

Jenny Lind (1851). Daguerreotype, quarter-plate, 10.6 x 8.1 cm.

Gift of Mrs. William Dodd (1900 loan converted to accession), 1981.181.

Provenance: Mrs. William Dodd, Cincinnati.

Exhibitions: Cincinnati Art Museum, *The Cincinnati Art Museum Photography Collection*, 1981-82.

On April 22, 1851, the *Cincinnati Daily Gazette* ran this story:

> *Jenny Lind and Faris.* – The "Nightingale" sat for her likeness to Faris on Saturday afternoon. Mr. Faris succeeded in getting a warm and life-like expression of the gifted woman who has set the world in such a *furor*. A good likeness is nothing unusual with our friend FARIS – "it's a way he has." There is no place of resort in this city which presents more numerous attractions than his gallery in the Melodeon Building. There can be found the "counterfeit presentments" of many familiar and distinguished citizens – as well as those of other portions of this country and Europe. Mr. FARIS has well won a high reputation in all the perfections of his beautiful art.[1]

The Swedish "Nightingale," Jenny Lind (1820-1887), gave five performances in the Queen City in 1851 between April 14 and 22. The enterprising showman P. T. Barnum (1810-1891) sponsored her concert tour to the United States in hopes of linking the "Barnum" name with culture. His flair for publicity put the talented soprano's voice and charitable donations on the tongues of Americans from New York and Boston to as far west as St. Louis. Perhaps Faris planted the story of Jenny Lind's portrait session in the *Cincinnati Daily Gazette*. Barnum would have been delighted to have the photographer advertise her visit to the Melodeon Gallery, for news about her of any sort fired the Jenny Lind mania which swept the country. After ninety-five concerts between September 1850 and June 1851, Lind parted company with Barnum whose profits exceeded half a million dollars. Under her own management, she presented a number of concerts on the east coast before returning to Europe in 1852.

In *The Camera and the Pencil*, the photographer Marcus Root credited Thomas Faris with the introduction of the daguerreotype to Ohio in 1841.[2] There are no documented records of where he worked prior to his arrival in Cincinnati. The *Williams' Cincinnati Directory* first records Faris in 1843 on Fifth Street between Main and Walnut as a partner in Hawkins and Faris.[3] Around 1846, Faris opened his own gallery at 175 Main Street, but by 1849 he had moved to the prestigious and elegant Melodeon building at the northwest corner of Fourth and Walnut where his Melodeon Gallery remained until 1857. The navy blue velvet pad opposite the daguerreotype in its case carries the inscription T. FARIS / MELODEON GALLERY. Prior to permanently relocating in New York City, he continued at the same address as a partner in Faris and Mullen in 1858 and Faris and Stillman in 1859. Faris was active in New York from 1858 to 1862

This quarter-plate daguerreotype presents a straightforward portrait of an intelligent, pious, yet plain woman. The Cincinnati Historical Society has a sixth-plate daguerreotype identical in all features. It is probably a copy daguerreotype, since it lacks the sharp definition and clarity of the museum's original.

1. *Cincinnati Daily Gazette*, 22 Apr. 1851, p. 3, col. 1.
2. M[arcus] A. Root, *The Camera and the Pencil: or the Heliographic Art* (Philadelphia: Lippincott; New York: Appleton, 1884), p. 360.
3. *Williams' Cincinnati Directory*, 1843, p. 155.

Unidentified Artist
American, 19th century

Henry Clay (by 1852). Daguerreotype, half-plate, 13.2 x 10.0 cm.

Annual Membership Fund, 1911.1375.

Provenance: Israel Quick, Cincinnati, d. 1901; F. M. Quick, Cincinnati (from the estate of his father Israel Quick, 1901; 1896 exhibition loan continued until purchased by museum in 1911).

Exhibitions: Cincinnati Art Museum, *A Group of Portraits Exhibited in the Art Museum during the Summer of 1896*, p. 12, no. 573 [a]; George Eastman House, Rochester, New York, 1949-60 (George Eastman House has no records to indicate loan was exhibited); Cincinnati Art Museum, *The Cincinnati Art Museum Photography Collection*, 1981-82.

Bibliography: Cotton, Bruce. *The American Heritage Picture History of the Civil War*. Ed. Richard M. Ketchum. New York: American Heritage Publishing, 1960, illus. p. 33.

Unidentified Artist
American, 19th century

Henry Clay (by 1852). Daguerreotype, quarter-plate, 10.5 x 8.1 cm.

Annual Membership Fund, 1911.1376.

Provenance: Israel Quick, Cincinnati, d. 1901; F. M. Quick, Cincinnati (from the estate of his father Israel Quick, 1901; 1896 exhibition loan continued until purchased by museum in 1911).

Exhibitions: Cincinnati Art Museum, *A Group of Portraits Exhibited in the Art Museum during the Summer of 1896*, p. 12, no. 573 [b]; George Eastman House, Rochester, New York, 1949-60 (George Eastman House has no records to indicate loan was exhibited); Cincinnati Art Museum, *The Cincinnati Art Museum Photography Collection*, 1981-82.

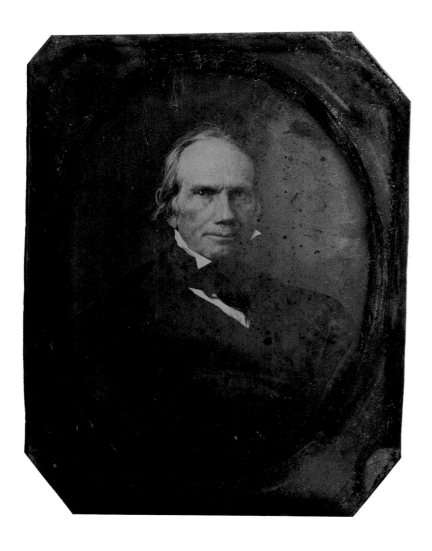

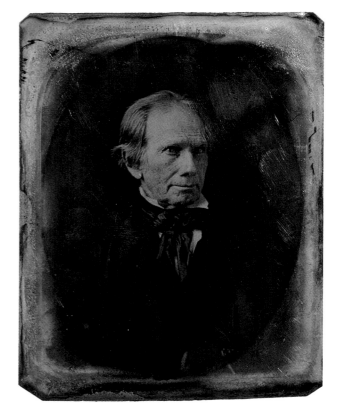

Unidentified Artist
American, 19th century

Daniel Webster (by 1852). Daguerreotype, quarter-plate, 10.5 x 7.9 cm.

Annual Membership Fund, 1911.1377.

Provenance: Israel Quick, Cincinnati, d. 1901; F. M. Quick, Cincinnati (from the estate of his father Israel Quick, 1901; 1896 exhibition loan continued until purchased by museum in 1911).

Exhibitions: Cincinnati Art Museum, *A Group of Portraits Exhibited in the Art Museum during the Summer of 1896*, p. 12, no. 573 [c]; George Eastman House, Rochester, New York, 1949–60 (George Eastman House has no records to indicate loan was exhibited); Cincinnati Art Museum, *The Cincinnati Art Museum Photography Collection*, 1981–82.

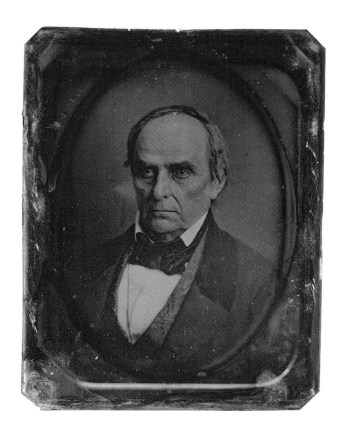

Henry Clay (1777–1852) and Daniel Webster (1782–1852), along with John C. Calhoun (1782–1850), were known as the "Great Triumvirate." By sheer force of personality they dominated the United States Senate in the second quarter of the nineteenth century. Each dreamed of becoming president. The daguerrean era coincided with their final struggles and exertions for that prize. Before their deaths in 1852, at the height of the daguerreotype, Clay and Webster probably posed for more camera operators than any other political celebrities of their day.

A conservative American statesman, Clay was one of the most important congressional leaders in the four decades preceding the Civil War. He was known as "The Great Compromiser" for his skill in mediating the question of slavery between the North and South. He served almost continuously in the House of Representatives, where as speaker, he pushed for the War of 1812 and promoted the Missouri Compromise of 1820. As a senator, between 1831 and 1842, he effected the Compromise Tariff of 1833 and returned to the Senate in 1849 where he masterminded the Compromise of 1850. He twice bid unsuccessfully as a Whig candidate for president in 1832 and 1844. These daguerreotypes capture the finely chiseled and weathered face of the elder statesman, yet they give no evidence of his grand gestures or actor's voice which made him a magnetic orator in an age that venerated oration.

Like Clay, Webster was a conservative politician and brilliant lawyer who practiced before the United States Supreme Court. He served as congressman between 1813 and 1827, and as a senator who advocated business interests from 1827 to 1850. He promoted the Compromise of 1850, denounced threats of secession by the South, and supported a strong fugitive slave law, which he enforced as secretary of state under Fillmore. Webster was a man of imposing presence with piercing, deep-set eyes and swarthy features.

Unfortunately the makers of these fine, previously unpublished daguerreotypes remain unidentified. The daguerreotypes' former owner, Cincinnati photographer and portrait painter Israel Quick (ca. 1830–1901), undoubtedly treasured their historic and aesthetic importance.

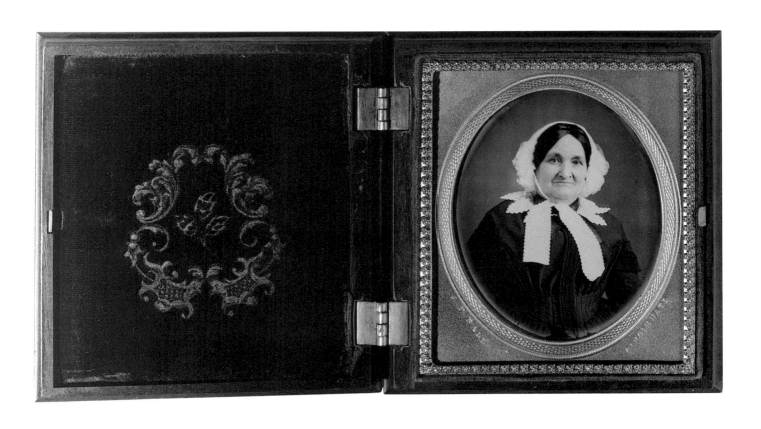

James Presley Ball

American, 1825-ca. 1902

Olivia Slocum Strong (mid-1850s). Hand-colored daguerreotype, sixth-plate, in "union" case, velvet-lined, 8.2 x 6.7 cm. Mat stamped lower left: *J. P. Ball*; lower right: CINCINNATI.

Gift of Mary O. E. Strong, 1923.1003.

Exhibitions: Cincinnati Art Museum, *The Cincinnati Art Museum Photography Collection*, 1981-82; Valencia Hollins Coar, *A Century of Black Photographers: 1840-1960*, Museum of Art, Rhode Island School of Design, Providence, and The Baltimore Museum of Art, 1983, pp. 16, 30, no. 1, illus.

In the antebellum 1850s, the most elaborate of Cincinnati's galleries was James P. Ball's Great Daguerrian Gallery of the West which opened in 1853. In April 1854 *Gleason's Pictorial Drawing Room Companion* carried a full-page story on the gallery owned by this successful and prosperous free black daguerreotypist.

> Balls' great Daguerrian Gallery of the West. . . . is located in Cincinnati, on Fourth Street, between Main and Walnut, in Weed's large building. It occupies four rooms and one ante-chamber, on the third, fourth and fifth stories. Two of these are operating rooms, each twenty-five by thirty, and fitted up in the best manner. One of these was prepared expressly for children and babies. . . . The third room is the workshop where the plates are prepared and likenesses perfected. . . . The fourth room is the great gallery; it is twenty feet wide by forty feet long. The walls are tastefully enamelled by flesh-colored paper, bordered with gold leaf and flowers. The panels on the south side and west end are ornamented with ideal figures. . . . The north wall is ornamented with one hundred eighty-seven of Mr. Ball's finest pictures. . . . Jenny Lind, with other distinguished personages, and five or six splendid views of Niagara Falls are among the collection. There are also six of Duncanson's finest landscapes hanging upon these walls as ornaments; . . . to cap the climax, there is a noble piano by whose sweet notes you are regaled, while the skillful operator is painting your face with sunbeams on the sensitive yet tenacious mirror. . . .[1]

James Presley Ball was born in Virginia in 1825.[2] His youth and early manhood were spent around Cincinnati or on the river. He learned daguerreotyping from the black Boston photographer, John B. Bailey, whom he met in Sulphur Springs, Virginia, in 1845. That fall he opened a one-room studio in Cincinnati which proved unprofitable. He became an itinerant photographer and traveled to Pittsburgh and Richmond, Virginia, in 1846, throughout Ohio in 1847-48, resettling in Cincinnati in 1849.[3] In 1851 he opened a gallery at 10 W. 5th Street and in 1853 he moved to 28 W. 4th Street. Here he employed "nine men in superintending and executing the work of the establishment. Each man has his own separate department, and each is perfect in his peculiar branch. . . ."[4] In March 1855 he exhibited *Ball's Mammoth Pictorial Tour of the United States. Comprising Views of the African Slave Trade; of Northern and Southern Cities; of Cotton and Sugar Plantations; of the Mississippi, Ohio and Susquehanna Rivers, Niagara Falls, and C.* The booklet accompanying this panorama presentation described it as being in

> length 600 yards, breadth 4; or 2400 square yards of canvas. This we take it is considerably longer and wider, than any other work of the kind. The sketches, (except the African views) were taken by the artist, upon the spots which they represent. . . . Each picture is a gem of itself. . . . Labor and expense have been disregarded in the effort to make the picture complete.[5]

In 1856 Ball traveled to Paris and London where he is said to have photographed Queen Victoria.[6] Financially overextended, he began a series of alliances with Robert Harlan, his brother-in-law Alexander Thomas, and finally his son, James Presley Ball, Jr., between 1857 and 1871. Over the years, his galleries offered ambrotypes, tintypes, cartes de visite, and cabinet cards as each new process became the craze. Upon leaving Cincinnati he practiced photography in Helena, Montana, Minneapolis, Minnesota, and Seattle, Washington, where he is last recorded in 1902.[7]

During the heyday of the daguerreotype, Ball's gallery was centrally located along the 4th Street promenade and was patronized by many of the best families of Cincinnati, white and black. Olivia Eliza Miller Slocum Strong was the wife of David E. A. Strong, who was associated with the drygoods wholesaler Blachley and Simpson. Based on the evidence of the pointed bodice and pleated skirt, this portrait was probably taken in the mid-1850s. The "union" case in which it is housed was patented in 1854 and the style of oval mat was popular between 1853 and 1855.[8] Olivia Strong, a robust woman, appears relaxed and confident before Ball's camera.

1. *Gleason's Pictorial Drawing Room Companion*, Apr. 1854, p. 208.
2. 1900 federal census for Montana: Enumeration District 173 (Helena), supplied by the Montana Historical Society, Helena, Montana.
3. James P. Ball, *Ball's Mammoth Pictorial Tour of the United States* (Cincinnati: Pugh, 1855), n. pag.
4. *Gleason's*, p. 208.
5. Ball, n. pag.
6. *Daily Commercial* [Cincinnati, OH], 12 Jan. 1857, p. 2, col. 7.
7. *Seattle Republican*, 13 June 1902, p. 4.
8. Floyd Rinhart and Marion Rinhart, *The American Daguerreotype* (Athens: Univ. of Georgia Press, 1981), pp. 313-15.

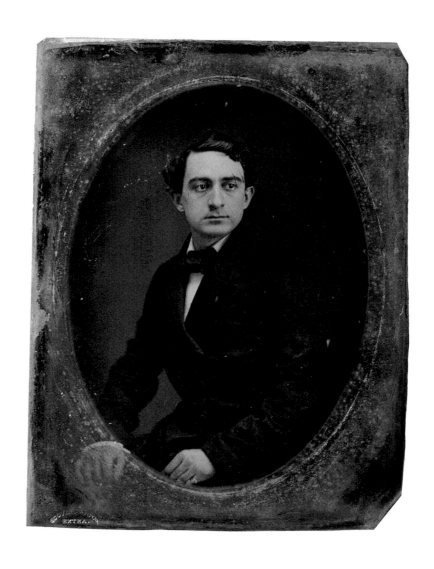

Unidentified Artist
American, 19th century

Edwin Booth (1856). Daguerreotype, half-plate, 13.5 x 10.1 cm. Hallmark lower left: SCOVILL MFG. CO. / EXTRA.

Gift of Mrs. James M. Landy in memory of James M. Landy, 1899.31.

Provenance: James M. Landy, Cincinnati, d. 1897; Mrs. James M. Landy, Cincinnati (from the estate of her husband, James M. Landy), 1897-99.

Exhibitions: Cincinnati Art Museum, *A Group of Portraits Exhibited in the Art Museum during the Summer of 1896*, p. 12, no. 574 [k], dated 1856. George Eastman House, Rochester, New York 1949-60 (George Eastman House has no records to indicate loan was exhibited); Cincinnati Art Museum, *The Cincinnati Art Museum Photography Collection*, 1981-82.

Bibliography: Skinner, Otis. *The Last Tragedian: Booth Tells His Own Story*. New York: Dodd, Mead, 1939, illus. opp. p. 38. (Although there is no picture credit, the illustration shows the identical flaws found in the original and its caption reads, "from daguerreotype taken 1856."). Kimmel, Stanley. *The Mad Booths of Maryland*. New York: Dover, 1969, illus., opp. p. 108. (Reproduction from a photograph in the author's collection. The original was probably a cabinet-mounted photographic reproduction taken from the original daguerreotype).

The fourth son of the great tragic actor, Julius Brutus Booth, Edwin Booth (1833-1893) apprenticed in the wings and as a stand-in for his unreliable father. During the summer of 1852, he accompanied his aging father on a tour of California's gold mining camps. When his father returned home, Edwin stayed on as a vagabond player. Performing opposite such leading ladies as Catherine Sinclair (Forrest) in San Francisco and Sacramento, and Laura Keene on an Australian tour, he acquired the experience and poise of a mature actor. In 1856, at the age of twenty-three, Booth returned to the east coast to conquer the stages of Boston and New York.

This half-plate daguerreotype taken in 1856 reveals a self-assured and determined young tragedian hailed by theater-going audiences as "the hope of living drama." His characterizations, unlike the melodramatic blood and thunder interpretations of the elder Edwin Forrest, represented an innovative naturalism combining spiritual and intellectual depths. Although he triumphed on the stage in such tragic roles as Hamlet, Richard III, and King Lear, he suffered numerous personal calamities: the deaths of both his wives; the scandalous assassination of President Lincoln by his younger brother, John Wilkes Booth, in 1865; and the bankruptcy of Booth's Theater in New York in 1874.

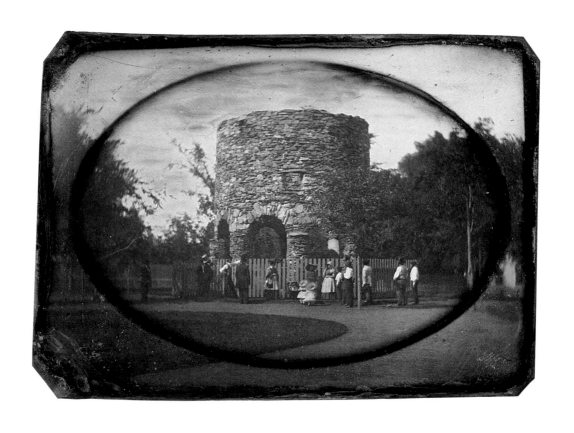

Charles Rees
American, active mid-1850s

Old Mill, Newport, R.I., 1857. Daguerreotype, half-plate, 10.0 x 13.3 cm. Scratched on verso of daguerreotype plate: *Old Mill at Newport R. I. / taken by Charles Rees in 1857 and / presented by him to J. Landy same year.*

Gift of Mrs. James M. Landy in memory of James M. Landy, 1899.35.

Provenance: James M. Landy, Cincinnati, d. 1897; Mrs. James M. Landy, Cincinnati (from the estate of her husband, James M. Landy), 1897-99.

Exhibitions: George Eastman House, Rochester, New York, 1949-60 (George Eastman House has no records to indicate loan was exhibited); Cincinnati Art Museum, *The Cincinnati Art Museum Photography Collection*, 1981-82.

During the nineteenth century, the Old Mill was a favorite tourist landmark in Newport, Rhode Island. Although popularly believed to have been built by Viking explorers or Celts from Ireland, current archeological evidence indicates it was built around 1680 as a mill for Benedict Arnold (1615-1678), thrice colonial governor of Rhode Island.

Charles Rees and Rees & Co. were listed in the New York City directories at 289 Broadway in 1853-54 and uptown at 385 Broadway in 1854-55. Rees probably took this half-plate daguerreotype while passing through Rhode Island since his name does not appear in the Newport directories. The scratched inscription on the verso of the daguerreotype plate attests to Rees's friendship with the precocious nineteen-year-old daguerreotypist, James M. Landy, who was in charge of the operating rooms at Meade Brothers at 233 Broadway in New York City in 1857.[1]

1. Sandra Roff, Letter to KS, Apr. 1982.

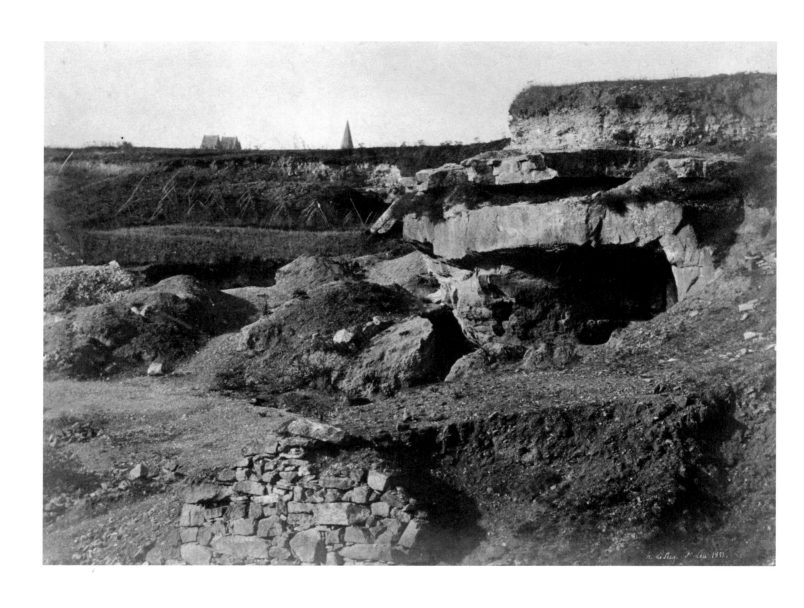

Jean-Louis-Henri Le Secq Destournelles
French, 1818-1882

The Quarries of St. Leu d'Esserent, 1851. Salted-paper print from waxed-paper negative, 23.1 x 31.0 cm on mount 34.8 x 46.3 cm. Inscribed on negative lower right: *h. Le Secq. St. Leu 1851*; Pencil by another hand on mount in lower left: *View near St. Leu 7/6*; Lower right: *Le Secq.*

Museum Purchase: Gift of Susan D. Bliss, by exchange, 1982.84.

Provenance: Thackrey and Robertson, San Francisco.

Henri Le Secq was one of the early masters of the French calotype. He studied in the atelier of the academic beaux-arts painter Paul Delaroche along with Gustave Le Gray, Charles Nègre, and probably Roger Fenton. He made his salon debut in 1842 and continued to exhibit paintings on a regular basis until his death. In the late 1840s he learned Le Gray's waxed-paper process (*papier ciré sec*). In 1851, he was a founding member of the Société Héliographique. Along with Édouard-Denis Baldus, Hippolyte Bayard, Le Gray, and O. Mestral, Le Secq was appointed in 1851 as a photographer for a Mission Héliographique to document French monuments threatened by decay and neglect. The Commission des Monuments Historiques assigned Le Secq the antique and medieval architecture in Champagne, Alsace, and Lorraine. The following year he photographed the sculpture of Chartres, Rheims, and Strasbourg cathedrals. At the same time he turned to landscape and recorded the stone quarries and forests around Montmirail. Around 1856, after producing an impressive group of still lifes, he abandoned photography to paint and collect antiquarian ironwork rather than take up the new wet-collodion process.

In 1851 Le Secq made a series of photographs of the quarries of St. Leu d'Esserent. There are other views taken the same year in the collections of André Jammes and the George Eastman House.[1] The *Quarries of St. Leu d'Esserent* has Le Secq's distinctive use of dramatic chiaroscuro which transfuses the landscape with vigor. The pockets of shadows and irregular land formations structure the composition abstractly. Eugenia Janis contends: "Le Secq pushed to an extreme the descriptive reticence of waxed paper and its potential for murky effects through long exposures."[2] This impression shows some of the yellowing which is typical of the unstable salted-paper process he used. The Bibliothèque du Musée des Arts Décoratifs, Paris, has three impressions from this negative; all, however, are cropped immediately above the inscription.[3]

1. See André Jammes and Robert Sobieszek, *French Primitive Photography* (New York: Aperture, 1970), no. 90, and Robert Sobieszek, *Masterpieces of Photography from the George Eastman House Collection* (New York: Abbeville Press, 1985), pp. 72-73.

2. André Jammes and Eugenia Parry Janis, *The Art of French Calotype* (Princeton: Princeton Univ. Press, 1983), p. 208.

3. Eugenia Parry Janis and Josiane Sartre, *Henri Le Secq. Photographe de 1850 à 1860* (Paris: Flammarion, 1986), p. 162, cat. no. 482.

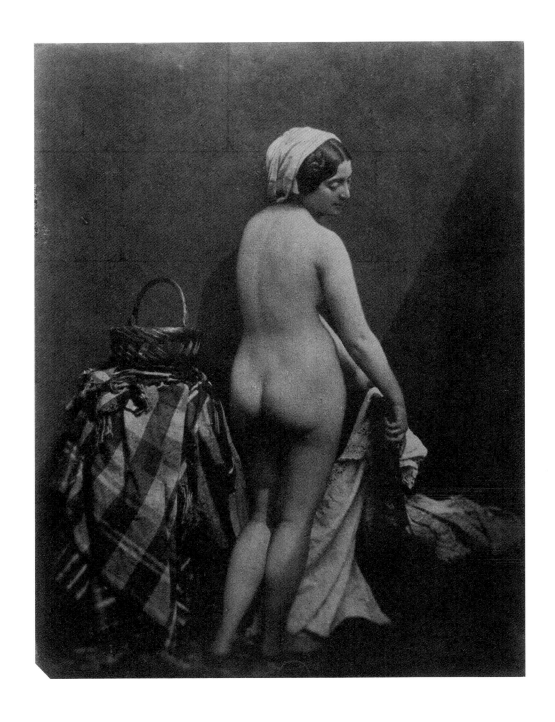

Julien Vallou de Villeneuve

French, 1795-1866

Study from Nature (ca. 1851). Salted-paper print from waxed-paper negative, 17.6 x 13.0 cm on mount 35.9 x 27.9 cm. Printed on mount lower center: ÉTUDE D'APRÈS NATURE/ (pencil) *1931*; lower left to lower right: *Photog. par J. Vallou de Villeneuve. r. Bleue, 18. Déposé Imp. de Lemercier, Paris*; oval stamp in red, 1/2 on print in lower center: BIBLIOTH. NATIONALE / EST; rectangular stamp in red lower right: DÉPÔT LÉGAL / *Seine / no. 7075* / (pencil) *1854*; verso oval exchange stamp in blue: *Echange / no. 2072* (pencil)

Museum Purchase: Gift of Emilie L. Heine in memory of Mr. and Mrs. John Hauck, by exchange, 1983.509.

Provenance: Bibliothèque Nationale duplicate, Lugt 248 and 668; Janet Lehr, Inc., New York (from Bibliothèque Nationale).

In the early 1850s, despite protests from the virtuous, photographs of nudes proliferated discreetly under the guise of studies for artists. Among the artists who produced some of the finest *academies* or nude studies during the Second Empire was Vallou de Villeneuve. Aaron Scharf observes:

> As a painter and lithographer in the 1820s and 1830s he enjoyed an international reputation through his large lithographic productions of *Les jeunes femmes*, a series of anaemic, erotic scenes of feminine intrigue and despair, of would-be lovers hidden in boudoirs and other piquant episodes in the daily life of the young female. . . .[1]

Although he turned to photography – probably the daguerreotype – in 1842 in order to facilitate the production of his popular subjects, no examples of his popular pornography are known. By 1853 Vallou de Villeneuve had mastered the paper-negative process and produced his *Études d'après nature* containing nudes and draped models to supply artists with information and voyeurs with pleasure. These small-scale salted-paper prints were meant to be studied in albums. Printed by the lithographer Lemercier, they were among the flood of nude images filed with the Dépôt Légal at the Bibliothèque Nationale in 1854. In addition, Vallou de Villeneuve did portraits of actors and actresses. He was a member of the Société Héliographique and the Société Française de Photographie during their formative years.

Vallou de Villeneuve's models forcefully impose their physical presence. His thoughtfully framed subject is brought into a coherent compositional whole by the use of chiaroscuro. The carefully orchestrated skylight, simple setting, and selected accessories reinforce the pose and graphic idea. These qualities distinguish the nudes of Vallou de Villeneuve from those of his contemporaries Eugène Durieu and B. Braquehais. Not only did Vallou de Villeneuve

> offer models in poses that conformed to the existing repertoire of subjects in painting; he invented new conceptions of the nude. . . . suited to artists who wished to liberate the nude from the stock classical rhetoric and the theatrics of literary Romantic narrative and situation. . . .[2]

The understated eroticism of his columns of flesh attracted the attention of the painter Gustave Courbet. Vallou de Villeneuve's inspiration can be seen in Courbet's paintings of the *Woman Bathing* (1853) and *The Artist's Studio* (1855).

This figure study from *Études d'après nature* acknowledges the established conventions of figure painting promoted by the École des Beaux-Arts. The unifying illumination reiterates the contraposto stance of the figure. The mildly erotic nude pays homage to J. A. D. Ingres and paintings such as *Bathers of Valpinçon* (1808).

1. Aaron Scharf, *Art and Photography* (Baltimore: Lane, 1969), p. 98.
2. Eugenia P. Janis, *The Second Empire: Art In France Under Napoleon III* (Philadelphia: Philadelphia Museum of Art, 1978), p. 433.

Félix Teynard

French, 1817-1892

Idfu, General View of the Town from the Central Platform of the Pylon (ca. 1851). Pl. 77 from *Egypte et Nubie. Sites et monuments les plus intéressants pour l'étude de l'art et de l'histoire.* Salted-paper print from paper negative, 30.8 x 25.1 cm.

Museum Purchase: Gift of Emilie L. Heine in memory of Mr. and Mrs. John Hauck, by exchange, 1982.82.

Provenance: Thackrey and Robertson, San Francisco.

The photographic pictures in the three parts now before us are on a larger scale than those that previously came into our hands [Du Camp], and are far more successful results of the process that created them. The views, generally, are also of more interesting subjects, speaking artistically, though to the antiquarian they may not be regarded as of less import. . . . [The photographs exhibit] the perfection to which the art of photography has at present reached: if the painter can throw into his picture all the fascinations, which colour, taste in the selection of material, and judicious arrangement place at his disposal; he must yield to the photographic camera the palm of accurate and minute delineation. . . .[1]

This unsigned review comparing the photographs of Maxime Du Camp unfavorably with those of Félix Teynard appeared in *The Art-Journal* in 1853. Teynard, a civil engineer, traveled to Egypt and Nubia in 1851 and again in 1869. Second only to Du Camp's *Egypte, Nubie, Palestine et Syrie* (1853), Teynard's *Egypte et Nubie. Sites et monuments les plus intéressants pour l'étude de l'art et de l'histoire* was an ambitious single-minded undertaking with the paper negative process. The Parisian printer, H. de Fonteny, prepared 160 salt prints from paper negatives taken in 1851-52. These were issued in thirty-two fascicles of five plates each in 1853 and 1854 by Goupil et Cie. in Paris and Gambart et Co. in London.[2] *Egypte et Nubie* contained extended text describing the history of the monuments shown in each plate and an introduction which discussed archaeology, architecture, history, and geography. The complete work in two volumes sold for one thousand francs.

The photographs depict buildings from a variety of periods, views of the Nile, and the Fellahs' miserable dwellings. Teynard's large-format images spontaneously record the drama of light and shadow which must have dazzled his eyes. He assigns a prominent role to shadows and their bizarre formations. The patterns of shadow create a syncopated rhythm which animates the landscape. *Edfou* appears as Plate 77 in *Egypte et Nubie.*[3]

1. Review of *Egypte et Nubie: Sites et Monuments les plus intéressants pour l'etude de l'art et de l'histoire, The Art-Journal*, 1 Sept. 1853, p. 235.

2. André Jammes and Eugenia Parry Janis, *The Art of French Calotype* (Princeton: Princeton Univ. Press, 1983), p. 249.

3. Bernard Marbot, Letter to KS, 9 Dec. 1986. According to Marbot this subject appears as pl. 77 in the Bibliothèque Nationale copy with the title *Edfou, aspect général de la ville vue de la plateforme centrale du pylône*. In the British Museum copy, "Edfu" appears as pl. 77. Miriam Stead, Letter to KS, 25 Mar. 1987.

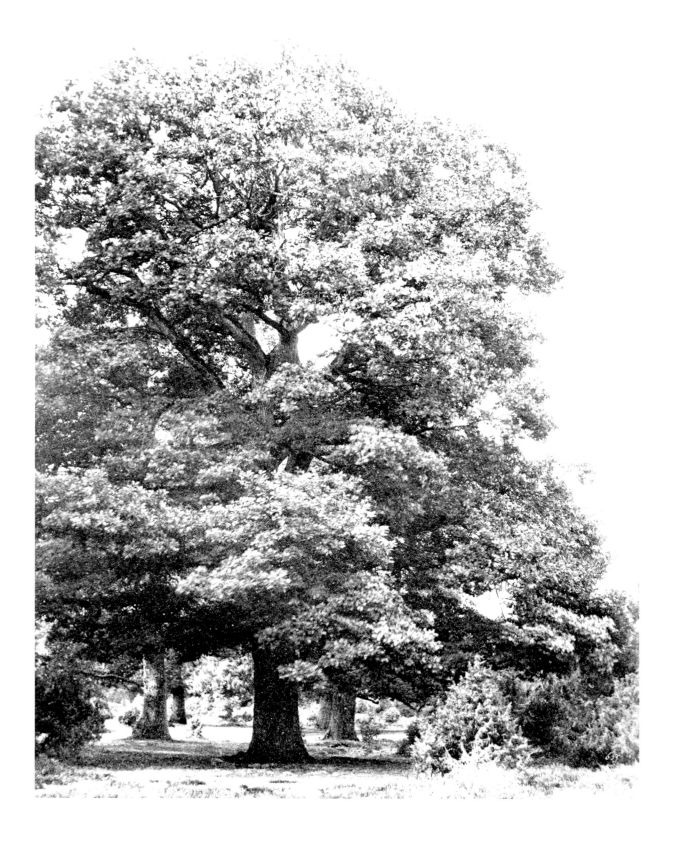

Charles Marville

French, 1816–ca. 1879

Tree (ca. 1852). Albumen print from paper negative ca. 1855, 33.8 x 25.3 cm on album sheet 49.9 x 36.4 cm. Number on negative lower right: 655; hidden rectangular blind stamp left center image: MARVILLE / PHOTOGRAPHE / PARIS.

Museum Purchase: Gift of John Sanborn Connor, by exchange, 1981.134.

Provenance: Gérard Lévy, Paris; Daniel Wolf, Inc., New York.

Exhibitions: Cincinnati Art Museum, *The Cincinnati Art Museum Photography Collection*, 1981–82.

During the Commune of 1871, the Paris Hôtel de Ville (City Hall) was destroyed by fire, and most personal and municipal documents relating to Charles Marville were lost. Electoral rolls record his date of birth as July 18, 1816.[1] He may have died outside the capital since his name does not appear in death records maintained in Paris after 1871. On September 20, 1879, his atelier was sold, suggesting that he died about that time.[2] In the 1830s and 1840s, prior to becoming a professional photographer, Marville was an illustrator and a painter-engraver. His first photographs are dated 1851. When and from whom he learned photography is not known. Between 1851 and 1855 he had an ongoing association with Blanquart-Evrard whose newly founded publishing house specialized in printing photographs. Blanquart-Evrard used over one hundred of Marville's architectural and landscape images in ten of his albums. Two of the albums, *Études Photographiques* (1853) and *Études et paysages* (ca. 1854) have incomparable studies of trees printed from calotype negatives.[3] Around 1856 Marville shifted, as did many photographers, to the wet-collodion glass plate negative. Marville used this new process in 1856 to record the baptismal ceremony of the Prince Imperial along with Mayer and Pierson, and Victor Plumier. Not only did he photograph events, but he reproduced works of art in the Louvre, documented historic restorations, and recorded the construction of the new Opéra. Today he is remembered for his methodical photographic survey of the old districts of Paris before Baron Haussmann's massive urban renewal project carved streamlined boulevards through the medieval cobbled byways romanticized in Victor Hugo's novels. Although he did not join the Société Française de Photographie, his work was exhibited in the Exposition Universelle of 1867 and 1878.

In his tree subjects, Marville explored an infinite variety of light and shadow, and figure-ground relationships. The waxed-paper negative permitted greater clarity and more translucency to describe light-struck leaves and deep shadows. This piece carries a hidden identifying mark. André Jammes has suggested that this previously unrecorded subject may be one of the trees in the Bois de Boulogne which was annexed to Paris in 1852. Marville contrasts the massive size of the venerable old tree against the light-mottled leaves which seem to disappear at the top. The airy peepholes to the sky and the allusion to the distant landscape are in marked contrast to the impenetrable shadows. It has been suggested that this new vision of nature through calotype landscape photography led innovative painters toward impressionism.

1. Marie de Thezy, "Charles Marville: Photographer of Paris between 1851 and 1879," trans. by Lorain Grandberg, in *Charles Marville: Photographs of Paris at the Time of the Second Empire*, ed. Jacqueline Chambord (New York: French Institute/ Alliance Française, 1981), p. 65.
2. Thezy, p. 65.
3. Isabelle Jammes, *Blanquart-Evrard et les origines de l'édition photographique Française: Catalogue raisonné des albums photographiques édités 1851-1855* (Geneva: Dorz, 1981), pp. 187-88, 195.

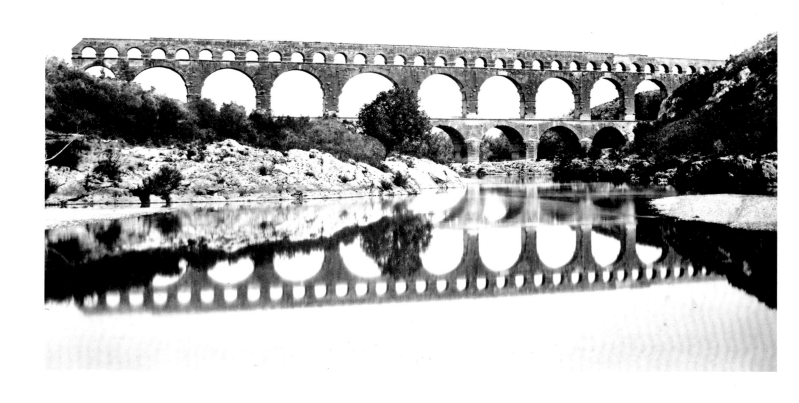

Édouard-Denis Baldus
French, b. Prussia, 1813-ca. 1890

Pont du Gard, Provence, (ca. 1852-53). Albumen print late.1860s, 19.2 x 28.0 cm on trimmed album sheet 31.2 x 40.3 cm. Artist's signature stamped in black on album sheet lower right: *E. Baldus*; title with pen and black ink on album sheet lower left: *Pont du Gard / Provence.*

Museum Purchase: Gift of H. Tracy Balcom, by exchange, 1978.250.

Provenance: Thackrey and Robertson, San Francisco.

Exhibitions: Cincinnati Art Museum, *The Cincinnati Art Museum Photography Collection*, 1981-82.

Édouard-Denis Baldus's monumental style exalted the expansionism of the Second Empire and celebrated the architectural heritage of France. Born in Prussia, June 5, 1813, he died around 1890.[1] Between 1842 and 1850 he exhibited paintings in four Paris Salons. His first dated photograph is from 1849. A founding member of the Société Héliographique in 1851, his career as an architectural photographer was advanced when the Commission des Monuments Historiques chose him for a Mission Héliographique along with Bayard, Le Gray, Le Secq, and O. Mestral to document imperiled classical and medieval architecture. Baldus's itinerary took him to Fontainebleau, Burgundy, through the Rhône Valley, and to Nîmes. The following year he received additional assignments in the Midi and subsequently he was assigned priority status as a photographer for Provence. Other governmental projects he undertook included documenting the sculpture and architectural motifs of the new wing of the Louvre (1854-56) and the floods of the Rhône (1856). Baron James de Rothschild commissioned several commemorative photograph albums as the railroad opened new lines to Boulogne (1855), and to Lyon and the Mediterranean (1859). From 1854 through the end of the Second Empire, Baldus exhibited in every important international photography exhibition and almost all of the exhibitions of the Société Française de Photographie of which he became a member in 1857.

Baldus was proficient with both paper and glass negatives. He devised a method of using gelatin-imbibed paper which yielded clarity comparable to the collodion negative with almost no evidence of paper fibers. This view of *Pont du Gard* was probably taken in 1852-53, before Baldus began using the wet-collodion negative. For this subject Baldus has extracted the absolute limit from the paper negative. He parlays the simple composition of the Roman aqueduct's impressive span and its reflection into a powerful abstract image of spatial grandeur. *Pont du Gard* appeared as Plate 32 in *L'Album des Chemins de fer de Paris à Lyon et à la Mediterranée* (1856).[2]

1. Philippe Néagu and Françoise Heilbrun, "Baldus: Paysages, Architectures," in *Photographies*, No. 1 (Spring 1983), pp. 57, 77.
2. Gordon Baldwin, Letter to KS, 16 Jan. 1987. The J. Paul Getty Museum has two copies of this album in which this subject appears as pl. 32. It is also pl. 32 in the International Museum of Photography at the George Eastman House album.

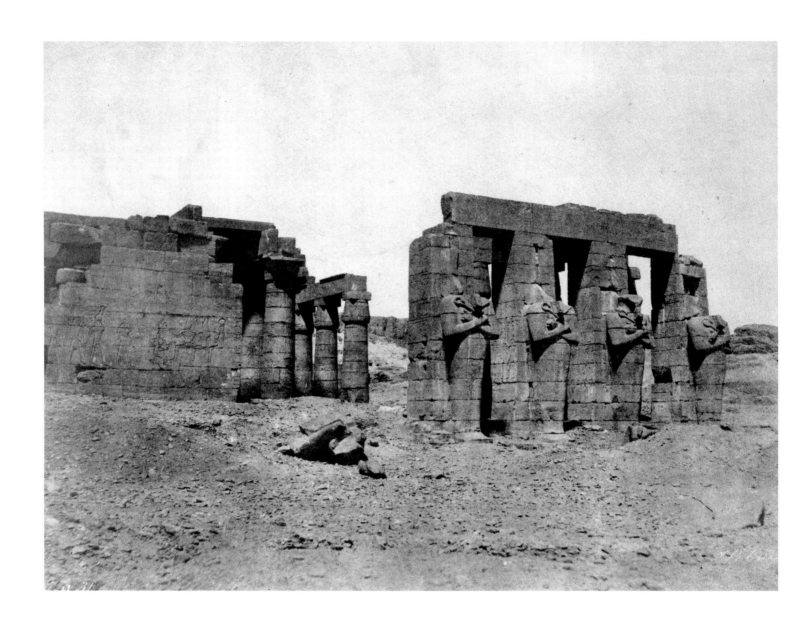

John Bulkley Greene
American, ca. 1832-1856

Ramesseum in Thebes (1853-54). Pl. from *Le Nil. Monuments. Paysages. Explorations photographiques.* Blanquart-Evrard process (salted-paper print from waxed-paper negative), 22.6 x 29.0 cm on album sheet 33.6 x 43.0 cm. Inscribed on negative lower left: *M 31*; Lower right: *J. B. Green[e].*

Museum Purchase: Bequest of Adele O. Friedman, by exchange, 1982.79.

Provenance: Robert Koch, Inc., Berkeley.

John Bulkley Greene was the first American Egyptologist abroad to make aesthetically and historically significant photographs at the height of the calotype era. Born around 1832, he was the son of an American banker based in Paris. In 1857 at the first annual meeting of the Société Française de Photographie of which Greene had been a founding member (1854), Eugène Durieu remarked:

> The President is sorry to report to the Society the recent loss of one of its foreign members, Mr. John Greene, who died last November at the age of 24. Mr. John Greene had made some very interesting journeys in Egypt and Algeria and had brought back many beautiful and remarkable pictures, of which some are exhibited in the halls of the Society.[1]

Although it is not known from whom Greene learned photography in the early 1850s, he used Le Gray's waxed-paper negative for his salted-paper prints. Without rights to excavate on his first journey to Egypt in 1853-54, he spent his time photographing. On his second trip in 1854 he received permission to excavate Deir-el-Bahari and Thebes. His photographs were shown at the Paris Exposition Universelle in 1855. Although Greene hoped that his health would improve, his third trip to the Near East in 1856 proved fatal to his brilliant career.

In 1854, the most important French printer and publisher of paper negative photographs, Louis-Désiré Blanquart-Evrard, issued *Le Nil. Monuments. Paysages. Explorations photographiques* containing a selection of about 94 calotypes chosen from approximately 200 taken on Greene's first Egyptian trip. This splendid illustrated album was preceded by Maxime Du Camp's *Egypte, Nubie, Palestine et Syrie* (1852), also printed by Blanquart-Evrard. A businessman and chemist, Blanquart-Evrard discovered a variation on Talbot's salted-paper process. The Blanquart-Evrard process chemically developed the paper positive rather than printing it out, thus reducing the exposure time. He established his Imprimerie Photographique near Lille in 1851 and promoted the advance of the calotype in France in the early 1850s.

This view of the funerary temple of Ramses II in Thebes (known as the Ramesseum) taken in 1853-54, shows the hypostyle hall with statues of Osiris facing the second courtyard. Its uniform steely gray color is typical of the Blanquart-Evrard process. It is signed in the negative and carries Greene's negative notation *M 31* which can generally be deciphered as *Monuments 31* (P for *Paysages* [landscapes]). This subject appears in *Le Nil.*[2] The album contained from ninety-two to ninety-six plates divided equally between monuments and landscapes.[3] In addition this image appears in a unique album, *Monuments et Paysages de la Nubie et de la Haute Egypte*, as Plate 29 with the title *Thèbes, Colosses du Memnonium; massif de gauche* which the photographer gave to the Bibliothèque de l'Institut de France.[4]

1. Bruno Jammes, "John B. Greene, An American Calotypist," *History of Photography*, 5, No. 4 (Oct. 1981), 305.
2. Bernard Marbot, Letter to KS, 11 Nov. 1986.
3. Jammes, p. 309.
4. Françoise Dumas, Letter to KS, 14 Oct. 1986.

Chærophyllum vasculata

Anna Atkins

British, 1799-1871

Myrrhis odorata (ca. 1854). Pl. from *Cyanotypes of British and Foreign Flowering Plants and Ferns*. Cyanotype, 34.2 x 24.2 cm on album sheet 46.7 x 37.2 cm. Handwritten label by another hand lower center: *Myrrhis odorata*; Watermark: *J. Whatman/Turkey mill*.

The Albert P. Strietmann Collection, 1985.21.

Provenance: Zeitlin and Ver Brugge, Los Angeles.

In the introduction to her *British Algae: Cyanotype Impressions*, Anna Atkins wrote:

> The difficulty of making accurate drawings of objects so minute as many of the Algae and Confervae, has induced me to avail myself of Sir John Herschel's beautiful process of Cyanotype, to obtain impressions of the plants themselves, which I have much pleasure in offering to my botanical friends.[1]

The details of Anna Atkins's life are sketchy since few personal or official documents have been located. She was born on March 16, 1799, in Tonbridge, Kent, to John George Children and Hester Anne Holwell, who died of childbirth complications. Atkins enjoyed a close relationship with her father, a highly respected scientist and secretary to The Royal Society, who fostered her study of science and facilitated her contacts within the tight-knit British scientific community in an era when women were not expected to contribute seriously to science. In 1825 she married John Pelly Atkins, a county sheriff, railway promoter, and plantation owner who was supportive of her scientific activities throughout their childless marriage.

Through her father who sat on The Royal Society's Committee of Papers, Anna Atkins followed Daguerre's sensational announcement of his photographic discovery, and more important for her own work, William Henry Fox Talbot's revelation of the photogenic drawing process. Mr. Atkins chaired the February 21, 1839, meeting where Talbot disclosed his process. Sir John Herschel, the inventor of the cyanotype, sent Children a copy of his paper published in 1842.[2]

Anna Atkins boldly pioneered the first photographically illustrated book using Herschel's cyanotype process. The prints in her privately published *British Algae: Cyanotype Impressions* (1843-53) preceded and have outlasted William Henry Fox Talbot's commercially produced *Pencil of Nature* (1844-46). *Myrrhis odorata* is a plate from *Cyanotypes of British and Foreign Flowering Plants and Ferns*, her most ambitious presentation album, given to her childhood friend and probable collaborator, Anne Dixon, in 1854.[3] Plates from this album, which was disbanded after it was sold at auction in 1981, were disbursed into collections including those of Hans P. Kraus, Jr., the Victoria and Albert Museum, and The J. Paul Getty Museum.[4] As with all of her subjects, the dried fern specimen, *Myrrhis odorata*, was thoughtfully arranged on the sensitized paper. The result was a brilliant Prussian blue cameraless image which was scientifically useful and aesthetically appealing

1. Larry J. Schaaf, *Sun Gardens: Victorian Photographs by Anna Atkins* (New York: Aperture, 1985), p. 13.
2. Scharf, p. 25.
3. Scharf, p. 35-36, 44.
4. Scharf, p. 44.

Nadar (Gaspard-Félix Tournachon)

French, 1820-1910

Sigismund Thalberg, (ca. 1854-60). Salted-paper print from waxed-paper negative, 20.7 x 14.9 cm. Inscribed with pencil on verso: *Thalberg / pianiste.*

Museum Purchase: Gift of Mrs. James Morgan Hutton, by exchange, 1978.252.

Provenance: Helios, Arts Inc., New York.

Exhibitions: Cincinnati Art Museum, *The Cincinnati Art Museum Photography Collection*, 1981-82.

During the second half of the nineteenth century, Nadar's notorious exploits and exuberant personality made him the most colorful photographer in France. Gaspard-Félix Tournachon was born in Paris on April 5, 1820, and died in the same city on March 21, 1910. A man of many talents, he was a journalist, caricaturist, and aeronaut, but foremost a portrait photographer. He took his pseudonym Nadar from *tourne à dard* (bitter sting), the nom d'artiste assigned to his caricatures which he began selling in 1842. In 1854 he released the first in a series of *Panthéon Nadar*, lithographs featuring prominent personalities of the day. His interest in photography seems to have been sparked by his efforts to establish his younger brother, Adrien Tournachon, in a lucrative career in 1853 and by his use of photographs in preparing his *Panthéon*. He took photographic lessons in January 1854 and immediately set up a studio on the roof of his home at 113, rue Saint-Lazare, where he invited artistic and intellectual friends for portrait sittings. A short-lived collaboration with his brother eventually lead to a lawsuit in 1855 forcing Adrien to drop the use of the pseudonym "Nadar jeune."

Nadar exploited his natural gift for publicity and self-promotion in 1858 when he made the first aerial photograph of Paris from his giant balloon *Le Géant*. Honoré Daumier ridiculed this milestone in 1862 with a lithograph *Nadar elevates photography to the height of art*. During 1861-62, Nadar pioneered the use of artificial lights to photograph the sewers and catacombs of Paris. A successful entrepreneur, he moved his studio to larger quarters at 35, boulevard des Capucines in 1860 where he emblazoned the front of the building with his signature in red letters. His last innovation was a photo-interview with the centenarian scientist Michel-Eugène Chevreul, "On the Art of Living A Hundred Years," photographed by his son Paul. After a decade, the shift in public demand for mass-produced cartes de visite introduced by Disderi using Archer's wet-collodion process, and Nadar's growing passion for aeronautics, led him to abandon photography and leave the operation of the studio to others. In 1871 he turned the business over to his son Paul.

Nadar's portrait of Sigismund Thalberg (1812-1871) was executed during his rue Saint-Lazare period rather than 1852, as Nigel Gosling suggests, which would have made it his earliest work.[1] His portraits of the intelligentsia are relaxed and spontaneous without traces of the satire by which he won his name. Nadar favored spartan three-fourth views unencumbered by studio props. He used high, natural side lighting against a neutral background to bring out the essentials of the sitter's character. The subtle gradation of halftones which remained transparent in shadow areas was characteristic of the salted-paper technique. Thalberg was a virtuoso Austrian pianist and composer whose popularity rivaled that of Franz Liszt in the 1830s.

1. Nigel Gosling, *Nadar* (New York: Knopf, 1976), p. 246. Pascal Gauthier, Letter to KS, 31 Mar. 1987. According to Gauthier, the illustration was made from a *contretype* copy negative print (NA 238/20950). The Caisse Nationale des Monuments Historiques et des Sites, Paris, has a variant pose (NA 237/488) which they date ca. 1860.

Louis-Auguste Bisson and Auguste-Rosalie Bisson, called Bisson frères

French, 1814-1876 and 1826-1900

Bourasque au Mont Blanc – Vue prise de Planpraz (ca. 1855). Pl. 6 from *Haute-Savoie: Le Mont-Blanc et ses glaciers, souvenirs du voyage de LL. MM. l'Empereur et l'Impératrice,* Paris, 1860. Albumen print from wet-collodion negative, 22.9 x 38.8 cm on album sheet 48.1 x 60.6 cm. Artist's circular monogram stamp in red lower left image ꟻBF; artist's signature stamp in red on album sheet lower right: *Bisson frères;* title printed in black lower center: BOURASQUE AU MONT BLANC – *Vue prise de Planpraz;* Imperial patronage blindstamp lower center: BISSON FRERES / PHOTOGRAPHIES / DE / S.M. L'EMPEREUR.

Museum Purchase: Bequest of Fanny Bryce Lehmer, by exchange, 1981.160.

Provenance: Zabriskie Gallery, New York.

Exhibitions: Cincinnati Art Museum, *The Cincinnati Art Museum Photography Collection,* 1981-82.

The photographic careers of Louis-Auguste Bisson and Auguste-Rosalie Bisson, called Bisson frères, lasted nearly a quarter of a century. In the 1830s Louis-Auguste, trained as an architect and chemist, worked as an architect for the city of Paris. His younger brother, Auguste-Rosalie, was employed by their father, Louis-François Bisson, as a heraldic painter. Their successful daguerreotype portrait studio, one of the first established in Paris, opened in 1840 or 1841. Between 1848 and 1849, they made nine hundred portrait daguerreotypes of the members of the Assemblée Nationale which were then lithographed. The Bisson frères are best remembered for their achievements with the wet-collodion negative and albumen positive processes which they adopted in 1851. Between 1852 and 1853, they produced *L'Oeuvre de Rembrandt reproduit par la photographie,* the first illustrated book using the wet-collodion negative. In addition they undertook an ambitious project to record in large format major historic monuments in Belgium, Germany, Italy, and France. *Reproductions photographiques des plus beaux types d'architecture et de sculpture d'après les monuments les plus remarquables de l'antiquité, de moyen âge, et de la Renaissance* was issued in installments between 1853 and 1862. In 1855 they first used mammoth wet plate negatives to photograph exhilarating views of Alpine mountains and glaciers. These they exhibited in 1855 at the Société Française de Photographie of which they were founding members. The public fad for carte de visite portraits and views in the mid-1860s forced them into bankruptcy. In 1865 Louis-Auguste retired, while Auguste-Rosalie worked for the Parisian photographic publishers Léon et Lévy who sent him to record the opening of the Suez Canal in 1869.

Bourasque au Mont Blanc is one of the early views of the Alps taken by the Bisson frères. In 1860 they accompanied Napoleon III and the Empress Eugénie on an unsuccessful assault of Mont Blanc, the tallest mountain in France at over fifteen thousand feet. This awesome vista appears as Plate 6 in *Haute-Savoie. Le Mont-Blanc et ses glaciers, Souvenir du voyage de LL. MM. L'Empereur et L'Impératice,* an album prepared to commemorate the tour.[1] The same subject also appears in an album entitled *Le Mont Blanc et ses glaciers par MM. Bisson frères* belonging to André Jammes which he dates ca. 1855-59.[2] It seems possible that the photograph could have been taken at an earlier date and included in the commemorative album.

In 1860, the Bisson frères became official photographers for the Emperor. The blindstamp certifying their new status appears on the mount. The following year Auguste-Rosalie reached the summit, from which he took photographs, none of which appear in the 1860 album.

This spectacular view is a *tour de force* example of what could be achieved with the mammoth wet-collodion negative. The cumbersome equipment had to be transported to the site, the negative prepared under adverse conditions, exposed and processed before the materials crystallized on the cold glass plate. The grandeur of the subject, the high perspective, and the transitory elements provided a splendid subject for the colossal format which the Bisson frères favored.

1. Robert A. Sobieszek, *Masterpieces of Photography from the George Eastman House Collections* (New York: Abbeville Press, 1985), p. 106.
2. André Jammes, Letter to KS, 20 Aug. 1982.

Roger Fenton
British, 1819-1869

Water Gate, Raglan Castle (1856). Pl. 4 from *Photographic Art Treasures: or Nature and Art Illustrated by Art and Nature* (London: Patent Photo-Galvano-Graphic Company, 1856), part 1. Photogalvanographic print by patent Photo-Galvano-Graphic Company, London, 22.6 x 18.2 cm image on trimmed sheet 24.3 x 18.3 cm. Artist's name printed in black lower left margin: *Photogr. Roger Fenton. B.A.*; title lower center: *Water Gate, – Raglan Casttle.; Eng.*[d] *Photo-galvano-graphic Process.* / (pencil) *1/6.*

The Albert P. Strietmann Collection, 1976.36.

Provenance: Thackrey and Robertson, San Francisco.

Exhibitions: Cincinnati Art Museum, *The Cincinnati Art Museum Photography Collection*, 1981-82.

Many facets of Roger Fenton's career and contributions to organized photography in Britain have been overshadowed by his war reportage. The son of a wealthy banker and mill-owner, he received his Masters of Arts from University College, London. He traveled to Paris in 1841 where he studied painting in the atelier of Paul Delaroche at which he might have met Le Gray, Le Secq, and Nègre, all of whom became important photographers. Cognizant that he would never be an outstanding painter, he returned to London in 1844 where he studied law and practiced as a solicitor. It was during this period that he purchased a license from Talbot to practice the calotype process as an amateur. In 1847 he was a founding member of the Calotype Club, which was the precursor of the Photographic Society of London of which he was an organizer and first secretary. After the successful photographic section of the Great Exhibition in 1851, which featured European and American photographers, Fenton was instrumental in arranging two major exhibitions of British photography.

Fenton's professional photographic career began in 1852 when he documented, with the dry waxed-paper negative learned from Le Gray earlier that year, a bridge which his friend, the engineer Charles Vignoles, was building in Russia over the Dnieper River, Kiev. When the British Museum embarked on a program to record objects within its collection, Fenton received the contract from 1853 through 1860. However, it is for Fenton's photographs of the Crimean War, taken in 1855 under the joint auspices of the government and the publisher Thomas Agnew, that he is remembered today. The views he took with the wet-collodion negative do not portray the carnage or actual battles, but are portraits of officers, scenes of camp life, and fortifications. Though public interest in the wood engravings after the photographs which appeared in the *Illustrated London News* ran high, it did not translate into sales.

Between 1856 and 1862 Fenton embarked on a variety of photographic enterprises and exceptionally fine architectural and landscape stereoscopic views of England, Scotland, and Wales. His legal background proved invaluable in securing an extension of copyright protection to include photographs. In 1862 he auctioned off his equipment, prints, and negatives in disgust over the reduction of quality of photographs in the wake of the carte de visite craze. He abandoned photography and returned to the practice of law until his death in 1869.

In the 1850s the problem of image fading had not been solved and a method was sought which would print the photographic image with printing ink. In 1856 Fenton began producing photographs for the Photo-Galvanographic Company. Patented in 1854 by Paul Pretsch, a Viennese printmaker who emigrated to London, the process achieved halftones which all previous photoengraving processes had failed to achieve. This photo-galvanographic print of *Water Gate, Raglan Castle* appeared in the first issue of *Photographic Art Treasures* in 1856.[1] Raglan castle was a fortified mansion begun in the fifteenth century which was damaged in the Civil War siege of 1646. It is typical of the picturesque landscape subjects which occupied Fenton after 1856. Much of the plate was reworked with roulette and burin due to faulty halftones. Although the critical reception was favorable, slow sales forced abandonment of the project.

1. John Hannavy, *Roger of Crimble Hall* (Boston: Godine, 1975), p. 67.

Francis Frith

British, 1822-1898

The Hypaethral Temple, Philae, Egypt, 1857. Pl. from Francis Frith, *Egypt, Sinai, and Jerusalem: A Series of Twenty Photographic Views*, (London: William Mackenzie; Glasgow and Edinburgh, [ca. 1860]), part 5. Albumen print from wet-collodion negative, 37.7 x 47.9 cm on album sheet 53.7 x 73.9 cm. Artist's name and date printed in black on mount lower right: *Frith Photo 1857*; title printed lower center: THE HYPAETHRAL TEMPLE, PHILAE.

Museum Purchase: Gift of Bertha Pfirrmann in memory of Emma Hoeller, Mrs. Joseph Eichberg, Mrs. Frank Shaffer, Jr., and Thekla Glemser, by exchange, 1978.245.

Provenance: Janet Lehr, Inc., New York.

Exhibitions: Cincinnati Art Museum, *The Cincinnati Art Museum Photography Collection*, 1981-82.

> Philae is the most beautiful thing in Egypt; and the temple, absurdly called Pharaoh's Bed, is the most beautiful thing upon the island. I flatter myself, too, somewhat upon the quality of my photograph, – light transparent shadows, sweet half-tones, oh discriminating Public![1]

Born into a Devon Quaker family, Francis Frith apprenticed to a Sheffield cutlery house (1838-43), ran a successful wholesale grocery business (1845-50), and turned a printing business into a profitable venture (1850-56). Frith's interest in photography coincided with the patent-free introduction of Frederick Scott Archer's collodion process in 1851. In 1853 he was one of the founders of the Liverpool Photographic Society. A shrewd entrepreneur, Frith recognized that there was a ready market for large-scale production of first-rate photographs of Egypt and Palestine to meet the Victorian appetite for exotic subjects. He made three trips to the Middle East between 1856 and 1860, taking with him all the accoutrements for the collodion wet plate process in formats ranging from 6 x 8 inches to 16 x 20 inches. One of the leading topographical photographers of the collodion era, his trips resulted in seven publications from his combined voyages and the successful establishment of F. Frith & Co., Reigate, Surrey, Britain's first and largest mass producer and distributor of British and Continental views. After his death in 1898, his children continued the business until 1968. The new owner liquidated the firm in 1971.

The Hypaethral Temple was taken on Frith's first trip to Egypt between September 1856 and July 1857. He systematically selected subjects which the Victorian public knew only through prints and drawings. Unlike such predecessors as Teynard and Greene, he manipulated the wet-collodion negatives under daunting circumstances of heat, dust, and flies.

> The difficulties which I had to overcome in working collodion, in those hot and dry climates, were also very serious. When (at the Second Cataract, one thousand miles from the mouth of the Nile, with the thermometer at 110° in my tent) the collodion actually boiled when poured upon the glass plate, I almost despaired of success. . . .[2]

The small boat with the tent in front of the moored Dahabieh was Frith's traveling darkroom, which he described in *Egypt and Palestine*:

> As for your artist, his clearest recollections are of a luxurious and effective field-day hereaway, for he rigged up his photographic tent in the small boat, and was pulled about by his shiny black Nubians from dawn till dusk, just landing and knocking off a view wherever and whenever the fancy struck him. . . .[3]

The Hypaethral Temple is Plate 10 of *Egypt, Sinai, and Jerusalem; A series of Twenty Photographic Views by Francis Frith* which was published in London by W. Mackenzie circa 1860 and republished in London by J. S. Virtue in 1862. The mother and son Egyptologists, Mrs. Sophia and Reginald Stuart Poole, provided descriptions of the colossal plates. Each of the ten parts containing two plates sold for a guinea.

The island of Philae, located six miles south of Aswan on the Nile, was considered the most beautiful place to visit in Egypt on the Grand Tour. In 1960 the temple was dismantled and reerected on the nearby island of Agikia to protect it from the rising water of the Aswan Dam.

1. Francis Frith, "'Pharaoh's Bed,' Island of Philae," *Egypt and Palestine* (London: Virtue, 1858-59?), I, n. pag.
2. Frith, "Introduction", n. pag.
3. Frith, "Antiquities upon the Island of Biggeh, Near Philae," n. pag.

Gustave Le Gray

French, 1820-1882

Harbor at Sète (1857). Albumen print from collodion negative, 30.9 x 39.4 cm. Numbered with pen and brown ink on verso: *11.233*.

The Albert P. Strietmann Collection, 1980.95.

Provenance: Daniel Wolf, Inc., New York.

Exhibitions: Cincinnati Art Museum, *The Cincinnati Art Museum Photography Collection*, 1981-82.

> In my opinion, the artistic beauty of a photographic print consists nearly always in the sacrifice of certain details; by varying the focus, the exposure time, the artist can make the most of one part or sacrifice another to produce powerful effects of light and shadow, or he can work for extreme softness or suavity, copying the same model or site, depending on how he feels.[1]

No artist-photographer had a greater impact artistically, technically, and theoretically during France's Second Empire than Gustave Le Gray. Through personal instruction or published treatises Le Gray influenced a generation of photographers such as Du Camp and Le Secq in the use of the dry waxed-paper negative process. Le Gray exhibited in all the major photographic exhibitions of the period. He was a founding member of both the Société Héliographique and Société Française de la Photographie.

Le Gray originally studied art in the atelier of Paul Delaroche, one of the most popular painters of the day, along with Fenton, Le Secq, and Nègre. His interest in photography began as early as 1847 when he assisted François Arago in daguerreotyping sun spots. An inveterate experimenter with new materials, he suggested the possibilities of collodion on glass at the same time he published his dry waxed-paper formula in 1850. While Frederick Scott Archer's collodion process appeared in a more workable version the following year, Le Gray's dry waxed-paper negative was the most successful paper negative process in the 1850s. It was one of the factors influencing the Commission des Monuments Historiques to undertake the Mission Photographiques in 1851. Selected along with Bayard, Baldus, Le Secq, and Mestral, Le Gray was assigned to record significant national sites and monuments in Aquitaine and Touraine.

In 1852 he recorded the galleries of the Salon des Beaux-Arts. Napoleon III retained him in 1857 to document his visit to the maneuvers at Camp Châlon. Like the Bisson frères and Nadar, he moved his studio to 35, boulevard des Capucines to cash in on the vogue for the carte de visite which proved disappointing. He closed his studio and left Paris in 1859. He surfaced in Palermo in 1860, and reappeared in Cairo in 1865 where he taught drawing and painting at the Viceroy's École Polytechnique. He died in Cairo in 1882.

Although Le Gray did pastoral landscapes and architectural views, it is his seascapes which are unique in nineteenth-century photography. His seascapes were all wet-collodion negatives printed-out on albumen paper toned with gold chloride to give them a rich purplish color. In 1856 his first group of seascapes was taken along the Normandy coast at Sainte-Adresse and Le Havre. In December, he exhibited these at the Photographic Society in London where they were received with great interest. In 1857 he produced a second group of seascapes in connection with a trip south to record the opening of a new railroad line from Toulouse to Sète, a small city on the south coast of France, near Montpellier. The Chicago Art Institute owns a unique album, *Vistas del Mar* (ca. 1857-59), containing views of the Harbor at Sète.[2]

Le Gray's seascapes range in mood from tempestuous, with billowing clouds as in *Great Wave*,[3] printed with combination negatives, to tranquil and serene. He manifested his coloristic and interpretive predisposition through the effective management of light and materials.

> I'm trying to imbue the collodion image, which is so highly finished in appearance, with more depth and strength in its all-over effect. This is a quality it still lacks, and which a good paper image possesses to such a high degree.[4]

A strong proponent for the pictorial harmonies of the paper negatives, it is unclear why Le Gray changed to wet-collodion negatives for his seascapes.

This view, which has been identified as the enclosed harbor of Sète, does not appear in the incomplete Chicago album. He seems deliberately to have vignetted the scene to focus attention on the tall ships anchored by the jetty. A master of design, Le Gray condensed the subject into a band which bisected the composition like a single brush stroke.

1. André Jammes and Eugenia Parry Janis, *The Art of French Calotype* (Princeton: Princeton Univ. Press, 1983), p. 202.
2. Nils Ramstedt, "An Album of Seascapes by Gustave Le Gray," *History of Photography*, 4, No. 2 (Apr. 1980), 121-37.
3. Nils Ramstedt, Letter to KS, 29 June 1981.
4. Jammes and Janis, p. 201.

Carlo Ponti
Italian, active ca. 1858-1875

Ponte di Rialto, Venice (ca. 1858-75). Albumen print 26.3 x 34.3 cm on album sheet 37.7 x 47.0 cm. Negative number scratched lower right: *12;* pen and purple ink on album sheet lower center: *Ponte di Rialto Venezia*; pencil lower right: *Carlo Ponti.*

Gift of Janet Lehr, 1978.343.

Exhibitions: Cincinnati Art Museum, *The Cincinnati Art Museum Photography Collection*, 1981-82.

Though Carlo Ponti stands out as the finest Venetian practitioner of the collodion process between 1858 and 1875, little is known about this optical instrument maker and topographical photographer. He maintained a shop at 52 Piazza San Marco, where he sold his *vedute* or views of Venice, Padua, Rome, and Verona, as well as fine lenses which successfully competed with foreign production. In 1860 he invented the megalethoscope, a panoramic photography viewer for which he received a medal at the 1862 World Exhibition in London. When Venice was reunited with Italy in 1866, he was made optician and photographer to King Victor Emmanuel II.

Ponti worked with large collodion glass negatives which he contact-printed on albumen paper. In addition to *vedute*, he also made genre portraits of colorful Venetian street people for the tourist trade. Beginning in the 1860s, he published albums titled *Ricordo di Venezia* containing twenty views by himself and other Venetian photographers including Giuseppe Coen, Antonio Perini, and Carlo Naya. His photographs were often mounted on a heavy board which carried printed descriptions and the history of the subject in Italian, French, or English on the verso.

The Ponte di Rialto is one of Venice's best-known monuments. This sixteenth-century marble bridge which arches over the Grand Canal is as much a symbol of Venice as is the Doge's Palace. Built by Antonio da Ponte between 1588 and 1592 to replace an earlier wooden bridge, it remained the only bridge connecting the east and west quarters until 1854. The area known as the Rialto ("Rivo-alto," "high bank") had been the commercial and economic center of Venice since the beginning of the Republic. It was widely known through Shakespeare's *Merchant of Venice* and Canaletto's eighteenth-century paintings. In 1883 it was the subject of an etching by Cincinnati's expatriate painter, Frank Duveneck. Ponti's *vedute* of the Rialto was preceded by Alexander John Ellis's 1841 daguerreotype.[1]

The thoughtfully composed view discloses Ponti's sensitive eye toward surface textures and atmospheric qualities. Empty gondolas and short shadows suggest the exposure was taken at midday. While the tranquility and calm probably result from the technical requirements of long exposures, the picture successfully captures the magic of sunlight and water that drew foreigners to Venice in the latter half of the nineteenth century.

1. Wendy M. Watson, *Images of Italy: Photography in the Nineteenth Century* (South Hadley, MA: Mount Holyoke College Art Museum, 1980), p. 29.

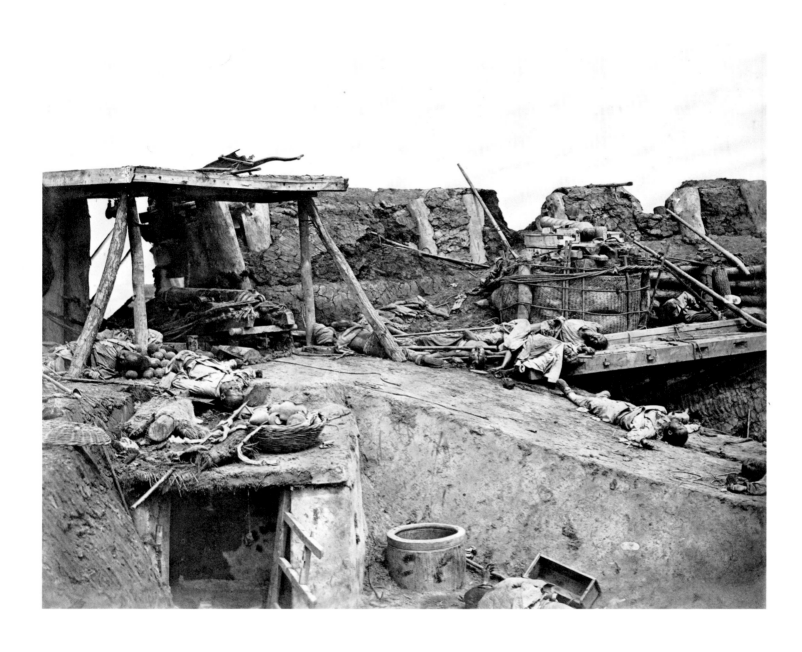

Felice Beato

British, born Italy, ca. 1820/25–ca. 1906

Interior of the Fort Immediately after Its Capture (1860). Albumen print from wet-collodion negative, 24.8 x 30.4 cm on album sheet 37.7 x 43.3 cm. Title with pen and brown ink on album sheet lower center: *Interior of the Fort immediately / after its capture.*

Museum Purchase: Gift of the heirs of Alma M. Ratterman, by exchange, 1978.247.

Provenance: Simon Lowinsky Gallery, San Francisco.

Exhibitions: Cincinnati Art Museum, *The Cincinnati Art Museum Photography Collection*, 1981–82.

> At Mr. Hering's, Regent Street, may be seen a large collection of photographic views and panoramas taken by Signor Beato during the Indian Mutiny and the Chinese War. . . . The Chinese forts of Pehtung and Tangkoo, with the North Fort [Taku], expand one's notions of the importance of the difficulties overcome in their capture. . . .[1]

Felice Beato, at the invitation of the British military, was the first Western photographer to penetrate China. His photographs taken immediately after the storming of North Taku Fort on August 21, 1860, record the gruesome human toll in the Second Opium War (1858–60), also known as the Anglo-French War. This blatantly aggressive war was fought by Britain and France against China which wished to restrict the importation of Indian opium by Western nations. The British Expeditionary Force gathered in Hong Kong and worked its way up the Peiho River to the four forts of Taku guarding the city of Peking. The Chinese had built such an elaborate network of obstacles around the fort that it made their own retreat difficult. Beato's photograph of the corpses strewn around the interior of the fort uncompromisingly chronicled the human carnage.

This image appeared in albums documenting the conflict, now in the collections of the Australian National Gallery, The Museum of Modern Art, National Gallery of Canada, and the Philadelphia Museum of Art.[2] In all instances the arrow rocket used by the defenders is missing from the parapet, as are the two thin poles or struts seen through the gun port.[3] This suggests that our print may be a proof before opaquing in the sky areas of the negative.

Exactly who Felice Beato was remained an enigma until recently. There were two separate Beatos, Felice and his brother, Antonio (d. 1903), who were active as photographers in the Middle East.[4] Felice Beato was probably a Venetian-born, naturalized British citizen. In 1850 he met James Robertson who was superintendent and chief engraver for the mint at Constantinople. Exactly what their relationship was requires further investigation. Perhaps Beato began as Robertson's assistant, then became his partner, since their photographs are variously signed "Robertson and Beato" and "Robertson, Beato and Co." They worked together in Malta (1850s), Constantinople (1853), Athens (1854), Egypt, and Palestine (1857). In 1855 they photographed the fall of Sebastopol which ended the Crimean War, and in 1858 they documented the aftermath of the Indian Mutiny.

Following the Second Opium War, Beato worked in Japan from 1862 until 1877, when he sold his studio and negatives to Baron von Stillfried. In 1884–85 he recorded the rebellion against the British at Khartoum in the Sudan. His final years were spent in Burma where he ran a mail-order business catering to the Victorian passion for the exotic.[5] A *Rangoon Times* announcement in 1906 of the sale of F. Beato Limited presumably coincided with his death.[6] During the latter half of the nineteenth century Beato was in the vanguard, vividly recording with skill and commercial acumen the expansion of the British Empire.

1. *The Athenaeum*, 14 June 1862, pp. 793–94.
2. Isobel Crombie, Letter to KS, 1 Apr. 1987; Peter Galassi, Letter to KS, 20 Apr. 1987; James Borcoman, Letter to KS, 24 Feb. 1982; and Martha Chahroudi, Letter to KS, 2 Apr. 1982.
3. Borcoman letter. I appreciate James Borcoman pointing out the changes in the image.
4. Italo Zannier, *Antonio e Felice Beato* (Venice: Ikona Photo Gallery, 1983), n. pag.
5. John Lowry, "Victorian Burma by Post," *Country Life*, 13 Mar. 1975, pp. 659–60.
6. Richard Pare, Catherine Evans Inbusch, and Marjorie Munsterberg, *Photography and Architecture: 1839–1939* (New York: Callaway, 1982), p. 245.

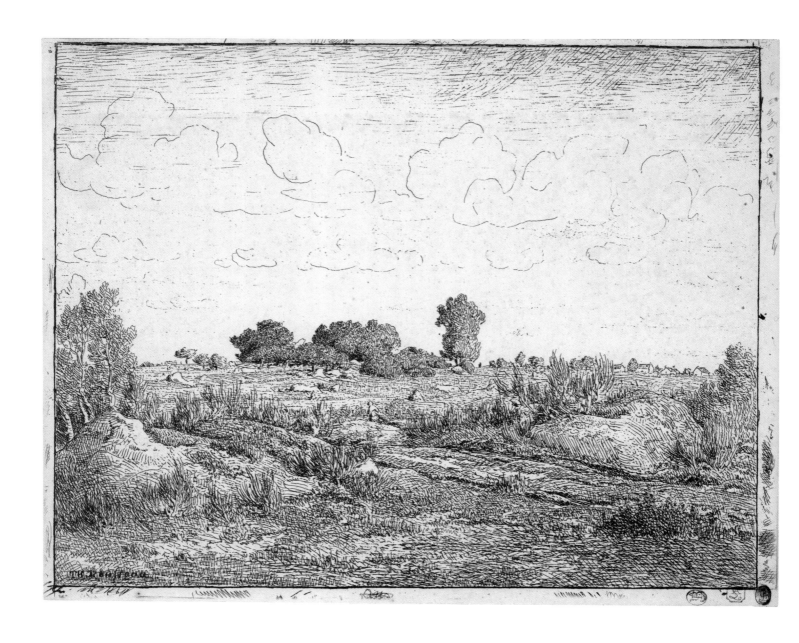

Pierre-Étienne-Théodore Rousseau

French, 1812-1867

The Plain at Plante-à-Biau (1862). Cliché-verre (salted-paper print), 22.9 x 28.5 cm on sheet 23.6 x 29.8 cm. Signed on plate lower left: *T. H. Rousseau*; collector's marks stamped lower right: Alfred Beurdeley (Lugt[1] 421 twice in black); Alfred Lebrun (Lugt 140 in red). Verso stamped: Herbert Greer French (Lugt S.1307a in black); in pencil: A L [Alfred Lebrun].

Bequest of Herbert Greer French, 1943.661.

Provenance: Alfred Lebrun, Paris; Alfred Beurdeley, Paris; Knoedler, New York (1937); Herbert Greer French (from Knoedler in 1937).

> The cliché-verre is a direct outgrowth of the invention of photography. The fundamental principle of the cliché-verre – superimposition of a hand-drawn, transparent matrix on a light-sensitive surface – evolved from the most primitive photographic experiments. . . .[2]

Barbizon, on the edge of Fontainebleau forest, had become the physical and spiritual focus of a group of French painters by 1862. In the aftermath of the revolution of 1848 they sought a return to naturalism, not only in the physical locale, but in their creative activities. A number of these painters including Jean-François Millet, Charles Jacque, and Théodore Rousseau tried the cliché-verre process which had been first experimented with as early as 1839, when William Henry Fox Talbot contact-printed and fixed natural and artistic objects on sensitized paper which he called "photogenic drawings."

Rousseau, along with his associate Millet, was the most important artistic influence in Barbizon. At the age of fifteen he apprenticed with the landscape painter Charles Rémond, and later with Guillon-Lethière. Although Rousseau made the required copies of seventeenth-century Dutch and French paintings, he preferred to work directly from nature. After a precocious beginning in the Salon between 1831 and 1836, he was systematically excluded from 1837 until the beginning of the Second Empire. Rousseau's reputation and patronage fluctuated over the years; however, his re-emergence in the Salon of 1847 firmly established him as a major landscape painter. He traveled widely during the early 1830s, but by 1836 settled in Auberge Ganne where his home became a meeting place for artist friends. Rousseau's two clichés-verre were probably executed in 1862, perhaps along with Millet's, under the supervision of photographer Eugène Cuvelier.[3]

Auberge Ganne was a small village close to the forest of Fontainebleau surrounded on three sides by endless plains. Both *The Plain at Plante-à-Biau* and *Cherry Tree at Plante-à-Biau* were undoubtedly done out of doors as was the artist's custom. A meticulous draftsman, Rousseau strove for overall harmony yet gave minute consideration to detail on the glass plate, using line to derive the tension and tonality of his composition.

Rousseau's experiments with cliché-verre had no inherent commercial value; however, his reputation as a painter was sufficiently great that two print connoisseurs affixed their collector's marks in the lower right corner as part of the prestige of ownership. The glass plate is now in the collection of the Museé du Louvre.[4]

1. Frits Lugt, *Les Marques de Collections de Dessins et d'Estampes* (The Hague: Martinus Nighoff, 1956); *Supplément* (The Hague: Martinus Nighoff, 1956).
2. Elizabeth Glassman, "Cliché-verre in the 19th Century," in Elizabeth Glassman and Marilyn F. Symmes, *Cliché-verre: Hand-Drawn, Light-Printed: A Survey of the Medium from 1839 to the Present* (Detroit: The Detroit Institute of Arts, 1980), p. 30.
3. Glassman and Symmes, p. 104.
4. Glassman and Symmes, p. 200.

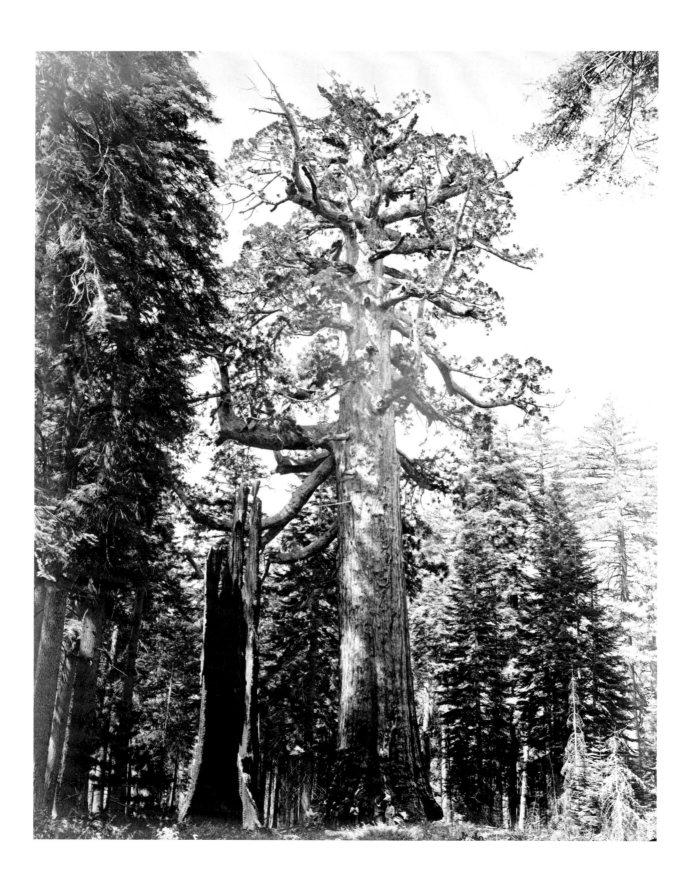

Carleton E. Watkins
American, 1829-1916

The Grizzly Giant (before 1864). Albumen print from wet-collodion negative, 52.3 x 40.0 cm on mount 61.0 x 48.0 cm.

Museum Purchase: Gift of Louise N. Anderson, by exchange, 1978.248.

Provenance: Daniel Wolf, Inc., New York.

Exhibitions: Cincinnati Art Museum, *The Cincinnati Art Museum Photography Collection*, 1981-82.

In 1861 Carleton Watkins pioneered the use of the mammoth-plate camera for landscape photography in North America. Recent research has shed light on details of Watkins's early training and activities. Born in Oneonta, New York, in 1829, he traveled west to California, settling first in Sacramento, then San Francisco. He learned the rudiments of daguerreotyping from Robert H. Vance of San Francisco, whose Marysville establishment he operated in 1854.[1] It is likely that he knew the three hundred daguerreotypes of San Francisco and the California goldfields which his mentor exhibited in New York in 1851. By 1856, Watkins had moved to the portrait studio of James M. Ford in San Jose, where he practiced the newer ambrotype and wet-collodion negative processes.[2]

Watkins established his reputation as a field photographer in the late 1850s by supplying clients with straightforward camera views for the settlement of property disputes. In 1860 Col. John C. Frémont, owner of the richest gold mines in the world, commissioned him to document the Mariposas estate to acquaint potential European investors with its assets.[3] The following year Watkins returned with a mammoth camera and cumbersome wet plate apparatus to photograph the awesome grandeur of Yosemite valley and the Mariposa Grove. His eloquent vision provided compelling support for the Congressional legislation which set aside Yosemite as a wilderness area, signed into law by President Abraham Lincoln in 1864.

The Grizzly Giant, a twenty-five-hundred-year-old sequoia standing 225 feet high with a circumference of 86 feet, was one of the natural wonders in the Mariposa Grove. This veteran giant demanded the grand format just as the mammoth-plate mandated spectacular views. The four men at the base who serve to provide scale are dwarfed by the immense tree which had withstood the ravages of time, fire, and weather. In 1864 the American painter Albert Bierstadt, who shared Watkins's sensibilities, used this photograph as a model for his painting *Grizzly Giant*.[4]

As with Francis Frith in the Middle East, Watkins's wet-collodion glass plate negatives, measuring approximately 18 x 22 inches, were executed under formidable odds. This view of the Grizzly Giant was probably one of thirty mammoth views done on Watkins's first trip to Yosemite. The print does not have the rounded top corners typical of his first Yosemite views, nor does it have the scratched negative number found on later views taken between 1865 and 1881. Watkins's mammoth Yosemite views were shown at Goupil's Art Gallery in New York in 1862 and at the Paris International Exposition in 1867, where they won a bronze medal.

Between 1861 and the mid-1890s Watkins traveled from British Columbia to the Mexican border, and from the Farrallon Islands to Wyoming on numerous surveys, private commissions, and entrepreneurial projects. His photographic consciousness was formed by the rapidly expanding West with its growing cities, mining operations, railroad lines and nouveau rich. His straightforward style remained consistent. Competition, piracy, and overextended publishing activities in the mid-1870s led sadly to the loss of his negatives and his Yosemite Art Gallery in San Francisco. Watkins immediately began to rephotograph his popular subjects, but failing health and near-total blindness put him in dire straights by the turn of the century. He lost everything in the San Francisco earthquake and fire of 1906, and died insane in 1916.

In spite of the vicissitudes of his career, he was a trailblazer whose perception of beauty set the aesthetic and technical standards against which the achievements of subsequent western landscape photographers such as Jackson, O'Sullivan, and Hillers were measured.

1. Peter E. Palmquist, *Carleton E. Watkins: Photographer of the American West* (Albuquerque: Univ. of New Mexico Press, 1983), p. 6, n. 11.
2. Palmquist, p. 6.
3. Palmquist, pp. 9-10.
4. Weston J. Naef, "Photographers, Artists, and Critics," in Weston J. Naef and James N. Wood, *Era of Exploration: The Rise of Landscape Photography in the American West, 1860-1885* (Buffalo, NY: Albright-Knox Art Gallery; New York: The Metropolitan Museum of Art, 1975), p. 62.

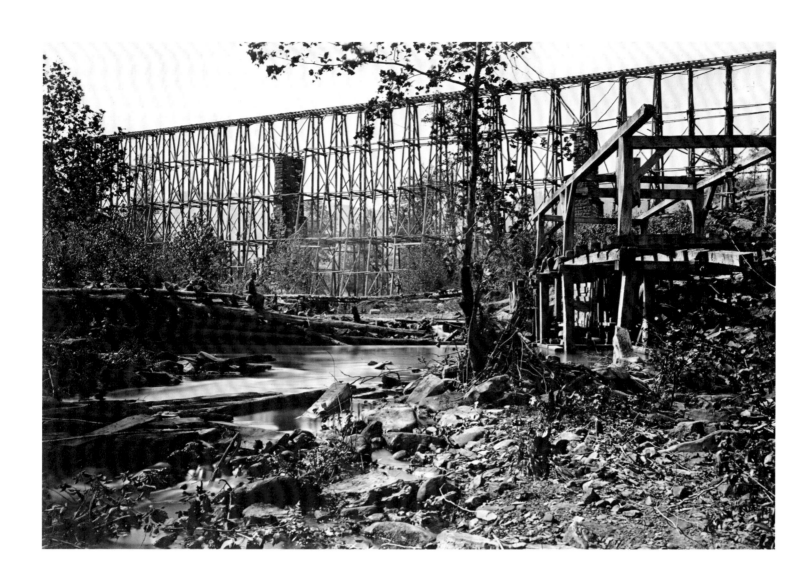

George N. Barnard

American, 1819-1902

Trestle Bridge at Whiteside (ca. 1863-64). Pl. 4 from George N. Barnard, *Photographic Views of Sherman's Campaign* (New York: Wynkoop and Hallenbeck, 1866). Albumen print from wet-collodion negative 25.6 x 35.6 cm on album sheet 40.9 x 51.2 cm. Artist's name and title printed in black on album sheet lower center: *Photo from nature By G. N. Barnard.* / TRESTLE BRIDGE AT WHITESIDE.

Museum Purchase: Gift of the heirs of Alma M. Ratterman, by exchange, 1978.244.

Provenance: Simon Lowinsky Gallery, San Francisco.

Exhibitions: Cincinnati Art Museum, *The Cincinnati Art Museum Photography Collection*, 1981-82.

Born in Connecticut in 1819, George Barnard opened his first daguerreotype studio in Oswego, New York, in 1843. His daguerreian reportage of the 1853 Ames Mill fire in Oswego brought him popular attention through reproductive engravings. The following year he moved to Syracuse where he opened a new studio. He took up the new collodion process in the late 1850s. Prior to becoming a member of Brady's photographic corps at the beginning of the Civil War, he assisted Brady in recording Lincoln's inauguration. In 1863 he was appointed official photographer of the military division of the Mississippi, and followed Sherman's Campaign to the sea. Following the war, while Northern public interest remained strong, he published an album of sixty-one photographs entitled *Photographic Views of Sherman's Campaign*. In 1869 he settled in Chicago where his studio was destroyed by the Great Fire of 1871, which he nonetheless photographed. Barnard worked briefly with George Eastman of Rochester, New York, to introduce gelatin dry plates in 1883. Prior to his death in Cedarvale, New York, in 1902, he operated a gallery in Plainsville, Ohio, between 1884 and 1886.

Photographic Views of Sherman's Campaign sold for one hundred dollars when it was published in 1866. This important album documenting American history records celebrated battle sites, soldiers at rest, and the war's devastation. Barnard's photographs of the destructive wake of the Union army are the work by which he is remembered today. On December 8, 1866, an anonymous review in *Harper's Weekly* declared:

> These photographs are views of important places, of noted battle-fields, of military works; and, for the care and judgment in selecting the point of view, for the delicacy of execution, for scope of treatment, and for fidelity of representation, they surpass any other photographic views which have been produced in this country – whether relating to war or otherwise. . . . Before seeing this collection of Mr. BARNARD we could not have believed that there were such magnificent possibilities in an art so purely mechanical as to its mode of operation. . . .[1]

Trestle Bridge at Whiteside appears as Plate 4 in *Photographic Views of Sherman's Campaign*. The original bridge at Whiteside was constructed on five masonry piers connected by timber arches. Because of its strategic importance, the structure was destroyed by retreating Confederate rebels shortly before the battle of Chickamauga. The replacement bridge was erected during the fall and winter of 1863 with timber hewn in the adjacent forests. Luxuriant tones and careful composition consistently characterize the photographs. The complexity of the wet-collodion process, large camera, and long exposures precluded action shots. The soldiers whose small scale established the formidable size of the span were of secondary importance. Barnard's prime concern was the terrain where the conflict occurred.

1. "Photographic Views of Sherman's Campaign," *Harper's Weekly*, 8 Dec. 1866, p. 771, col. 3.

Charles Aubry

French, active 1864

Roses (ca. 1864). Albumen print from wet-collodion negative, 24.9 x 32.7 cm. Artist's name and number on negative lower left: *ch. aubry / 41*.

The Albert P. Strietmann Collection, 1980.93.

Provenance: Daniel Wolf, Inc., New York.

Exhibitions: Cincinnati Art Museum, *The Cincinnati Art Museum Photography Collection*, 1981-82.

Almost nothing is known about Charles Aubry. Isolated works carry a blue rubber stamp: "Ch Aubry / PHOTOGRAPHIE / (interlaced artist's monogram)? 8, RUE DE LA REINE BLANCHE." This address is close to the manufactory of Gobelins. In addition, a few individual pieces carry a blindstamp noting that Aubry won a gold medal in 1864. Beyond these few details, the photographer remains an enigma.

The Bibliothèque Nationale owns a collection of fifteen photographs entitled "Studies of Leaves, Series One."[1] The humble dedication reads:

> Prince, in order to facilitate the study of nature, I caught it in the act, and I hereby offer to workers some models that may increase our productivity in the industrial arts, so far hampered somewhat by the inadequate portfolios from the schools of design. In dedicating this revitalizing work to you, I declare to the apprentices that, as during childhood one thinks of material needs, readying oneself for future work, one must also think about that which develops the soul and the best sentiments, that is, beauty and truth. With profound respect, your humble and obedient servant, Ch. Aubry. To the imperial prince. Paris, May 31, 1864.[2]

This awkward dedication suggests that Aubry was a craftsman who intended his photographs to serve as models for designers of the applied arts. During the Second Empire floral motifs were prevalent in fabric and wallpaper design, and are often seen in painted interiors.

This photographic translation of the age-old tradition of still life painting is marvelous in its unadulterated freshness and simplicity of composition. With the detailed clarity possible by use of the wet-collodion negative, Aubry captured the exquisite beauty of the roses with botanical precision. His bouquet of roses rivals the photographs of Adolphe Braun who created this genre during the previous decade.

1. Bernard Marbot and Weston Naef, *After Daguerre: Masterworks of French Photography (1848-1900) from the Bibliothèque Nationale* (New York: The Metropolitan Museum of Art, 1980), cat. nos. 6-7.

2. Marbot and Naef, no. 6.

Charles Nègre

French, 1820-1880

Plants in Sunlight (ca. 1865). Albumen print from wet-collodion negative, 21.3 x 16.7 cm on 21.3 x 18.9 cm.

Museum Purchase: Gift of John Sanborn Conner, by exchange, 1981.157.

Provenance: Joseph Nègre, south of France (Nègre's great-nephew); Daniel Wolf, Inc., New York.

Exhibitions: Cincinnati Art Museum, *The Cincinnati Art Museum Photography Collection*, 1981-82.

An academic painter and avant-garde photographer of some prominence, Charles Nègre split his energies between advancing the "grand style" of painting and justifying the new artistic directions of photography. His paintings and photographs both won gold medals and received international awards between 1850 and 1867.

He was born on May 9, 1820, in Grasse in the same house where he would die fifty-nine years later. In 1839 he arrived in Paris and studied in the prestigious atelier of Paul Delaroche where he met Fenton, Le Gray, and Le Secq. Nègre made his first daguerreotype in 1844, the year after he made his Salon debut as a history painter. His initial use of photography was as *esquisses* (sketches) for genre paintings of street people.

In 1851 Nègre took up photography in earnest. He mastered Le Gray's dry waxed-paper process and designed a special lens with a wide opening and a sophisticated diaphragm making near-instantaneous photographs possible. In March 1851 his photographs were shown at the Société Héliographique. *The Little Rag-Picker* was selected to illustrate the best examples of French photography. Passed over by the Commission des Monuments Historiques for a Mission Héliographique, he embarked on his own project to document the geographical and social character of Midi. However, only two installments of *Le Midi de la France* were issued (1854) and showed only ten photographs from more than two hundred taken.

He was concerned, as were many photographers of the period, about print permanence and began experimenting with Niépce de Saint-Victor's photogravure process and patented an improved method in 1856. His investigations were spurred on by Duc de Luynes' competition, which sought a practical process for producing photomechanical images, announced by the Société Française de Photographie of which Nègre was a member. Although Nègre was one of the three finalists, he was passed over when the prize was finally awarded in 1867, not because his prints were not beautiful, but because the practicality of his process was doubted.

In the 1850s Nègre received two major government commissions. In 1855 he photographed the architecture and sculpture of Chartres for eventual publication as photogravures. Napoleon III retained Nègre to prepare an album of photographs on the new Imperial Asylum of Vincennes, an institution for disabled workers. By 1863 ill health forced him to retire to Nice where he taught drawing at the Lycée Impérial and opened a photographic studio catering to the tourist trade.

Almost nothing is known about Nègre's late photographic work after his return to Nice. *Plants in Sunlight*, formerly in the collection of the artist's great-nephew Joseph Nègre, clearly shows the photographer continued to explore the potentials of the new medium as a vehicle for recording visual data and a means of artistic expression. About 1852, Nègre first examined the effects of strong light and shadow on a lemon tree in Grasse with the calotype process.[1] After he moved to Nice, Nègre began working with collodion. This cluster of mallow, thistle, wild arum, and field horsetail[2] was transformed by the intense Mediterranean sunlight into a shimmering mass of perceptual ambiguities. André Jammes suggests a date around 1865, and points out the comparison with *Aloes at Menton* and *Hillside with Waterfall and Figures* of the same date.[3] Undoubtedly, once more is known about mid-nineteenth-century photography, it will be necessary to reassess the importance of this body of work in creating a new pictorial syntax for landscape painters.

1. James Borcoman, *Charles Nègre 1820-1880* (Ottawa: The National Gallery of Canada, 1976), p. 98.

2. Drs. Nancy and Ronald Dengler, Letter to KS, Oct. 2, 1981. I would like to thank Drs. Nancy and Ronald Dengler of the Department of Botany of the University of Toronto for making these identifications.

3. André Jammes, Letter to KS, Aug. 11, 1981. See Borcoman, pp. 249-50.

Thomas Annan

British, born Scotland, 1829-1887

Close No. 193 High Street, 1868. Pl. 9 from William Young, introd., *The Old Closes & Streets of Glasgow* (Glasgow: T. and R. Annan & Sons or James Maclehose & Sons, 1900). Photogravure 1900, 22.2 x 18.2 cm image on 37.4 x 27.3 cm. Title and date printed in black lower center margin: *Close No. 193 High Street / 1868.*

The Albert P. Strietmann Collection, 1976.34.

Provenance: Private Collection, Great Britain; Thackrey and Robertson, San Francisco.

Exhibitions: Cincinnati Art Museum, *The Cincinnati Art Museum Photography Collection*, 1981-82.

> The value of many of the plates embraced in this volume consists in their true presentation or suggestion of the seamy side of the city's life; in their depicting with absolute faithfulness, the gloom and squalor of the slums. They afford a peep into dark and dismal dens unvisited by the great purifying agencies of sun and wind, and in surveying them, we instinctively feel that human life born, bred, or led within their shades is sorely handicapped, and that the day of their extinction is more than due.[1]

Pre-nineteenth-century Glasgow centered on High Street, which was a prosperous trading, commercial, and academic center. During the first three decades of the nineteenth century, merchants moved to the West End and their Georgian houses were rented at high prices to the poor immigrants who worked in mills, factories, and foundries springing up in the wake of the industrial revolution. Swollen Victorian slums were hotbeds of cholera epidemics; the Glasgow epidemic was considered the worst in Great Britain. In 1866 Parliament approved the Glasgow City Improvement Act, an unprecedented redevelopment scheme to alter the density of population and improve sanitary conditions. The commercially successful Glasgow photographer, Thomas Annan, was hired by the trustees of the Improvement Act to document important buildings and streets slated for demolition. Thomas Annan was not a social reformer or an investigator with a camera, but this landmark commission, the first of its kind, left a clinical record of Glasgow's decaying structures and anonymous inhabitants.

Trained as a copper-plate engraver, Annan set up a calotype printing studio in 1855, perhaps with the encouragement of his friend D. O. Hill. By the time he was commissioned, he had already established a body of work which demonstrated his technical proficiency and aesthetic sense. It was, however, his photographs of the wynds and closes of Glasgow's slums, taken between 1868 and 1877, which climaxed his career as a photographer. In 1877, upon completion of the first phase of the redevelopment, the Glasgow City Improvement Trust published forty carbon prints from his glass negatives under the title *Photographs of Old Closes, Streets, & c., taken 1868-1877* in an edition of one hundred. This was not Annan's first use of the carbon process. In 1865 he photographed Hill's recently completed commemorative painting, *The Signing of the Deed of Demission*, and in 1866 acquired the rights to Swan's permanent pigment carbon process for printed editions.

In 1900, at the completion of the second Glasgow redevelopment phase, two editions of one hundred each were published by T. and R. Annan and Sons and James Maclehose and Sons as *The Old Closes and Streets of Glasgow*, containing fifty photogravures, thirty-eight of which had been taken in 1868.[2] *Close No. 193 High Street* appeared in both the 1868 and 1900 editions.

In 1883 Annan and his son traveled to Vienna to acquire the rights for the photogravure process from Karel Klíč. This permanent pigment process permitted alterations on the copperplate. A comparison of the 1870 carbon print and the 1900 photogravure shows that his son, James Craig Annan, had altered his father's photograph. The clouds in the sky have been eliminated and the prominence of the upper left chimney has been diminished. The far end of the close has been lightened and the laundry altered. In the foreground the ghost of a figure to the right of the small child has been deleted, while the child was reworked for clarity.

1. William Young, Introd., *The Old Closes and Streets of Glasgow* (Glasgow: Maclehose, 1900), p. 22.
2. Anita Ventura Mozley, "Introduction," in Thomas Annan, *Photographs of the Old Closes and Streets of Glasgow 1868/1877* (New York: Dover, 1977), p. vi. Mozley discusses the deletions and additions to the 1900 edition.

Julia Margaret Cameron
British, b. India, 1815-1879

Days at Freshwater, 1870. Albumen print from wet-collodion negative, 34.5 x 27.6 cm on mount 58.4 x 46.3 cm. Inscribed with pen and black ink on mount lower left to lower right: *From Life Registered Photograph copy right Julia Margaret Cameron Freshwater Aug. 1870 / Days at Freshwater / given to Mrs. Mayor by Mrs. Cameron;* oval blindstamp on mount lower center: REGISTERED PHOTOGRAPH / SOLD BY / MESS^RS. COLNAGHI / 14 PALL MALL EAST / LONDON.

The Albert P. Strietmann Collection, 1976.430.

Provenance: Mrs. Mayor (from Julia Margaret Cameron); The Halsted 831 Gallery, Birmingham, Michigan.

Exhibitions: Cincinnati Art Museum, *The Cincinnati Art Museum Photography Collection,* 1981-82; Joanne Lukitsh, *Cameron: Her Work and Her Career* (International Museum of Photography at George Eastman House, Rochester, NY; The Sterling and Francine Clark Art Institute, Williamstown, MA; The Detroit Institute of Art; and Cincinnati Art Museum, 1986), p. 92, illus. p. 70.

> I longed to arrest all beauty that came before me, and at length the longing has been satisfied. Its difficulty enhanced the value of the pursuit. I began with no knowledge of the art. I did not know where to place my dark box, how to focus my sitter, and my first picture I effaced to my consternation by rubbing my hand over the filmy side of the glass. . . .[1]

In "Annals of My Glass House," an unpublished manuscript of 1874, Julia Margaret Cameron reminisced about her ten years as a photographer.[2] She took up photography at the age of forty-eight with the tastes and opinions of a mature woman who was passionately interested in literature, drama, and art. Her social milieu included many of the great Victorian personalities of the arts, letters, and sciences, whose faces are remembered today by her photographs.

Julia Margaret Pattle was born in Calcutta, India, June 11, 1815, the third daughter of James Pattle, a civil servant stationed in Bengal. In 1834 she became the second wife of Charles Hay Cameron, a philosopher, Benthamite jurist, and member of the Council of Calcutta. Upon his retirement in 1848, she moved from her prominent position in the expatriate society of India to the stimulating weekly gatherings of her sister Sara Prinsep's London salon. In 1860, during one of her husband's absences to visit their Ceylon coffee plantations, she visited the Alfred Lord Tennysons at their home in Freshwater, Isle of Wight, where she purchased two cottages. During the fall of 1863 her daughter and son-in-law gave her a folding camera for 9 x 11-inch glass plate negatives with a 12-inch Jamin lens to entertain herself during her solitude. With characteristic zeal she tackled the complexities of the wet-collodion negative and produced her first successful albumen print by January 1864. She converted her chicken shed into a studio and her coal house into a darkroom where she worked until 1875.

Cameron's aspirations were "to ennoble Photography and to secure for it the character and uses of High Art."[3] Her use of images apparently out of focus was criticized by the contemporary press for faulty technical manipulation.

Cameron's iconography fell within the conventional Victorian categories of subject pictures, illustration, and portraiture popular during the second half of the nineteenth century. Joanne Lukitsch has written:

> With her High Art aspirations Cameron idealized women's experiences, particularly marriage and maternity, and illustrated inspirational and famous women characters from religion, history, and literature.[4]

She conscripted her family, servants, and neighbors as models to portray her allegorical, literary, and religious subjects. Cameron's contemporaries understood her posed and costumed tableau cast in an idyllic Pre-Raphaelite mode. Her portraits, equally romantic in conception, achieved a psychological intensity through dramatic lighting and extreme close-up, life-size images. From the beginning she made powerful portraits of the notable men in her circle, including Thomas Carlyle, Alfred Lord Tennyson, Henry W. Longworth, Sir John Herschel, and Charles Darwin.

Days at Freshwater exemplifies the idyllic tone of Cameron's subjects. Claud and Florence Anson, the children of the Earl of Lichfield,[5] were frequent visitors to Freshwater. Cameron probably worked with a camera for 12 x 15-inch glass plate negatives fitted with a Dallmeyer Rapid Rectilinear lens, which she used at a wide aperture, requiring exposure times of three to seven minutes. As was her practice, Cameron inscribed on the mount *From Life Registered Photograph copyright*. Although she copyrighted almost five hundred photographs between 1864 and 1875, this image was never registered[6] and the negative was damaged.[7]

Although unusual for a woman of the Victorian era to seek public recognition and financial success beyond the home, Cameron pursued both. She was elected a member of the photographic societies of London and Scotland in 1864. She hired Colnaghi's in 1866 and the German Gallery in 1868 for one-woman exhibitions. She maintained an active exhibition schedule between 1864 and 1874 in London and abroad, where her work won acclaim in Vienna, Berlin, and Paris. In 1874 at Tennyson's request, she made photographic illustrations for his *Idylls of the King* as well as publishing her own edition illustrating his poems. In 1875 she returned to Ceylon with her husband where she died four years later. By sheer determination and confidence in the artistic merit of her work, she gained respect from her contemporaries; commercial success never materialized in her lifetime.

1. Mike Weaver, *Julia Margaret Cameron 1815-1879* (Boston: Little, Brown, 1984), p. 155.

2. Weaver, p. 155.

3. Colin Ford, *Camera,* 58, No. 6 (June 1979), 46.

4. Joanne Lukitsh, *Cameron: Her Work and Career* (Rochester, NY: International Museum of Photography at George Eastman House, 1986), p. 26.

5. Joanne Lukitsh, Letter to KS, 5 Dec. 1986, and Pamela Roberts, Letter to KS, 7 Jan. 1987. The Royal Photographic Society, Bath, has four prints of this subject (2144/1-4).

6. Lukitsh letter.

7. Roberts letter. The Royal Photographic Society No. 2144/4 carries the inscription "£2 because negative has perished."

Timothy Henry O'Sullivan
American, b. Ireland?, ca. 1840-1882

Ancient Ruins in the Cañon de Chelle, N.M., 1873. Pl. 10 from *Photographs Showing Landscapes, Geological and Other Features, of Portions of the Western Territory of the United States Obtained in Connection with Geographical and Geological Explorations & Surveys West of the 100th Meridian-Seasons of 1871, 1872, and 1873.* Washington, D. C.: U. S. Government Printing Office, 1875 (?). Printed on mount in black upper left to upper right: *Geographical and Geological Explorations & Surveys West of the 100th Meridian* – War Department insignia surrounded by: WAR DEPARTMENT / CORPS OF ENGINEERS, U. S. ARMY. / *Expedition of 1873* – *Lieut. Geo. M. Wheeler, Corps of Engineers Commanding;* lower left: *T. H. O'Sullivan, Phot;* lower right: *No. 10.;* lower center: ANCIENT RUINS IN THE CAÑON DE CHELLE, N.M. / *In a niche 50 feet above present Cañon bed.* Albumen print from wet-collodion negative, 27.5 x 20.1 cm on album page 53.1 x 42.4 cm.

The Edwin and Virginia Irwin Memorial, 1985.24

Provenance: Janet Lehr Inc., New York.

Ancient Ruins in the Cañon de Chelle[1] is Timothy O'Sullivan's most memorable late work. Unlike Eadweard Muybridge and William Henry Jackson, O'Sullivan dismissed picturesque formulae for themes of isolation in his western landscapes. His perception of the western wilderness as hostile, vast, and arduous was epitomized in the White House Ruin of Canyon de Chelly. As James Wood has argued, in a single image he superimposes "the present – in the form of the tiny figures standing amidst the ruins – the historic past, and the timeless pace of erosion. . . ."[2]

The Anasazi dwellings and kivas built about 1060 A.D. and abandoned by 1275 A.D. are overwhelmed by the monolithic cliff which rises vertically five hundred feet. The understated design, quality of light, and range of tonal values reflect the delicate balance between subjectivity and objectivity which he used consistently throughout his career as an expeditionary photographer.

O'Sullivan was probably born in Ireland around 1840, and emigrated to the United States with his family about 1842. He apprenticed in the fashionable Washington, D. C. studio of Mathew B. Brady under Alexander Gardner. Throughout the Civil War he was a field photographer, first as part of Brady's corps, then as superintendent of field or copy work to the Army of the Potomac from 1862 to 1866 under Gardner. His first body of notable work was published in Gardner's *Photographic Sketchbook of the War* in 1866, documenting the death and devastation of battle.

Between 1867 and 1869 he served under Clarence King as photographer for the Geological Exploration of the Fortieth Parallel, recording geological and topographical features between the Rocky Mountains and the Sierra Nevada. In 1870 he sailed as photographer for the Darien Expedition under Commander T. O. Selfridge to record the Atlantic side of the Isthmus of Panama. His final years as an experienced survey photographer were spent under Lieutenant George Wheeler on explorations of the Southwest between 1871 and 1873. As executive in charge of side parties in 1873, he led an independent expedition to the Canyon de Chelly where this photograph was taken. In 1880 he was appointed as photographer to the Department of the Treasury, from which he was forced to resign the following year due to ill health. He died of pulmonary tuberculosis at his parents' home on Staten Island, New York, in 1882.

1. Original spelling conventions have been retained: Cañon for canyon, Chelle for Chelly.
2. James N. Wood, in Weston J. Naef and James N. Wood, *Era of Exploration: The Rise of Landscape Photography in the American West, 1860-1885* (Buffalo, NY: Albright-Knox Art Gallery; New York: The Metropolitan Museum of Art, 1975), p. 132.

Eadweard J. Muybridge

British, 1830-1904

Panorama of San Francisco from California Street Hill, 1877.

a. Eleven-panel albumen print panorama from wet-collodion negatives, each approximately 18.6 x 20.5 cm mounted on cloth and accordion bound between covers, the whole panorama 228.9 cm. Printed on panel 6 lower left to lower right: MUYBRIDGE, *photo. / Entered according to Act of Congress, in the year 1877, by* EDW. J. MUYBRIDGE, *in the office of Librarian of Congress at Washington,* / MORSE'S GALLERY, / PANORAMA OF SAN FRANCISCO, / FROM CALIFORNIA-ST. HILL.

b. Key for panorama of San Francisco from California Street Hill. Albumen print from wet-collodion negative 19.5 x 29.4 cm on mount 21.0 x 26.8 cm. Printed on mount lower left: MUYBRIDGE, *Photo., Morse's Gallery,*; lower right: *San Francisco.*

The Edwin and Virginia Irwin Memorial, 1985.20: a-b.

Provenance: Janet Lehr, Inc., New York.

In October 1874, Eadweard Muybridge shot Major Henry Larkyns, theater critic and man about town, over the questionable paternity of the son born to his wife, Flora Stone Muybridge. Although he was acquitted on grounds of justifiable homicide, he left the country immediately after the trial until the scandalous episode quieted down. In 1877 he reasserted his presence in the Bay Area by undertaking the first of several ambitious panoramas of San Francisco from California Street Hill. This accordion-bound eleven-panel panorama was the first version published by Morse's Gallery and publicly announced on July 13, 1877, in the *San Francisco Call-Bulletin.*[1] His photographic documentation and accompanying key remain the most vivid and comprehensive record of the physiognomy of San Francisco before the earthquake and fire on April 18, 1906. The 360° sweep of the Bay was taken on a clear day from the roof of Mark Hopkins's residence at the corner of California and Mason streets.[2]

The first version was probably taken on a Monday (traditionally washday) between June 10th and July 3rd, 1877.[3] This 1877 version dates before the California Street Railroad was laid and a new boardwalk between Powell and Stockton Streets was built.[4] Two negatives were made on the same day for Plate 5. The Museum's earlier version shows the western face of the tower's clock reading 1:44 p.m.[5]

Edward James Muggeridge was born in Kingston-on-the-Thames, Great Britain, in 1830 and came to the United States in the early 1850s. In 1855 he established a successful antiquarian bookstore catering to culture-hungry gentlemen in San Francisco. At some point in the mid-1860s he learned photography, perhaps from the New York daguerreotypist Silas Selleck who had set up a gallery in the area at that time. Leaving the bookstore in the hands of his brother, he changed his name, and embarked on a career of outdoor photography.

During this first phase of his photographic activities he chronicled the daily life, developing industry, and expanding agriculture of California and the West coast. His 1872 mammoth-plate views of Yosemite, with their atmospheric effects and dynamic space, won him recognition at the International Exposition in Vienna and eclipsed Watkins's market for views. In 1872 Leland Stanford, the former governor of California and president of the Central Pacific Railroad, commissioned Muybridge

Étienne Carjat
French, 1828-1906

Henri Monnier (ca. 1877). Pl. 2 from *Galerie contemporaine, littéraire, artistique (deuxième semestre, 1re série)*, (Paris: Ludovic Baschet, 1877). Woodburytype print from wet-collodion negative by Goupil et Cie., Asnières, France, 23.5 x 18.7 cm on mount 34.4 x 25.7 cm. Printed in black on mount lower left to lower right: *Galerie Contemporaine HENRI MONNIER cliché Carjat.*

Gift of Janet Lehr, 1978.342.

Exhibitions: Cincinnati Art Museum, *The Cincinnati Art Museum Photography Collection*, 1981-82.

Galerie Contemporaine was a significant landmark in French printing and photomechanical reproduction during the late nineteenth century.[1] This serial publication was issued in installments by Ludovic Baschet, Paris, between 1876 and 1884. The series contained 244 biographical sketches. Between 1876 and 1880 this pantheon of French worthies dealt with celebrities from politics, religion, literature, music, and the visual arts. After 1881 the periodical focused on personalities from the pictorial and plastic arts. The 241 portraits which accompanied the biographies were by the most eminent Parisian photographers including Adam-Salomon, Carjat, Nadar, and others. Their photographs were photomechanically reproduced by Goupil et Cie. who had acquired the exclusive French rights to the woodburytype process from its inventor in 1867. This permanent pigment process, usually printed in a reddish brown, did not fade like albumen prints.

Étienne Carjat, a noted portraitist, caricaturist, and writer, was overshadowed by his flamboyant contemporary Nadar. Yet both contributed at least thirty-five portraits to *Galerie Contemporaine*, and Carjat's portrayals were equal, if not superior, to those of his competitor. Among his notable sitters were Emile Zola, Gioacchino Rossini, Charles Baudelaire, Gustave Courbet, Georges

Clemenceau, and Henri Monnier. Monnier (1805-1877) was a comedian, painter, and writer. Carjat captured Monnier in the role of the comic character Joseph Prudhomme which he had created and successfully portrayed throughout his career. Like Nadar, Carjat preferred a neutral setting. However, he heightened the gesture and expression with acerbic light. Unlike Nadar, he took his own portraits. The base of the head clamp appears below the chair. This issue may have been a memorial tribute to Monnier who died March 6, 1877; the undated negative could have been taken at an earlier date.

Carjat continued his activities as caricaturist, amateur actor, and playwright during his photographic career. In 1861 he opened his first photographic studio on rue Laffitte. Friends, actors, musicians, painters, and writers were his initial models. He won awards in London (1861), Paris (1863 and 1864), Berlin (1865), and the Paris Exposition Universelle (1867). Around 1876, disheartened and exhausted, Carjat gave up photography. During the final three decades of his life he eked out a bare existence from his writing, with additional assistance from his friends.

1. Robert A. Sobieszek, "The Facsimile Photographs in *Galerie Contemporaine*," *Image*, 15, No. 2 (July 1972), 21-24, 31-32. This article provides an excellent description of the serial publication.

Sitsomovi

Hillers, photo.

John K. Hillers

American, b. Germany, 1843-1925

Siteumavi (1879). Albumen print from wet-collodion negative, 25.1 x 33.2 cm on gray mount with decorative border 40.6 x 50.7 cm. Title on negative lower left: *Siteumavi*; signature lower right: *Hillers, photo.*

The Albert P. Strietmann Collection, 1980.96.

Provenance: Pueblo Public Schools District 60; Janet Lehr, Inc., New York.

Exhibitions: Cincinnati Art Museum, *The Cincinnati Art Museum Photography Collection*, 1981-82.

Born in Hanover, Germany, in 1843, John K. Hillers emigrated to the United States in 1852. He enlisted in the Union army during the Civil War and saw action at Petersburg and Richmond. In 1871, while working as a teamster in Salt Lake City, he met Major John Wesley Powell, who signed him on as an oarsman for his second survey of the Green and Colorado Rivers in 1871-72. Financed by the U. S. government, the post-war Powell Surveys between 1869 and 1879 were commissioned to map the Green and Colorado River areas of Utah and Arizona, to collect geological data about the terrain, and assemble ethnographic information about the Indians.

As assistant to E. O. Beaman and subsequently James Fennemore, Hillers learned the intricacies of the wet-collodion process in the field. In 1872, when Fennemore became ill and could not continue, Hillers was appointed as chief photographer for the survey, beginning a long and fruitful association with Powell. In 1879 Powell became first director of the Bureau of (American) Ethnology for the Smithsonian and two years later head of the United States Geological Survey. Hillers served as chief photographer for the Geological Survey from 1881 until his retirement in 1900, when he continued on a part-time basis until 1919. He was buried in Arlington National Cemetery in 1925.

Although he was the first to photograph the Colorado River, Hillers's importance remains as a photographer of the American Indians of the Southwest. In 1886-87 Powell surveyed the plateaus of Tusayan. The Hopi pueblo of Sichomovi is on the East mesa of the Tusayan, between Hano and Walpi in Northeast Arizona.[1] In *Siteumavi*[2] Hillers added a seated male figure holding a bow in the foreground, while the mule and women in the courtyard were already present. In spite of the photographer's intervention, the view documents the architecture and activities of the pueblo. During his twenty-nine years with the Powell Survey, the Bureau of Ethnology, and the Geological Survey, Hillers took several thousand negatives of ethnological and geological subjects. These contributed to the tremendous impact that Powell and his research associates had on the course of American anthropology, geology, and conservation practices.

1. Paula Fleming, Letter to KS, 16 Sept. 1981.
2. The original spelling is retained.

COPYRIGHT 1880 BY N. SARONY.

SARAH BERNHARDT. NEW YORK.

Napoleon Sarony
American, b. Canada, 1821-1896

Sarah Bernhardt as Frou-Frou, 1880. Albumen print, 30.6 x 18.3 cm on panel mount 32.9 x 18.9 cm. Inscribed in negative lower center: COPYRIGHT 1880 BY N. SARONY. N.Y.; printed in gold on mount lower left to lower right: *Sarony* SARAH BERNHARDT NEW YORK.

Library Transfer, 1978.205.

Exhibitions: Cincinnati Art Museum, *The Cincinnati Art Museum Photography Collection*, 1981-82.

On February 3, 1881, the French actress Sarah Bernhardt (1844-1923) appeared at Pike's Opera House, Cincinnati, in the role of Frou-Frou.[1] In Meilhac and Helévy's drama, the enchanting Gilberte (Frou-Frou), a social butterfly, is caught up in the *demimonde* of Paris. She ignores her child and husband, until too late she realizes that her sister had assumed her domestic role. During Bernhardt's six-month tour of the United States and Canada, she played a total of 157 performances in dozens of cities. Although American theater-hungry audiences did not comprehend her classical repertoire, they were enthusiastic for *Adrienne Lecouvreur, Frou-Frou,* and especially *La Dame aux Camélias* which she performed sixty-five times.

During the last three decades of the nineteenth century, the popularity of the American theater reflected the post-Civil War economic prosperity and geographical expansion. Among the professions which profited from and helped nurture the cult of personality during the golden age of American theater was photography. Napoleon Sarony brought these two streams of popular culture together. His eccentric appearance and flamboyant behavior masked a shrewd business sense which made him America's best-known portraitist whose forty thousand negatives remain the most complete visual record of the celebrities on the New York stage. In 1871 he moved his studio from 630 Broadway to 37 Union Square, located in the heart of the theater district.

Each Sarony sitting was a dramatic event set against painted backgrounds with unusual accessories. The stylized poses and expressions of his full-length portraits suggest the paintings in the "grand manner" by eighteenth-century British portraitists Joshua Reynolds, Thomas Gainsborough, and Thomas Lawrence. Sarony paid Sarah Bernhardt fifteen hundred dollars for the exclusive rights to her photographs.[2] This is one of several poses taken at the same session,[3] utilizing an elaborate fabricated backdrop in his skylight studio, with Bernhardt costumed as the pampered Frou-Frou in "swirling taffeta encrusted with beads of real crystal and inserts of mother-of-pearl."[4]

The craze for cabinet photographs began around 1866, when Sarony first opened his Broadway studio. Over the next thirty years his studio turned them out in the tens of thousands in a variety of sizes. The glossy gold-toned purple-brown albumen prints were impressive artifacts:

> mounted on curved cards with rounded-off corners and beveled edges trimmed with maroon or gold ink, and featuring Sarony's flamboyant signature printed in color in the lower left corner, a Sarony cabinet portrait is a handsomely crafted product. . . .[5]

Although he sold his cabinet cards through his gallery, the bulk of his business was handled by salesmen who sold them to theaters, agents, and by mail. Perhaps this panel mount was sold to an enthusiastic Cincinnati fan during Bernhardt's first tour to the city.

Sarony was born in Quebec in 1821 and moved to New York at the age of ten. He trained as a lithographic draftsman and worked under Nathaniel Currier. In 1848 he formed the firm Sarony, Major, and Knapp and rose to prominence during the Civil War as an enterprising publisher of edifying, humorous, and sentimental lithographs, conventional both in subject and style. He spent six years in Europe where he learned photography from his brother Olivier François Xavier Sarony, who ran a successful provincial portrait studio in Scarborough, Britain. Napoleon realized that a photographic portrait provided a better likeness than a lithograph, and would make a hand-drawn original obsolete. In his New York studio, Sarony captured the glamour and larger-than-life theater personalities of the late nineteenth century as Nadar had recorded the literary and intellectual circles of Paris.

1. *Cincinnati Daily Gazette*, 3 Feb. 1881, p. 4, col. 5.
2. Ben L. Bassham, *The Theatrical Photographs of Napoleon Sarony* (Kent, OH: Kent State Univ. Press, 1978), p. 4.
3. Bassham, p. 105, illustrates a full-length standing back view.
4. Cornelia Otis Skinner, *Madam Sarah* (Boston: Houghton Mifflin; Cambridge: Riverside Press, 1967), p. 147.
5. Bassham, p. 14.

CURICANTE NEEDLE, BLACK CANON OF THE GUNNISON. W.H.JACKSON &C.º PHOT. DENVER.

William Henry Jackson
American, 1843-1942

Curicante Needle, Black Canon of the Gunnison (ca. 1881-82). Albumen print from gelatin dry plate negative, 53.3 x 41.4 cm. Number and title on negative lower center: *1053. CURICANTE NEEDLE, BLACK CANON OF THE GUNNISON.*; signature lower right: W. H. JACKSON & CO. PHOT. DENVER.

The Edwin and Virginia Irwin Memorial, 1985.23.

Provenance: Frederick Candee Nims; Janet Lehr, Inc., New York.

Between 1870 and 1878 William Henry Jackson participated in seven United States Geological and Geographical Surveys of the Territories under F. V. Hayden. In 1869, two years after establishing Jackson Brothers, Photographers, with his brother Edward in Omaha, Nebraska, Jackson undertook his first extensive outdoor campaign with A. C. Hull along the Union Pacific line shortly after the golden spike had been driven. During the two years under the influence of panoramic landscape painters S. R. Gifford and Thomas Moran, who accompanied Hayden on the 1870 and 1871 surveys, Jackson's early journalist approach matured. By 1872, bound albums of his 1872 Yellowstone photographs helped inspire legislators to declare it the nation's first national park. By 1875 his talents as a panoramic landscape photographer in complete control of the esthetic and picturesque reached their zenith.

Beginning in the 1880s, the wide distribution of Jackson's scenic photographs made his vision of the western landscapes more familiar than that of any of his contemporaries. Jackson's railroad photographs, totaling thirty thousand negatives, are generally less well known though they contain many of his best images between 1881 and 1896. In 1881, he received a major commission from the Denver and Rio Grande Railway to make a series of views along the longest narrow-gauge line in the world. This project coincided with his shift to 18 x 22-inch gelatin-dry plates. *Curicante Needle* in the Black Canyon of the Gunnison was one of the points of interest along the Denver and Rio Grande Railway.[1] Jackson characteristically framed the distant landscape between the steep canyon cliffs. A master at the nineteenth-century convention of placing the human element in the landscape to establish scale and heighten the picturesque effect, he waited until high noon, when the sun penetrated the deep canyon striking the railroad engine, to make his photograph. This albumen print was listed in the estate inventory of Frederick Candee Nims, general agent for the Denver and Rio Grande Railway, when he retired in 1883.[2] The 18 x 22-inch glass plate negative is in the collection of the Colorado Historical Society, Denver, Colorado.[3]

In the ensuing years Jackson's clientele included the Colorado Midland, Denver, South Park and Pacific Railroads. Between 1894 and 1896 he made a tour of the Far East and Russia as official photographer with the World Transportation Commission. In 1897 he sold out to the Photochrom Company owned by the Detroit Publishing Company of which he became part owner and chief cameraman for two-and-a-half decades. His final years were spent as research secretary for the Oregon Trail Memorial Association. Shortly before his death in 1942, after a career that paralleled the first century of photography, he saw his work in The Museum of Modern Art's exhibition, *Photographs of the Civil War and the American Frontier.*

1. Mary K. Pozzi, Letter to KS, 4 Nov. 1986.
2. Janet Lehr, *William Henry Jackson: Picture Maker of the American West* (New York: Janet Lehr, Inc., 1983), p. 403.
3. Pozzi, Letter.

Attributed to Kusakabe Kimbei

Japanese, active 1880s–1912

Woman at her Toilet (ca. 1880s). Albumen print, 20.9 x 26.7 cm on 20.9 x 27.2 cm.

Gift of William J. Baer (Archives Transfer), 1981.711:39.

Provenance: Robert F. Blum; William J. Baer (executor of Blum's estate).

Exhibitions: Cincinnati Art Museum, *The Cincinnati Art Museum Photography Collection*, 1981–82.

In 1899, the Cincinnati-born painter, Robert Frederick Blum (1857–1903) was retained by Scribner's to illustrate Sir Edwin Arnold's *Japonica* which appeared serially in 1890–91. "This commission, entailing a trip to Japan, was the realization of an ambition Blum had had since he was fifteen when he first bought some Japanese fans."[1]

Blum was probably the first American painter to travel to Japan since Commodore Matthew C. Perry opened it to the West in 1854. His drawings, watercolors, and pastels stimulated America's interest in this exotic country. During his stay in Japan he collected over two hundred Japanese *ukiyo-e* prints and albums. In addition, he acquired over three hundred albumen prints depicting the habits, customs, costumes, and landscape of Japan. The prints and photographs were undoubtedly used as resource material for his own Japanese subjects.

Kusakabe Kimbei was the greatest Japanese commercial photographer of the Meiji period (1868–1912). He was active in Yokohama from the mid-1880s until 1912.[2] He probably began as an operator for the Austrian photographer Baron von Stillfried, who sold Kusakabe his stock when he left the country in 1885. This acquisition ended a cross-cultural chain which began when Felice Beato arrived in Japan in 1862. Upon his departure in January 1877, Beato sold his stock to Stillfried. References to Kusakabe disappear in 1912.

It seems probable that *Woman at her Toilet* is the work of Kusakabe.[3] His studio photographs are notable for their elegant simplicity and calm serenity. Scenes showing customary activities were set against plain backdrops with only the pertinent accessories. Unlike photographs prepared for foreign markets, these albumen prints were never mounted or hand-colored. Blum may have acquired this albumen print during his stop in Yokohama.

1. Richard J. Boyle, *A Retrospective Exhibition: Robert F. Blum 1857–1903* (Cincinnati: Cincinnati Art Museum, 1966), p. 4.
2. Clark Worswick, *Japan Photographs 1854–1905* (New York: Pennwick Publishing and Knopf, 1979), p. 146.
3. Worswick, p. 80, illustrates a comparable subject to the Museum's photograph.

Peter Henry Emerson

British, b. Cuba, 1856-1936

Rowing Home the Schoof-Stuff (1885-86). Pl. XXI from Peter Henry Emerson and T. F. Goodall, *Life and Landscape on the Norfolk Broads* (London: Sampson, Low, Marston, Searle and Rivington, 1886). Platinum print, 13.8 x 27.8 cm on album sheet 28.6 x 41.1 cm. Title printed in black on tissue cover sheet: PLATE XXI. / ROWING HOME THE SCHOOF-STUFF.

The Albert P. Strietmann Collection, 1976.35.

Provenance: Russ Anderson, Ltd., London, 1976; The Halsted 831 Gallery, Birmingham, Michigan (from Russ Anderson, Ltd.).

Exhibitions: Cincinnati Art Museum, *The Cincinnati Art Museum Photography Collection*, 1981-82.

Peter Henry Emerson was a professional amateur photographer. His lectures, writings, and photography promoted a "scientific naturalism" to present the external world. It was based on the physiological optics, the actual way the eye perceives, of the German scientist Herman von Helmholtz and the British naturalistic school of painting. While he championed a naturalistic approach, he venomously attacked the "high art" theories set forth by Henry Peach Robinson in *Pictorial Effect of Photography* in 1869 and his anemic, composite painting-derived images. Emerson believed that photography was a valid medium in its own right for artistic expressiveness and not the handmaid of the other arts.

In 1869 he defended his approach and scientific theories in *Naturalistic Photography*. The key to true art, he felt, rested in the selection of a principal subject in a natural setting discovered by the photographer. Emerson's strongest images, including *Rowing Home the Schoof-Stuff* (rushes), were of the eel catchers and reed cutters of the Norfolk Broads, in their boats amid a vast expanse of still water and flat land. The spare, almost abstract composition is reminiscent of the paintings and etchings of James Abbott McNeill Whistler whom he admired. His emphasis on atmospheric effects and controversial differential focusing, which sharply brought out the principal subject while softening other contours, rested on his scientific pursuit of "naturalism." Emerson's atmospheric subjects were greatly enhanced by the delicate mid-tones of the commercially available platinum papers, which he was one of the first photographers to use.

Between 1886 and 1899 he published eight sets of photographs in books and portfolios. The finest and rarest, *Life and Landscape on the Norfolk Broads*, containing forty platinum prints, was co-published with T. F. Goodall in 1887. The album contained short essays on the flora and fauna, landscapes, and social life of the strange marsh dwellers of East Anglia. His heroic peasant types reflect the rustic naturalism of young British painters Herbert La Thangue, George Clausen and Thomas F. Goodall, who served as intermediaries to the French naturalist painters, Jules Bastien-Lepage, Pascal Dagnan-Bouveret, and Leon Lhermitte.[1]

Emerson was born to an American father and British mother on their Cuban sugar plantation. After the death of his father in 1864, the family moved to Britain where he studied medicine at Clare College, Cambridge. Although he completed his medical degree in 1885, the acquisition of a camera in 1882 led to his abandonment of the medical profession in 1886. A founding member of the Camera Club of London in 1885, he joined the Photographic Society of Great Britain as a representative of amateurs the following year. In 1895 The Royal Photographic Society (formerly the Photographic Society) awarded him the Progress Medal, its highest honor and first ever given for artistic rather than technical achievement. A major retrospective exhibition was held at The Royal Photographic Society in 1900. After a well-publicized decade of promoting his own work and violently attacking his contemporaries, Emerson ceased exhibiting and publishing. Although his theories had little impact on the development of photography, his work has survived the vicissitudes of time.

1. Kenneth McConkey, "Dr. Emerson and the Sentiment of Nature," *Life and Landscape: P. H. Emerson: Art & Photography in East Anglia 1885-1900*, ed. Neil McWilliam and Veronica Sekules (Norwich, Great Britain: Sainsbury Centre for Visual Arts, 1986), pp. 48-56.

Frank Meadow Sutcliffe

British, 1853-1941

Whitby Harbor (1880s–mid-1890s). Gelatin silver print, 11.1 x 15.5 cm. Artist's signature with pencil lower right: *F. M. Sutcliffe;* title, number and signature with pencil on verso: *Whitby Harbour . Copyright / no. 106 / F. M. Sutcliffe / Whitby.*

Museum Purchase: Gift of Samuel S. Pogue, by exchange, 1978.243.

Provenance: Janet Lehr, Inc., New York.

Exhibitions: Cincinnati Art Museum, *The Cincinnati Art Museum Photography Collection*, 1981-82.

Frank Meadow Sutcliffe's career spanned the collodion wet plate process to the Kodak era. He was born October 6, 1853, in Heading, Leeds, Britain. His father, Thomas Sutcliffe, was a talented painter, printmaker, and amateur photographer, whom he accompanied on painting expeditions. Frank Sutcliffe began photographing at the age of fifteen. Between 1872 and 1873 he photographed Yorkshire abbeys and castles for Francis Frith of Reigate. He made an abortive effort to set up a portrait studio in Tunbridge Wells, the famed Victorian watering place, in 1875, but returned to live in Whitby and its vicinity for the next sixty-five years.

In successive studios between 1876 and 1922 when he sold his business, Sutcliffe made his living from the seasonal trade in portraits. During the off season he pursued his personal work which was noted for its naturalistic and spontaneous style. His subjects were the harbor and landscape of the small sea-town, its fishermen and farmers, and their families at work and play. In 1888 he received the first one-man show at the Camera Club, London. Between 1881 and 1905 he received sixty-two gold, silver, and bronze medals at home and abroad for his non-commercial photography. Although he found little financial recognition,

> Frank Sutcliffe had a host of would-be imitators. Amateur photographers made pilgrimages to Whitby and environs, "The Photographer's Mecca," in hopes of capturing his moody harbour scenes, the activities of the fisher-folk and the "Water Rats" of whom many inferior versions appeared in exhibitions. . . .[1]

In addition to his photographic activities, he frequently served as a photographic juror, wrote a column for the *Yorkshire Evening Post* from 1908 to 1930, and contributed to other periodicals. Upon his retirement in 1922, he became curator of the Whitby Literary and Philosophical Society.

Sutcliffe used atmospheric effects with differential focusing to direct attention to a particular area of his photographs in the early 1880s prior to Peter H. Emerson and the pictorialists. In this view of lower *Whitby Harbor* from Scotch Head,[2] the center of attention is focused on the sailboat silhouetted against the distant buildings shrouded in mist or fog. He was able to obtain both the seascape and sky by using a technique known as *contre-jour* – against the light. When the sun was sufficiently obscured by a light cloud or mist he pointed the camera toward it, achieving a more luminous effect without detrimental results on the negative. His working method resulted from his search for ways to achieve truth to nature modified by imagination and the practical limitations of his equipment. He used a camera designed to take the large wet-collodion plates. These were supplanted by the gelatin dry plate after 1880.[3] It had a lens with long focal length which he used at a wide aperture to preserve the aerial and linear perspective. Thus, the background appeared out of focus – but in combination with the *contre-jour* approach the effects appeared natural. The activity along the waterfront is sublimated to the realistic atmosphere.

In 1892, by the time he became a founding member of The Linked Ring, a group which seceded from the Photographic Society of Great Britain to promote the highest form of art of which photography was capable, his distinctive style had been formulated for at least a decade. Sutcliffe favored the purist point of view concerned with "truth to nature."[4] Combination printing, alterations in tonal relationships, and diffusion of detail were permitted when achieved by photographic means.

1. Margaret Harker, *The Linked Ring: The Secession Movement in Photography in Britain, 1892-1910* (London: Heinemann, 1979), p. 94.

2. Bill Eglon Shaw, *Frank Meadow Sutcliffe Photographer: A Selection of His Work* (Whitby, Yorkshire: Sutcliffe Gallery, 1974), p. 28.

3. Bill Eglon Shaw, Letter to KS, 1 Apr. 1987. According to Shaw, the negatives once in the possession of the Whitby Literary and Philosophical Society now belong to the Sutcliffe Gallery. Negative no. 106 is a 6.5 x 8.5-inch dry glass plate negative.

4. Harker, p. 92.

Alfred Stieglitz
American, 1864-1946

Winter on Fifth Avenue (1893). Pl. 1 from Alfred Stieglitz, *Picturesque Bits of New York and Other Studies* (New York: Robert Howard Russell, 1897). Photogravure, 28.3 x 22.2 cm on 43.3 x 35.3 cm. Inscribed in margin upper left: COPYRIGHT 1897 BY ALFRED STIEGLITZ.

Gift of Mrs. A. H. Chatfield, 1912 (Library Transfer), 1981.324:1.

Alfred Stieglitz's half-century career bridged the transition from the Victorian to the modern world. His photographic sensibilities mirrored the range of artistic ideals from pictorialism to straight photography. Through his images, writings, publications, and galleries, he vigorously campaigned for the recognition of photography as a distinct art form. More than any other single individual, his photographic work and proselytizing activities shaped the course of aesthetic photography in America.

Stieglitz was born on January 1, 1864, in Hoboken, New Jersey, into a prosperous family of German Jewish descent. He spent his youth in a comfortable milieu which emphasized education, culture, and accomplishment. In 1881 his retired father took his family to Germany where Stieglitz enrolled in mechanical engineering at the Technische Hochschule, Berlin, to complete his education. After buying his first camera in 1883, he became absorbed in photochemistry and optics. He transferred to the lectures of Herman Vogel, the inventor of the orthochromatic dry plate. Stieglitz's photographs received their first recognition in 1887 when he was awarded first prize by the eminent British photographer and theoretician Peter Henry Emerson in the Holiday Work Competition sponsored by *Amateur Photographer*.

In spite of Emerson's articulate spokesmanship, photography as art had not been widely accepted, exhibited, or collected in Europe. When Stieglitz returned to the United States in 1890, he found that the general public had not been touched by the controversial beginnings of the aesthetic movement in Europe. Instead he encountered a provincial attitude equating photography as a faddish hobby comparable to bicycling. He soon became more interested in crusading for the recognition of photography as a means of artistic expression than in his partnership in the Photochrome Engraving Company (1890-95). He became editor of the *American Amateur Photographer* (1893-96), and later of *Camera Notes*, the periodical of the Camera Club of New York (1897-1902).

In the 1890s, unable to fall back on traditional European themes, Stieglitz took to the streets of New York to hunt for picturesque motifs. He adopted as his subject man's relationship to nature in the modern city. His most innovative works from this period necessitated overcoming technical problems or pushing the medium beyond accepted limits. Although he advocated straight, unmanipulated imagery, Stieglitz softened the harshness of the city by deliberately photographing it under adverse weather or light conditions.

Stieglitz used a hand-held camera considered by most pictorialists as unworthy of serious work. He took his first successful preconceived photograph with a hand camera during a blizzard on February 22, 1893.

On Washington's birthday in 1893, a great blizzard raged in New York. I stood at the corner of 35th Street and Fifth Avenue, watching the lumbering stagecoaches appear through the blinding snow and move northward on the Avenue. The question formed itself: Could what I was experiencing, seeing, be put down with the slow plates and lenses available? The light was dim. Knowing that where there is light one can photograph, I decided to make an exposure.

Later, at the New York Society of Amateur Photographers, before my negative was dry, I showed it with great excitement. Everyone laughed. 'For God's sake, Stieglitz,' someone said, 'throw that damned thing away. It is all blurred and not sharp.'

'This is the beginning of a new era,' I replied. 'Call it a new vision if you wish. The negative is exactly as I want it to be.' What I was driving at had nothing to do with blurred or sharp. And when, twenty-four hours later, the men saw my lantern slide, they applauded. No one would believe it had been made from the negative considered worthless. I call my picture *Winter – Fifth Avenue*. It was the first photograph I had taken with a hand camera.[1]

Winter on Fifth Avenue, according to Edward Steichen, was "his most exhibited, reproduced, and prize-awarded print, and was a technical achievement considered impossible" at the time it was made.[2] Stieglitz published it as part of a portfolio of twelve photogravures titled *Picturesque Bits of New York* in 1897, and again as a hand-pulled gravure in *Camera Work* 12.[3] Stieglitz planned his negatives for enlargement and rarely used more than a portion of the original frame.[4] He significantly cropped this subject on the sides.[5] His high estimation of his work was reflected in his high prices. While other amateurs set their prices between five and twenty-five dollars, at the American Institute exhibition of 1898, he listed *Winter on Fifth Avenue* for seventy-five dollars.[6] Stieglitz hoped one day to fetch prices comparable to fine prints and drawings.

During the late 1890s Stieglitz gathered around him a group of amateur photographers whose aesthetic conviction was that photography should be suggestive of meanings and ideas, and expressive of artistic personality.[7] These ideas he championed with missionary zeal by spearheading the organization of the Photo-Secession in 1902, editing its periodical *Camera Work*, and directing The Little Galleries of the Photo-Secession, later known as "291." He considered his campaign for the artistic merits of photography accomplished when in 1910 the Albright Art Gallery in Buffalo, New York, asked him to organize an exhibition of the Photo-Secessionists and purchase photographs for its permanent collection. The Photo-Secession had demonstrated that photography could be artistic. It had done so by appropriating the style, subject, and look of other late nineteenth-century art, yet it left the issue of photography as a distinct medium unresolved.[8]

(continued to page 216)

Clarence Hudson White

American, 1871-1925

The Orchard (1902). Platinum print 1902?, 23.8 x 19.2 cm mounted on tissue 29.7 x 22.8 cm. Artist's signature with pencil lower right: *Clarence H. White*; signature on tissue lower right: *Clarence H. White*.

Bequest of Herbert Greer French (Library Transfer), 1943.1513.

Provenance: Herbert Greer French, Cincinnati.

Exhibitions: Cincinnati Art Museum, *The Cincinnati Art Museum Photography Collection*, 1981-82.

At the turn of the century, Clarence Hudson White was considered one of the most influential pictorialists and subsequently became highly esteemed as a photographic educator. He was born in West Carlisle, Ohio, on April 8, 1871. His family moved to Newark, Ohio, where he graduated from high school and became a bookkeeper for Fleek and Neal, wholesale grocers. In 1893, he and his bride Jane Felix honeymooned at the World's Columbian Exposition in Chicago, which provided a significant opportunity to study contemporary painters first hand. White made his first photographs in 1893 and seriously took up the study of photography the following year. In 1897 he won the Ohio Photographer's Association Gold Medal in Cincinnati and the following year he participated in the First Philadelphia Photographic Salon where his work attracted the attention of Alfred Stieglitz. In 1899 he exhibited in London in the Photographic Salon organized by The Linked Ring. In the same year Stieglitz organized a one-man show at the Camera Club in New York, and at the Second Philadelphia Photographic Salon, where White was a juror as well as a participant. Alfred T. Goshorn, first director of the Cincinnati Art Museum, solicited 108 photographs for an exhibition including other pictorialists in 1900.[1]

Between 1900 and 1910 White participated in every major national and international exhibition in London, Paris, Glasgow, Berlin, and Vienna. He was elected as a member of The Linked Ring, London, in 1900 and became a founding member of the Photo-Secession, New York, in 1902. Stieglitz's landmark photographic periodical of the Photo-Secession, *Camera Work*, featured White's work in five issues between 1903 and 1910, including a 1908 issue devoted entirely to his photographs. In 1904 White quit his bookkeeper position, and spent two years traveling throughout the Midwest primarily working as a portrait photographer. He moved to New York in 1906, where he became a lecturer on photography at Columbia University between 1907 and 1925, and an instructor of photography at the Brooklyn Institute of Arts and Sciences between 1908 and 1921. In 1910 he began a summer school of photography at Sequinland, Maine, which led to the founding of the Clarence White School of Photography in New York in 1914. Among his students were Karl Struss, Dorothea Lange, Margaret Bourke-White, Doris Ulmann, Anton Bruehl, Paul Outerbridge, Laura Gilpin, and Ralph Steiner. In 1916, he was elected first president of the Pictorial Photographers of America of which he was an organizer. He died in 1925, while on a field trip with students to Mexico.

White's most productive period was between 1893 and 1906. A self-taught amateur, he seriously explored the capacities of his photographic materials, including platinum and gum bichromate prints, and palladium prints after 1906. In spite of limited time and finances, he intuitively created images of compelling beauty and originality. His subjects were his family and friends in simple domestic scenes of Midwestern middle-class life, which he knew intimately. *The Orchard* of 1902 betrays the influences of Japanese *ukiyo-e* prints and American tonalists such as William Merritt Chase, which were particularly strong around the turn of the century. White used the Japanese system of diagonals to compress the composition into a shallow space between the bending figure (Julia McCune) in the foreground and the tree at the upper left. His careful asymmetric organization of the flat picture plane is obvious by the placement of the two standing figures (Letitia Felix and Stella Howard)[2] above and behind. His skillful arrangement of light behind the subjects silhouettes the figures, while in the shadowy foreground white plays against white and dark against dark. The Whistlerian soft focus, Arcadian beauty, and serene lyricism reveal the basis of White's international reputation as a pictorialist. This print once belonged to Herbert Greer French, the only Cincinnati member of the Photo-Secession.

1. Cincinnati Museum Association, *A Special Exhibition of Photographs,* Feb. 25 to Mar. 11, 1900, pp. 5-8, nos. 1-108.
2. Peter Bunnell, Letter to KS, 12 Sept. 1981.

Edward Sheriff Curtis

American, 1868-1952

Cheyenne Girl (1905). Proof for Pl. 212 of Edward S. Curtis, *The North American Indian: Being a Series of Volumes Picturing and Describing the Indians of the United States and Alaska*, (Cambridge: Univ. Press, ca. 1911), folio VI. Photogravure print before inscription by John Andrews & Son, Boston, 39.2 x 28.0 cm image on 44.8 x 31.7 cm plate on sheet 55.5 x 46.2 cm. Inscribed by unidentified hand with pencil in margin lower right: *Vol VI P 667*.

The Albert P. Strietmann Collection, 1976.32.

Provenance: The George Lauriat Company, Boston; Carl Solway Gallery, Cincinnati.

Exhibitions: Carl Solway Gallery, Cincinnati, *Edward S. Curtis*, 1976; Cincinnati Art Museum, *The Cincinnati Art Museum Photography Collection*, 1981-82.

Today Edward S. Curtis has become the most popular photographer of Indian customs, ceremonials, and life-styles west of the Mississippi. His multivolume work *The North American Indian* stands as a hallmark of artistic photography and influenced the prevailing contemporary perspective on the Indian. Only recently has its documentary significance been critically questioned and its pictorialist merit appreciated.

Curtis was born in Whitewater, Wisconsin, in 1854. He moved to Seattle, Washington, with his family in 1887 where he went into partnership with Rasmen and Rothi in 1891. By 1897 he had launched a successful commercial photographic business as a romantic portraitist and landscapist. Although he took his first photographs of Indians in 1898, it was not until 1900, after a stint as official photographer on the E. H. Harriman Expedition to Alaska, that he seriously committed himself to photographing the vanishing Indian way of life.

In 1906, with the enthusiastic support of President Theodore Roosevelt, he secured financial backing from J. Pierpont Morgan to begin publication and continue his field work. He made over forty thousand negatives which imaginatively depicted the ethnicity of eighty-eight tribes. The resulting publication comprised 1,505 small photogravures in twenty volumes and 723 large photogravures in twenty accompanying portfolios. The folio plates printed on Holland Van Gelder paper, Japan vellum, or Japanese tissue, were accompanied by a protective mat. Although the subscription prospectus announced an edition of five hundred copies, probably no more than half that number were ever issued. This deluxe publication issued between 1907 and 1930 had a limited circulation, since only museums, well-endowed libraries, and wealthy private collectors could afford the set, priced at $3,000 to $3,850.

In the introduction to *The North American Indian*, Curtis described his conception of the project as "a comprehensive and permanent record of all the important tribes of the United States and Alaska that still retain to a considerable degree their primitive customs and traditions. . . ."[1]

Curtis was both victim and perpetrator of his generation's perception of "Indianness," a romantic stereotype of the pre-acculturated noble savage. Curtis undoubtedly saw his choice of subject matter, staging of the subject, and manipulation of the photographic process as adding truthfulness to the inherently accurate camera made image.

The first six volumes were devoted to the Great Plains tribes which were the most familiar to his prospective audience. His pictorial interpretation of fierce warriors and pliant maidens was dignified and picturesque. *Cheyenne Girl*, a photogravure proof before inscription for portfolio VI, was probably taken against a neutral backdrop in Curtis's darkroom tent which he took with him into the field. The proud and dignified young woman wears a breastplate of bone hair pipes (cattle bones), French brass trade beads, and leather, which was normally worn by men.[2] That this neckpiece and the penny earrings were actually traded by the white men to the Indians did not seem to concern Curtis, since they met his and his audience's expectation of what exotic Indian accessories should be. His use of pictorialist soft focus and dramatic side lighting contributes to the romantic and aesthetic appeal of the subject. That Curtis created a convincing reality in his efforts to preserve ethnicities which never were, is a testament to his artistic skills and technical expertise.

1. Edward S. Curtis, *The North American Indian, Being a Series of Volumes Picturing and Describing the Indians of the United States and Alaska* (Cambridge: Univ. Press, 1907), I, p. xiii.
2. I would like to thank Christine Mullen Kreamer for this information.

Émile Joachim Constant Puyo

French, 1857-1933

The Straw Hat (ca. 1905-10). Oil pigment print, 27.6 x 21.0 cm. Circular monogram blindstamp lower right: CPUYO.

Museum Purchase: Gift of John Sanborn Connor, by exchange, 1981.154.

Provenance: Puyo's granddaughter; Janet Lehr, Inc., New York.

Exhibitions: Cincinnati Art Museum, *The Cincinnati Art Museum Photography Collection*, 1981-82.

Émile Joachim Constant Puyo was one of the most notable fin-de-siècle French secessionists. He was born in Morlaix, France, in 1857. A squadron leader at the School of Artillery in La Fère, he resigned from the army in 1902 to pursue his hobby. In 1894 he joined the Photo-Club de Paris and with Robert Demachy, Maurice Bucquet, and Rene Le Bègue organized the first Salon Photographie. Over the years he authored *Notes sur la Photographie Artistique* in 1896 and many other books and articles on equipment and processes. Along with Leclerc de Pulligny, he developed anachromatic lenses which were used by the artist-photographers of the Photo-Club for their pictorial images by the mid-1900s. Alfred Stieglitz published three of Puyo's photogravures in *Camera Work* 16 and exhibited his photographs in an exhibition of French work in January 1906. In 1931, two years before his death, he had a joint retrospective with Robert Demachy in Paris.

Like British and American fin-de-siècle counterparts, French secessionists led the crusade for the acceptance of photography as art. To achieve work of true artistic character, the *Flouistes Impressionists* used a variety of means to alter their images including scratching negatives, drawing on prints, and manipulating printing processes. Not only was the realization of the final print important, but selective composition and diffuse focus during the negative-making stage were prerequisites for artistic success. The secessionists turned to the impressionists as role models in their desire to produce beautiful objects and to provide authentic moral and artistic substance for their cultivated audience.

Puyo developed an elegant style with a touch of *joie de vivre* in his best portraits and figure studies. *The Straw Hat* is typical of the feminine grace of his female subjects. The nearly life-size head has lost its hard outline, yet retains its impression of sharpness. His preference for general diffusion of the image (soft focus) was one of the major characteristics associated with impressionist photography. Puyo favored extra rough printing papers which enhanced the breadth of tones of his hand-manipulated prints. Puyo was instrumental in the development of a number of pigment processes, including gum bichromate, oil pigment, and oil transfer which gave him greater freedom and considerable control in the definition, tonal qualities, and color of his image. The articulation of light in conjunction with multiple layers of semi-transparent ochre, orange, and brown oil pigments created a reflective luminosity comparable to that of a watercolor. Puyo proudly affixed his circular monogram to this image, which epitomized his impressionist pictorial aesthetic. Within a decade, a reaction against such excesses of manipulative techniques gave rise to a call for a straight, unmanipulated photography.

Carl Christian Heinrich Kühn

German, 1866-1944

Walter Kühn (ca. 1906-08). Gum bichromate print, 38.9 x 28.6 cm on 39.4 x 29.5 cm. Inscribed with pencil on verso: *Kna (illegible) 50.*

Museum Purchase: Gift of Charlotte Groom Braunstein and Pauline J. Fihe, by exchange, 1978.246.

Provenance: Simon Lowinsky Gallery, San Francisco.

Exhibitions: Cincinnati Art Museum, *The Cincinnati Art Museum Photography Collection*, 1981-82.

Heinrich Kühn was one of the most pictorially sophisticated photographers involved in the international aesthetic movement at the turn of the century. He led the Austro-German pictorialists known as the Secession in clubs, exhibitions, and periodicals beginning in the 1890s. Born the son of a Dresden merchant on February 25, 1866, he studied science and medicine in the 1880s. Around 1888, shortly after his arrival in Innsbruck, he quit medicine to devote himself to photography. He was particularly struck by effects achieved by members of the progressive new British amateur association, The Linked Ring, included in the 1891 International Exhibition of Photography organized by the Vienna Camera Club.

In 1894 Kühn joined the Vienna Camera Club and struck up a friendship with Hans Watzek (1848-1903) and with Hugo Henneberg (1863-1918) the following year. Members of The Linked Ring since 1894, they may have been instrumental in Kühn's election to this elite body in 1896. It was Henneberg who saw the gum-bichromate prints by the French photographer Robert Demachy (1859-1936) either in London or Paris in 1895, and introduced Kühn and Watzek to the resurrected technique. Together they elaborated on the process, inventing the multiple gum-bichromate print, which Kühn was the first to exhibit in 1896. Known as the Trifolium, the three friends showed in the Munich Secession international exhibition in 1898 and at the prestigious Berlin Gallerie Schulte in 1900. The momentum of the Trifolium was cut short at its zenith by the death of Watzek in 1903 and by Henneberg's return to painting and printmaking in 1905

Kühn was introduced to American audiences through his friendship with Alfred Stieglitz. Although they knew of each other's work in 1894 when they both exhibited in the Milan International Exhibition, they did not meet until a decade later. Both were leaders of major national photographic communities at the height of the pictorialist era, when there was an unprecedented international exchange in salon-style exhibitions and journal notices. Stieglitz declared his convictions about Kühn's importance by featuring his work in 1906 and 1911 issues of *Camera Work*, his photographs in exhibitions at the Little Galleries of the Photo-Secession, and in the landmark International Exhibition of Pictorial Photography in Buffalo. Inspired by Stieglitz, Kühn organized a major international exhibition for the Vienna Camera Club at the avant-garde Galerie Miethke in 1905 and the artistic photography section for the Dresden International Exhibition in 1909. After the Dresden exhibition Kühn worked in increasing isolation as the pictorialist movement began to dissipate.

The works of pictorialist photographers paralleled landscape, genre, and portrait subjects in painting and printmaking of the period. The multiple gum-bichromate allowed Kühn and other photographers to achieve greater painterly effects by altering the image or making expressive tonal adjustments during printing. The photographer, Kühn wrote,

must control nature. For it is now entirely within his power to translate colors into their monochromatic values; and if the negative should show any discord, the gum process enables him at will to attune the discordant elements in the print. Thus, on the one hand, he can subdue or entirely suppress anything too prominent in the less important parts of the picture, while, on the other, he can emphasize all the subtleties where they are interesting and of importance for a pictorial effect. This naturally requires mastery of the technique. The apparatus, the soulless machine, must be subservient, the personality and its demands must dominate. The craftsman becomes an artist.[1]

After 1900 Kühn's portraits of his children in Tirolean landscapes and dark interiors reflect his admiration for the calotype portraits of Hill and Adamson and the photographs of American photographers Käsebier, Steichen, and White. His portrait of Walter Kühn (1893-1973), half emerging from a palpable darkness, demonstrates his preference for the broad effects, diminished detail, and coloristic richness possible with the multiple gum-bichromate technique. The photograph probably dates after 1906 since wood paneling was a feature of his new studio on Richard Wagner Straße. Walter Kühn began to wear glasses sometime around 1908, suggesting a terminal date for this sitting.[2]

Suffering financial reverses in the aftermath of World War I, Kühn closed his studio in 1919 and moved to the nearby village of Birgitz. During the 1920s he continued to make technical innovations and became active as a writer for *Photographische Rundschau* (1917-20) and *Das Deutsche Lichtbild* (1928-37). His style, unchanged after 1912, was eclipsed by the crisp realism of the "Neue Sachlichkeit." The University of Innsbruck gave him an honorary doctorate in 1937. He died in Birgitz at the age of seventy-eight on October 9, 1944.

1. Fritz Matthies-Masuren, "Hugo Henneberg – Heinrich Kühn – Hans Watzek," in *Camera Work*, 13 (Jan. 1906), p. 28.
2. Ronald J. Hill, Letter to KS, 30 Jan. 1982.

Herbert Greer French

American, 1872-1942

Winged Victory (1907). Platinum print, 22.8 x 18.4 cm with brown and pale green paper borders on brown mount 46.0 x 31.7 cm. Artist's signature with pencil on verso mount: *H. G. French.*

Gift of Margaret L. Smith, 1970.345.

Provenance: Dudley K. French, Winnetka, Illinois (from the estate of Herbert Greer French, 1942); Margaret L. Smith, Cincinnati and New York (from Dudley K. French), 1942-70.

Exhibitions: Cincinnati Art Museum, *The Cincinnati Art Museum Photography Collection*, 1981-82.

In the Spring of 1904 Herbert Greer French was elected to the Photo-Seccessionists as its only Cincinnati member.[1] Through his vision and commitment to the mission of the Photo-Secession, an *Exhibition of Photographic Art* was arranged in cooperation with Alfred Stieglitz and shown at the Cincinnati Art Museum in February 1906.[2] In the preface to the seventy-five-piece exhibition checklist, French described the Photo-Secession as "a Society of protest against the use of photography as a purely mechanical means of reproduction; and its chief objective is the establishment of photography as a recognized art medium."[3] This amateur movement promoted photography as a vehicle for visual expression and experimentation, capable of the highest aesthetic standards, and eschewed the crass commercialism of stilted professional portrait photography.

French was born in Covington, Kentucky, in 1872. In 1893 he was employed by the Procter and Gamble Company, Cincinnati, as an underclerk in the freight department. He rose to become senior vice-president. He became a prominent citizen and involved himself in many civic activities. Beginning in 1926, he assembled a collection of over 800 old master and modern prints which he bequeathed to the Cincinnati Art Museum, where he served as honorary curator of prints beginning in 1929. He died in 1942 at his beloved "Reachmond" estate.

It is not known when French took up photography. His photographs were exhibited in 1900 and 1901 in the Third and Fourth Philadelphia Photographic Salons. Between 1902 and 1909, he exhibited in major national shows and internationally in London, Dresden, Paris, and Vienna. At what point and how he became acquainted with Stieglitz is also a matter of speculation. He may well have been introduced by his fellow Ohioan, Clarence White, who had a major exhibition at the Cincinnati Art Museum in 1900. French not only made offers of assistance to Stieglitz, but contributed financially to the "Little Galleries of the Photo-Secession" and subscribed to *Camera Work.* On January 26, 1906, French showed forty-five of his photographs illustrating Tennyson's "Idylls of the King" in the galleries and participated in four group exhibitions between 1905 and 1908. In response to Stieglitz's request for photographs for the International Exhibition of Pictorial Photography at the Albright Art Gallery, Buffalo, in 1910, French responded on September 13, 1910:

I have decided that, partly owing to lack of time, and partly to other reasons, which I can hardly outline in a letter but the value of which you may be able to surmise, I shall ask you to show no more of my work at any exhibitions whatsoever for the next few years . . . That you may always count on me to do anything in my power for the Photo Secession goes without saying.[4]

To the best of our knowledge, he did no more photographs.

Winged Victory was exhibited in a group show at the Photo-Secession Galleries in 1907 and in Dresden in 1909.[5] The subject was also reproduced in the July 1909 issue of *Camera Work*, which featured five of French's images. His approach to focus and concept of beauty falls within the formal pictorial ideas explored by many as the aesthetics of modernism.

1. Herbert Greer French, Letter to Alfred Stieglitz, 16 May 1904, Stieglitz Archives, *Collection of American Literature*, Beinecke Rare Book and Manuscript Library, Yale University, New Haven.
2. Herbert Greer French, Letters to Alfred Stieglitz, 2 Mar. 1904, 18 Oct. 1905, 13 Nov. 1905, 22 Dec. 1905, 10 Jan. 1906, 11 Feb. 1906, 22 Feb. 1906, 9 Mar. 1906, and 12 Mar. 1906, Stieglitz Archives.
3. Herbert Greer French, Pref., *Exhibition of Photographic Art* (Cincinnati: Cincinnati Art Museum, 1906) n. pag.
4. Herbert Greer French, Letter to Alfred Stieglitz, 13 Sept. 1910, Stieglitz Archives.
5. Weston J. Naef, *The Collection of Alfred Stieglitz: Fifty Pioneers of Modern Photography* (New York: Viking Press, 1978), p. 364.

Alvin Langdon Coburn

British, b. United States, 1882-1966

Canal in Rotterdam (1908). Photogravure print, 30.2 x 39.1 cm on 32.4 x 40.8 cm.

Museum Purchase: Gift of Fred Schroeder, by exchange, 1981.137.

Provenance: Stephen T. Rose, Boston.

Exhibitions: Cincinnati Art Museum, *The Cincinnati Art Museum Photography Collection*, 1981-82.

> I have the very greatest respect for photography as a means of personal expression, and I want to see it alive to the spirit of progress; if it is not possible to be "modern" with the newest of all the arts, we had better bury our black boxes, and go back to scratching with a sharp bone in the manner of our remote Darwinian ancestors. I do not think that we have begun to even realize the possibilities of the camera. . . .[1]

At the precocious age of twenty-one, Alvin Langdon Coburn belonged to the two most avant-garde and aesthetically conscious internationally known organizations of pictorialists. Although he was a founding member of the Photo-Secession in 1902 and elected a member of The Linked Ring in 1903, Coburn transcended the pictorialist desire to validate photography as an artistic medium. He saw photography as a vehicle in his quest for spiritual values which joined aesthetic and philosophical elements with craftsmanship and technical proficiency.

Born in Boston in 1882, Coburn received a 4 x 5-inch Kodak at the age of eight. His earliest serious encouragement came from F. Holland Day, a distant cousin, who included nine of his prints in an exhibition at the Royal Photographic Society and introduced him to Edward Steichen. During his formative transatlantic years between 1900 and 1905, he was influenced by Day, Steichen, Whistler, the impressionists, and Arthur Wesley Dow, whose composition class gave him a sound foundation in Japanese aesthetics. He used soft-focus lenses and the platinum printing process to achieve his desired photographic qualities. In 1904 he made his first celebrity portrait of George Bernard Shaw. Shaw subsequently introduced Coburn to artistic and literary giants, whose penetrating portraits he published in *Men of Mark* (1913). Between 1910 and 1912, Coburn's photographs of Yosemite Valley and the Grand Canyon became design oriented. His 1912 views "New York from Its Pinnacles" preceded the abstractions of the Bauhaus and Moholy-Nagy by more than six years. Coburn had his first one-man show at the New York Camera Club in 1903, followed by exhibitions at the Royal Photographic Society (1906, 1924, and 1957) and the Photo Secession Galleries (1907 and 1909). During a one-month period in 1917 Coburn made Vortographs, the British response to Cubo-Futurism, with a kaleidoscopic arrangement of mirrors that fractured the image. In the 1920s his growing commitment to Freemasonry and mysticism removed him from the competitive photographic world. Naturalized as a British citizen in 1932, he resided in North Wales where he died in 1966.

Coburn believed that the new medium of photography was equal to the other traditional graphic arts. In addition, he regarded photogravure as the ideal medium to reproduce his photographic negatives for exhibition and in book and magazine form. The consummate craftsman, he studied the process at the London County Council School of Photo-Engraving between 1906 and 1908 in order to control the production of his photogravures. He set up his own presses in Hammersmith, where between 1909 and 1914 he etched and steelfaced eighty-three plates, inked them with hand-ground pigments, and experimented with various papers before releasing the proofs to his printer who hand-pulled forty thousand gravures for his books, notably *London* (1909), *New York* (1910), and *Men of Mark* (1913).

In addition, he printed six large landscapes in limited editions, among them *Canal in Rotterdam* which epitomizes his symbolist period, his most important period when his work was neither naturalistic nor totally abstract.

> Sunshine and water form, I believe, the landscape photographer's finest subject matter. Is there a more perfect way of studying and permanently recording the subtle play of sunlight on moving water than photography?[2]

Equal importance given to the fixity and flux of light and dark imbue the subject with spiritual meaning as well as creating a strong diagonal design. Seeking the reward of self-expression, his aim in landscape photography was "always to convey a mood and not to impart local information."[3]

1. Alvin Langdon Coburn, "The Future of Pictorial Photography," *Photograms of the Year*, 12 (1916), pp. 23-24, rpt. in *A Photographic Vision: Pictorial Photography 1899-1923*, ed. Peter C. Bunnell (Salt Lake City: Smith, 1980), p. 195.
2. Helmut and Alison Gernsheim, ed., *Alvin Langdon Coburn Photographer: An Autobiography* (New York: Dover, 1978), p. 44.
3. Gernsheim, p. 44.

Lewis Wickes Hine

American, 1874-1940

"Radishes! Penny a bunch!" Sixth Street Market, Cincinnati. 10:00 p.m. Saturday. Boys and girls sell all day, and till 11:00 p.m., 1908. Gelatin silver print, 16.9 x 11.8 cm on 17.7 x 11.8 cm. Number with pencil on verso: 45.

The Albert P. Strietmann Collection, 1975.359.

Provenance: National Child Labor Committee, New York; Univ. of Maryland Baltimore County Library, Baltimore; Lunn Gallery/ Gallery International Ltd., Washington, D. C. (from Univ. of Maryland, 1974).

Exhibitions: Lunn Gallery/Gallery International Ltd., Washington, D. C., *Lewis W. Hine: Photographs from the Child Labor Series*, 1975; Cincinnati Art Museum, *The Cincinnati Art Museum Photography Collection*, 1981-82.

At the turn of the century, when photographing the working class was not popular in either Europe or the United States, the National Child Labor Committee was committed to photography as a weapon for social change. For nearly a decade (1908-16), the patronage of this committee enabled Lewis Wickes Hine, a crusading reformer, to amass a significant body of photographs conceived as visual evidence to sway middle-class public opinion against the injustice, indignities, and exploitation suffered by underprivileged workers, and the scandal of child labor.

Hine was born in Oshkosh, Wisconsin, in 1874. At the age of fifteen he worked in a furniture factory for long hours under miserable conditions for a pittance of a salary. Through a series of better jobs and correspondence courses, Hine enrolled in 1900 at the University of Chicago where he studied to become a teacher. In 1901 he taught at the Ethical Culture School in New York, while continuing his studies at New York and Columbia Universities, and graduated with a degree in sociology.

Hine took up photography in 1903. The following year he began his first important body of work: recording immigrants from Europe pouring through Ellis Island. Hired by the National Child Labor Committee in 1908 to fuel its campaign with photographs and words, he made eloquent photographs of children in New York tenements, New England and Carolina mills, and Baltimore and California canneries. According to National Child Labor Committee Chairman Owen R. Lovejoy,

> The work Hine did for this reform was more responsible than all other efforts in bringing the need to public attention. The evils were intellectually but not emotionally recognized until his skill, vision and artistic finesse focussed [*sic*] the camera intelligently on these social problems.[1]

Hine's pioneering photographs were instrumental to the passage of the Child Labor Laws.

Hine was a private person, yet someone who could translate his special qualities of observation, sensitivity, and thoughtfulness into photography which had the ability to speak to others. He was keenly aware of aesthetics, the essentials of composition, and the possibilities as well as the limits of his photographic tools.[2]

Although he was aware of the avant-garde pictorialist movement lead by Stieglitz, Hine was more interested in photography's investigative role for social issues. With the outbreak of World War I, he joined the Red Cross to survey the European refugee situation. After the war he focused on the nobility of man's ties to machinery, which culminated in photo-documentation of the construction of the Empire State Building published under the title of *Men at Work* (1931). In the 1930s he photographed for the Tennessee Valley Authority and the Works Progress Administration where he investigated unemployment due to technological displacement. But none of these later projects matched the spell-binding humanity of his child labor photographs.

As a field investigator during 1908, Hine worked in Cincinnati where he made approximately fifty photographs of messengers, newspaper boys, and young market vendors. As with many of his images, he provided a commentary on the subject. This photograph of a pre-adolescent girl selling radishes was captioned *"Radishes! Penny a bunch!" Sixth St. Market, Cincinnati. 10 p.m. Saturday. Boys and girls sell all day, and until 11 p.m. Aug. 22, 1908.*[3] This night subject was undoubtedly taken with Hine's cumbersome and unpredictable magnesium powder flash. The novel directness and simplicity of the image made it effective propaganda for the National Child Labor Committee. This was one of five thousand photographs made by Hine, a social advocate with the personal conviction that human will would transcend and transform the evils of exploitation.

1. Robert Doty, "The Interpretative Photography of Lewis W. Hine," *Image*, 6, No. 5 (May 1957), 114, 116.

2. Verna Posever Curtis, "Lewis Hine's Child Labor Photographs," *Photography and Reform: Lewis Hine and The National Child Labor Committee* (Milwaukee: Milwaukee Art Museum, 1984), p. 43-44.

3. The Library of Congress, Washington, D. C., lot 7480, I, No. 45 caption card.

Arnold Genthe

American, b. Germany, 1869-1942

Irma Duncan, Isadora Duncan Dancer (ca. 1915-16). Gelatin silver print, 33.1 x 20.6 cm on mount 45.7 x 35.5 cm. Inscribed with pencil on verso mount: *Irma Duncan / Isadora Duncan Dancer / no. 55*; erased inscription by another hand with pencil: *Property of Dorothy (illegible)*.

Museum Purchase: Gift of Mrs. Max Stern, by exchange, 1978.358.

Provenance: The Witkin Gallery, Inc., New York.

Exhibitions: San Francisco Museum of Modern Art, Minneapolis Institute of Arts, Los Angeles County Museum of Art, and University Art Museum, The University of Texas at Austin, *California Pictorialism*, 1977, p. 71, no. 73 (lent by The Witkin Gallery, New York); Cincinnati Art Museum, *Collectors' Choice*, 1978 (lent by The Witkin Gallery, New York); Cincinnati Art Museum, *The Cincinnati Art Museum Photography Collection*, 1981-82.

Arnold Genthe pioneered dance photography. Born in Berlin in 1869, he came from a distinguished academic family. He studied at the Universities of Berlin and Jena, receiving a doctorate in philology in 1894. An expert in eight modern and ancient languages, he came to San Francisco in 1895 as the tutor to the German Baron Heinrich von Schroeder's son instead of assuming an academic post. Between 1896 and 1906 Genthe photographed the street life and exotic traditions of Chinese merchants, opium addicts, and children in San Francisco's Chinatown with a hidden camera, for his subjects feared the black devil box which captured their images. A self-taught hobbyist, Genthe opened his first San Francisco portrait studio in 1897. His scholarly background, artistic sensibility, and genteel behavior gave him immediate social status in the city's society. Right from the beginning he used a candid portrait style. Prominent sitters and world celebrities relaxed, unposed before his camera, unaware of the precise moment the photograph was taken.

In 1906 he lost everything in the San Francisco earthquake except his Chinatown negatives which had been stored in a bank vault. Realizing the importance of recording this natural disaster, Genthe borrowed a 3A Kodak Special to document the aftermath and fire. Two years later he published his negatives of the then-destroyed Chinatown in *Pictures of Old Chinatown* with an introduction by Will Irwin. In 1910 Genthe participated in the International Exhibition of Pictorial Photography in Buffalo.

Genthe opened a portrait studio in New York on 46th Street at Fifth Avenue in 1911. For the next three decades hundreds of celebrities of dance, stage, society, and politics passed before his camera, including three presidents, Theodore Roosevelt, William Howard Taft, and Woodrow Wilson. During the 1920s he traveled to Guatemala, Mexico, New Mexico, and New Orleans. In 1926 he published *Impressions of Old New Orleans*, immortalizing the relics of faded splendor. Six years before his sudden death, he wrote *As I Remember*, an autobiography of his life and career.

Genthe was a seminal figure in the history of dance photography. His aesthetic was formed during the turn-of-the-century pictorialist movement. Among the performers he photographed with his soft-focus, romantic style were Anna Palova, Ruth St. Denis, and Isadora Duncan. Between 1915 and 1918, the "prophet and liberator" of dance, Isadora, made several visits to the United States with her pupils known as "Isadorables." The most influential of her protégés was Irma Duncan, born Irma Ehrich-Grimme (1897-1978). Irma made her debut as a Duncan dancer in 1905. She was one of the founders of the Duncan School in Moscow in 1921 and its principal after Isadora's death. Irma Duncan appears ethereal in this half-seen, soft-focus image. The light reveals a figure suspended in motion without the encumbrances of setting. This was one of a hundred photographs Genthe chose for *The Book of Dance* of 1916.[1] Following Isadora's death, he immortalized the innovator in *Isadora Duncan: Twenty-Four Studies*.

1. Arnold Genthe, *The Book of Dance* (Boston: International Publishers, 1916), p. 22.

Paul Strand

American, 1890-1976

Chair Abstraction, Twin Lakes, Connecticut (1916). Gelatin silver print ca. 1930s, 32.8 x 24.3 cm.

Museum Purchase: Gift of the estates of Clara J. Schawe and Mary Louise Burton, by exchange, 1987.96.

Provenance: Paul and Hazel Strand; Frank Kolodny, Princeton, NJ (from Strand agent, June 1975); Edwynn Houk Gallery, Chicago.

Exhibitions: Philadelphia Museum of Art; City Art Museum of St. Louis; Museum of Fine Arts, Boston; Metropolitan Museum of Art, New York; Los Angeles County Museum of Art; and M. H. de Young Memorial Museum, San Francisco, *Paul Strand Photographs*, 1971-73; Helen Gee, *Stieglitz and the Photo-Secession: Pictorialism to Modernism 1902-1917*, New Jersey State Museum, Trenton, 1978, p. 51, illus. p. 43; David Travis, *Photography Rediscovered: American Photographs, 1900-1930*, Whitney Museum of American Art, New York and The Art Institute of Chicago, 1979-80, p. 179, no. 178, illus. frontispiece.

Bibliography: Brody, Jacqueline. "Photography: A Personal Collection." *The Print Collector's Newsletter,* VII, No. 2 (1976), illus. p. 37.

By the 1910 International Exhibition of Pictorial Photography in Buffalo, pictorialism had become mannered in treatment and repetitive in theme. Inspired by modernist painting and sculpture shown in the landmark 1913 Armory Show and at Alfred Stieglitz's influential avant-garde "291" gallery, Paul Strand's work of 1915 and 1916 was a prophesy of the reorientation of photographic aesthetics. Strand was the earliest photographer to explore the visual problems of form and design which by 1924 would be assimilated into the mainstream of modern photography.

Born to parents of Bohemian descent in New York City on October 16, 1890, Strand received a Kodak Brownie camera at the age of twelve. His interest in photography was crystallized by two influential figures, Lewis Hine and Alfred Stieglitz. Enrolled at the Ethical Culture School between 1904 and 1909, he studied photography with Hine who fired his social conscience. Between his inspirational class visit in 1907 to the Photo-Secession Gallery at 291 Fifth Avenue, and his exhibition nine years later, he was stimulated to explore visual problems and the expressive possibilities of the medium. After a brief journey to Europe in 1911, he established himself as a freelance commercial photographer using the facilities of the New York Camera Club as his base of operation. Repeated visits to "291" brought Strand into contact with works of Picasso, Braque, Cézanne, and Matisse which revealed new ways of organizing space, handling tonal values, and using unusual vantage points.

In 1915, he began shifting away from the soft-focus romanticism of pictorialism. During the summer of 1916, Strand created a series of near-abstractions from architectonic elements and household objects. *Chair Abstraction* epitomizes his work at this critical juncture. Rather than relying on standard horizontal-vertical relationships, he shifts the point of view forty-five degrees creating dramatic opposing diagonals. The formal organization of the composition is emphasized without totally dismissing the identifiable features of the chair seat and turned back. The close-up view concentrates attention on the geometric shapes, betraying the influence of cubism and constructivism. Strand amplifies the dynamic tension by backlighting the top, and reiterating the opposing diagonals on the reflective seat. In addition, he emphasizes the shallow picture space by the regular shadow pattern of a porch railing. His semi-abstractions were a vital step in his development. In Strand's own words: "I learned how you build a picture, what a picture consists of, how shapes are related to each other, how spaces are filled, how the whole must have a kind of unity."[1] Once he understood the principles, he applied them to his future work without pursuing further abstract images. As was his practice, *Chair Abstraction* was printed from a 10 x 13-inch glass plate negative enlarged from a 3 1/4 x 4 1/4-inch negative taken with an Ensign camera.[2]

Simultaneously with his Connecticut abstractions, Strand made a series of close-up portraits of anonymous street people which expressed his social consciousness. These two rather different artistic viewpoints were the subject of Alfred Stieglitz's final show at "291" in 1916 and were featured in the final numbers 48 and 49/50 of *Camera Work* (1916-17). Following his discharge in 1919 from two years of service as an X-ray technician in the United States Army Medical Corps, Strand explored in the 1920s organic and machine forms and in the 1930s man in his environment. Simultaneously he became active as a cinematographer. In 1921, he made the film *Mannahatta* with Charles Sheeler. The following year he acquired an Ackeley motion picture camera and worked as a freelance Ackeley specialist. In 1932, after twelve years of cinematic experience and the opportunity to make a more politicized statement, Strand became chief photographer and cinematographer for the Mexican government. Two years later he produced the film *Redes* (released in the United States as *The Wave*.) The following year with Ralph Steiner and Lew Hurwitz, he photographed Pare Lorentz's *The Plow that Broke the Plains*. Between 1937 and 1942, he was president of the non-profit educational motion picture group, Frontier Films.

After a ten-year hiatus, Strand returned to still photography with an emphasis on the photographic book. Over the next quarter of a century, he sought to extract the feeling of a place, the land, and its inhabitants and link the synergetic energy of image and text in a series of books. Beginning in 1946, he collaborated with Nancy Newhall on *Time in New England* (1950). In 1950, disenchanted with the climate of McCarthyism in the United States, Strand settled in Orgeval, France.

During the 1950s and 1960s, he traveled in Europe and Africa, making photographs for books including *La France de profil* with text by Claude Roy (1952); *Un Paese* with text by Cesare Zavattini (1955); *Tir a'Mhurain* with text by Basil Davidson (1962); and *Living Egypt* with text by James Aldridge (1969). With the exception of a major retrospective at The Museum of Modern Art in 1945, his

(continued to page 216)

Frederick Henry Evans

British, 1853-1943

Herstmonceux Castle, Sussex: In the Upper Garden Looking South, 1918. Platinum print, 16.7 x 23.6 cm on mount 32.0 x 43.9 cm. Artist's rectangular initial blindstamp on mount lower right: FHE; affixed to verso: EX LIBRIS / FREDERICK H. EVANS; inscribed by another hand with black pentel: HERSTMONCEUX CASTLE SUSSEX. IN THE UPPER GARDEN, LOOKING SOUTH 1918.

Museum Purchase: Gift of Jeannette White Martz and William R. Martz, by exchange, 1981.133.

Provenance: Daniel Wolf, Inc., New York.

Exhibitions: Cincinnati Art Museum, *The Cincinnati Art Museum Photography Collection*, 1981-82.

Alfred Stieglitz considered Frederick Henry Evans "the greatest exponent of architectural photography."[1] He invited Evans to be the first British photographer to contribute to *Camera Work*, the Photo-Secessionists' official publication. Six of Evans's cathedral interiors were reproduced in the October 1903 issue accompanied by the following editorial note:

> He stands alone in architectural photography, and that he is able to instil into pictures of this kind so much feeling, beauty, and poetry entitles him to be ranked with the leading pictorial photographers of the world. His work once more exemplifies the necessity of individuality and soul in the worker, for of the thousands who have photographed cathedrals, none has imbued his pictures with such poetic qualities coupled with such masterful treatment. . . .[2]

Evans was born in London on June 23, 1853. In the 1880s he opened a bookshop in London where he championed writers and artists. It was through his association with George Smith, a lantern slide manufacturer who made slides from Evans's negatives taken through a microscope, that he acquired his flawless technique and respect for pure photography. His early photomicrographs won Evans a medal at the Photographic Society of London exhibition in 1887. Three years later he first showed his cathedral photographs at the annual exhibition of the Photographic Society. He retired from bookselling in 1898. His one-man exhibition at the Royal Photographic Society in 1900 secured his reputation and The Linked Ring, an organization dedicated to the promotion of photography as an art, elected him as a member.

Between 1902 and 1905 he revolutionized the design and installation of the Photographic Salon. Evans turned professional in 1905, accepting a position as a roving photographer for the illustrated weekly magazine, *Country Life*. In 1906 Stieglitz exhibited his work along with J. Craig Annan and David Octavius Hill at the Little Galleries of the Photo-Secession. Evans joined the Salon des Refusés in 1908, when the selecting committee of the Photographic Salon showed only one of his prints, but resigned two years later. Eleven of his prints were selected by Stieglitz for the 1910 International Exhibition of Pictorial Photography in Buffalo. During the 1910s he privately published volumes illustrated with platinum prints of work by Blake, Holbein, and Beardsley. The Royal Photographic Society gave him a one-man exhibition in 1922 and elected him as an Honorary Fellow in 1928. Evans died two days short of his ninetieth birthday on June 24, 1943.

Although Evans was associated with prominent figures in the pictorialist movement, he did not adopt their elaborate manipulation of negatives or prints. Instead he advocated and practiced the doctrine of "the straightest of the straight"[3] for his architectural, portrait, and landscape subjects. This view of the upper garden looking south at Herstmonceux Castle is a natural continuation of the photographs of French châteaux which he made for *Country Life* between 1905-06. Herstmonceux was built by Sir Roger Fiennes, Lord Treasurer under Henry VI, in 1440. Largely demolished in 1777, the moated castle remained a romantic symbol of the Middle Ages. In this photograph Evans used one of his favorite compositional devices, exploiting light and shadow for dramatic and visual purposes, to emphasize the substance of the crenelated walls and the delicacy of vegetation. A master of composition, he framed the composition to emphasize the variety of textures and lure the viewer from the garden to the picturesque ruin. By selecting the smallest aperture time would allow and printing on platinum paper he achieved the desired softness and tonal gradations of the image without losing precision of definition. Evans abandoned photography in the 1920s when he could no longer produce with the new gelatin silver papers the same timeless images of the buildings and landscapes he had portrayed in platinum.

1. Alfred Stieglitz, *Camera Work*, 4 (Oct. 1903), p. 25.
2. Stieglitz, p. 25.
3. Beaumont Newhall, *Frederick H. Evans* (Rochester, NY: George Eastman House, 1964), p. 9.

Edward Jean Steichen
American, b. Luxembourg, 1879-1973

Time-Space Continuum (1920-21). Gelatin silver print, 19.4 x 24.4 cm on 20.3 x 25.4 cm. Inscribed with pencil on verso: *"Time Space Continuity" / 1920 or 21 / 1-6-12.*

Library Transfer, 1977.25.

Exhibitions: Cincinnati Art Museum, *The Cincinnati Art Museum Photography Collection*, 1981-82.

The influential images, ideas, and energy of the photographer and curator, Edward Steichen, shaped twentieth-century photography. Born Eduard Jean Steichen in Luxembourg in 1879, he emigrated as an infant with his family to Michigan, finally settling in Milwaukee. In 1894 he began a four-year lithographic apprenticeship at the American Fine Art Company in Milwaukee, while pursuing painting and exploring photography. His first recognition came at the Second Philadelphia Photographic Salon in 1899. The following year, while on his way to Paris to further his artistic studies, he met Alfred Stieglitz in New York. Steichen's meteoric rise as a pictorialist photographer was affirmed by the selection of twenty-one of his prints for "The New School of American Photography" exhibition organized by F. Holland Day in London, and his inclusion in the Third Philadelphia Photographic Salon in 1900. Elected to The Linked Ring in 1901, he joined Stieglitz in promoting photography as art as a founding member of the Photo-Secession in 1902. He designed the cover and layout of the organization's quarterly, *Camera Work*, which between 1903 and 1917 illustrated more of his work than any other artist. Shortly before returning to France in 1906, he collaborated with Stieglitz in organizing "The Photo-Secession Galleries" at 291 Fifth Avenue. From Paris he advised Stieglitz on the work of avant-garde artists including Rodin, Matisse, Marin, Cézanne, Picasso, and Brancusi who were shown at the Galleries. Of all the Photo-Secession photographers he was the most accomplished printer of gum-bichromate and other manipulative processes, producing memorable portraits of Rodin and his *Balzac*.

With the outbreak of World War I, Steichen returned to New York. Commissioned as a first lieutenant in the United States Army, his experience in an aerial photography unit brought a dramatic change in his work.

> The wartime problem of making sharp, clear pictures from a vibrating, speeding airplane ten to twenty thousand feet in the air had brought me a new kind of technical interest in photography completely different from the pictorial interest I had had as a boy in Milwaukee and as a young man in Photo-Secession days. Now I wanted to know all that could be expected from photography.[1]

He torched his paintings and abandoned soft-focus pictorialism to concentrate on straight photography. He spent a year experimenting with the effects of light on form, shape, and space. In *Time-Space Continuum* he explored the possibility of implying abstract meanings in a literal photograph. Using objects as symbols he tried to convey Einstein's idea of "Time-Space Continuum" from the Theory of Relativity, which was receiving a lot of popular attention at the time.

In 1923 he became chief photographer for Condé Nast Publications replacing Baron de Meyer. During the 1920s his theatrical flair for dramatic artificial lighting and simple, geometric props created a chic style of fashion and celebrity image consistent with the vocabulary of "New Objectivity" for *Vogue* and *Vanity Fair*. Without the challenge of new problems to solve, he closed his New York studio in 1938. Between 1941 and 1946 he played a prominent role as a lieutenant commander in the United States Navy in charge of combat photography in the Pacific. From 1947 to 1962 he directed the Department of Photography at the Museum of Modern Art curating sixty-five shows, including the famous *Family of Man* exhibition in 1955.

Throughout his careers he received numerous awards and citations, among them the Presidential Medal of Freedom in 1963. Steichen's work has been exhibited in group shows worldwide and the subject of one-man shows at the Photo-Secession Galleries (1906, 1908, 1909), Museum of Modern Art (1938, 1978), Bibliothèque Nationale, Paris (1965), and *A Centennial Tribute* at the George Eastman House, Rochester, New York (1979).

1. Edward Steichen, *A Life in Photography* (Garden City, NY: Doubleday, 1963), n. pag.

Jean-Eugène-Auguste Atget
French, 1857-1927

Versailles, Dying Gaul (Apollo Belvedere in the background)
(1922-23). Albumen printing-out-paper, 18.2 x 21.7 cm irregular.
Numbered on negative (in reverse) lower right: *1167;* inscribed with
pencil on verso: *Versailles 1167.*

Museum Purchase: Gift of Thomas Emery, by exchange, 1978.249.

Provenance: Julien Levy, New York ?; Yarlow / Salzman Gallery,
Toronto.

Exhibitions: Marcuse Pfeifer Gallery, New York, *The Male Nude,*
1978; Cincinnati Art Museum, *The Cincinnati Art Museum
Photography Collection*, 1981-82.

Atget has been acclaimed as a quintessential documentary
photographer and championed as the precursor to modernism.
According to his friend André Calmettes, Atget's ambition was to
create a collection of "everything artistic and picturesque in and
about Paris."[1] He himself simply referred to his photographs as
"Documents pour Artistes."

Born February 12, 1857, in Libourne, France, Jean-Eugène-
Auguste Atget was orphaned by the age of five. During his teens
he signed onto a merchant sailing vessel as a cabin boy. Although
successful on his second attempt to gain admittance to the National
Conservatory of Music and Drama in 1879, the army had drafted
him the previous year to perform the mandatory five years of
service. With inadequate time to study, he was expelled from the
Conservatory after two years, and forced to pursue an
unremarkable stage career playing third-rate roles with a touring
troupe of actors. One of his fellow performers, Valentine Delafosse
Compagnon, whom he met in 1886, became his life-long
companion.

Around 1888 Atget acquired an ordinary 18 x 24-cm bellows
view camera with a retractable wooden tripod, rectilinear lens, and
negative plate holders. He required only the most rudimentary
know-how to calculate exposures and develop the gelatin dry
plates. His negatives were printed by daylight on printing-out
paper, and toned with gold chloride to achieve a rich purplish
brown color. Although his first efforts were directed toward
providing subjects for artists, in 1897 he judiciously shifted his
oeuvre to documenting Old Paris. This strategic new direction
broadened his market to include not only artists, but craftsmen and
institutions at a time when preservationists sought to save the
venerable monuments up to and including the Ancien Régime. As
an independent one-man documentary business, he systematically
chronicled Old Paris as his predecessor, Charles Marville, had done
during the Second Empire. Maria Morris Hambourg wrote that:

> By 1910 Atget had become well known for a documentary
> oeuvre distinguished by its probity and beauty and by the
> sensitivity and affection it displayed for Old Paris. These
> qualities in the work, together with Atget's persistence,
> dedication, and personal accountability, earned him a respected
> reputation in the community. . . .[2]

Between 1901 and 1921 his photographs of buildings, streets,
courtyards, interiors, and signs were acquired by the Bibliothèque
Historique de la Ville de Paris, the Bibliothèque Nationale, the
École des Beaux-Arts, the Musée Carnavalet, and the Victoria and
Albert Museum. World War I interrupted his success and
photographic activities. Concerned that twenty years of work
would be lost, he sold twenty-six hundred negatives to Les
Monuments Historiques in 1920. With replenished supplies and
renewed vigor, he resumed photographing with a new personal
freedom.

Atget first photographed the palace and gardens of Versailles
between 1901 and 1906. These he included in his cataloguing system
under the Landscape-Documents series. This Renaissance garden,
with its series of perspective views, was once the center of the
political world. Atget portrayed the park on a human scale. He
recorded it as it was changed by the passing of the seasons. After a
fourteen-year absence, he began an extensive series on Versailles
with a dramatically altered aesthetic. John Szarkowski pointed out

> . . . his earlier affection for rushing Baroque space and high
> drama has been replaced by a taste for the serene and pellucid.
> His best new pictures are now flatter and quieter in their
> construction, but are no less vital. . . . the later pictures are not
> composed out of knowledge, but discovered out of a great and
> generous openness to the possibilities of sight.[3]

Atget refocused his environs series by establishing consecutively
numbered subseries for Versailles and St. Cloud in 1922.

Michael Mosnier's (died 1686) copy of the famed Roman
sculpture of the Dying Gaul in the Capitoline Museum was one of
many specially commissioned for Versailles. Atget placed the
sculpture off-center against a flat, dark backdrop of foliage. The
elevated, oblique point of view reveals the presence of Apollo
Belvedere in the immediate background. As with many of his
subjects, Atget explored his subject from more than one angle.
Negative 1166, taken in the same session, is a close-up, back view of
the lichen covered, weather pitted Dying Gaul.[4] This melancholy
image taken in 1922 or 1923[5] demonstrates the latent poetic power
of straight photography.

By the 1920s Atget was an anachronism. His equipment was
old-fashioned and he eschewed the artifices and manipulation of the
pictorialists. Shortly before his death on August 4, 1927, his work
was discovered by a new generation of artists who appreciated his
unself-conscious and honest approach.

1. Arthur D. Trottenberg, ed., *A Vision of Paris* (New York: Macmillan, 1963), p. 20.
2. John Szarkowski and Maria Morris Hambourg, *The Work of Atget: The Art of Old
Paris* (New York: The Museum of Modern Art, 1982), II, p. 19.
3. John Szarkowski and Maria Morris Hambourg, *The Art of Atget: The Ancien
Régime* (New York: The Museum of Modern Art, 1983), III, p. 165.
4. William Howard Adams, *Atget's Gardens* (Garden City, NY: Doubleday, 1979), p.
115, illus. fig 8.
5. Maria Morris Hambourg, Letter to KS, 8 Sept. 1981. According to Hambourg
the Versailles album was purchased by Julien Levy and Atget did not have a chance to
reprint it before his death.

László Moholy-Nagy
American, b. Hungary, 1895-1946

Militarismus (1924). Gelatin silver print from rephotographed photomontage, 17.1 x 12.3 cm. Inscribed with pencil on verso: *moholy-nagy / militarismus* / blue ink: *(photomontage)*; artist's address stamp in purple: *moholy-nagy / berlin-chbg 9 / fredericlastr. 27 atelier.*

Museum Purchase: Gift of the heirs of Alma M. Ratterman, by exchange, 1978.25.

Exhibitions: Cincinnati Art Museum, *The Cincinnati Art Museum Photography Collection*, 1981-82.

A Renaissance figure of the Weimar Republic, László Moholy-Nagy was active as a painter, designer, film maker, photographer, theoretician, teacher, and writer. His photographic output spanned the entire spectrum of ideas, processes, and techniques associated with the postwar modernist movement in photography called "new vision," which he promoted. An advocate of wedding traditional arts with twentieth-century technology, he considered the camera a creative tool to extend public perception through its ability to manipulate light and its capacity to complete or supplement the normal vision of the eye.

The publication of his *Malerei, Photographie, Film* in 1925 was a milestone with a tremendous impact on photography in the late 1920s. Moholy's theoretical statements coupled with a diversity of photographic illustrations culled from a variety of sources served as the basis for his future ideas and work. Beginning in 1922, in collaboration with his wife Lucia Moholy (who became a talented photographer in her own right), he explored the artistic potential of the camera through experimental techniques, among them photograms (cameraless images), photomontages, negative images, and straight photographs with vertiginous viewpoints, dramatic diagonals, and extreme close-ups.

Moholy's interest in formal composition and process finds its most succinct expression in his photomontages. In them, he satisfied two of his theoretical criteria for photographs: imparting information while organizing dissimilar visual components into a unified whole. He termed his photomontages *fotoplastik* to distinguish them from the postwar nihilistic Berlin dadaist's photomontages. Eleanor Hight has argued,

> Moholy organized found photographs to create his own narratives, which encompassed visual puns and social commentary as well as more personal themes. His work is clearly influenced by both the Russian constructivists and the Berlin dadaists, although he was not strictly limited to the dogmatic ideology of the former nor the biting political satire of the latter.[1]

The few extant photomontages show Moholy's use of color, graphic media, and found photographs from magazines and newspapers. Lucia rephotographed them for exhibition and publication.

In *Militarismus* (Militarism), a puzzled army officer observes jubilant cricket players running toward a curved dividing line in advance of a column of tanks. In the foreground, blacks administer to one of their own against a trail of corpses. Moholy often symbolized victims of military rule (Western European imperialists) with blacks (colonials). *Militarismus* was one of the subjects he included in the second edition of *Malerei, Photographie, Film* (1927).[2]

Born in Bácsborsod, Hungary, on July 20, 1895, Moholy fled to Vienna to escape the White Terror Counterrevolution in 1919. He moved to Berlin in 1920 where he participated in the Erste Internationale Dada-Messe (First International Dada Fair), along with Raoul Hausmann, Hannah Höch, and Kurt Schwitters, and became a prominent member of the avant-garde community. In 1923, at the invitation of Walter Gropius, he joined the faculty of the Staatliches Bauhaus in Weimar where he headed the metal workshop and taught the introductory course. Although Moholy played a major role in disseminating the attitudes toward art, architecture, and design through books, journals, and exhibitions, it is unclear what immediate influence his theories on photography had on students, since photography did not become part of the Bauhaus curriculum until after he departed.

In 1928 he resigned from the Bauhaus, along with Gropius and Herbert Bayer, and returned to Berlin where he pursued graphic, industrial, and stage design. In 1929 he played a principal role in the organization of the *Film und Foto* exhibition organized by the Deutscher Werkbund in Stuttgart where he was able to promote photographs in keeping with his new vision. In the years immediately preceding World War II he emigrated to Amsterdam (1933-34), London (1935-36), and, finally, Chicago (1937) where as director and teacher of the short-lived New Bauhaus and, subsequently, the School of Design, he successfully transplanted the concepts of his new vision for photography. The year following his death, his *Vision in Motion* was published reiterating his conviction in the creative potential of the photographic medium.

1. Eleanor M. Hight, *Moholy-Nagy: Photography and Film in Weimar Germany* (Wellesley, MA: Wellesley College Museum, 1985), pp. 106, 108.
2. László Moholy-Nagy, *Malerei, Photographie, Film* (Munich: Langen, 1927), p. 107.

Baron Adolf de Meyer

American, b. France, 1868–1946

Berthe (1926). For *Harper's Bazaar*, July 1926, p. 60. Gelatin silver print, 47.1 x 36.1 cm.

Museum Purchase: Gift of John G. Hamilton, by exchange, 1981.156.

Provenance: Estate of Baron Ernst de Meyer, Los Angeles (from Baron Adolf de Meyer; his sale 4437M, Sotheby Parke Bernet, Inc., New York, October 20, 1980, lot 134); Daniel Wolf, Inc., New York (from Sotheby Parke Bernet, sale 4437M).

Exhibitions: Cincinnati Art Museum, *The Cincinnati Art Museum Photography Collection*, 1981–82.

Baron Adolf de Meyer was one of the most colorful personalities of the pictorialist movement and the first great fashion photographer. There are several contradictory accounts regarding de Meyer's early life. According to the French society painter, Jacques-Émile Blanche, de Meyer was born in Paris to a Jewish father and a Scottish mother in 1868. The fashion photographer Cecil Beaton, who called him "the Debussy of the camera," wrote that he was born in Austria, while *Who's Who* of 1905 claims he was born in Paris, but educated in Dresden.[1] This handsome young man with aristocratic aspirations had by 1895 been introduced into the fashionable Jewish set surrounding the Prince of Wales. In 1899 de Meyer married Olga Alberta Caracciolo, a well-connected beauty and the epitome of chic, whose godfather, Edward, Prince of Wales, was rumored to be her natural father. At the request of the Prince, the King of Saxony created a baronetcy for de Meyer so that he could attend the king's coronation in 1901. This gorgeous young couple became part of the international smart set.

An Edwardian gentleman photographer, de Meyer drew his subjects from the beautiful socialites and talented stage performers who became part of the British and European social circles in which he and Olga moved. As early as 1894 he exhibited in London, Paris, and New York under the name Adolf Meyer from Dresden. In 1898, the year he was elected to The Linked Ring, he participated in the London Photographic Salon under the name Baron A. de Meyer-Watson.[2] Alfred Stieglitz arranged a two-man show at the Photo-Secession Galleries with George Seeley in 1907, and illustrated seven of his works in *Camera Work* 24 (1908). Disenchanted with the selection procedure of the London Salon of The Linked Ring, de Meyer resigned in 1908. Stieglitz championed de Meyer's work in exhibitions at the Photo-Secession Galleries in 1909 and 1911. In 1910 he included de Meyer's work in the Buffalo exhibition and two years later devoted the entire issue of *Camera Work* 40 to his work.

With the death of Edward VII in 1910, the de Meyers assumed a nomadic life as aficionados and unofficial impresarios for Diaghilev's Ballets Russe. In 1914 de Meyer published, in a limited edition, his famous photographs of Nijinsky in *L'Après-Midi d'un faune*. Shortly after the outbreak of World War I the de Meyers were forced to flee penniless to New York. Hired by Condé Nast to provide fashion photographs and celebrity portraits for *Vogue* and *Vanity Fair*, de Meyer's opulent soft-focus images of sophisticated luxury made him a leading arbiter of taste, while attracting buyers. The de Meyers resumed their old life-style in Paris as soon as the Armistice was signed, keeping *Vogue* up to date with masterpieces from couturiers like Lanvin and Chanel. In 1923 de Meyer was lured away by Hearst to *Harper's Bazaar*, *Vogue's* great rival.

De Meyer's distinctive style featured flattering backlighting, elegant settings, and poses of ultra-casual sophistication. He used a Pinkerton-Smith lens which produced a sharply focused center, surrounded by diffuse edges, creating images of ethereal radiance. This is epitomized in the fashion photograph of a summer evening hat by Berthe which appeared in *Harper's Bazaar* in 1926.[3]

Although the fashions of the aristocratic world he depicted became increasingly passé, de Meyer did not change his technique or aesthetic to keep up with new directions. In the wake of Olga's death, de Meyer was dismissed from *Harper's* in 1934. He settled in Hollywood where he wrote Alfred Stieglitz in 1940:

> Like you – I have in 1934 destroyed all that was superfluous – it seemed to me a burden – all my photographic work especially – what is left – is due to fortunate incidents Now I regret it – since I take a serious interest in all I have done myself! – My object at present is to assemble a small collection of my life work . . . to leave to someone or some institution – when I die.[4]

He died in January 6, 1946, a photographer in eclipse. This dazzling confection was one of the few remaining photographs his adopted son Ernest had put in a trunk. It was found after his death thirty years later.

1. Philippe Jullian, *De Meyer* (New York: Knopf, 1976), p. 14.
2. Weston J. Naef, *The Collection of Alfred Stieglitz: Fifty Pioneers of Modern Photography* (New York: The Metropolitan Museum of Art and Viking Press, 1978), p. 334.
3. Baron de Meyer, "The Elegante in Summer," *Harper's Bazaar*, July 1926, p. 60.
4. Baron de Meyer, Letter to Alfred Stieglitz, 15 Feb. 1940. Stieglitz Archives, *Collection of American Literature*, Beinecke Rare Book and Manuscript Library, Yale University, New Haven, CT.

André Kertész

American, b. Hungary, 1894-1985

Chez Mondrian (1926). Modern gelatin silver print, 24.6 x 18.7 cm on 25.7 x 20.4 cm. Inscribed with pencil on verso: A. KERTÉSZ.

Gift of Elaine and Arnold Dunkelman, 1984.147.

André Kertész was born in Budapest, Hungary, on July 2, 1894. Encouraged by his family to follow in his uncle's footsteps, he became an accountant at the Budapest Stock Exchange between 1912 and 1925. At the age of eighteen he purchased a 35mm hand-held camera with his savings. Although his business career was interrupted during World War I when he was inducted into the Austro-Hungarian Army, he continued to pursue his interest in photography. A self-taught amateur, the photographs he made during his Hungarian years record the daily fabric of experience on the street, in the country, and behind the front line with a direct and naturalistic style

Intent on pursuing a career as a photographer, Kertész emigrated to Paris in 1925 where most French photographers were still under the influence of the painterly pictorialism of Demachy and Puyo. In the stimulating environment associated with the leading international artistic, literary, and musical personalities who made Paris their home in the late 1920s, Kertész's photography reached artistic maturity. In the words of Keith Davis,

> Kertész absorbed that era's modernist lessons of geometric purity, perceptual complexity and surrealist ambiguity. His photographs embodied all that was new and exciting in the avant-garde visual culture of his period. However, the distinctive vitality of Kertész's work stems from its union of the formal rigors of post-war modernism with fundamentally humanist and emotional concerns.[1]

His photographs of artists, musicians, and writers during the 1920s and 1930s provide a collective portrait of the Parisian avant-garde. In 1926 the painter Piet Mondrian invited him to visit his third-floor apartment and studio on Rue du Départ. Although *Chez Mondrian* depicts an interior space with ordinary household furniture and objects, Kertész transformed the simple interior into a still life composition which was, by inference, a portrait as well. The geometry of the door frames, architectural details, and table top counterbalance the arc of the railing and artificial floral arrangement. His careful orchestration of available light fused the bisected composition into a coherent whole. *Chez Mondrian* brilliantly pits the tensions of light and shadow, form and space, plane and solid, against the implied aesthetic preferences and spirit of Mondrian. This photograph was included in his first one-man exhibition at the gallery Au Sacre du Printemps in 1927.

In the 1920s and the 1930s, he pioneered subjective photojournalism with a hand-held 35mm camera. Kertész did not make his living from the sale of his prints to collectors or institutions, but from fees for reproduction rights paid by magazines and newspapers, including the *Berliner Illustrirte Zeitung*, *Münchner Illustrierte Presse*, *Vu*, *Art et Médecine*, and the London *Times*. In 1936 he traveled to New York under a one-year contract with Keystone Studios. With the escalation of World War II, he remained in the United States freelancing as a fashion and interior photographer for *Harper's Bazaar*, *Look*, *Town and Country*, and *Vogue* between 1937 and 1949. In 1949 he signed an exclusive contract with Condé Nast Publications as photographer for *House and Garden* where he remained until 1962 when he resigned to pursue his personal work.

His commercial work in the 1940s and 1950s diverted attention from his influential role in France as a mentor to such photographers as Brassaï, Henri Cartier-Bresson, and Robert Capa. Although he received a major one-man show at The Art Institute of Chicago in 1946, it was not until the 1960s that he was recognized in the United States as an important figure in modern photography. During the last two decades he received one-man exhibitions at the Bibliothèque Nationale, Paris (1963), The Museum of Modern Art, New York (1964), Centre Beaubourg, Paris (1977), and shortly before his death on September 27, 1985, at the age of ninety-one, at The Art Institute of Chicago and The Metropolitan Museum of Art, New York (1985-86). He actively worked as an artist until his death.

1. Keith F. Davis, *Andre Kertész: Vintage Photographs* (Chicago: Edwynn Houk Gallery, 1985), p. 4.

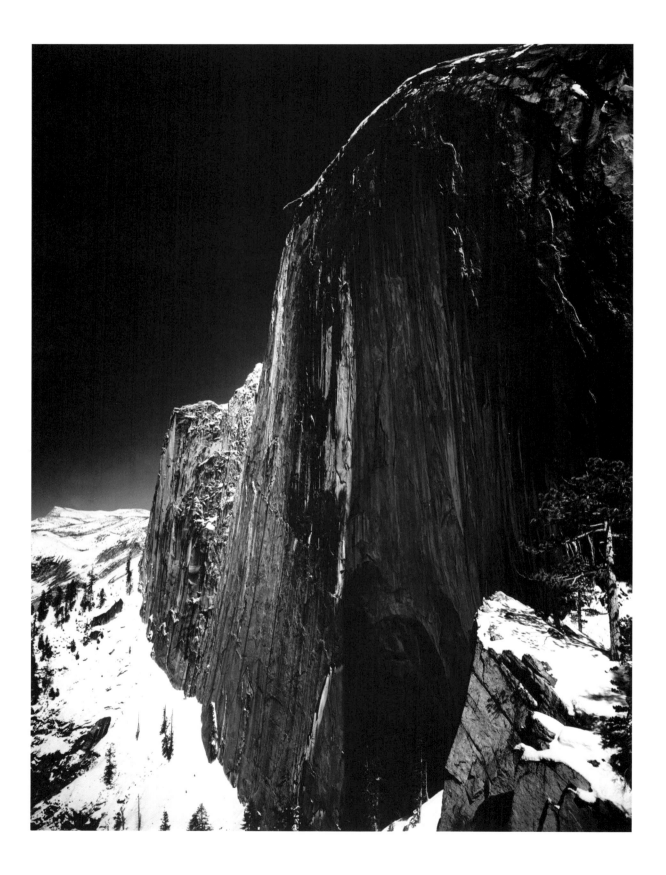

Ansel Adams
American, 1902–1984

Monolith, The Face of Half Dome, Yosemite National Park, California (1927). Gelatin silver print 1974-75, 49.4 x 36.5 cm on mount 71.0 x 55.6 cm. Signed with pencil on mount lower right: *Ansel Adams*; artist's stamp in black on verso mount: *Photographs by Ansel Adams*; inscribed with pen and black ink within artist's Carmel address stamp in black on verso: *Monolith, The Face of Half Dome / Yosemite National Park, California c. 1926.*

The Albert P. Strietmann Collection, 1975.358.

Provenance: Lunn Gallery / Graphics International, Ltd., Washington, D. C.

Exhibitions: Cincinnati Art Museum, *The Cincinnati Art Museum Photography Collection*, 1981-82.

A great photograph is one that fully expresses what one feels, in the deepest sense, about what is being photographed, and is, thereby, a true manifestation of what one feels about life in its entirety. This visual expression of feeling should be set forth in terms of a simple devotion to the medium. It should be a statement of the greatest clarity and perfection possible under the conditions of its creation and production.

My approach to photography is based on my belief in the vigor and values of the world of nature, in aspects of grandeur and minutiae all about us I believe man must . . . build strength into himself, affirming the enormous beauty of the world and acquiring the confidence to see and to express his vision. And I believe in photography as one means of expressing this affirmation and of achieving an ultimate happiness and faith.[1]

For over half a century, Ansel Adams's work as photographer, teacher, writer, and conservationist, had a tremendous impact on American photography, education, and preservation. His visionary western landscapes have become the definitive pictorial statement for several generations of Americans.

Born in San Francisco on February 20, 1902, he developed an early interest in music and the piano which he pursued as his future career. At the age of fourteen, during a family vacation to Yosemite Valley, he had his first opportunity to record spectacular scenery with his first camera, and the groundwork was laid for his lifelong activities as an artist and conservationist. During the 1920s Adams juggled his interests in music and photography. With the support of the San Francisco philanthropist, Albert Bender, Adams published his first portfolio, *Parmelian Prints of the High Sierras*, devoted to the majestic Sierra Nevada in 1927.

Adams considered *Monolith, the Face of Half Dome*, taken on April 17, 1927, for this portfolio, to be his first intellectually determined photograph. In his autobiography he recounts this breakthrough:

I had only *one* plate left. I attached my other filter, a Wratten #29(F), increased the exposure by the sixteen-times factor required, and released the shutter. I felt I had accomplished something, but did not realize its significance until I developed the plate that evening. I had achieved my first true visualization! I had been able to realize a desired image: not the way the subject appeared in reality but how it *felt* to me and how it must appear in the finished print. The sky had actually been a light, slightly hazy blue, and the sunlit areas of Half Dome were moderately dark gray in value. The red filter dramatically darkened the sky and the shadows on the great cliff. Luckily I had with me the filter that made my visualized image possible.[2]

It was only in 1930, after seeing Paul Strand's negatives in Taos, that Adams dedicated himself to a full-time career in photography. In 1932 Adams was a founding member of the Group *f*/64 which promoted "straight photography" along with Imogen Cunningham, Willard Van Dyck, and Edward Weston. The following year he showed his portfolio to Alfred Stieglitz, the American seer of art photography, who gave him a one-man show in New York at An American Place in 1936. Adams balanced his creative work with commercial photography. Beginning in 1949, he served as a consultant for the Polaroid Corporation.

As a teacher, Adams inspired several generations of photographers. He refined his concept of visualization by introducing his Zone System in 1941, which gave photographers the means to evaluate and preplan the tonal range of the subject before exposure and development. His *Basic Photo Series*, first published in 1948, was completely revised and issued under the title *The New Ansel Adams Photography Series* in the early 1980s.

Committed to the importance of photography, Adams helped to establish the Department of Photography at The Museum of Modern Art, New York (1940), founded the Department of Photography at the California School of Fine Arts (now the San Francisco Art Institute, 1946), and played an instrumental role in organizing the Friends of Photography in Carmel (1966). As a member of the Board of Directors of the Sierra Club from 1937 to 1971, he promoted wilderness preservation.

For over fifty years his photographs of the High Sierras, national parks, his portraits, and Manzanar relocation study, have been the subject of numerous books, portfolios, and over 500 one-man exhibitions. Among the many awards he received were Guggenheim Fellowships (1946, 1948, 1958) and the United States Medal of Freedom (1980).

Adams called the negative "the score" and the print "the performance." This large format print of *Monolith*, from the original 1927 negative, reflects a late interpretation of the subject which has become an icon of the American West.

1. Ansel Adams with Mary Street Alinder, *Ansel Adams: An Autobiography* (Boston: Little, Brown, 1985), p. 235.
2. Adams and Alinder, p. 76.

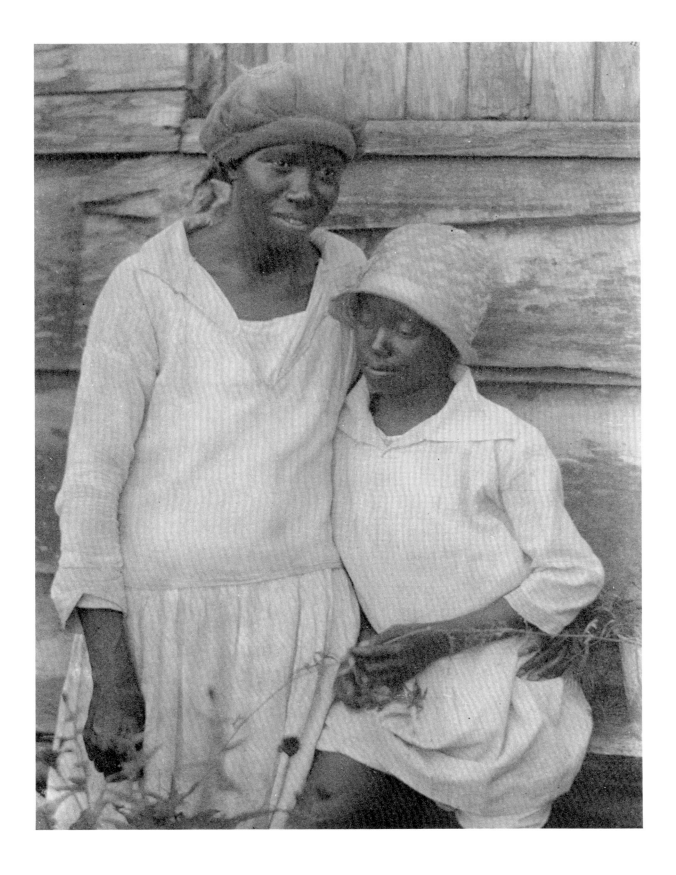

Doris Ulmann

American, 1884-1934

Black Mother and Daughter (ca. 1929-30). Platinum print, 20.4 x 15.3 cm on mount 35.6 x 27.9 cm. Signed with pencil on mount lower right: *Doris Ulmann*; numbered with pencil on verso mount: *388* (red) and *36*.

The Albert P. Strietmann Collection, 1980.69.

Provenance: John Jacob Niles, Lexington, KY; The Witkin Gallery, Inc., New York.

Exhibitions: Cincinnati Art Museum, *The Cincinnati Art Museum Photography Collection*, 1981-82.

A fragile, sophisticated woman, Doris Ulmann was born into a wealthy New York family on May 29, 1882. Between 1900 and 1903 she studied at the Ethical Culture School under Lewis W. Hine and attended Columbia University where she pursued psychology and law. In 1914 she became one of Clarence White's first students at the Clarence White School of Photography. In 1918 she became a member of the Pictorial Photographers of America.

Ulmann is best known for her images that document the native handicrafts and customs of rural Appalachia and the South. Inspired by the renewed interest to preserve America's pre-industrial heritage in the mid-1920s, she photographed the Amish, Mennonites, and Shakers of New York and Pennsylvania. For her field work, she shunned hand-held cameras, roll film, and light meters in favor of her portrait studio equipment – a clumsy shutterless view camera with soft-focus lens, which along with glass plate negatives, had to be lugged to her subject. Between 1927 and her death she traveled with Kentucky-born singer and American folk music collector, John Jacob Niles, who acted as a guide and assisted by carrying the heavy photographic paraphernalia. She traveled in a Lincoln sedan driven by a German chauffeur to the nearest large town, then changed to a Chevrolet sedan driven by Niles to reach often inaccessible locations. Along with her equipment she also transported food and her stylish dresses which she wore regardless of the situation. Ulmann photographed her urban and rural sitters using a half-length portrait format. Her soft-focus, pictorial lighting glossed over the miserable reality of her subjects' lives brutalized by poverty, but her straightforward images were unpretentious and dignified, without contrived pictorialist sentimentality.

During the winter of 1929-30, with the writer Julia Peterkin as her guide, she traveled south to record old Negro religious rituals – baptism, feet-washing, shouting, and cotton picking. She photographed the blacks of the Gullah region along the coast and on Peterkin's Lang Syne Plantation near Fort Motte, South Carolina. It was only outside New York that Ulmann's images attained such poignant unself-conscious intensity. Although this platinum print of a *Black Mother and Daughter* once belonging to Niles did not appear as an illustration in Peterkin's *Roll, Jordan, Roll* (1933), it was undoubtedly taken at the same time. Three years after Ulmann's death a second book by Allen H. Eaton, *Handicrafts of the Southern Highlands* (1937) was published illustrating her last photographs made between 1933 and 1934.

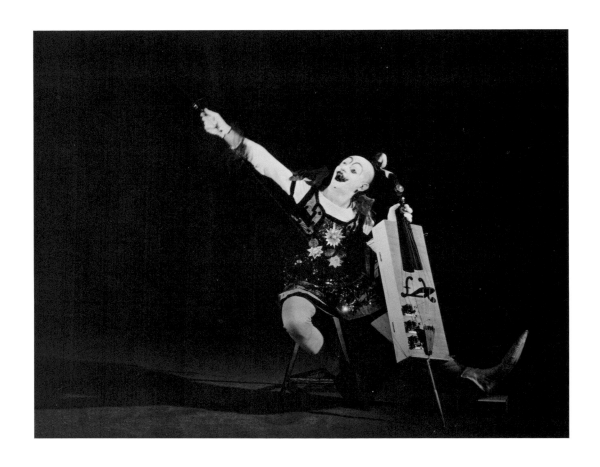

Theodore Lukas (T. Lux) Feininger

American, b. Germany, 1910

Oskar Schlemmer as "Musical Clown," Bauhaus, Dessau
(1928). Gelatin silver print, 11.3 x 14.2 cm. Verso inscribed with pen and blue ink: *Oscar Schlemmer (Bauhaus Dessau) / als Music-Clown (1929-30) / Erläuterung siehe auf F 18 / Eigenhum von Werner Siedohoff. Frankfort a Main / Cornelius str. 17.*

The Albert P. Strietmann Collection and Deaccession Funds, 1983.46.

Provenance: Werner Siedhoff, Frankfort am Main; Prakapas Gallery, New York.

Oskar Schlemmer (1888-1943) joined the Bauhaus in Weimar as artistic director of murals in 1920. He directed the Dessau Bauhaus stage from the fall of 1925 through 1929. He presided over the design and realization of dances and pantomimes. Some roles, like the "Musical Clown," he acted himself. The role has been described as

> intentionally exalted to be grotesque, with his bare-ribbed umbrella, glass curls, colored pompom tuft, goggle eyes, balloon nose, toy saxophone, accordion chest, xylophone arm, miniature fiddle, funnel-shaped leg with military drum attached. . . .[1]

The son of one of the original Bauhaus "Masters," Lyonel Feininger, and the brother of the photographer Andreas, T. Lux Feininger was born in Berlin in 1910. He arrived at the Bauhaus at its opening in Weimar in 1919 and studied stage design with Schlemmer between 1926 and 1929. Although there was no formal course in photography at the Bauhaus until 1929, the presence of Moholy-Nagy and Lucia Moholy served as a catalyst for the energetic exploration of the camera and photographic perception. Primarily known as a painter, the sophisticated snapshots of this self-taught young artist reflect the exhilarating visual atmosphere of the Dessau years. Hired by Schlemmer, Feininger used bird's-eye and worm's-eye views to record the special effects of the school's theater workshop. As one of the few individuals consistently photographing Bauhaus activities, his work represents an important visual archive of this progressive institution. This print belonged to Werner Siedhoff, one of the workshop dancers.

During the late 1920s Feininger was introduced to the Berlin photographic agency Dephot by Umbo whose work they already represented. Dephot placed his photographs in publications throughout Germany. Moholy selected his work as representative of new vision photography for the now famous *Film und Foto* exhibition in Stuttgart in 1929. When he left Germany in 1937, Feininger left behind his negatives which were never recovered. In subsequent years he exhibited his paintings in the United States and taught drawing and painting at Harvard University and the Museum School of the Boston Museum of Fine Arts until he retired in 1975.

1. Hans M. Wingler, *The Bauhaus: Weimar, Dessau, Berlin, Chicago,* trans. Wolfgang Jabs and Basil Gilbert (Cambridge, MA: The Massachusetts Institute of Technology Press, 1969), p. 474.

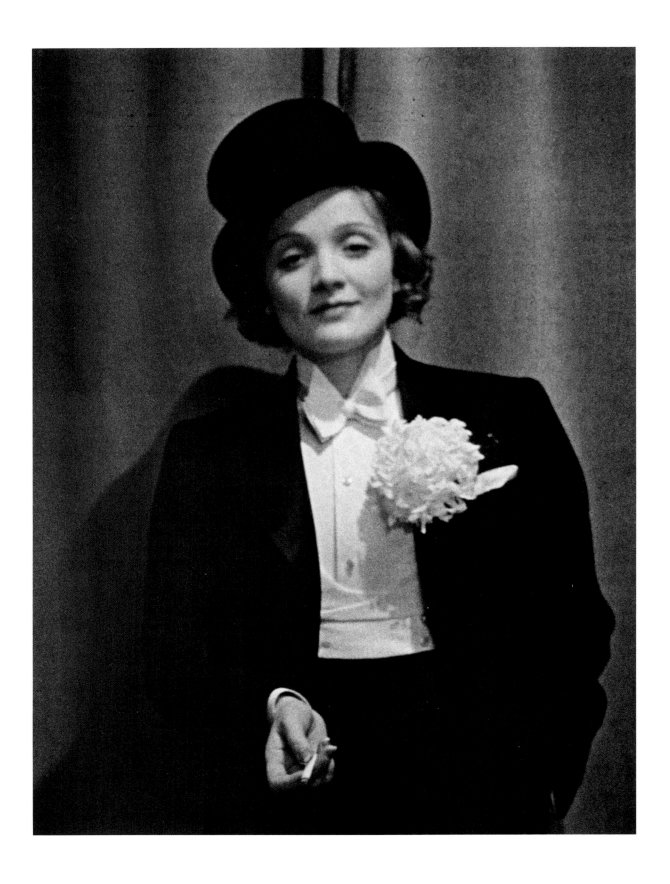

Alfred Eisenstaedt
American, b. West Prussia (now Poland), 1898

Marlene Dietrich (1929). Modern gelatin silver print, 35.8 x 26.6 cm on 50.6 x 40.5 cm. Signed with black ball point in margin lower right: *Eisenstaedt*; inscribed with pencil on verso: *Marlene Dietrich, 1928 © Time Inc.*; Stamped with black ink: THIS IMAGE IS LIMITED TO FIFTY / PLUS TEN ORIGINAL SILVER PRINTS / OF WHICH THIS IS NUMBER (pencil) *2/50*.

Israel and Caroline Wilson Fund, 1985.25.

Provenance: Images, Cincinnati.

Albert Eisenstaedt was born in Dirschau, West Prussia (now Poland), on December 6, 1898. His father, a retired department store owner, moved the family to Berlin in 1906. During World War I, while serving in the German army, Eisenstaedt was wounded in the offensive at Dieppe. In the late 1920s and early 1930s Eisenstaedt was one of a handful of pioneers who developed photojournalism simultaneously with the introduction of lightweight hand-held cameras. As a free-lance photographer, while employed as a salesman of buttons and belts, he was assigned to cover major conferences and balls by the Associated Press and German publications. One of his early subjects was the rising actress and singer Marlene Dietrich (b. 1901) who became the star of Josef von Sternberg's first talking motion picture *Der blaue Engel (The Blue Angel)* in 1930. Eisenstaedt's portrait of Dietrich at the annual ball for foreign press in top hat and tails with a lighted cigarette represents the sensational usurpation of traditional male attributes in the postwar decade. Dietrich had to stand very still because of the long exposure between half a second and a second.

Once he turned professional in 1929, his first assignment was to cover Thomas Mann receiving the Nobel Prize for literature in Stockholm. Thereafter he traveled widely: to resorts where the titled and wealthy gathered; to capitals of Europe where he photographed eminent leaders and important events such as the first meeting of Hitler and Mussolini; and to Ethiopia on the verge of war with Italy. In 1935 he emigrated to the United States where he became one of the elite corps of photographers, along with Margaret Bourke-White, Thomas McAvoy, and Peter Stackpole, hired by Henry R. Luce for the new "picture" magazine, *Life,* in 1936. *Life*'s picture essays provided the photographer with an entry into the lives of people and events inaccessible to most individuals. In describing his experiences to the noted photo-historian Beaumont Newhall, Eisenstaedt wrote:

> My approach was not that of a photographer with a lot of equipment doing a job, but of a casual visitor, who incidentally brought a Leica, three lenses and a little tripod along. . . . The longest time I spent with each was 28 minutes.[1]

During his career Eisenstaedt has done over twenty-five hundred assignments and ninety-two covers for *Life*. He remained with the magazine until its demise in 1972 and has done occasional assignments for the new *Life* since 1978.

Among the eleven books devoted to his photographs are *Witness To Our Time* (1966), *The Eye of Eisenstaedt* (1969), *People* (1973), *Eisenstaedt: Germany* (1980), and *Eisenstaedt On Eisenstaedt* (1985). His many honors include Photographer of the Year (Encyclopedia Britannica, 1951), International Understanding Award for Outstanding Achievement (1967), Photographic Society of America achievement award (1967), and Joseph A. Sprague Award (National Press Photographers Association, 1971). His most recent one-man showings include the International Center of Photography, New York, Canadian Centre of Photography, Toronto, and Fotomuseum, Munich (1981).

1. Beaumont Newhall, *The History of Photography From 1839 to the Present* (New York: The Museum of Modern Art, 1982), p. 263.

Umbo (Otto Umbehr)

German, 1902–1980

Face and Hands, 1930. Gelatin silver print, 16.8 x 11.4 cm. Inscribed with pen and black ink on verso: UMBO–FOTO / *1930.*

The Albert P. Strietmann Collection and Deaccession Funds, 1983.47.

Provenance: Werner Siedhoff, Frankfurt am Main; Prakapas Gallery, New York.

An inventive and versatile photographer, Umbo was one of the pioneers of modern photojournalism. Born Otto Umbehr in Dusseldorf on January 18, 1902, he changed his name to Umbo in 1924. His early interests were acting, pottery-making, and woodcarving. From 1921 through 1923 he was a student of painting and design at the Bauhaus in Weimar where he studied under Walter Gropius, Wassily Kandinsky, Lyonel Feininger, and Paul Klee. In 1923 he moved to Berlin where he was active in the Arts and Crafts Workshop of the Theater Berthold Viertel. Between 1924 and 1926, he served as film assistant for Kurt Bernhardt and later as camera assistant to Walter Ruttmann on his documentary *Berlin, Die Sinfonie einer Grosstadt (Berlin, Symphony of a Great City)*. With the gift of a studio camera from his father and assistance in constructing a darkroom from former Bauhaus colleague, Paul Citroen, Umbo embarked on a photographic career in 1927.

Sharp focus, unusual vantage-points, and bold geometric compositions were the hallmarks of new directions in photography. These strategies were employed to disorient the viewers' perceptions of familiar subjects, and to compel them to take an active role in relation to the photographic image. In his portraits of actresses and notables, Umbo typically used extreme close-ups tightly framed with vivid contrasts of highlights and shadows. The simple geometry of the starkly lit face and hands of actress Rut Landshoff impassively looming out from an impenetrable background evokes a haunting confrontation with the viewer.

Umbo's success as a portraitist naturally led to photojournalism. In 1928 he met Simon Guttmann who was the director of the newly established agency, Dephot (Deutsche Photodienst). Umbo worked for the agency along with Felix H. Man, Andreas Feininger, and Robert Capa, until its demise in 1933. Umbo specialized in photoreportage and in writing about avant-garde film, theater, and dance. His work appeared in a variety of publications, including the *Berliner Illustrirte Zeitung, Münchner Illustrierte Presse,* and *Dame.* In 1929 Moholy-Nagy included his work in the selection of German photographs in the important *Film und Foto* exhibition in Stuttgart. Umbo continued to work in Berlin as a freelance photojournalist until 1943, when he served in the German army.

In 1945 his Berlin studio containing his negatives and photographs was destroyed. Thus this vintage print from the collection of a former Bauhaus student, Werner Siedhoff, is extremely rare.

Albert Renger-Patzsch

German, 1897-1966

Sunflower (ca. 1930). Gelatin silver print, 16.9 x 22.7 cm on 17.1 x 22.9 cm. Artist's stamp in purple on verso: RENGER-FOTO D.W.B. / *Jede Reproduction / verboden.*

The Albert P. Strietmann Collection, 1980.22.

Provenance: Kurt Wolff ?, Munich; Allan Frumkin Gallery, Chicago.

Exhibitions: Cincinnati Art Museum, *The Cincinnati Art Museum Photography Collection*, 1981-82.

In Germany the most renowned advocate of *Neue Sachlichkeit* (New Objectivity) was the pioneer realist photographer Albert Renger-Patzsch. One of the hallmarks of the new photography was the close-up, that focused attention on structures, patterns, and textures which might ordinarily be overlooked. Renger-Patzsch sought to reveal analogies between natural forms and factory-made products, thereby suggesting that the same structure underlay all objects, old and new, animate or inanimate, manufactured or natural. In addition he may have implied that the objects photographed should inspire pride in German industrial ingenuity during the postwar period.

Renger-Patzsch was born in Würzburg on June 22, 1897. Educated in Dresden, where he studied classics, he acquired an appreciation for clarity and order. After two years of service in the German army, he received a three-year appointment as the director of the Folkwang Photographic Archives in Hagen, after which he worked as a freelance documentary and press photographer in Bad Harzburg and Essen between 1925 and 1933. In 1928 he published the first of his many photographically illustrated books, *Das Chorgestühl von Kappenberg (The Choir Stalls of Cappenberg)*. After teaching a year at the Folkwangschule in Essen in 1933-34, he left to pursue his own work.

Like his contemporary Moholy-Nagy, Renger-Patzsch considered photography an autonomous branch of art with its own unique qualities. In the first issue of *Deutsche Lichtbild* in 1927 he wrote:

> The secret of a good photograph – which, like a work of art, can have aesthetic qualities – is its realism . . . Let us therefore leave art to artists and endeavour to create, with the means peculiar to photography and without borrowing from art, photographs which will last because of their photographic qualities.[1]

In 1928 the avant-garde Munich publisher Kurt Wolff released *Die Welt ist Schön (The World is Beautiful)*, illustrating one hundred images testifying to Renger-Patzsch's special eye for design and juxtaposition of textures. Although this photograph is purported to have belonged to Wolff, it did not appear in *Die Welt ist Schön*. It exemplifies the strong, direct, extreme close-up Renger-Patzsch used to convey the essence of the object. Instead of photographing the face of the sunflower, he reveals the beauty of the fecund head and arched stem in contrast with the lacy edge of the leaf.

During World War II Renger-Patzsch served as a war correspondent. He lost eighteen thousand negatives when his studio was destroyed during a 1944 air raid. From 1944 until his death Renger-Patzsch lived in Wamel bei Soest where he concentrated on landscape photography. In 1957, on his sixtieth birthday, the Gesellschaft Deutscher Lichtbildner awarded him the David Octavius Hill Medal and three years later he received the Culture Prize from the Deutsche Gesellschaft für Photographie. Beginning with his first one-man exhibition in Haden in 1925, he exhibited in Germany and abroad, including the important *Film und Foto* exhibition in Stuttgart (1929) and in all major shows focusing on German photography between the wars. Most recently his work was featured in *Avant-Garde Photography in Germany 1919-39*, San Francisco (1980).

1. Albert Renger-Patzsch, "Ziele," *Das Deutsche Lichtbild* (1927), p. 18; trans. in Ute Eskildsen, "Photography and the Neue Sachlichkeit Movement," in David Mellor, ed., *Germany: The New Photography 1927-33* (London: The Arts Council of Great Britain, 1978), p.·103.

August Sander

German, 1876-1964

Frau Lindemann, Cologne, 1930. Gelatin silver print, 27.9 x 19.7 cm sight. Circular blindstamp lower left: AUG. SANDER / KÖLN / LINDENTHAL; signed and dated with pencil on window mat lower right: *Aug Sander / Köln* 1930; inscribed with pencil lower left: *Frau Lindemann Köln*; printed label affixed on verso mat: SANDER „MENSCHEN DES 20 JAHRHUNDERTS".

The Albert P. Strietmann Collection, 1976.431.

Provenance: Halstead 831 Gallery, Birmingham, Michigan.

Exhibitions: Cincinnati Art Museum, *The Cincinnati Art Museum Photography Collection,* 1981-82.

In the early 1920s August Sander began to make photographic portraits for *Menschen des 20. Jahrhunderts (Citizens of the Twentieth Century).* This projected atlas of German types was to provide a photographic cross-section of aspirations, fantasies, and barriers in the stratified social hierarchy of the Weimar Republic. The realization of this great portrait atlas was forestalled by economic, political, and publishing difficulties.

August Sander was born November 17, 1876, in the small village of Herdorf, in Siegerland, a mountainous farming and mining region near Cologne. The third of nine children, he became an apprentice miner at the age of fourteen. A chance encounter at the mine with a landscape photographer set him single-mindedly on his future course. Following mandatory military service in 1896, he began a series of apprenticeships with various photographic firms and attended the Dresden Academy of Art to study painting. He established his first commercial studio in Linz, Austria, in 1903, where he mastered all the painterly effects then in vogue. His early "art" photographs received critical acclaim and awards. In late 1909 he gave up his Linz studio and moved his family to Cologne where he set up a studio in the suburb of Lindenthal. Sander eventually abandoned the painterly gum-bichromate process in favor of glossy gelatin silver prints designed for technical purposes.

In search of customers, he bicycled to the nearby countryside farms in Siegerland and Westerwald where he photographed the peasants in a clear, unadorned, matter-of-fact documentary style. With the success of his Lindenthal Studio, this documentary direction might have been abandoned had it not been for World War I, which disrupted everything.

In the postwar years, Sander became a dispassionate taxonomist of society under the influence of the artist group Kölner Progressive. His portraits catalogue the psychological and social archetypes of the classes, occupations, and lifestyles in Germany. In 1929 the German publisher Kurt Wolff published a collection of sixty of Sander's portraits under the title *Antlitz der Zeit (Faces of Our Time).* Sander's calculated layout was intended to make an individual and aggregate visual statement. The Nobel prize-winning writer Thomas Mann wrote:

This collection of photographs, as finely delineated as they are unpretentious, is a treasure-trove for the student and lover of physiognomy and provides an excellent opportunity to explore the occupational and class-structured imprints on humanity.[1]

His posing strategy encouraged his subjects to project their self-image and aspirations through attire, gesture, and surroundings. Frau Lindemann, the wife of a well-to-do Cologne industrialist who owned a quartz quarry near Frechen,[2] was photographed at home in her role of wife and hostess. Sander's simple pose, uncluttered composition, and undramatized illumination influenced painters of the "Neue Sachlichkeit" movement.

Unfortunately Sander's photographs were perceived as a threat to Nazi mythmakers attempting to fashion an Aryan ideal. In 1934 the Bureau of Visual Arts ordered the printing plates for *Antlitz der Zeit* destroyed and the available copies seized. Sander devoted himself to landscapes and nature studies. In 1945, during a World War II bombing of Cologne, his studio was destroyed.

During the final decade of his life he received both national and international recognition in exhibitions, including *The Family of Man* at The Museum of Modern Art, New York (1955), and a one-man exhibition in Cologne (1959). In 1960, four years before his death at the age of eighty-eight, he received the Order of Merit of the Federal Republic of Germany. Although he returned to work on *Citizens of the Twentieth Century* during his final years, he never completed his portrait atlas.

1. *International Center of Photography Encyclopedia of Photography* (New York: Crown Publishers, 1984), p. 443.
2. Gerd Sander, Letter to KS, 9 Sept. 1981.

Herbert Bayer

American, b. Austria, 1900-1985

Self Portrait, 1932. Gelatin silver print from rephotographed photomontage, 34.0 x 24.0 cm on 35.4 x 28.0 cm. Signed and dated with pencil in margin lower right: *Bayer 32*; numbered lower left: *17/40*.

The Albert P. Strietmann Collection, 1976.31.

Provenance: Carl Solway Gallery, Cincinnati.

Exhibitions: Cincinnati Art Museum, *The Cincinnati Art Museum Photography Collection*, 1981-82.

Herbert Bayer's career epitomized the Bauhaus ideals. He fused artistic creativity, skilled craftsmanship, and modern technology by working in all available media. While still painting, he pursued a highly successful commercial career as a graphic designer, architect, photographer, and exhibition designer.

He was born in Haag, Austria, on April 5, 1900. Between 1919 and 1921, following his service in the Austro-Hungarian army, he apprenticed in architecture and decorative arts under the architect George Schmidthammer in Linz and later as a graphic design assistant to the architect Emanuel Margold, Darmstadt, Germany. In 1921 he enrolled at the Staatliche Bauhaus, Weimar, where he studied mural painting and design. As a Master teacher from 1925 to 1928, Bayer taught graphic design and typography at the Bauhaus in Dessau.

The Bauhaus's ready acceptance of technology and machine aesthetics provided an atmosphere conducive to experiments with the camera. Bayer's early explorations shared many of the novel visual devices of Moholy-Nagy's work. Everyday subjects were presented from exaggerated vantage points or extreme close-ups. Bayer's highly personal approach to photomontage dates after he left the Bauhaus and moved to Berlin where he worked as a commercial artist and exhibition designer. He was one of the first to utilize photography and photo-collages, and other dada or surrealist devices for posters, advertisements, and magazine covers.

Bayer's *Self Portrait* plays one layer of reality against another, creating dream-like situations and spatial ambiguities. Originally it was one of a series of photomontages intended for a picture story on "Man and Dream" which was never completed, although a selection was issued in a small edition as a portfolio in 1936. That same year he fabricated a series of *fotoplastiken,* in which he illusionistically staged objects into three-dimensional compositions. This became his stock-in-trade.

Jan van der Marck wrote the following about his *Self Portrait*:

one of herbert bayer's best-known photomontages, [this picture] has entered the annals of photography as an example of the influence of surrealism on the photographic medium. metamorphosis, the mirror, the handsome youth and the conjunction of marble and flesh are straight from the surrealist vocabulary. specifically, it is possible to establish an analogy with jean cocteau's *the blood of a poet*, a film which had its first public showing in paris in january 1932. the beauty of classical, especially greek, sculpture was much on bayer's mind, from 1930 until 1938, as he used it in conjunction with . . . layout of magazines, catalogues and posters. . . .[1]

After serving as art director in Berlin for Dorland Studio (1928-38) and at German *Vogue* magazine (1928-30), he emigrated to the United States, where he continued his commercial career. His photographs had the dubious honor of appearing both in the avant-garde *Film und Foto* exhibition in Stuttgart in 1929 and the Nazi *Entartete Kunst* (Degenerate Art) exhibition in Munich in 1936.

Beginning in 1938 he designed several exhibitions for The Museum of Modern Art, New York, including *Bauhaus 1919-1928, Road to Victory* (1942), and *Airways to Peace* (1943). Between 1946 and 1967 he was design consultant, and from 1956 chairman of the Department of Design, for the Container Corporation of America. In addition, from 1946 to 1976, he was design consultant for the development of Aspen, Colorado, and architect for the Aspen Institute of Humanistic Studies. From 1966 to his death, he served as art and design consultant for Atlantic Richfield Company.

1. Jan van der Marck, *Herbert Bayer: From Type to Landscape* (Hanover, NH: Hopkins Center, 1977), p. 22.

Brassaï (Gyula Halász)

French, b. Hungary (now Romania), 1899-1984

Giacometti Sculpture *Femme qui marche*, 1933. Gelatin silver print, 29.2 x 19.1 cm. Inscribed with pencil on verso: *Alberto Giacometti / «Femme qui marche» / plâtre 1933 / (Coll. Pierre Matisse) / New York* (blue pencil) *A.234.*; artist's copyright and studio stamp in black on verso: © COPYRIGHT *by* / BRASSAÏ / *81, Faubourg St. Jacques / Paris 14ᵉᵐᵉ Tél 707.23.4*; signed with pencil: *Brassaï.*

Gift of the Cincinnati Print and Drawing Circle, 1978.363.

Provenance: Pierre Matisse, New York; Zabriskie Gallery, New York.

Exhibitions: Cincinnati Art Museum, *The Cincinnati Art Museum Photography Collection*, 1981-82.

Gyula Halász was born on September 9, 1899, in Brasso, Transylvania, then part of Hungary, now Romania. At the age of four he spent an impressionable year in Paris with his father, a professor of French literature. Intent on becoming a painter, he studied at the Académie des Beaux-Art, Budapest (1918-19), and the Academische Hochschule, Berlin-Charlottenburg (1921-22). In 1924 he moved to Paris where he adopted the name Brassaï, meaning "from Brasso," after his birthplace. Soon penetrating the Parisian art world, he worked from 1924 to 1930 as a painter, sculptor, and journalist.

In 1930, with a camera borrowed from another Hungarian émigré, André Kertész, Brassaï tried his hand at photography. Pleased with the results, he set his other artistic activities aside, bought a camera and began to prowl Parisian streets in pursuit of the denizens of night. In his preface to the photographer's novel *Histoire de Marie* (1949), Henry Miller called Brassaï "the eye of Paris."

> You can meet him in the most unexpected places and always with the same smile, the same enquiring look, always anxious to tell you the latest story. He was always alert . . . his eyes peering in the corners, his glance always in the distance, beyond the man speaking to him. Literally everything is of interest to him. He never criticizes, never passes judgment on things or events. He simply reports what he has seen and heard.[1]

In 1933 Arts et Métiers Graphiques published Brassaï's first book, *Paris de Nuit*, which received critical acclaim. This was followed by one-man exhibitions in Paris and London, where he established his reputation as a photographer overnight. He began to receive assignments from magazines in France and elsewhere, including *Minotaure*, *Verve*, and *Harper's Bazaar*.

One of his first assignments in 1933 was to photograph the ateliers of Brancusi, Despiau, Giacometti, Laurens, Lipchitz, and Maillol for Téraide, who published *Minotaure*, a new review of art and literature. Although this photograph of Giacometti's plaster modello *Femme qui marche* was not selected for *Minotaure*,[2] it was undoubtedly taken at that time. The headless, armless, slenderly stylized representation of a young woman's body looming out of the cavernous darkness was alien to the spirit of Giacometti's other work of his surrealist period. Brassaï continued to record the artist's work over the next thirty-three years.

During the German occupation in 1944, Brassaï fled to Cannes, but returned to rescue his negatives which were not stored in a waterproof location. With his free-roaming photography curtailed by the occupation, he returned to drawing and photographed Picasso sculpting in his Paris atelier while writing his highly acclaimed book on the artist, *Conversations avec Picasso* (1964). In the postwar years he resumed his photographic career and designed the first photographic backdrops for Jacques Prévert's ballet *Les Rendezvous* and Jean Cocteau's *Phèdre*.

Among his distinguished awards are the Peter Henry Emerson Medal (1934), a gold medal from the Centenaire de Daguerre Exhibition, Budapest (1937), the American Society of Magazine Photographers Award (1966), and the Grand Prix National de la Photographie, France (1978). Although it was not until 1954 that he received a one-man exhibition in the United States at The Art Institute of Chicago, his work was known through publications. He is best remembered for his documentation of Paris's nocturnal pulse and the avant-garde artists' community prior to World War II. Brassaï died in Paris in July 1984.

1. Henry Miller, quoted in *Camera*, 5 (May 1956), p. 197.
2. Maurice Raynal, "*Dieu-table-cuvette; Les Ateliers de Brancusi, Despiau, Giacometti, Laurens, Lipchitz, Maillol, photographies par Brassaï,*" *Minotaure*, No. 3-4 (1933), n. pag.

George Hurrell
American, b. 1904

Jean Harlow (1934). Pl. from *Hurrell* published by Creative Art Images, Los Angeles, 1980. Gelatin silver print 1980, 33.7 x 26.6 cm on 35.6 x 27.7 cm. Inscribed with pen and black ink in margin lower left: *108/190*; lower right: *Hurrell*.

Gift of Alfred B. Katz, 1982.144.

Exhibitions: Cincinnati Art Museum, *Cincinnati Collects Photographs*, 1985, n. pag., no. 108.

The Golden Age of Hollywood began during the Depression, when Americans were desperately looking for some type of diversion from their daily problems. Many escaped to the movies to fantasize about their favorite stars who, although mere mortals, had been transformed into gods and goddesses on the big screen. What the public wanted was an ideal vision of beauty and glamour, a world of luxury and sophistication that was unattainable.

The Hollywood studios recognized that what the public remembered most about its favorite stars did not necessarily come from any of their films. The person most responsible for creating and maintaining this carefully crafted image of magic and drama was the Hollywood portrait photographer. It was a very difficult and demanding position, as hundreds of promotional stills were distributed daily to newspapers, trade journals, and fan magazines.

Among the talented portrait photographers working in Hollywood at this time, George Hurrell is considered to be one of the very best. But a career in painting, not photography, was his first real dream and the reason he moved to the artists' colony of Laguna Beach, California, in the mid-1920s. Hurrell was born in 1904 in Covington, Kentucky, and lived in Cincinnati for several years as a child. He studied painting and drawing at The Art Institute of Chicago. He was introduced to the camera while working for tuition money by the highly respected Chicago architectural photographer Eugene Hutchinson. After moving to California, Hurrell decided to pursue photography when his portrait stills of artists and area socialites were more popular than his landscape paintings. In the autumn of 1927 he worked briefly for Edward Steichen who was doing set-ups for advertising agencies. Then, according to Hurrell, "it dawned on me what enormous sums could be made from commercial photography."[1]

Through a friend, socialite-aviatrix Florence "Poncho" Barnes, Hurrell took some portrait stills of silent film star Ramon Novarro in 1928. Impressed with the results, Novarro showed the photographs to Norma Shearer, who was trying to change her rather prosaic screen image. Shearer wanted to convince her husband, MGM president Irving Thalberg, that she could handle the aggressive yet seductive lead in *The Divorcee*. Hurrell's alluring images not only got her the part (for which she later received an Academy Award) but landed him the position of head portrait photographer at MGM. For George Hurrell, this would be the beginning of a Hollywood career that would outlast many of the very stars he would photograph.

At MGM, Hurrell introduced his own ideas for depicting Hollywood glamour. Unhappy with the soft-focus, even-lighting techniques found in most publicity photographs of the 1920s, he traded in the Vertone or diffusion lens for a sharper image and manipulated the deep shadows (often created by using only a single spotlight) for added drama. Hurrell moved quickly around his studio, squeezing the bulb end of a 15-foot cord that was attached to his cumbersome 8 x 10-inch view camera to capture the spontaneous moment. This tactic worked as many stars had no idea when the shutter was actually snapped. For special effects, he invented the "boom light" (based on the boom microphone), which later became part of the standard equipment in every studio portrait gallery. During his career, Hurrell worked for most of the major studios, either as an independent or as a member of their gallery.

Stars like Bette Davis, Jean Harlow, and Joan Crawford understood the importance of the Hurrell image and relied heavily on his skill to promote their careers. Hurrell set a personal record with Joan Crawford by exposing five hundred plates in one sitting. With his careful understanding of his sitter, Hurrell's images often evoke a special character that goes deeper than mere physical beauty.

He found Jean Harlow to be extremely photogenic, one of the few celebrities who could actually project glamour. Transferring that quality to a black and white print, however, presented Hurrell with one of the biggest challenges. In this photograph of Jean Harlow lying on a bearskin rug, he carefully arranged the lights "at a low angle, because a top light exaggerated her deep-set eyes, which literally vanished in the camera."[2] Hurrell also noted that since her platinum hair "catches the light and provides contrast to the face,"[3] he preferred to photograph her in white.

Unlike many of his colleagues, Hurrell remained active throughout the 1950s and 1960s by adapting to current trends. He somewhat reluctantly moved on from the 8 x 10 inch to the 4 x 5 inch and 35mm formats. Hurrell considered retiring in the mid-seventies, but a renewed interest in his work resulted in a number of gallery and museum exhibitions, including *The Hollywood Photographs of George Hurrell* at the Cincinnati Art Museum in 1987. Although he feels that the glamour of the past is gone, he continues to photograph and is once again one of the highest-paid portrait photographers in the business.

—D.K.

1. Whitney Stine, *The Hurrell Style* (New York: Day, 1976), p. 3.
2. Stine, p. 41.
3. Stine, p. 41.

Man Ray (Emmanuel Rudnitzky?)

American, 1890-1976

Sonia (1935). Gelatin silver print (Sabattier effect), 23.0 x 17.0 cm. Inscribed with pen and black ink on verso: "*Sonia*"/ *MR*; artist's stamp in black: EPREUVE ORIGINALE / *Atelier Man Ray / Paris.*

The Albert P. Strietmann Collection, 1980.21.

Provenance: Man Ray, Paris; Allan Frumkin Gallery, Chicago.

Exhibitions: Cincinnati Art Museum, *The Cincinnati Art Museum Photography Collection*, 1981-82.

Born Emmanuel Rudnitzky (?) in Philadelphia on August 27, 1890, Man Ray's family moved to New York in 1897. During his twenties, he supported himself doing commercial work for a publisher of maps and atlases. At night he studied painting and drawing at the National Academy of Design (1908-12) and at the avant-garde Francisco Ferrer Social Center (1912-13). While a struggling young artist, his enthusiasm for modern developments was fired through visits to Alfred Stieglitz's "291" gallery beginning in 1910 and by the Armory Show in 1913. He had changed his name to Man Ray by 1913, since he used it when he registered his marriage to Adon Lacroix (divorced 1918). Man Ray had his first one-artist exhibition of paintings and drawings at the Daniel Gallery in 1915. The same year he began a lifelong friendship with Marcel Duchamp. Together with Duchamp and Francis Picabia, he was a pivotal member of the New York dada immediately preceding and during World War I.

Although he acquired a camera about 1915 for documentary records of his paintings, he did not seriously consider it an artistic tool until 1920. Following Duchamp to Paris in 1921, he was introduced to the Paris dada group and after 1924 he associated with the surrealists. At a time when pictorialism was still the principal mode, he favored natural light, clean, clear pictures, and informal poses. His portraits of the Parisian intellectual elite include Breton, Joyce, Schoenberg, Artraud, Ernst, Stein, and Brancusi. In his personal work he was at the forefront of experimental photography in Europe. He explored cameraless images, i.e., photograms which he called "Rayographs" and solarizations.

The cameraless photograph had been known since the invention of photography, beginning with Talbot and Atkins. Christian Schad (1918) and Moholy-Nagy, independently but simultaneously with Man Ray in 1922, rediscovered the photogram technique in the twentieth century. These unique shadow images reflected Man Ray's preoccupation with objects conceived by chance, ambiguity, and unconscious association, which he pursued without concern for craft. Around 1929, he began using solarization, which had accidently been discovered by his darkroom assistant and student,

Lee Miller. Man Ray, more than any other contemporary photographer, established solarization and the Sabattier effect as creative tools in the 1920s and 1930s. These innovative processes used to metamorphose images made Man Ray a sorcerer in the eyes of his fellow surrealist painters and poets, who sought him for collaborations on articles and illustrated books. In 1922, Man Ray published an album of twelve Rayographs (copied from originals), with an introduction by Tristan Tzara, entitled *Les Champs délicieux.* This was followed by *Electricité* a privately published portfolio of ten Rayographs with an introduction by Pierre Bost.

The nude lent itself to the eroticizing surrealist sensibility. Among the women with whom he was involved who repeatedly appear as models were Kiki of Montparnasse, Lee Miller, Nusch Eluard, Dora Maar, and Julie Browner, whom he married in 1946. Sonia was a Russian émigré who was killed by the Germans during the occupation of Paris.[1] Man Ray used the phenomenon of edge reversal known as the Sabattier effect to rim the figure contours with a black line. In places the solid flesh seems to dissolve into thin air and the shadow of the head takes on an independent existence. The hand-drawn eyebrows are a wonderful dadaist touch.

In 1925 he participated in the surrealist exhibition at Galerie Pierre and in 1929 he was included in the *Film und Foto* exhibition in Stuttgart. His first one-man photographic exhibition in the United States was at The Arts Club of Chicago in 1929 and in 1931 Julien Levy, whom he had met through Duchamp, included his work in his gallery exhibition *Surréalisme.*

In 1940, Man Ray fled the Nazi occupation of Paris and settled in Hollywood where he continued to paint and photograph. Returning to Paris in 1951, he concentrated on painting until his death on November 18, 1976. In the late 1950s and early 1960s Man Ray experimented with color photography. He received the Gold Medal for photography at the 1961 Biennale in Venice. His photographs have been shown in one-man exhibitions both in the United States and Europe, most recently in a monumental retrospective of his photographs, paintings, sculptures, and assemblages at the Centre Georges Pompidou, Paris, in 1982.

1. Carol Ehlers, letter to KLS, 18 Jan. 1980. When Alice Adam bought this photograph for the Allen Frumkin Gallery from Man Ray, he supplied her with this information about the subject. According to Juliet Man Ray, her husband knew at least two or more Sonias. She did not know which one this was. Juliet Man Ray, Letter to KS, 6 May 1982.

Margaret Bourke-White

American, 1904-1971

Boulder Dam (1935). Gelatin silver print, 32.6 x 22.8 cm on 33.0 x 23.1 cm. Artist's stamp in black on verso: A / MARGARET BOURKE-WHITE PHOTOGRAPH; stamp in red: PHOTO BY / MARGARET BOURKE-WHITE; inscribed with pencil: 15 / Boulder / Dam.

The Albert P. Strietmann Collection, 1980.94.

Provenance: Daniel Wolf, Inc., New York.

Exhibitions: Cincinnati Art Museum, *The Cincinnati Art Museum Photography Collection*, 1981-82.

Margaret Bourke-White rose to pre-eminence in that remarkable decade – 1925-1935 – when camera development, editorial imagination and a breakthrough in printing processes combined to bring about a revolution in communications through the still picture. As the first photographer for *Fortune* and later as one of the four original staff photographers for *Life*, her monumental work became known throughout America and the far reaches of the world – beyond that of any other photographer of her time.[1]

Bourke-White was born in New York City on June 14, 1904, to Joseph White, a successful engineer-designer in the printing industry, and his wife Minnie (Bourke) White. In 1921, during her freshman year at Teachers College, Columbia University, she studied photography with Clarence H. White, a founding member of the Photo-Secession. She continued her photographic activities while drifting through several schools, finally graduating from Cornell University in 1927. Bourke-White settled in Cleveland, Ohio, where she established her reputation as an industrial photographer recording the drama and energy of smoke stacks, railroads, and steel mills in the industrial flatlands.

In 1929 Henry Luce, publisher of *Time*, was considering a new business magazine illustrated with photographs which would symbolize industry and make its machines dramatic and beautiful. Based on her published work he hired Bourke-White and illustrated the first issue of *Fortune* exclusively with her photographs. Between 1929 and 1936 she split her time between *Fortune* assignments and independent advertising and industrial work.

In 1930, her portfolio of industrial photographs extolling the machine aesthetic secured her entry into the Soviet Union as the first foreign photographer to record the results of Stalin's first five-year plan. Her earliest book, *Eyes on Russia* (1931), opened with a dramatic grouping of three vertical piers of the Dnieper Dam. She turned to the theme of the dam again in 1935. One of the seven wonders of American engineering, Boulder Dam (renamed Hoover Dam), on the Colorado River, was the tallest arch gravity dam in the western hemisphere. Built between 1928 and 1935, its 726-foot containment wall backed up Lake Mead 115 miles. The dam symbolized American technology and progress by its compositional boldness and sense of design. Although there were no workers present, the catwalk and stairs emphasize the massive size of the intake towers. This photograph was made in the spring of 1935 when she was under contract to Newspaper Enterprise Association and TWA.[2]

On November 23, 1936, her photograph of Fort Peck Dam became the first cover of Luce's newest venture, *Life*, a pictorial tabloid which depended on photographs to carry the story line. Talented and ambitious, Bourke-White became one of a new breed of socially concerned photojournalists who pioneered the photo-essay. Between 1936 and 1957 she completed 284 assignments in forty-five countries and twenty *Life* covers. With style and grace and the highest standards for photojournalistic excellence, she relentlessly recorded the essence of the human condition – whether it was abject poverty, floods, droughts, or war. She covered the German bombardment of Moscow (1941), the American liberation of Buchenwald (1945), the agonizing partitioning of India (1946-48), and the labor unrest in South Africa (1949-50). *Life* shaped the public opinion of an entire generation worldwide. Bourke-White's photographs and unique vision without a doubt contributed in large measure to its reception. She died on August 27, 1971, after a heroic nineteen-year battle with Parkinson's disease.

1. Carl Mydans, "A Tireless Perfectionist," in *The Photographs of Margaret Bourke-White*, ed. Sean Callahan (Greenwich, CT: New York Graphic Society, 1972), p. 25.
2. Carolyn A. Davis, Letter to KS, 25 July 1983.

Walker Evans
American, 1903-1975

A Miner's Home, West Virginia (1935). Gelatin silver print, 33.0 x 26.2 cm (vertical crop mark 32.3 cm) on 35.3 x 27.8 cm. Artist's stamp in black on verso: *Walker Evans*; negative numbers in boxes with pencil: *1, 54, 26*

The Albert P. Strietmann Collection, 1977.28.

Provenance: The Halstead 831 Gallery, Birmingham, Michigan.

Exhibitions: Cincinnati Art Museum, *The Cincinnati Art Museum Photography Collection*, 1981-82.

Walker Evans was a man of acute visual perception. He had a profound sense of the American myth and a marvelous sensitivity to materials. He has become the progenitor of the contemporary approach to photography which is most frequently referred to as documentary. . . . In Evans' photographs his subjects are not stereotyped or sentimentalized, but displayed in terms of their inherent qualities and meanings.[1]

Evans was born on November 3, 1903, in St. Louis, Missouri. He studied literature and languages at Philips Academy, Andover, and Williams College, Williamstown, Massachusetts (1922-23). Instead of completing college, he traveled to Paris in 1926 where he audited courses at the Sorbonne and absorbed himself in the writings of Flaubert and Baudelaire. Returning to New York in 1927, he began to photograph with a vest-pocket camera. Three of his photographs of the Brooklyn Bridge appeared as photogravures in Hart Crane's book *The Bridge* in 1930. The same year he began photographing early New England Victorian houses he exhibited in 1933 at The Museum of Modern Art.

During the Depression, the Resettlement Administration was created when President Franklin D. Roosevelt signed Executive Order 7027 on April 30, 1935. In 1935 Evans was one of the photographers hired by Roy Stryker, chief of the Historical Section, which was absorbed in 1937 as part of the Department of Agriculture, and renamed the Farm Security Administration (FSA). Orchestrated by Stryker, the photographers' mandate was to document the work and living conditions of America's rural poor displaced by economic depression and drought. Evans worked intermittently for the FSA from June 1935 through the summer of 1938. His subjects were rich in expressive content yet unequivocally direct and economical in style. Evans's vision affected the way we now see not only photographs, but billboards, junkyards, postcards, gas stations, colloquial architecture, Main Streets, and the walls of rooms.[2]

His first assignment in June and July 1935 was to photograph the coal mining towns of West Virginia. In this interior of a miner's home located in the Scott's Run area of West Virginia, the basic tenets of Evans's FSA style are already present. The straightforward presentation taken with his 8 x 10-inch view camera unemotionally inventories the spare furnishings of the cardboard-insulated room. In the face of adversity, the occupant – whose moving hand is visible at the left – has taken symbols from the commercial environment to dignify the surroundings. A variant of this subject showing the woman holding a fan is in the FSA collection at the Library of Congress.[3]

During the next several years, subsequent assignments took Evans throughout the Southeast. In the summer of 1936 he lived with Alabama sharecroppers and intimately detailed the people and places. This unused project for *Fortune* magazine was published in 1941 in his celebrated *Let Us Now Praise Famous Men*, with text by James Agee. Winner of a Guggenheim Fellowship in 1940, 1941, and again in 1959, Evans's FSA work and this book represent his most important and influential photographs. In 1938 Evans began to take candid shots with a vest-pocket camera of subway riders and people on the streets. He was a writer for *Time* magazine (1943-45) and writer and photographer for *Fortune* (1945-65), contributing forty portfolios and photographic essays. Retiring from professional photography in 1965, he served as professor of graphic arts at Yale University, New Haven (1964-75), where he died on April 10, 1975.

1. Peter C. Bunnell, "An Introduction to Evans' Work and His Recollections," *Exposure*, 15, No. 1 (Feb. 1977), 17.
2. John Szarkowski, introd. in Walker Evans, *Walker Evans* (New York: The Museum of Modern Art, 1971), p. 17.
3. Jerald C. Maddox, introd. in *Walker Evans: Photographs for the Farm Security Administration, 1935-1938* (New York: De Capo Press, 1973), no. 15, n. pag. Taken in July 1935. The Library of Congress number is LC-USF342-895A.

Dorothea Lange
American, 1895-1965

Once a Missouri farmer, now a migratory farm laborer on the Pacific Coast, California (1936). Gelatin silver print, 20.4 x 19.8 cm on 25.3 x 20.5 cm. Titled with pencil on verso: *Migrant pea pickers in the rain / Calif.*; Stamped in purple on verso: RESETTLEMENT ADMINISTRATION PHOTOGRAPH BY LANGE.

Museum Purchase: Bequest of Adele O. Friedman, by exchange, 1981.151.

Provenance: Janet Lehr, Inc., New York.

Exhibitions: Cincinnati Art Museum, *The Cincinnati Art Museum Photography Collection*, 1981-82.

Born in Hoboken, New Jersey, on May 26, 1895, Dorothea Lange was stricken with polio as a young girl, which left her with a lifelong limp and a heightened compassion for the suffering of others. Deciding at an early age to make photography her career, she apprenticed in Arnold Genthe's New York studio (1915) and studied at Columbia University with the pictorial photographer Clarence H. White (1917-18). Setting out to see the world in 1918, a pickpocket ended her round-the-world trip in San Francisco, where the following year she opened a fashionable portrait studio.

Lange's documentary activity began in the early 1930s when she went into the street to record labor unrest and mushrooming unemployment as the Depression deepened. In 1934 a one-woman exhibition of her street photographs at Willard Van Dyke's Brockhurst Gallery in Oakland captured the attention of a University of California economics professor, Paul S. Taylor. Taylor, whom she later married, hired her to provide photographs for a series of reports on migrant agricultural worker conditions for the California Rural Rehabilitation Administration during 1934 and 1935. The Taylor/Lange photographically illustrated reports established a prototype for documenting conditions for American policy makers and culminated in the nation's first federally sponsored housing project.

The establishment of the Resettlement Administration (RA) in 1935 consolidated the activities of the Rural Rehabilitation Division under its aegis. Roy Stryker, the new head of the RA Historic Section, hired Lange as a photographer-investigator, while Taylor was appointed regional labor advisor. Between 1935 and 1939, Lange made four thousand negatives documenting the plight of agricultural unemployment in twenty-two states for the RA/FSA (Farm Security Administration). She intimately portrayed hungry migrant workers, sharecroppers, and tenant farmers without jobs and homes. Compelled by their fate, she sought not only to ameliorate the social crisis by forcefully presenting the conditions she saw, but she had faith that her photographs would provide action on their behalf.

Along with the famous *Migrant Mother* (1936), this photograph of a desperate and destitute "Okies" couple in their worn jalopy is one of her most memorable images. Their disillusionment with America's agrarian ideal was captured by Lange for the RA files in February 1936. Officially described "Once a Missouri farmer, now a migratory farm laborer on the Pacific Coast. California,"[1] it is occasionally titled "Ditched, stalled, and stranded." As a project photographer for the RA/FSA, Lange did not own the negatives nor did she have control over how the images were cropped or captioned in newspapers, magazines, and exhibitions. In 1938, a significantly cropped version appeared as an illustration in *Land of the Free*, accompanying Archibald MacLeish's poem.[2]

Concentrating on gesture and expression, Lange's unstudied portraits provide a direct and unflinching analysis of the human spirit disillusioned by farm mechanization, natural disaster, and the Depression. Lange's maturation as a photographer coincided with this tragic moment in American history. John Steinbeck studied her photographs in the RA/FSA file while writing his poignant novel, *The Grapes of Wrath* (1939). Lange and Taylor collaborated on *An American Exodus: A Record of Human Erosion* in 1939, interweaving text and photographs. It never was fairly tested on the market because public attention had shifted to the ominous war clouds gathering over Europe.

With the outbreak of World War II, Lange gave up her Guggenheim Fellowship (1941) to continue her migrant work, and photographed evacuated Japanese-Americans from the Pacific Coast for the War Relocation Authority in 1942. She worked for the Office of War Information from 1943 to 1945. After 1945, ill health intermittently interrupted her career for the remainder of her life. Between 1953 and 1954 she did several assignments for *Life*. In the late 1950s and early 1960s she traveled to Asia, Latin America, and the Near East with Taylor. Her work was exhibited in major shows organized by The Museum of Modern Art including *The Family of Man* (1955) and *The Bitter Years* (1962). She died of cancer on October 11, 1965, shortly before a major retrospective of her work at The Museum of Modern Art in 1966.

1. Howard M. Levin and Katherine Northrup, eds., *Dorothea Lange: Farm Security Administration Photographs, 1935-1939* (Glencoe, IL: Text-Fiche Press, 1980), I, p. 132. The Library of Congress number is LC USF34-2470-E.

2. Archibald MacLeish, *Land of the Free* (New York: Harcourt, Brace, 1938), n. pag., no. 2. In addition this image was exhibited in cropped form in Lange's 1966 retrospective exhibition. See George P. Elliott, *Dorothea Lange* (New York: The Museum of Modern Art, 1966), p. 26.

Sir Cecil Walter Hardy Beaton

British, 1904-1980

Gertrude Lawrence, 1937. Gelatin silver print, 24.6 x 19.5 cm on 25.3 x 20.3 cm. Artist's stamp in black on verso: *Beaton*; studio stamp in black with annotations: MODEL (pencil) *Gertrude Lawrence* / DATE OF SITTING (pencil) *10/14/37*; publication stamp in black with annotation: *Am. Vogue* (pencil) *12/15/37* / PAGE / (pencil) *61*; Condé Nast Publication copyright stamp in black.

Centennial Gift of the Fleischmann Foundation in memory of Julius Fleischmann, 1981.155.

Provenance: Condé Nast Publications, Inc., New York; Janet Lehr, Inc., New York.

Exhibitions: Cincinnati Art Museum, *Cincinnati Art Museum Photography Collection*, 1981-82.

Bibliography: Cecil Beaton, "Gertrude Lawrence in 6 Comedy Gestures," American *Vogue*, 15 Dec. 1937, p. 37, illus.

> The dressmaker provides the dress, but the photographer must make the woman in that dress appear in a manner that will give all other women a feeling of covetousness.[1]

Fashion photography is a complex blend of artistry, ideal beauty, artifice, technical facility, and commercial requisites. An extraordinarily talented photographer, painter, writer, and theatrical designer, for over half a century Cecil Beaton contributed to the success of *Vogue* magazine. British, French, and American *Vogue* published his photographs, writings, drawings, designs, and paintings. His reputation as one of the foremost chroniclers of international fashion evolved from his penchant for staging apotheoses. In his later years Beaton wrote:

> In the thirties the fashion photographers came into their own. As one of them, I must confess to having indulged myself in the generally prevailing recklessness of style. My pictures became more and more rococo and surrealist. Society women as well as mannequins were photographed in the most flamboyant Greek-tragedy poses, in ecstatic or highly mystical states. . . . [L]adies of the upper crust were to be seen in *Vogue* photographs fighting their way out of a hat box or breaking through a huge sheet of white paper. . . . Princesses were posed trying frantically to be seen through a plate-glass window that had been daubed with whitewash. . . . Backgrounds were equally exaggerated and often tasteless. . . .[2]

The son of a wealthy timber merchant, Cecil Beaton was born in London on January 14, 1904. During his years at Harrow and St. John's College, Cambridge, his *photophiliac* tendencies and theatrical passion were already in evidence. Hired by *Vogue* as an illustrator in 1928, his society photographs landed him a contract with Condé Nast in 1930. The social elite and high fashion milieu he recorded was for him the stage on which his many-faceted professional activities unfolded.

Impressed in his formative years by early photographers, among them Baron Adolf de Meyer who idealized his subjects with stylish poses and shimmering light effects, Beaton brought to bear his artistic eye for effects of imagery, light, and space. By 1936 a reaction had set in against surfeit romanticism and opulent spectacles, which had been the hallmark of his early style. His 1937 fashion photograph of Gertrude Lawrence (1898-1952), the comedienne of *Susan and God*, in a comic gesture swamped in sable,[3] reflects the distinct shift in mood toward a more constrained realism. Though still stage-managed in expression and pose, his subject is less rarefied. Beaton was one of the earliest illustrators to use actresses as fashion models.

In February 1938, a dispute with the art director of Condé Nast Publications, Dr. Mehemed F. Agha, resulted in the termination of his American contract and a significant reduction in his fashion output. During World War II, Beaton was hired by the Ministry of Information to document war-torn London and Allied action in North Africa and the Far East. These propaganda pictures sharply contrasted with his decorative fashion tableaux. Following the war, Beaton resumed his multifaceted career, continuing his contracts with *Vogue* and as a socially prominent portraitist of eccentrics, celebrities, and British royalty. In the late 1950s and early 1960s, he turned his attention to designing sets and costumes for theater and film as younger fashion photographers made his work appear old-fashioned. His costume designs won Oscars for the film versions of *Gigi* (1958) and *My Fair Lady* (1964). He was knighted for his many cultural achievements in 1972. Beaton died on January 17, 1980, less than a year after photographing the "return to elegance" of Paris couture for French *Vogue*.

1. Cecil Beaton, *Photobiography* (Garden City, NY: Doubleday, 1951), p. 100.
2. Cecil Beaton, *The Glass of Fashion* (London: Weidenfeld & Nicolson, 1954), p. 191, in Philippe Garner, "The Fashion Photography of Cecil Beaton," in *Cecil Beaton: A Retrospective*, ed. David Mellow (Boston: Little, Brown, 1986), p. 73.
3. Cecil Beaton, "Gertrude Lawrence in 6 Comedy Gestures," American *Vogue*, 15 Dec. 1937, p. 61, illus.

Ben Shahn
American, b. Lithuania, 1898-1969

Mr. Virgil Thaxton, Ohio Farmer, near Mechanicsburg, Ohio
(1938). Gelatin silver print, 16.4 x 24.2 cm on 20.6 x 25.3 cm.
Inscribed with pencil on verso: *6467 M4*; stamped in black on
verso: BEN SHAHN / PHOTOGRAPHER / FARM SECURITY
ADMINISTRATION / *formerly from the collection of the Fogg Museum.*

Museum Purchase: Gift of Augusta and Sallie Harbeson, by
exchange, 1981.152.

Provenance: Bernarda B. Shahn; Fogg Art Museum, Harvard
University, Cambridge, MA; Janet Lehr, Inc., New York.

Exhibitions: Cincinnati Art Museum, *The Cincinnati Art Museum
Photography Collection*, 1981-82.

Ben Shahn was born in Kovno, Lithuania, on September 12, 1898.
In 1906 he emigrated to the United States with his family where he
resided in New York and became a naturalized citizen. Between
1913 and 1917, Shahn apprenticed in Heisenberg's Lithography
Shop, New York. To develop his skills as a painter, muralist, and
graphic artist, he attended the Art Students League (1916), New
York University (1919), and the National Academy of Design
(1917-22). In the late 1920s he traveled twice to Europe and North
Africa.

Although he was always interested in photography, it was not
until 1933 when he received a Leica from his brother, in payment
for a bet, that he began to photograph. He learned the rudiments of
his craft from his friend, Walker Evans, with whom he had shared a
flat in New York's Greenwich Village in 1930.

> Now, my knowledge of photography was terribly limited. I
> thought I could ask Walker Evans to show me what to do. . . .
> He said, "Well, it's very easy, Ben. F9 on the sunny side of
> the street. F45 on the shady side of the street. For 1/20th of a
> second hold your camera steady" – and that was all. This was
> the only lesson I ever had. Of course, photography is not so
> much the technical facility as it is the eye and the decision that
> one makes about the moment at which one is going to
> snap. . . .[1]

Between 1934 and 1935, Shahn and the painter Lou Block
collaborated on an uncompleted mural project for the Rikers Island
Penitentiary. To prepare studies for the project, they photographed
extensively on New York's Lower East Side and in prisons. In 1935
Shahn was employed by the Resettlement Administration (later the
Farm Security Administration) for the Special Skills Division to
design posters, pamphlets, and murals. To collect raw data for his
work, he photographed in the South, Kentucky, and West Virginia.
Roy Stryker, who was head of the Historic Section, recalled his
impression of Shahn's work.

> I was taken by Ben's photos because they were so
> compassionate. Ben's were warm. Ben's had the juices of human
> beings and their troubles and all those human things[2]

At Stryker's request he contributed copies to the photography
file and in the summer of 1938 he went on Stryker's payroll to
photograph the harvest in Ohio. Shahn wrote of the assignment:

> It was so completely different from the South and from the
> mine country. It was neat and clean and orderly, and I didn't
> think it had any photographic qualities for me. At first I said,
> "Well, I can't do anything about it." Then one day it sort of
> came to me. I felt it after about two weeks, so I called Roy and I
> said, "I'll take the job." I stayed about six weeks with this, and
> worked just day and night on the scene. It was an entirely
> different thing. In the South or in the mine country, wherever
> you point the camera, there is a picture. But here you had to
> make some choices. . . .[3]

A review of the photographs reveals that Shahn traveled within a
fifty-mile radius of Columbus, the capital, to towns like Ashville,
Circleville, Marysville, Mechanicsburg, Springfield, and Urbana.

> There were nice orderly frame houses, nice orderly roads, and
> so on. . . . Not only was it the actual harvest. I wanted to know
> what they did on Sundays. . . . I used what is called an angle
> finder. . . . The angle finder lets you look off in another direction
> when you focus, so it takes away any self-consciousness people
> have. . . .[4]

Shahn's Ohio photographs capture the integrity of the hard-
working farmers, the fertile yield of the farmland, and the friendly
tranquility of small-town life. Though he was as adept at social
comment with his camera as with his brush, he used the lens to
extract the documentary truth from the particulars of the moment.
This put him in the vanguard of social realism in the 1930s. His
powerful close-up of *Virgil Thaxton*[5] freezes the farmer's expression
during a moment of relaxation, allowing an intimate look into his
stoic, hard-working character. Shahn's inner eye abstracts the forms
providing formal strength to what appears to be a casual snapshot.

Shahn left the Farm Security Administration after his Ohio trip.
He continued to use photographs as reference aids, but he ceased to
use photography as an independent creative medium.

1. Richard Doud, "Interview: Ben Shahn" in John D. Morse, ed., *Ben Shahn*
(New York and Washington: Praeger Publishers, 1972), p. 135.
2. Davis Pratt, *The Photographic Eye of Ben Shahn* (Cambridge, MA: Harvard
Univ. Press, 1975), p. ix.
3. Doud, pp. 136-37.
4. Doud, p. 137.
5. Jerald Maddox, Letter to KS, 29 Aug. 1981. The photograph is titled "Mr.
Virgil Thaxton, Ohio Farmer, near Mechanicsburg, Ohio." The Library of
Congress number is LC-USF33-6467-M4.

Berenice Abbott
American, b. 1898

Consolidated Edison Power House, 666 First Avenue, Manhattan (1938). Gelatin silver print, 23.8 x 17.2 cm on 25.2 x 20.3 cm. Artist's stamp in black on verso: BERENICE ABBOTT / PHOTOGRAPH: Inscribed with pencil: *Consolidated Edison Power House / 666 First Avenue, Man. / 1937 / Berenice Abbott.*

The Albert P. Strietmann Collection, 1977.27.

Provenance: The Halstead 831 Gallery, Birmingham, Michigan.

Exhibitions: Cincinnati Art Museum, *The Cincinnati Art Museum Photography Collection*, 1981–82.

A native of Springfield, Ohio, Berenice Abbott was born on July 17, 1898. She left Ohio State University at the age of twenty to study journalism and later, sculpture in New York. To broaden her experience with sculpture, she went to Paris in 1921 where she studied with Emile Bourdelle and then to the Kunstschule, Berlin, in 1923. Although she had never intended a career as a photographer, upon her return to Paris she became a darkroom assistant for her fellow American expatriate Man Ray.

Striking out on her own in 1926, Abbott opened a portrait studio and photographed many of the Parisian intelligentsia including James Joyce, Jean Cocteau, André Gide, Edna St. Vincent Millay, and Marcel Duchamp. Her portrait of Eugène Atget shortly before his death is the only extant photograph of this important documentary photographer. In 1927 Abbott saved Atget's negatives and prints of the French capital and countryside and promoted his work through exhibitions and publications over the next forty years. Abbott's own portraits received critical acclaim at Jan Slivinsky's avant-garde gallery *Au Sacre du Printemps* in 1926 and were included in the *Film und Foto* exhibition in Stuttgart in 1929.

During a short trip to New York in 1929, she was overwhelmed by the city's pulse and the dynamic changes there. She decided to close her Paris studio and become New York's interpreter. She returned to America before the Crash of 1929. Deflated dollars made portraits an unaffordable luxury, and Abbott sustained herself with freelance magazine assignments and a few portrait commissions. Although she was unable to find outside financial support for the project, her growing body of work was exhibited at the Museum of the City of New York in 1934. This excerpt from her solicitation letter to potential sponsors concisely summarized her ambitious project.

My project is to record by camera the fast disappearing vestiges of early New York which, as time goes on, increase in interest and historical value. Thus I hope to present a coherent idea of this great uncrystallized city, the truest phenomenon of the twentieth century which, in its present form, combines so dramatically the old with the evolving new.[1]

In 1935 her "Changing New York" project was finally sponsored by the Federal Art Project of the Works Progress Administration. She focused primarily on the borough of Manhattan and secondarily on Brooklyn and the Bronx. With her 8 x 10-inch Century Universal view camera she inventoried the diversity and richness of the city's streets and characterized its neighborhoods. Her precise, systematic, and detailed views reflected the changing patterns of urban society as new means of commerce, mass transit, and symbols of corporate identity were juxtaposed with tenements and historic landmarks. She faithfully recorded the crucial information on the verso of each photograph.

On November 9, 1938,[2] she photographed the *Consolidated Edison Power House*. A high percentage of her images was made in the morning or afternoon when the light was stronger. The position she selected allowed her to backlight the building, utilizing the coal shuttle system and the shadows as compositional devices, while silhouetting the billowing steam. The automobiles in the foreground establish the structure's massive scale. This was one of the last photographs that she took for the WPA, which eliminated her support staff early in 1939. That same year she culminated the documentary project when she published her first book, *Changing New York*, with text by the critic Elizabeth McCausland.

During the 1940s and 1950s, Abbott shifted her attention to photographs demonstrating physical and chemical reactions as well as inventing and developing photographic apparatus. After twenty-three years of teaching at the New School of Social Research, she resigned in 1958 to work for the Physical Science Study Committee of Educational Services where she prepared illustrations for a new high school physics text. Among the books she herself published were *A Guide of Better Photography* (1941, revised 1953), *The View Camera Made Simple* (1948), and *Greenwich Village Today and Yesterday* (1949). In 1953 Abbott photographed the full length of U. S. Route 1 from Florida to Maine, where she moved in 1968. Her work has been the subject of two recent books, *Berenice Abbott: Photographs* (1970) and *Berenice Abbott: American Photographer* (1982).

1. Michael G. Sundell, "Berenice Abbott's Work in the 1930s," *Prospects: An Annual of American Cultural Studies*, 5 (1980), p. 269.
2. Terry Ariano, Letter to KS, 15 July 1987.

Clarence John Laughlin

American, 1905-1985

Neo-Classic Elegy No. 2 (Belle Grove Plantation), 1940.
Gelatin silver print 1979, 34.5 x 26.8 cm on mount 43.2 x 35.6 cm.
Inscribed on mount with black ballpoint lower left to lower right:
*Neo-Classic Elegy: 1939 (Belle Grove Plantation) Clarence John
Laughlin*; Artist's copyright stamp in purple on verso: *Print No. 53*
(black ballpoint) / *Photograph copyright 1948 & 1963* (black ballpoint)
by / *C. J. Laughlin* / *All Reproduction Rights Reserved*; inscribed with
pen and black ink: *Print made by* / *C.J.L. on 1/30/79. Farewell to the
Past (#2)* / *Resurgence of the Shell* / *Neo-Classic Elegy.*

Museum Purchase: Gift of James Reis, by exchange, 1981.139.

Provenance: Robert Miller Gallery, Inc., New York.

Exhibitions: Cincinnati Art Museum, *The Cincinnati Art Museum
Photography Collection*, 1981-82.

> Poetic concept intended to tie in with the hyper-romantic feeling
> of the great house known as Belle Grove – which, though based
> on Greek Revival forms – had, nevertheless, so little Classical
> coldness. The figure is seen near the fallen-in flooring of the
> front verandah. Note the size of the huge cypress beam. Note,
> also, the massive plastered brick columns, and delicate details of
> the gigantic 12' [*sic*] high hand-carved cypress Corinthian
> capitals – which were gilded, originally. The figure helps to
> accentuate the feeling of ruin-haunted magnificence, of beings
> and things lost in time. The shell has been used to concentrate
> the Neo-Classic feeling everywhere visible – while the black-
> draped figure of the model suggests the malevolent Fate which
> pursued this great house to its end.[1]

John Clarence Laughlin's prose eloquently complements his
vertiginous image. Belle Grove, the center of a nineteenth-century
American sugar cane empire, was the largest plantation house built
along the Mississippi in Louisiana. Upon its completion in 1857, it
represented the efflorescence of architectural achievement which
would within a century succumb to the ravages of impoverished
neglect, heat and dampness, flood and fire. Laughlin visited this
majestic classic revival structure, stripped of its rosy purple *faux*
marble, in 1939-40[2] and between 1945 and 1953 to preserve its
poetic beauty and mourn its tragic decay and destruction.

In many of his photographs he integrated evocative figures.[3]
They seem to represent states of mind, and produce disturbing and
haunting "Gothic" images amid the declining architecture.
Laughlin has described the symbolism and subjectivity behind his
images.

> One of my basic feelings is that the mind, and the heart
> alike . . . must be dedicated to the glory, the magic, and the
> mystery of light. The mystery of time, the magic of light, the
> enigma of reality – and their interrelationships – are my constant
> themes and preoccupations. . . .[4]

A native of Louisiana, Laughlin was born in Lake Charles on
August 14, 1905. He spent the early part of his life on a sugar cane
plantation near New Iberia. He moved to New Orleans with his
parents in 1910. After his father's death in 1918, he worked in several
banks to support his family between 1924 and 1935. During his
twenties, under the influence of the French symbolists, he wrote
prose poems and gothic fiction.

Around 1930, he began to photograph, inspired by the work of
Alfred Stieglitz, Paul Strand, and Edward Weston. His first one-
man exhibition was at the Isaac Delgado Museum (now the New
Orleans Museum of Art) in 1936. Four years later, Julian Levy
exhibited his photographs of old New Orleans along with those of
Eugène Atget at his New York gallery. Between 1936 and 1940 he
worked for the United States Engineer Corps as a civil service
photographer of levee construction along the Mississippi. During
World War II he served in the United States Army as part of the
Signal Corps Photographic Unit, New York (1942-43), from which
he was requisitioned by the Office of Strategic Services in
Washington, D.C. (1943-46). Upon his discharge, he returned to
New Orleans to work as a freelance architectural photographer. His
book, *Ghosts Along the Mississippi*, was published in 1948 and was
followed by an exhibition with the same title. In the years that
followed, he designed touring exhibitions of his work: *Sculpture
Seen Anew: The Bronze Age to Brancusi* (1957), *Old Milwaukee
Rediscovered* (1965), *Phoenix Re-arisen: A Vision of Victorian Chicago*
(1967). In 1973, twelve years before his death, the Philadelphia
Museum of Art organized a major retrospective of his work, *The
Transforming Eye.*

1. Clarence John Laughlin, Letter to KS, 16 Nov. 1981. The capitals are six feet high.
2. John H. Lawrence, Letter to KS, 18 July 1987. According to Lawrence, Laughlin's
ID card at The Historic New Orleans Collection gives the date of this exposure as 19
May 1940. It was one of 116 negatives he made there. He classed it as group M.
3. The model was Elaine Duke, one of several he used.
4. Clarence John Laughlin, *Clarence John Laughlin: The Personal Eye* (Millerton, NY:
Aperture, 1973), p. 13.

Edward Henry Weston
American, 1886-1958

Cincinnati, 1941. Gelatin silver print, 19.2 x 24.4 cm on mount 35.3 x 39.3 cm. Signed and dated with pencil on mount in lower right: *E W 1941*; inscribed with pencil on verso: *Cincinnati / Edward Weston 1941*.

The Albert P. Strietmann Collection, 1984.144.

Provenance: Fraenkel Gallery, San Francisco.

April 28, 1941

I have thought over the subject pro and con, questioned "am I the one to do this?" This I should tell you; there will be no attempt to "illustrate," no symbolism except perhaps in a very broad sense, no effort to recapture Whitman's day. The reproductions, only 54, will have no titles, no captions. This leaves me great freedom – I can use anything from an airplane to a longshoreman. I do believe, with Guggenheim experience, I can and will do the best work of my life. Of course I will never please everyone with *my* America – wouldn't try to.[1]

In 1937 Edward Weston was the first photographer to be awarded a Guggenheim Fellowship (renewed in 1938). Freed for the first time from the constraints of earning a living by his commercial portrait photography, he traveled throughout the West, primarily in California, taking fifteen hundred photographs over two years. At a moment when new objectivity was beginning to ossify, Weston turned away from a preoccupation with reductive abstraction to tightly composed close-ups of human and natural forms, and unposed portraits. Andy Grundberg has written that after 1937, Weston's late modernist work was "marked by an increasingly open style involved with complex spatial organization and pictorial depth, while conveying intimations of ruin, decay and death."[2]

It was probably Merle Armitage, the California typographer and designer who published Weston's first book *The Art of Edward Weston* in 1932, who brought Weston's work to the attention of The Limited Editions Club of New York. According to its November 1942 newsletter, they approached Weston

> to make photographs of American faces and American places which, when printed in an edition of *Leaves of Grass*, would form for the reader a clear, real reproduction of the America which Walt Whitman celebrated in his poems.[3]

Although Weston was cautious about accepting a commercial assignment which might compromise his artistic integrity, he finally agreed to undertake the project on the condition that he could trek cross-country photographing subjects which appealed to him. He saw this project as a natural extension of his Guggenheim work. With his wife Charis as driver, Weston logged twenty-five thousand miles through twenty-four states in ten months. Challenged to explore new terrain, he crossed Texas to Louisiana, traveled through Cincinnati to Pennsylvania, New York, and West again. The trip was shortened by the bombing of Pearl Harbor which forced him to return home. He submitted seventy-two photographs of which forty-nine were used. Contrary to his agreement Walt Whitman's verses appeared under each.

The Cincinnati view which appeared in *Leaves of Grass* featured the new commercial high rise city center, rather than this variant taken from Mt. Auburn, which pictures the heart of old Cincinnati. Weston used an 8 x 10-inch view camera to get the greatest possible depth of field and resolution of detail. Near the horizon, it is possible to pick out nineteenth-century landmarks, including the towers of Issac M. Wise Temple, St. Peter in Chains, City Hall, and Music Hall, bracketed between railroad bridges across the Ohio River. By raising the horizon, Weston concentrated not on the elegiac vista, but on the microcosm of sunstruck domestic rooftops. After 1937 his style reflected a newly relaxed and inclusive realism, inseparable from his expanded range of subjects embracing urban civilization and rural landscape. It points directly to the socially conscious but stylistically restrained "New Topographics" landscape photography of the late 1970s of such photographers as Robert Adams and Lewis Baltz.

Edward Henry Weston was born on March 24, 1886, in Highland Park, Illinois. At the age of sixteen he received a Kodak Bull's-Eye 2 view camera from his father. In 1906, he visited his sister May Seaman in California, and decided to settle. Weston began his photographic career as an itinerant portraitist. Between 1908 and 1911 he attended the Illinois College of Photography before launching his portrait studio in Tropico (now Glendale), California. There he produced work in the soft-focus pictorialist mode which enjoyed both commercial and artistic success from 1911 to 1922.

Dissatisfied with the direction of his work, about 1920 he began to experiment with semi-abstract, hard-edged images. A major turning point in his style came in 1922 when he photographed the ARMCO steel mill in Middletown, Ohio, while visiting his sister. He continued East to New York where he met Alfred Stieglitz, Paul Strand, and Charles Sheeler, who reaffirmed Weston's inclination to "straight" photography. Between 1923 and 1926 he lived in Mexico and contributed to the Mexican Renaissance. When he finally settled in Carmel, California, in 1929, he simplified his life and technique to the point of asceticism. He produced the crisp, rich 8 x 10-inch contact prints from tightly organized, unretouched negatives of extreme close-ups and nudes in motion for which he is today best known. In 1948, crippled by Parkinson's disease, he took his last photograph at Point Lobos which had been a constant source of inspiration for almost two decades. This view of Cincinnati was one of approximately eight hundred negatives selected by Weston as representative of his life's work.[4] A limited number of project prints were printed from these negatives by his sons Brett and Cole Weston under his supervision in the early 1950s. Weston died on June 1, 1958.

1. Cited in *Edward Weston Photographer: The Flame of Recognition*, ed. Nancy Newhall (New York: Grossman Publishers, 1965), p. 64.
2. Andy Grundberg, "Edward Weston's Late Landscapes," in *EW:100: Centennial Essays in Honor of Edward Weston*, eds. Peter C. Bunnell and David Featherstone (Carmel, CA: The Friends of Photography, 1986), p. 93.
3. The Limited Editions Club Newsletter, Nov. 1942, cited in Richard Ehrlich, intro., *Edward Weston: Leaves of Grass by Walt Whitman* (New York: Paddington Press, 1976), p. v.
4. Larry Fong, Letter to KS, 10 Oct. 1986.

Barbara Morgan

American, b. 1900

Merce Cunningham – Root of the Unfocus, 1944. Gelatin silver print 1976 from planned double image negative, 35.5 x 46.7 cm on mount 55.9 x 68.5 cm. Signed and dated on mount with pencil lower right: *Barbara Morgan – 1944*; titled lower left: *Merce Cunningham – Root of the Unfocus*; titled and signed with black ballpoint on verso: *Merce Cunningham – Root of the* UNFOCUS *– 1944 / Barbara Morgan*; artist's copyright stamp in black.

The Albert P. Strietmann Collection, 1980.102.

Provenance: Carl Solway Gallery, Cincinnati.

Exhibitions: Cincinnati Art Museum, *The Cincinnati Art Museum Photography Collection*, 1981-82.

Born in Buffalo, Kansas, on July 8, 1900, Barbara Brooks Johnson was raised on a peach ranch in Southern California. As a student at the University of California at Los Angeles (UCLA) between 1919 and 1923, she studied painting and printmaking. Two years later, she married the writer and photographer Willard Morgan and joined the art faculty at UCLA, teaching design, landscape, and woodcut. In 1930 they moved to New York where she established a studio for painting and printmaking. The birth of her second son in 1935 and the responsibilities for a growing family made painting impossible, so Morgan turned to photography as her primary means of visual expression because it could be done at night.

The work she began in 1935 with dance and photomontage represented a shift in prewar American photography. Her dance photographs of José Limon, Valerie Bettis, Merce Cunningham, and Martha Graham bridged the gap between the experimental freedom of the European avant-garde and austere straight photography nurtured in this country. Using a 4 x 5-inch speed graphic accompanied by artificial lighting and synchroflash, Morgan sought to arrest the energy of imagination and movement in 1/10 to 1/1000 of a second. She attended performances and rehearsals so that she knew the dance story and content and was able to anticipate every gesture and expression of the face and body. She could then visualize memorable peaks of emotional intensity which would be reenacted in her studio or in a non-commercial theater. In 1941 a number of her photographs of Graham were published in *Martha Graham: Sixteen Dances in Photographs*. It received the American Institute of Graphic Art Trade Book Clinic Award.

This 1944 photograph of the young Merce Cunningham (b. 1919) in *Root of the Unfocus* was a pre-planned double-exposed negative. Cunningham was a member of the Martha Graham Company from 1939 to 1945 where he created roles in *Every Soul is a Circus* (1939), *El Penitente* (1940), and *Appalachian Spring* (1944) before founding his own company in 1952. With her flash Morgan arrested two instants in which the feet, hands, and gesture contribute to the physical and psychic climax. Not only did Morgan record what are now considered classical images of dance, but she transcended mere documentation of the art of dance to create images of great emotional intensity.

Although Morgan's dance photographs are her best-known work, she developed a multiplicity of styles. Her interest in photomontage was concurrent with her images of children and nature studies when she shifted from painting to photography in 1935. Peter Bunnell has pointed out that her use of photomontage

> represents an exceptionally early articulation of this technique by an American. . . . [H]er pictures reflect an urban lifestyle which lends itself to this fractured, layered structuring – strata of people, place, mood, and meaning. . . .[1]

Today, Morgan still uses various forms of photomontage to express her concern for mankind in the face of increasingly complex world problems. She hopes to stimulate positive changes. She has had numerous one-woman and group exhibitions since her photographic debut in 1938.

1. Peter Bunnell, "Introduction," in *Barbara Morgan* (Hastings-on-Hudson, NY: Morgan and Morgan, 1972), p. 10.

Ralph Steiner
American, 1899-1986

Gypsy Rose Lee and Girls (ca. 1944). Gelatin silver print, 26.7 x 34.4 cm on 27.7 x 35.5 cm. Inscribed with black felt tip pen on verso: *Vintage Print Ralph Steiner – neg. & print c. 1944 #36.*

Gift of Thomas R. and Donna L. Schiff, 1986.122.

Provenance: Ralph Steiner, Thetford Hill, VT (purchased from the artist in 1982).

Gypsy Rose Lee (Rose Louise Hovich, 1914-1970) was the queen of American burlesque. For this tongue-in-cheek promotional photograph, Ralph Steiner took the strip-tease artist and her girls to a country road in the Bronx, where they posed with luggage in front of a Rolls Royce.

> The photograph was fun to do, but serious for Gypsy – she had to wear a costume weighing seventy pounds on a hot day, and it took her two solid hours to make up. But she knew the value of publicity and was willing to invest in it. Since Gypsy's acts all kidded sex, I could kid it in my stage setting and direction.[1]

Ralph Steiner had a long career in professional photography and documentary film. Born in Cleveland, Ohio, on February 8, 1899, Steiner began taking pictures with a Premo camera in 1911. Although he enrolled in Dartmouth College in 1917 to study chemical engineering, after his graduation in 1921 he seriously pursued his passion for photography. Steiner was one of the students who studied at the Clarence H. White School of Photography in New York. He was quick to recognize the new aesthetic of straight photography. He developed a facility for handling the modernist idiom in both his personal and commercial work. Throughout his career, he alternated between periods of earning money by doing advertising, public relations, and editorial photography, and periods of making photographs for himself. Beginning in 1929, he added filmmaking to his interests.

In the early 1920s, his gentle humor appeared in photographs of billboards, posters, and windows relentlessly admonishing city inhabitants to purchase, gawk, and consume. Walker Evans has acknowledged Steiner's early influence on his work. Although Steiner took his magazine and advertising assignments in a precisionist mode with precise geometrical forms and crisp clean lines, he could not pass up an opportunity to infuse his work with satire. He plays with the idea of "curves ahead" in *Gypsy Rose Lee and Girls*. In the late 1940s at the invitation of Evans, he made portraits for *Fortune* magazine of corporation presidents doing such things as riding a donkey or driving a fork lift.

Steiner made over thirty films in his career. One of his early experimental films, *H₂O*, is considered to be the second 'art' film made in the United States after Strand and Sheeler's *Mannahatta*. It won the Photoplay Award in 1929. He was co-cameraman in 1935 with Paul Strand on Pare Lorentz's film, *The Plow that Broke the Plains*. Three years later, with Willard Van Dyke, he founded American Documentary Films, Inc., for the American Institute of City Planners. Using music by Aaron Copland, they directed and filmed *The City*, which was shown at the New York World's Fair in 1939. From 1939 to 1941 he was photography editor for *PM*, an experimental daily. His interest in film led him to Hollywood in the 1940s where he worked for MGM and later RKO studios. By the 1960s he was able to devote himself to turning out art films.

Because of his alternation between filmmaking and photography, his photographs have not received continuous exposure. Steiner's work did appear in the landmark 1929 *Film und Foto* international exhibition in Stuttgart. Julien Levy included his photographs in gallery shows in 1931 and 1932. In addition, his work was shown at The Museum of Modern Art, New York, in *Photography 1839-1937* (1937), *Art in Our Time* (1939), and *Photo Eye of the 20's* (1969). Since 1970 his photographs have been included in major exhibitions including *Photography in America* (1974), *Photographs from the Julien Levy Collection, Starting with Atget* (1976) and *Photography Rediscovered: American Photographs 1900-1930* (1979). In 1978 Steiner published his autobiography, *Ralph Steiner: A Point of View*. He died on July 13, 1986.

1. Ralph Steiner, *Ralph Steiner: A Point of View* (Middletown, CT: Wesleyan Univ. Press, 1978), p.22.

Arnold Newman

American, b. 1918

Joan Miró, N.Y.C., 1947. Gelatin silver print torn with stencil, 18.8 x 34.6 cm irregular on mount 40.5 x 50.8 cm. Inscribed with pencil lower right: *Joan Miro NYC 1947/ © Arnold Newman.*

Museum Purchase, 1975.46.

Provenance: Arnold Newman, New York.

Exhibitions: Cincinnati Art Museum, *Cincinnati Art Museum Photography Collection,* 1981-82.

Bibliography: Newman, Arnold. *One Mind's Eye: The Portraits and Other Photographs of Arnold Newman.* Boston: Goldine, 1974, illus. pl. 37.

Arnold Newman has written:

> A preoccupation with abstraction, combined with an interest in the documentation of people in their natural surroundings, was the basis upon which I built my approach to portraiture. The portrait of a personality must be as complete as we can make it. The physical image of the subject and the personality traits that image reflects are the most important aspect, but alone they are not enough. . . . We must also show the subject's relationship to his world either by fact or by graphic symbolism. The photographer's visual approach must weld these ideas into an organic whole, and the photographic image produced must create an atmosphere which reflects our impressions of the whole.[1]

As photographer of the politicians, emperors, scientists, musicians, and artists of the last five decades, Arnold Newman has assembled an encyclopedic index of prominent twentieth-century figures. Unlike the professional portraitists of the nineteenth century and early twentieth century, Newman transports his studio to the subject. His portraits are distinguished by his insistence on integrating objects symbolic of the vocation or interests of his sitters into richly orchestrated representations. He has been particularly interested in the contemporary artists whose vision shaped modernism and beyond.

In the 1940s, the war in Europe shifted the center of the art world to America where many famous Europeans took refuge, introducing American audiences to avant garde movements. Thus it is not surprising that in 1947 Thomas Emery's Sons of Cincinnati commissioned the Spanish painter, Joan Miró (1893-1983), to execute a mural to decorate one wall of the Gourmet Room of the Terrace Plaza Hotel (now Terrace Hilton) then under construction. The thirty-one-foot-long painting was executed in New York in Carl Holty's studio on East 119th Street.

Newman recalled that he first photographed Miró on June 27, 1947, in Stanley William Hayter's Greenwich Village studio. In September he made a second series of photographs of Miro in Carl Holty's studio on the upper East side. This, again, was for myself. . . . When I arrived at Holty's loft I found a large hole had been knocked out of one of the plasterboard dividing walls. It seemed a movie company had been doing a documentary on the painting of the mural and had made the hole in order to shoot a scene. Its shape and location interested me. . . . While shooting, Miro gestured with his hand and I got him to do it again for this shot.[2]

The painting, the largest ever executed by Miró, and now in the Cincinnati Art Museum, literally dwarfs the artist. His playfully extended arm points out the broad gestures needed to paint the flat, humorous, biomorphic shapes associated with organic surrealism. Newman had first explored collage in the early 1940s as a means of expanding the possibilities of his portraits. It was only natural to use this in connection with an artist who likewise used this technique. In essence, the portrait demonstrates Newman's skill in interpreting Miró and rendering not only a likeness but a symbolic distillation of the artist's inner character. Newman last photographed Miró at Palma, Mallorca, in 1979.

Newman was born in New York City on March 3, 1918. Demonstrating an early aptitude for art, he attended the University of Miami in Florida on a scholarship. In 1938, financially unable to continue school, he accepted a job in a Philadelphia portrait studio. He continued to work for commercial portrait studios until 1941 when he freelanced in New York. Between 1942 and 1946 he owned a successful portrait studio in Miami Beach, Florida. In 1946 he finally established his own studio in New York City. The Philadelphia Museum of Art gave him his first one-man show *Artists Look Like This* in 1945-46. He immediately began receiving lucrative assignments from *Life, Harper's Bazaar, Fortune,* and other publications. His work has been the subject of a number of books including *Bravo Stravinsky* (1967), *One Mind's Eye* (1974), *The Great British* (1979), and most recently *Arnold Newman: Five Decades* (1986), which accompanies a major traveling retrospective. Among his many awards are the Photokina Award, Cologne (1951), a Gold Medal at the Fourth Biennale Internazionale Della Fotografi, Venice (1963), and Life Achievement Award from the American Society of Magazine Photographers (1975) of which he has long been an active member.

1. Robert Sobieszek, "Introduction," in *One Mind's Eye: The Portraits and Other Photographs of Arnold Newman* (Boston: Goldine, 1974), p. vii.
2. Arnold Newman, Letter to KS, 24 Dec. 1986.

Gjon Mili

American, b. Albania, 1904-1984

Steinberg posing during recess from work on his mural for the Terrace Plaza Hotel in Cincinnati (1947). Gelatin silver print, 34.2 x 26.9 cm on 35.3 x 27.9 cm. Signed with pencil on verso: *Gjon Mili*.

Museum Purchase: Gift of Mary Hanna, by exchange, 1981.167.

Provenance: Gjon Mili, New York.

Exhibitions: Cincinnati Art Museum, *The Cincinnati Art Museum Photography Collection*, 1981-82.

Gjon Mili turned photojournalist in 1937 at a time when the photograph was receiving parity with the written word. He pioneered the use of the then-experimental strobe light for stop-action photography. Born in Albania on November 28, 1904, he emigrated to the United States at the age of nineteen. In 1927 he graduated with a degree in electrical engineering from the Massachusetts Institute of Technology. His route to prominence was circuitous. For ten years he worked as a lighting research engineer at Westinghouse Electric Company where he improved tungsten filament designs for photographic lamps and lighting for color photography. During this period he met and worked with Dr. Harold Edgerton, the developer of the electronic flash and stroboscope.

During the late 1930s, Mili used this new technology to expand the visible limits of motion in still photographs. Although throughout his career he maintained his freelance status, in 1938 he began a lifelong association with *Life*. He produced photo-essays on dancers and athletes, and musical and theatrical performances, all using the electronic flash and stroboscope. His initial work was done in his new second floor studio at 6 East 23rd Street (the American Art Gallery Building) which had seven thousand square feet of floor space and a high ceiling with an extended skylight thirty-three feet high. This studio became his laboratory. It accommodated subjects in motion and permitted an exceptionally high backdrop for back lighting and low camera angles.

In 1947 Saul Steinberg was commissioned by Thomas Emery's Sons of Cincinnati to paint his first large-scale mural for the Terrace Plaza Hotel in Cincinnati. Steinberg required an inexpensive space to paint the large scale canvases. He asked Mili for use of his studio space.[1] This photograph captures a whimsical moment when Steinberg donned top hat and false nose glasses during a painting recess before a section of his portrait of the life and times of Cincinnati. In 1965, when the hotel was sold, the mural (which was reserved from the sale) was given to the Cincinnati Art Museum.

Steinberg was just one of the numerous famous and infamous personages Mili photographed. He photographed the greats of jazzdom including Duke Ellington and Billie Holiday. The dancers who passed before his camera range from the doyenne of dance, Martha Graham, to Lindy Hop dancers Willa Mae Richer and Leon James. Wherever he went – to the Riviera to photograph Picasso, to Prades for Casals, or to Hollywood for Sinatra – he caught the flash of personality of artists, celebrities, musicians, and politicians. On the occasion of Mili's 1946 exhibition at the Paris Galerie, Paris, Jean-Paul Sartre wrote:

> Before I met Mili I had been familiar only with those thin-blooded photographers who take pictures out of a kind of resentment. . . . Mili is without resentment: he likes everything. . . . For him there are as many ways of being photographed as there are people. If he makes you a part of his collection . . . he will have observed you, he will know you through and through.[2]

In 1980, four years before his death, the International Center of Photography in New York held the first major retrospective of his work simultaneously with the publication of *Gjon Mili: Photographs and Recollections*.

1. Telephone interview with Gjon Mili, by KS, May 1981.
2. Gjon Mili, *Gjon Mili: Photographs and Recollections* (Boston: New York Graphic Society, 1980), p. 8.

John Vachon

American, 1914-1975

Allentown, Pennsylvania (1947). Gelatin silver print, 18.8 x 19.4 cm. Signed with pen and brown ink on verso: *Vachon*; inscribed with pen and black ink: *Allentown, PA / 53976*; with pencil: *53976*.

Museum Purchase: Gift of Mrs. R. M. W. Taylor, by exchange, 1981.153.

Provenance: Janet Lehr, Inc., New York.

Exhibitions: Cincinnati Art Museum, *The Cincinnati Art Museum Photography Collection*, 1981-82.

With the shift from a Depression-era to a war-oriented economy, the federal government relinquished its role as a sponsor of unemployed artists through programs such as the Resettlement Administration/Farm Security Administration (RA/FSA) which was transferred to the Office of War Information (OWI). Instead of documenting migrants and sharecroppers in rural and small town America, Roy Stryker at OWI was charged with depicting shipyards, steel mills, and aircraft plants. Stryker left the government in October 1943 to oversee the Standard Oil Company of New Jersey photographic project. This public relations effort, the largest photographic project next to the FSA, heralded private enterprise's new role of utilizing the talents of artists. While the popular press covered the cataclysmic world events of the 1940s – the war, the atomic bomb, Nazi atrocities, America's revitalized economy – Stryker directed a team of photographers in creating a photographic archive of the day-to-day life of ordinary Americans on the home front whose existences were directly or tangentially affected by the production or marketing of petroleum products.

Assignments were concentrated in the company's largest oil-producing, refining, and consuming states: Texas, Louisiana, Oklahoma, Montana, Wyoming, New York, New Jersey, Pennsylvania, and parts of New England. Stryker was allowed an unprecedented degree of aesthetic and interpretive freedom. His project photographers were given license to document every conceivable way that oil permeated the fabric of daily life. Among the photographers who worked for Stryker between 1943 and 1950 were Russell Lee, Gordon Parks, Todd Webb, and John Vachon.

Vachon was the first photographer hired by Stryker. Born in St. Paul, Minnesota, on May 19, 1914, he was hired by Stryker for the Historic Section of the RA/FSA as an assistant messenger with responsibilities to label, stamp, and file the work of such project photographers as Walker Evans, Ben Shahn, Arthur Rothstein, and Dorothea Lange. Although he was not officially classified as a photographer until 1940, as early as 1937 Vachon began to contribute works to the photographic file. He visited Cincinnati in October 1938 and documented the urban resettlement in nearby Greenhills. In 1941 Stryker sent him to the small towns of the Great Plains in Dakota and Montana, where he made an extraordinary series of near-abstract photographs of grain elevators and railroad cars. Shortly after Stryker's departure from the OWI, Vachon joined him at Standard Oil. Drafted into the army, Vachon's tenure was interrupted until the end of the war. Upon his return, Stryker sent him to Venezuela (1945-47) to record the lives of workers employed by Jersey Standard's affiliate Creole Petroleum Corporation. In the fall of 1947 he traveled through West Virginia and Pennsylvania. In December, he arrived in Allentown, a major manufacturer of trucks and gas-generating equipment.

This view of rowhouse front porches is one of several he made.[1] The rushing perspective emphasized by the heavy shadow along the continuous façade directs attention through the diminishing squares to the distant square of light. This stark and beautiful image exemplifies Vachon's desire to record images of what pleased or astonished his eye and share them with others. This subject did not meet Standard Oil's project requirements so the negative was destroyed.[2]

Lured away by former FSA photographer Arthur Rothstein, Vachon became a staff photographer for *Look* magazine from 1948 until its demise in 1971. In 1973, two years before his death, he received a Guggenheim Fellowship to record the desolate and frozen landscape of North Dakota in winter.

1. There is another view of the rowhouse porches (neg. no. 53974) illustrated in Steven W. Plattner, *Roy Stryker: U.S.A., 1943-1950* (Austin: Univ. of Texas Press, 1983), p. 34, no. 10.
2. James C. Anderson, Letter to KS, 14 July 1987.

Vilem Kriz

American, b. Czechoslovakia, 1921

Samurai, 1948. From *Visions of the Times*. Toned gelatin silver print, 34.0 x 26.3 cm on 35.5 x 27.7 cm. Signed and dated with pen and black ink upper right: *V Kriz 48*; artist's stamp in green on verso; PHOTO: VILEM KRIZ / ORIGINAL PRINT / V KRIZ / © COPYRIGHT 1948 VILEM KRIZ..

The Albert P. Strietmann Collection, 1979.14.

Provenance: Vilem Kriz, Berkeley.

Exhibitions: Cincinnati Art Museum, *The Cincinnati Art Museum Photography Collection*, 1981–82.

Vilem Kriz has always been inclined towards romanticism, and a nostalgia for the past.

> I am interested in deja vu. I am interested in recapturing or recreating images in the present which have occurred to me in the past, either in dreams or as fragments of waking experience, or a combination of both. My images always have their source in the past.[1]

Born Vilém Kříž in Prague, Czechoslovakia, on October 4, 1921, Kriz inherited an appreciation for the charm and mystery of that ancient city. He learned to photograph before he learned to write. Between 1940 and 1946 he studied with Jaromír Funke, Josef Ehm, and František Drtikol at the State School of Graphic Art, Prague. In 1945 he served as press photographer and reporter in Prague before becoming a foreign correspondent for Czech newspapers in Paris.

In 1948 Kriz became an artist-in-exile when political upheavals plagued Czechoslovakia. In Paris's post-war artistic community, he found friends who shared his inclinations to explore surrealist ideas. One of those who encouraged and inspired Kriz's vision was the poet Jean Cocteau, who wrote a preface for his series of photographs entitled *Vision of the Times*:

> One is always surprised by the mystery which gives personality to a camera. It would be too simple to explain it merely as the angle of focus or the photographer's manner of seeing. There is something else, more or less inexplicable, which personalizes a lens and transforms it into an eye. The camera seems to become a part of the photographer, to extend him, to give him, somehow, a new organ.
>
> Vilem Kriz combines noble ruins with those of our Flea Market. He proves how intensely ruins confer grandeur to objects and presents them to us, captured at the vivid moment of death and wearing the grimace of the cadavers at the Museum of Pompeii, sculptured by anguish, lava and ashes. . . .
>
> Above all, I congratulate Vilem Kriz for having breathed into his camera a heart and a soul.[2]

Conceived between 1948 and 1949 as a parable on the war and the resulting human conditions, *Vision of the Times* was never published. Kriz used a variety of techniques, including close-ups, montage, and solarization, to express his intuitive perception of the symbolism of found objects. This hauntingly beautiful image exemplifies Kriz's surrealist spirit. Without violence or shock he reveals a new reality with its own poetic logic. The antique armor, symbolizing an impotent present chained in the past and incapable of fighting, assumes an importance beyond the European conflict.

In 1952 Kriz emigrated to the United States and became a citizen in 1958. During those years he settled in Berkeley, California, where he freelanced. He worked in New York for three years in the photography department of the Metropolitan Museum of Art, then returned to the Bay Area where he taught at various schools. Since 1974 he has been professor of photography at the California College of Art and Crafts in Oakland. After a barren period, Kriz's recent photographs remain rooted in a surrealist sensibility. Objects assembled in his Berkeley backyard have become the raw material for his photographs. Over the years his technique has undergone little change. He still uses a 9 x 12-cm Linhof camera received as a gift from his father in 1935. His Dagor lenses are without shutters. Exposures are made by removing and replacing the lens cap. Using chemical formulas he developed while still in Prague, he tones each one of his prints individually.

1. Cited in David Featherstone, *Vilem Kriz Photographs (Untitled 19)* (Carmel, CA: The Friends of Photography, 1979), p. 8.
2. Featherstone, pp. 9–10.

Harry Callahan
American, b. 1912

Eleanor, Chicago (1948). Gelatin silver print, 19.3 x 24.3 cm on 20.3 x 25.2 cm. Signed with stylus in margin lower right: *Harry Callahan*; numbered with pencil on verso: *S-97 EM 15*.

The Albert P. Strietmann Collection, 1980.92.

Provenance: Edwynn Houk Gallery, Ann Arbor.

Exhibitions: Cincinnati Art Museum, *The Cincinnati Art Museum Photography Collection*, 1981-82.

James Alinder has written:

> Eleanor does not conform to any stereotype of female beauty. She is a real woman who ages, becomes a mother, and is always beautiful. . . . There is a warm human energy that radiates from these images. Through them we see a couple expressing the quiet intensity of their harmonious and lasting relationship. . . . They reveal the mystery, the beauty, and the force of love.[1]

Harry Callahan was born on October 22, 1912, in Detroit, Michigan. During the early 1930s, he briefly studied engineering at Michigan State College, then joined the Accounting Department at Chrysler Motor Parts Corporation in Detroit (1934-44). Intrigued by the mechanics of cameras, he purchased a Rolleicord in 1938 and began photographic experiments. In 1941 he was profoundly affected by an Ansel Adams lecture and exhibition sponsored by the The Detroit Photo Guild, of which he was a member. That same year he made his first successful photographs with his newly acquired 9 x 12-cm Linhof Technica and 8 x 10-inch Deardorff.

Turning seriously to photography, he worked as a processor in the photo lab at General Motors Corporation (1944) before taking a six-month leave to work in New York City. Since 1946 Callahan has been an important influence on photography through his teaching. He joined the faculty of the Institute of Design (formerly The New Bauhaus – later part of the Illinois Institute of Technology) where he was chairman of the Photography Department between 1949 and 1961. He left Chicago in 1961 to assume a similar post at the Rhode Island School of Design through 1973, when he stepped down. He continued to teach until he retired in 1977.

Callahan's first images were intimate landscapes. The linear qualities of these thoughtfully arranged, pristine, and elegant subjects were accentuated by extreme tonal contrasts. Callahan had met Eleanor Knapp (b. 1916) on a blind date in 1933. Three years later they were married. Eleanor became the primary inspiration for his art from the mid-forties to the early sixties. His studies of her are intimate celebrations of the eternal feminine. His Eleanor images demonstrate the range of Callahan's work as a whole, as they include straightforward, manipulated, and multiple exposures.

The technical lucidity and quiet eloquence of this interior view draw the viewer into the heart of Callahan's private sensibility. He took advantage of the unusual architectural setting with its dual sources of illumination. Light caresses Eleanor's torso, visually describing its three dimensionality, yet suggesting only puritanical feelings. After 1950, their daughter Barbara often joins Eleanor, symbolizing her life-giving capacity. Over 150 photographs of his wife, many of which were previously unknown, were the subject of a recent book, *Eleanor*, published by Callaway Editions (1984).

In addition to landscape, details of nature, and intimate images of loved ones, he also made pictures of cities and passers-by on the street. Upon his retirement, he shifted exclusively to color photography, applying the same spirit of formal investigation which characterized his earlier black and white work. The subjects and styles he pursued in the past continue to reappear. He continues to see photography as an adventure:

> The photographs that excite me are photographs that say something in a new manner; *not* for the sake of being different, but ones that are different because the individual is different and the individual expresses himself. I realize that we all do express ourselves but those who express that which is always being done are those whose thinking is almost in every way in accord with everyone else. Expression on this basis has become dull to those who wish to think for themselves.[2]

Callahan has had major retrospectives at the International Museum of Photography at George Eastman House in Rochester, New York (1958), Hallmark Gallery, New York (1964), The Museum of Modern Art (1976), and the Venice Biennale (1978). In 1972, he was granted a Guggenheim Fellowship. He has received numerous awards for his work and teaching since the 1950s. Callahan has donated his archives to the Center for Creative Photography in Tucson, Arizona. He resides with his wife in Providence, Rhode Island.

1. James Alinder, *Eleanor* (*Untitled 36*) (Carmel, CA: The Friends of Photography, 1984), p. 13.
2. Harry M. Callahan, "An Adventure in Photography," in *Minicam Photography*, 9, No. 6 (Feb. 1946), 29.

Aaron Siskind
America, b. 1903

Chicago, 1948. Gelatin silver print, 35.0 x 49.5 cm on 36.8 x 50.4 cm. Titled, dated and signed with pencil on verso: *Chicago 1949 / Aaron Siskind.*

Museum Purchase: Gift of Mrs. Joseph K. Pollock, by exchange, 1981.161.

Provenance: Light Gallery, New York.

Exhibitions: Cincinnati Art Museum, *Cincinnati Art Museum Photography Collection,* 1981-82.

When I make a photograph I want it to be an altogether new object, complete and self-contained, whose basic condition is order – (unlike the world of events and actions whose permanent condition is change and disorder).[1]

Aaron Siskind has been a key figure in the development of twentieth-century photography. The dramatic new direction in his photographs between 1943 and 1945 eerily predicted some of the abstractions that his friend Franz Kline would paint in 1949-50. Siskind's iconography of found configurations gave meaning to a purely pictorial world.

Siskind was born in New York City on December 4, 1903. In 1926 he received a bachelor of social science degree from the City College of New York where he had concentrated on literature and music. He taught English in the New York City public schools until he resigned in 1949. Self-taught in photography, which he began in 1930, he joined the Film and Photo League to develop his craft and work in the documentary mode. This organization promoted photography as a social tool. An active participant in the League's activities, Siskind organized the "feature group" which produced several documentary projects, among them *Harlem Document.* On his own he undertook series on *Tabernacle City, Bucks County,* and *The Most Crowded Block in the World.* In 1941, when he exhibited his *Tabernacle City* photographs at the League, he was criticized for pursuing formalistic concerns rather than social issues. In response to this criticism and the League's leaders' general intolerance to the new and different, he left the League and dropped the social documentary in favor of an abstract and personal style.

Over a period of several years he searched for a subject which would allow him to express subjective reality in the photographic medium. His mature vision coalesced over two summers at Gloucester, Massachusetts (1943-44). Siskind sacrificed naturalistic space for the primacy of the picture plane where objects no longer functioned as objects. He concentrated on the evocative forms, shapes, and textures that carry emblematic or symbolic associations. He frequently found the embodiment of his ideas in the inanimate rubble of the urban environment. He transformed his subjects – peeling paint, decaying signs, weathered stone, graffiti fragments, and isolated objects – by selection, framing, and control of tonal values.

Chicago generates its tension in the shallow pictorial space between figure and ground from the zoomorphic paint fragments. Siskind describes the process:

The business of making a photograph may be said in simple terms to consist of three elements: the objective world . . . the sheet of paper on which the picture will be realized, and the experience which brings them together. . . . I accept the flat plane of the picture surface as the primary frame of reference of the picture. The experience itself may be described as one of total absorption in the object. But the object serves only a personal need and the requirements of the picture. . . . And these forms, totems, masks, figures, shapes, images must finally take their place in the tonal field of the picture and strictly conform to their space environment. The object has entered the picture, in a sense; it has been photographed directly. But it is often unrecognizable; for it has been removed from its usual context, disassociated from its customary neighbors and forced into new relationships.[2]

Siskind's concern for formal and abstract qualities was both broadened and consolidated through his association with the Egan Gallery, a major hub for Abstract Expressionist painters. There he had almost yearly one-man exhibitions between 1947 and 1950. In 1948 he met Harry Callahan who later lured him in 1950 to Chicago to teach photography at the Institute of Design. He headed the Institute's department for a decade. In 1971 Callahan again induced him to move – this time to the Rhode Island School of Design in Providence, where he continued his influential role as a teacher until his retirement in 1976.

His academic schedule permitted him to travel to Italy, Greece, Mexico, and Peru, stalking unassuming subject matter which he turned into abstract images of aesthetic importance. In 1966, he received a Guggenheim Fellowship to pursue his work. His photography has been exhibited extensively nationally and in Europe and was the subject of a major traveling retrospective, *Aaron Siskind: Fifty Years,* accompanied by a comprehensive monograph, *Aaron Siskind: Pleasure and Terrors.* The artist currently works and lives in Providence.

1. Aaron Siskind, "Statement," in *Aaron Siskind: Photographer,* ed. Nathan Lyons (Rochester, NY: George Eastman House, 1965), p. 24.
2. Siskind, p. 24.

Elliott Erwitt
American, b. Paris, 1928

New Haven (1955). Gelatin silver print, 16.2 x 24.1 cm on 20.3 x 25.2 cm. Signed and numbered with pencil on verso: IV/XX / *Elliott Erwitt* / *737/2*.

Gift of Dr. Barry Leon, 1978.476.

Provenance: Barry Leon, New York (through Burton Wolf, New York).

Elliott Erwitt was born to Russian émigré parents in Paris on July 26, 1928. During his formative years he was confronted with a kaleidoscope of cultural differences between his parents' social backgrounds and a variety of living experiences in Italy, France, and the United States from New York to Hollywood. Perhaps this accounts for his perception of universal incongruities among people and places which he distills onto film with wit and clarity.

Erwitt began his freelance activities in Hollywood at the age of sixteen. He studied photography at Los Angeles City College (1945-47) and film at the New School for Social Research, New York (1948-50), while taking his personal pictures on the side. He gained valuable experience as a cameraman in France (1949-50); as photographic assistant to the Valentino Sarra Studio, New York (1950); as staff photographer under Roy Stryker for Standard Oil Company of New Jersey and the Pittsburgh Photo Library (1950-52); and as photographic assistant in the United States Army Signal Corps in Germany and France (1951-53). In 1953 he joined Magnum Photos, a cooperative agency begun in 1947 by Robert Capa, Henri Cartier-Bresson, George Rodger, and David Seymour. Magnum allowed him to retain ownership and control of his negatives. During the 1950s and 1960s he specialized in photojournalism and commercial photography. At the same time he continued to pursue his personal muse, non-judgmentally photographing anticlimactic non-events. Sean Callahan has described his work:

> Like Erwitt himself, many of these photographs project a wit, a smile at the edge, that adds a universal charm to their incisiveness, lifting them into a realm where they seem to tell us something of the entire human experience by looking at small slices of the world.[1]

Among his frequent subjects are dogs which mimic or otherwise provide a vehicle of commentary on human activities. A selection of these images was published in *Son of a Bitch* in 1974. However, Erwitt's most memorable photographs are his unobtrusively recorded, contradictory images of the unrehearsed and punctilious behaviors of men, women, and children. His subjects attest to his particular twist of humor: a woman playing a cowboy slot machine, a discussion in the hallway of mummies, or women waiting in the lost persons area. Yale's oldest living graduate, depicted in *New Haven*, is a slice of life which epitomizes America's ritualistic passion for creating instant history suitable for the *Guinness Book of World Records*.

Erwitt's photographs have been the subject of one-man exhibitions at The Museum of Modern Art (1965) and The Art Institute of Chicago (1972). In addition, he has been featured in some of the most significant group exhibitions including *The Photographer's Eye* (1966), *Mirrors and Windows: American Photography since 1960* (1978), and *Photography of the 50's* (1980). Since the 1970s he has made several documentary films including *Beauty Knows No Pain* (1973), *Red, White and Bluegrass,* and *Beautiful, Baby, Beautiful.*

1. Sean Callahan, *The Private Experience: Elliott Erwitt* (Los Angeles and London: Alskog, 1974), p. 11.

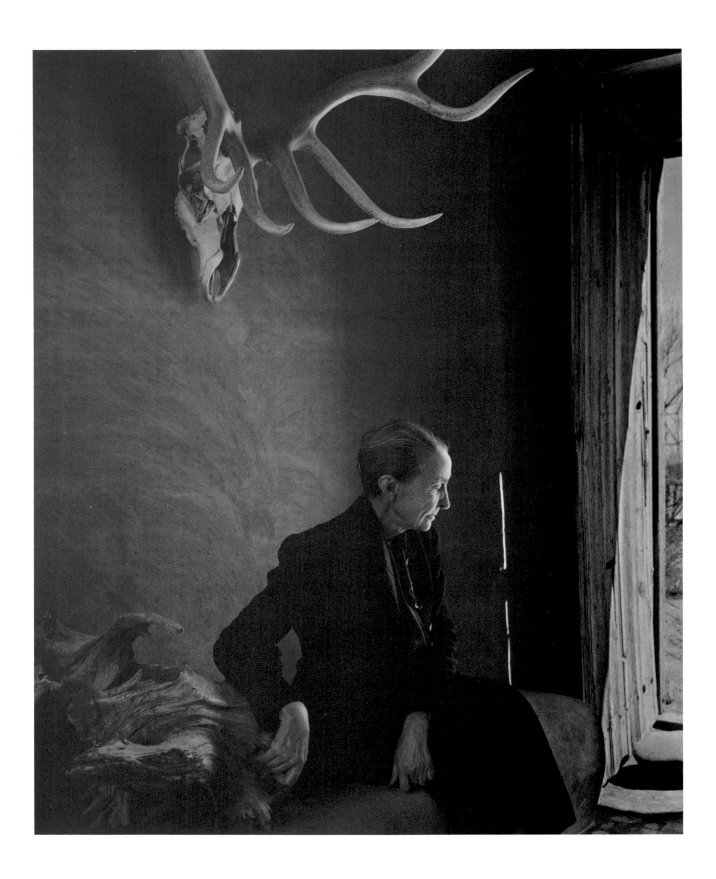

Yousuf Karsh

Canadian, b. Armenia, 1908

Georgia O'Keeffe, 1956. Gelatin silver print, 50.2 x 40.1 cm on mount 71.0 x 55.8 cm. Signed with pen and black ink on mount lower left: *Karsh*; artist's stamp in black on verso: *Photograph by Yousuf Karsh* / (pencil) *Georgia O'Keeffe 1956.*

Gift of Elaine and Arnold Dunkelman, 1982.215.

> The aim and the art of the portraitist who works with a camera are not merely to produce a likeness but to reveal the mind and the soul behind the human face. When I have had the opportunity of studying those who have left their mark upon our time, I have tried to focus my camera on that quality which has made my subjects stand out from among their contemporaries. . . .[1]

Yousuf Karsh photographed Georgia O'Keeffe (1887-1986), the doyenne of American modernist painting, on March 18, 1956,[2] at age sixty-nine. After the death of her husband, Alfred Stieglitz, in 1946, O'Keeffe permanently retreated to Abiquiu, New Mexico. Karsh recalled his portrait session:

> I expected to find some of the poetic intensity of her paintings reflected in her personality. Intensity I found, but it was the austere intensity of dedication to her work which has led Miss O'Keeffe to cut out of her life anything that might interfere with her ability to express herself in paint. . . . As though to concentrate her vision inwardly Miss O'Keeffe has banished colour from her surroundings. Her adobe home, with wide windows on every side overlooking the mountains, and almost completely empty of ornament, seemed stark to me, but when I asked Miss O'Keeffe why she chose to live in such a remote area she replied, 'What other place is there?' In the end I decided to photograph her as yet another friend had described her: 'Georgia, her pure profile against the dark wood of the paneling, calm, clear; her sleek black hair drawn swiftly back into a tight knot at the nape of her neck; the strong white hands, touching and lifting everything. . . .[3]

Using the natural light of an open doorway, Karsh placed O'Keeffe in a sparse adobe room amidst specimens of driftwood and magnificent antlered skull. This profile of her weathered countenance suggests a dogged determination with which she pursued her career as a painter.

Karsh was born in Armenia on December 23, 1908, and emigrated to Canada in 1924. Financial constraints forced him to give up aspirations to be a doctor. His uncle, George Nakash, a commercial photographer who taught him the rudiments of the profession, arranged for him to study in Boston under John H. Garo, an eminent portrait photographer, between 1929 and 1931. In 1932 he returned to his adopted country and opened a studio in Ottawa. By 1941 he was an established portraitist of politicians and statesmen. Karsh's *Life* cover of Winston Churchill, the "English bulldog," launched his international career. Since the beginning of World War II, Karsh's photographic odyssey has taken him around the world to record faces of royalty, popes, presidents, celebrated artists, authors, scientists, and businessmen. Among his many awards are the Medal of Service of the Order of Canada (1968), and Honorary Fellow of the Royal Photographic Society, London (1970). In 1971 he received the United States Presidential Citation for meritorious service on behalf of the handicapped. He has had many one-man exhibitions including the Museum of Fine Arts, Boston (1967), The Corcoran Gallery of Art (1969), and the National Portrait Gallery, London (1984). In February 1988 the Barbican Center, London, mounted a major European traveling retrospective entitled *Karsh: A Birthday Celebration*, organized by the International Center of Photography to mark Karsh's 80th birthday. In his most recent book, *Karsh: A Fifty Year Retrospective* (1983), there are four previously unpublished photographs of O'Keeffe made at the same 1956 sitting.[4] The artist continues to reside in Ottawa, and to travel throughout the world photographing his well-known subjects.

1. Yousuf Karsh, *Portraits of Greatness* (London, Toronto, and New York: Thomas Nelson, 1959), p. 11.
2. Estrellita Karsh, Letter to KS, 23 Dec. 1986.
3. Yousuf Karsh, *Karsh Portraits* (Boston: New York Graphic Society, 1976), p. 150.
4. Yousuf Karsh, *Karsh: A Fifty Year Retrospective* (Boston: Little, Brown, 1983), pp. 112-13.

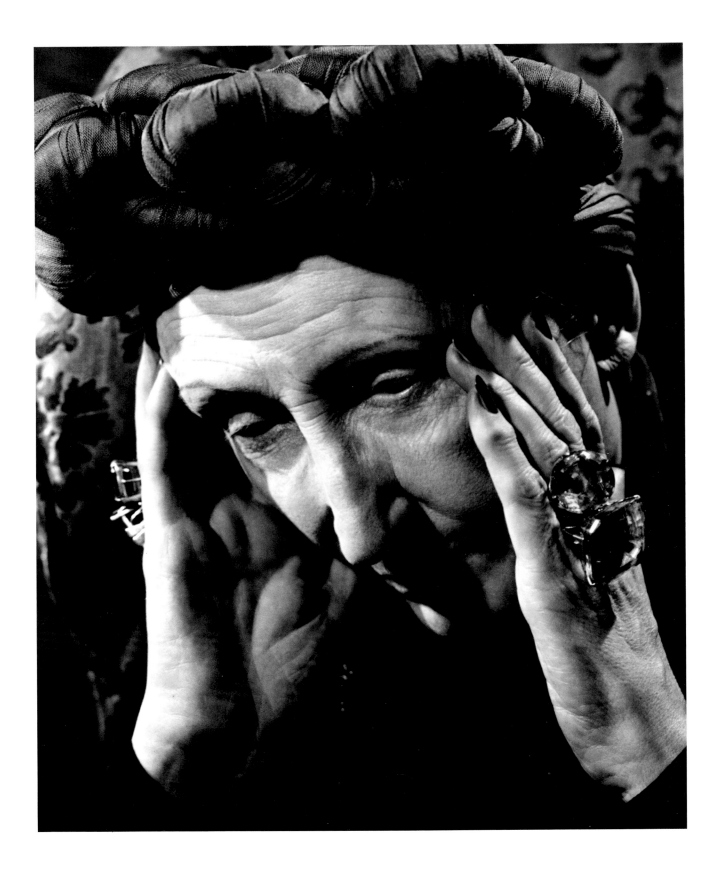

Philippe Halsman
American, b. Latvia, 1906-1979

Dame Edith Sitwell (1958). Gelatin silver print, 49.7 x 39.8 cm on 50.5 x 40.6 cm. Artist's stamp in black on verso: © COPYRIGHT / BY / PHILIPPE HALSMAN.

The Albert P. Strietmann Collection, 1980.101.

Provenance: Walt Burton Galleries, Cincinnati.

Exhibitions: Cincinnati Art Museum, *The Cincinnati Art Museum Photography Collection*, 1981-82.

Philippe Halsman achieved his photographic reputation in the United States as a master of psychologically astute, technically superb, and graphically potent portraiture. Joan Cook observes:

> He insisted on sharpness of image, careful delineation of tonal values, mastery of lighting and the revelation of both principal and contrasting textures. Above all, he sought to capture the essence of his famous subjects.[1]

The son of a dentist, Halsman was born in Riga, Latvia, on May 2, 1906. He studied electrical engineering at the Technische Hochschule, Dresden, between 1924 and 1928. His interest in photography proved to be the stronger lure, and shortly before graduating he gave up engineering and emigrated to Paris. In 1931 he set up a studio on the Left Bank where he freelanced as a portrait and fashion photographer for French *Vogue*, *Vu*, and *Voila*. In 1937 he married his former studio apprentice Yvonne Moser. As German troops approached Paris in 1940, Halsman obtained an emergency exit visa through the intervention of Albert Einstein, which permitted him to leave Occupied France and emigrate to New York.

His first real breakthrough in the new city was a photograph of an unknown young model, Connie Ford, profiled against an American flag. Acquired by Elizabeth Arden to advertise her "Victory Red" lipstick, the photograph won Halsman the Art Directors Club Medal. Although never on the staff of *Life*, he furnished the magazine with 101 covers beginning in 1942. Over the next thirty years he worked for *Look*, *Saturday Evening Post*, *Paris Match*, and *Stern*. He approached his sitters as an *agent provocateur*, releasing emotion with conversation, or creating concentration with a carefully phrased question.

Dame Edith Sitwell (1887-1964) was the high priestess of twentieth-century British poetry when Halsman photographed her in London in October 1958. She and her brothers Osbert and Sacheverell were a legendary triumvirate who considered themselves the arbiters of taste and purveyors of the avant garde. In her twilight years, Sitwell cultivated her odd appearance of majestic brocade clothes and Oriental turban, with huge lumps of topaz and sparkling turquoise on her attenuated Gothic fingers. Emphasizing her eyes by overhead lighting and the gesture of her hands, Halsman illuminated the intellect and soul of his sitter.

Halsman photographed for the printed page most of the celebrated personalities of the times: Winston Churchill, the duke and duchess of Windsor, John F. Kennedy, Marilyn Monroe, Albert Einstein, Adlai Stevenson, and John Steinbeck. The latter three photographs were selected for United States stamps. Photography was deadly serious for Halsman but at times he had great fun. He collaborated with the surrealist painter Salvador Dali in a series of inventive and amusing surrealist images published in *Dali's Mustache* (1954). Many of his famous subjects were photographed in midair for *Philippe Halsman's Jumpbook* (1959). He served as the first president of the American Society of Magazine Photographers (ASMP) in 1944, and was elected president again in 1954. He received the ASMP Life Achievement Award in 1975. Shortly before his death in 1979, the International Center of Photography, New York, mounted a major traveling retrospective of his photographs.

1. Joan Cook, "Philippe Halsman, Photographer," *The New York Times*, 26 June 1976, sec. 3, p. 17, col. 1.

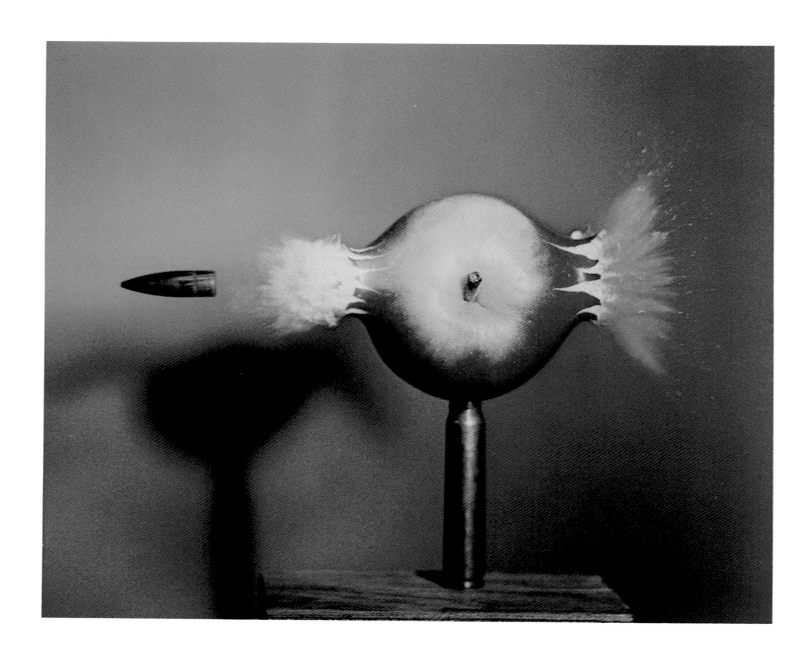

Harold Eugene Edgerton
American, b. 1903

Bullet and Apple (ca. 1964). Pl. from the portfolio *Seeing the Unseen*, published by the artist, 1977. Dye imbibition (Kodak Dye Transfer) print by Boris Color Laboratory, Boston, 24.9.x 30.2 cm on 30.4 x 35.7 cm. Signed with pencil on verso: HAROLD EDGERTON.

Museum Purchase: Gift of Ruth Friedmann, by exchange, 1981.158.

Provenance: Stephen T. Rose, Boston.

Exhibitions: Cincinnati Art Museum, *The Cincinnati Art Museum Photography Collection*, 1981-82.

The pioneering research in stroboscopic photography by Harold Edgerton in the 1930s laid the foundation for the development of the modern electronic flash. In 1926 he developed a light which produced a brilliant flash with a duration of less than one-millionth of a second. He perfected stroboscopic lights for both ultra-high-speed still and motion photography. This new technology opened up a universe of hidden forms and processes beyond the perceptive capacity of the unaided human eye.

This image of an apple pierced by a bullet traveling at nine hundred meters per second was photographed with a microflash stroboscope brighter than the sun at an exposure of one-third of one-millionth of a second. The electronic flash was triggered by sound. While intended for purposes of analysis and research, Edgerton's scientific demonstrations were skillfully and imaginatively presented to provide comprehensible and memorable images for the layman. Who would have thought that the apple exploded outward at the point of entrance as well as exit?

By a variety of methods of flash synchronization, Edgerton froze the movements of bats, birds, and fluid drops. He photographed athletes in motion with a sequential series of stopped-action exposures. These multiple images are admired not only for what they reveal about figures in motion, but for their intrinsic beauty. During World War II, he perfected the strobe flash for nighttime aerial reconnaissance photography used to monitor German and Japanese troop movements. In 1947 he and his partners were called upon to design equipment for the Atomic Energy Commission to film nuclear tests. Since the 1950s he has been active in oceanographic work. He has designed watertight cameras, strobes, and sonar devices, collaborating with Jacques Costeau and others, to aid underwater oceanographic and geological research and archaeological explorations.

An inventor, scientist, and teacher, Edgerton was born in Fremont, Nebraska, on April 6, 1903. He received his bachelor of science degree from the University of Nebraska, Lincoln, in 1925. Before pursuing advanced studies, he worked for the General Electric Company, Schenectady, New York, in 1926. He earned a master of science degree in 1927 and graduated with a doctorate in electrical engineering from Massachusetts Institute of Technology. Since 1932 he has been a teacher (now Institute Emeritus Professor) of his speciality. Over his long career he has received over forty-five patents, written innumerable technical papers, and won countless honors and awards. The sorcerer of "Strobe Alley" continues to develop new tools for extending our means of charting the unknown and seeing the unseeable.

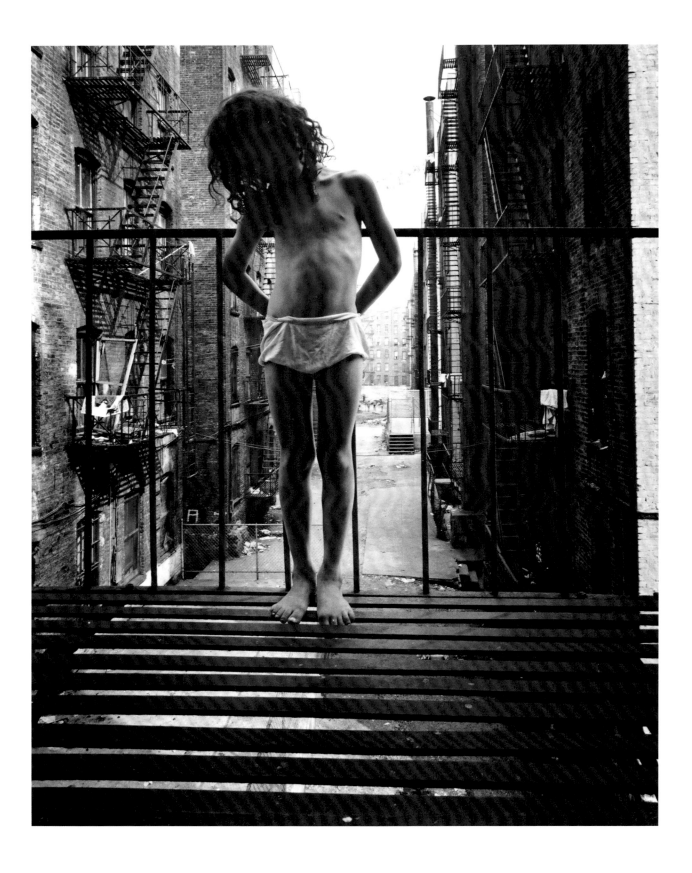

Bruce Davidson

American, b. 1933

East 100th Street, New York (1966-68). Gelatin silver print, 27.8 x 21.5 cm on 35.4 x 27.9 cm. Signed with pencil on verso: *Bruce Davidson*.

The Albert P. Strietmann Collection, 1980.90.

Provenance: Edwynn Houk Gallery, Ann Arbor.

Exhibitions: Cincinnati Art Museum, *The Cincinnati Art Museum Photography Collection*, 1981-82.

In the 1960s, volatile social events and the emergence of funding support through government and private agencies helped create a revival of interest in the still image as a vehicle of social documentation. One of the outstanding documentary photo-essayists who emerged during this decade was Bruce Davidson.

Born in Oak Park, Illinois, on September 5, 1933, Davidson was captivated by the magic of photography at the age of ten. In his senior year of high school he won first prize in the Kodak National Snapshot Contest. He studied photography at the Rochester Institute of Technology, New York (1951-54), and was recruited upon graduation by Eastman Kodak in New York. He opted to continue his studies in painting, philosophy, and photography at Yale University under Josef Albers in 1955. His budding career as a freelance photographer was interrupted by service in the United States Army between 1955 and 1957. While stationed at the Supreme Headquarters Allied Powers in Europe near Paris, Davidson struck up a friendship with Mme. Fauchet, the widow of the impressionist painter Léon Fauchet, who became the subject of his first photo-essay "Widow of Montmartre." After army service, he returned to New York where he worked for *Life* magazine in a young photographers' freelance program. Uninspired by the work he was doing, Davidson recalls "I felt the need to belong when I took pictures – to discover something inside myself while making an emotional connection with my subjects."[1] He looked to the intimate *Life* photo-essays of W. Eugene Smith for direction. In 1958 he joined the international cooperative, Magnum Photos, which allowed him the flexibility to pursue his own work while undertaking interesting assignments.

What followed were documentary essays on a circus dwarf and a Brooklyn youth gang, the Jokers. In 1961 he was sent on assignment to record the Freedom Riders of the civil rights movement, and returned the following year on a Guggenheim Fellowship to document black Americans. In 1966, using a 4 x 5-inch view camera and support from the National Endowment for the Arts, Davidson undertook one of his most important essays on the "worst block" in New York City.

'What you call a ghetto, I call my home.' This was said to me when I first came to East Harlem, and during the two years that I photographed people of East 100th street, it stayed with me. . . . I entered a life style, and, like the people who live on the block, I love and hate it and I keep going back.[2]

His continual presence earned him the nickname "picture man," and the trust and cooperation of the block's inhabitants. Stripped to their essential humanity, his subjects retain their spirit to survive. Davidson's images such as the girl on the fire escape transcend the decaying neighborhood. Its resemblance to an image of the crucifixion reminds us of human isolation and greater mystery. In 1970 this photo-essay was the subject of a book and a one-man exhibition at The Museum of Modern Art.

In the early 1970s, Davidson directed his energies to film. His first film, *Living off the Land* (1970), won the Critics Award at the American Film Festival. In 1973 *Isaac Singer's Nightmare and Mrs. Pupko's Beard* won first prize in fiction from the Festival. While he was learning filmmaking, he supported himself with industrial and advertising assignments. In 1980 he began what became his second major photo-essay about New York's subway. In Davidson's own words

I wanted to transform the subway from its dark, degrading, and impersonal reality into images that open up our experience again to the color, sensuality, and vitality of the individual souls that ride it each day.[3]

Davidson's personal study of the contemporary world can best be described as a series of essays in discovery and self-definition. At present he lives and works in New York.

1. Bruce Davidson, *Bruce Davidson Photographs* (New York: Agrindle Publications, 1978), p. 9.
2. Bruce Davidson, *East 100th Street* (Cambridge, MA: Harvard Univ. Press, 1970), n. pag.
3. Bruce Davidson, *Subway* (Millerton, NY: Aperture, 1986), dustcover.

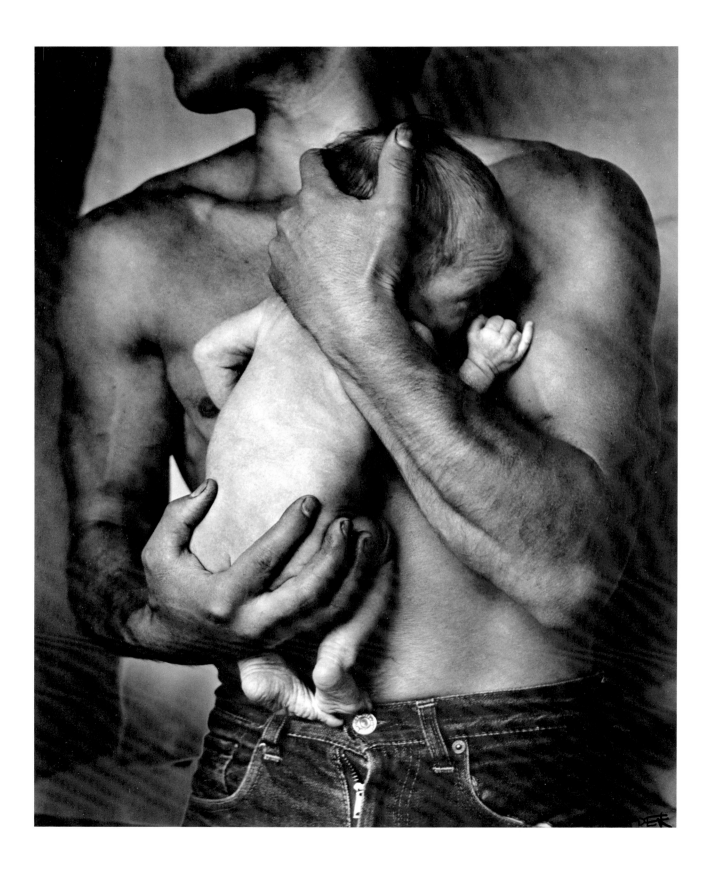

Jan Saudek
Czechoslovakian, b. 1935

Image #35 (Another Child, David is Born) (1966). Gelatin silver print, 24.4 x 19.4 cm on 25.2 x 20.2 cm. Signed with pen and black ink lower right: *Jan Saudek.*

Gift of Anne and Jacques Baruch, 1977.185.

Exhibitions: Cincinnati Art Museum, *The Cincinnati Art Museum Photography Collection,* 1981-82.

Jan Saudek's international reputation has been won in the face of great adversity. He was born in Prague, Czechoslovakia, on May 13, 1935. Shortly after the German occupation his father, a Jewish bank clerk, was forced to become a street cleaner and spent time in a concentration camp. Poverty and starvation haunted Saudek's childhood years and the memories of the loss of his family continue to haunt him. At the age of fifteen, to avoid being sent to the coal mines, he took a job as a photographer's apprentice in a printing firm and studied at the School for Industrial Photography, Prague (1950-52). Until 1965 he used nineteenth-century equipment for his factory copy work. He acquired a Baby Brownie Kodak in 1952. It was not, however, until the completion of his military service in the late 1950s that he began to take his personal photography seriously as a means of visual communication. A friend showed him Edward Steichen's classic anthology, *The Family of Man* (1955), which had an important influence on his early personal work. "I was shocked, out of my mind, felt dizzy – I *cried.*"[1]

Saudek worked at various jobs in factories or on farms, doing his personal work with a Flexaret VI as time and finances permitted. In 1969 he traveled to the United States where he had a small exhibition at Indiana University, Bloomington. His only previous showing had been at the Théâtre de la Ballustrade in Prague. Since 1970 he has been in group exhibitions across the United States, throughout Western Europe, and in Australia. He received major one-man exhibitions at The Art Institute of Chicago (1976), Jacques Baruch Gallery, Chicago (1979), a two-man exhibition with his fellow countryman, Josef Sudek, at the University of Iowa Museum of Art (1983), and a major retrospective at the Musée d'Art Moderne de la Ville de Paris (1987).

Saudek is a rugged individualist who is intense, romantic, and moody. He has worked in isolation, away from the stimulus of mainstream modern movements without the baggage of an academic heritage. Nearly all of his work has been done against the decaying wall of his cellar studio. His initial subjects were family and friends, people with whom he has established rapport. Within this limited framework he produced a powerful group of portraits, much in contrast with the officially acceptable documentary realism of his countrymen. His strongest and most popular early photograph was of a man holding a newborn baby to his chest.

Before I took the photograph I imagined that I'd show an enormous man's chest and superhuman arms holding the tiny newborn baby. But when I brought my friend who was a weight-lifter to pose for the photograph, I discovered that he didn't know how to hold the baby. Because it wasn't my first child, I finally took my shirt off and held the baby myself. And the gesture, although I am not big and the baby was normal, surpassed the sensation originally intended, of the contrast between a huge man and the little boy. Then I . . . began to understand that to photograph is not to click the camera, but to understand the relationships between people.[2]

The newborn baby in his arms was his son David.

In the mid-1970s Saudek's images of women and prepubescent girls took on a provocative tone. His partially clad subjects, overweight, pregnant, or impishly erotic, cooperate with the photographer's fantasies. He shifts from classical nudes to the coy sentimentality of Edwardian girlie picture postcards. Saudek began to hand-tint his photographs in 1977 which contributed to the artifice of his subject. Since the late 1970s he has contrasted twosomes – male and female, child and adult, dressed and undressed – gazing wryly at the photographer or interacting with each other, still within the confines of the same cellar studio. The private alchemy of his surreal, symbolist photographs transcends the barriers of language and geography to celebrate human triumph. Anná Farová writes:

> Guided by instinct, he paints not merely people and their bodies, but extrapolates their relationships to each other and to us. Saudek's photographs reflect not only what the eye sees, but also what he feels to be the abiding truth of the situation.[3]

1. Jan Saudek, "Story from Czechoslovakia, My Country," *Aperture,* 89 (1982), p. 75.
2. Jan Saudek, in "Jan Saudek Interviewed by Liba Taylor," *Creative Camera,* No. 225 (Sept. 1983), pp. 1084-85.
3. Anná Farová, *The World of Jan Saudek* (Millerton, NY: Aperture, 1983), pp. 13-14.

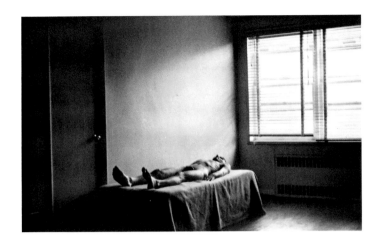
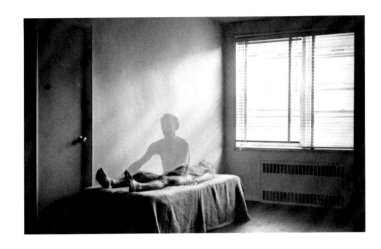
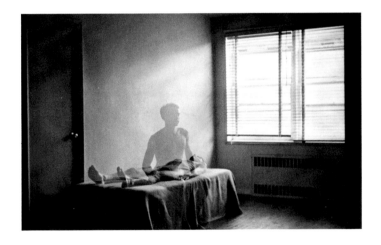
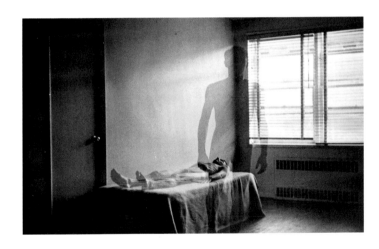
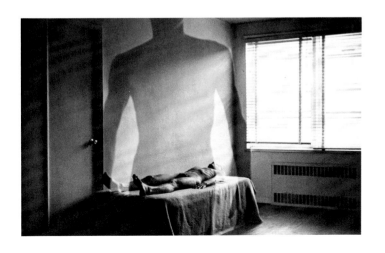
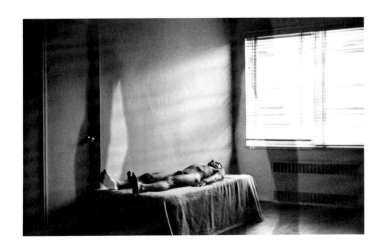

Duane Michals
American, b. 1932

The Spirit Leaves the Body (1968). Seven gelatin silver prints, each 8.3 x 12.6 cm on 12.6 x 17.8 cm. Titled with pen and black ink upper center no. 1: *The Spirit Leaves the Body*; signed lower center: *Duane Michels 8/25*; nos. 2-7 individually numbered upper center: *2; 3; 4; 5; 6;* and *7.*

The Albert P. Strietmann Collection, 1980.103:1-7.

Provenance: Sidney Janis Gallery, New York; Carl Solway Gallery, Cincinnati.

Exhibitions: Cincinnati Art Museum, *The Cincinnati Art Museum Photography Collection*, 1981-82.

In 1972, Carter Ratcliff wrote:

> Duane Michals' photographs demythologize on a double front. First, with their ghostly presences, they undercut the medium's claim to an objective recording of an external appearance. Next, by making the technical origin of those presences so clear (double exposure, camera motion, superimposition of negatives) they call into question the traditional notions of appearance in the spirit world. . . .[1]

Born in Mckeesport, Pennsylvania, on February 18, 1932, Michals received a bachelor of arts degree from the University of Denver, Colorado, in 1953. He subsequently attended the Parsons School of Design, New York (1956-57), and did design and layout work for several magazines. In 1958, at the age of twenty-six, his vague ambitions to be a photographer were strengthened during a trip to Russia where he made his first portraits with a borrowed camera. During the 1960s he established a successful freelance career while experimenting with a personal style.

About 1966, he began using sequential images to construct visual narratives which he gave provocative literary titles. Andy Grundberg comments:

> Their suprarational subject matter was often biblical stories in contemporary mise-en-scène, re-incarnational fantasies or tales of

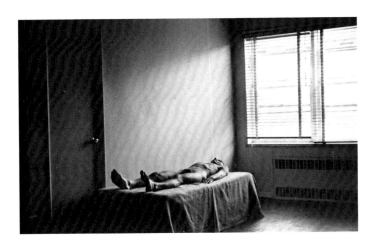

sexual ambiguity partaking at times of Freud, at times of Jung. Decidedly Surreal, the imagery was often derivative, sometimes purposely sophomoric, but the stories were told succinctly, without wasting a breath. . . .[2]

Michals's role as auteur of visual fables, allegories, and parables which subvert the viewers' perceptions of reality are not without precedent, but have no parallels in photography of the 1960s. Each of his *tableaux vivants* is scripted to reveal a sequence of events and the passage of time. These highly cinematic playlets have a beginning, middle, and end; principal characters; and a set for action. His emotionally charged, unconventionally humorous, or sexually provocative scenarios deal with a variety of concepts – chance, loss, change, disappointment, or death.

Michals has described this series of pictures, *The Spirit Leaves the Body*, as dealing with

> ideas concerning the act of death. When photographers concern themselves with death, it is usually as a fact: the sorry bodies in a ditch at Belsen, weeping women in black, or the sheet covering a corpse near a motor accident. I am . . . concerned with the more speculative, metaphysical aspect of death which is in fact unphotographable. Like any mystery it can only be suggested.[3]

This narrative sequence, obviously based on a spiritual theme and invoking Christian imagery and parables, is staged in an ordinary contemporary setting. Michals frequently uses blurred and superimposed figures to imply spiritual, ghostly qualities, characters and stories. Michals elected to use a nude because he wanted the character "to be the eternal figure without personality."[4] In certain situations, he argues that nudity actually intensifies the subject.

In the early 1970s, Michals began to inscribe on his photographs a narrative or anecdotal voice-over which explicates or parallels the photographic image and determines the inner dialogue of his characters. His mysterious dramas and altered realities are diametrically opposed to the assumed certifiable truth of the photographic record. By achieving narrative clarity and visual interest, his tableaux become visible symbols of invisible reality.

Michals's photographs have been featured in countless one-man exhibitions including shows at The Museum of Modern Art, New York, (1970), the Contemporary Art Center, Cincinnati (1976), Musée d'art Moderne, Paris (1982), and Museum of Modern Art, Oxford, England (1984). In addition, his work has been included in selected group shows: *Towards a Social Landscape*, George Eastman House, Rochester (1966), *Being Without Clothes*, Massachusetts Institute of Technology, Cambridge (1970), *Biennial*, Whitney Museum of American Art, New York (1977), and *Content: A Contemporary Focus 1974-1984*, Hirshhorn Museum and Sculpture Garden, Washington, D. C. (1984). He has used the photographic book to his advantage. Since his first book, *Sequences*, in 1970, his

(continued to page 216)

Lee Friedlander
American, b. 1934

London, 1969. Gelatin silver print, 19.0 x 28.4 cm on 27.9 x 35.2 cm. Signed with pencil on verso: *Lee Friedlander*; artist's copyright and reproduction restriction stamp in black on verso; title, date and negative number in pencil: *London 1969 58-19.*

The Albert P. Strietmann Collection, 1980.70.

Provenance: Robert Freidus Gallery, Inc., New York.

Exhibitions: Cincinnati Art Museum, *The Cincinnati Art Museum Photography Collection*, 1981–82.

I suspect it is for one's self-interest that one looks at one's surroundings and one's self. This search is personally born and is indeed my reason and motive for making photographs. The camera is not merely a reflecting pool and the photographs are not exactly the mirror, mirror on the wall that speaks with a twisted tongue. Witness is borne and puzzles come together at the photographic moment which is very simple and complete. The mind-finger presses the release on the silly machine and it stops time and holds what its jaws can encompass. . . .[1]

Born in Aberdeen, Washington, in 1934, Lee Friedlander began photographing in 1948. He studied with Edward Kaminski at the Art Center School in Los Angeles from 1953 to 1955. His 1950s photographs of jazz musicians in New York and New Orleans earned him in 1960 the first of three Guggenheim fellowships (1962, 1977) for photographs which chronicle the look and character of the changing American scene. The hallmarks of his style were tongue-in-cheek ironies, a distant coolness, and an ambiguous stance between straight documentary and biting commentary of the social landscape.

Friedlander's photographic syntax, deceiving in its understatement, appears to violate good photographic norms. One of his trademarks is the use of a hand or object in the foreground of the image, a device which allows him to assault pictorial conventions which dictate that representational photography should represent rationally perceived space. With wide-angle lens and flash, Friedlander's early work exploited qualities that have traditionally been considered signs of inept craft, including burnt-out and out-of-focus foregrounds. Friedlander's *London* portrait of the American artist Jim Dine (b. 1935) violates the conventional formal canons of space. The resulting near-surrealist juxtaposition emphasizes the two-dimensional picture plane and enigmatically metamorphoses familiar forms, such as Dine's foot. Friedlander's visual assertions were symptomatic of the new direction in documentary photography in the 1960s, which has been termed "social landscape."

In 1969 Friedlander and Dine, whom he had first met in 1962 when the artist purchased one of his photographs, collaborated on a portfolio and book of photographs and etchings entitled *Work from the Same House*. Dine has described Friedlander's work:

Lee's work is so very difficult — this is what attracts me to it all the time. The images are very difficult, images within images. The metaphor is strong for other things. His photographs are very complicated I think, and terribly American. But very complicated and that was what I first liked about them. I felt that that was the thing which in a certain way was akin to me.[2]

Although the photographs and prints in the book were arbitrarily juxtaposed, Friedlander's images of the social landscape thematically paralleled many of the themes of Pop Art in Dine's graphic work. This was one of the rare successful collaborations between a photographer and an artist in another medium. *London* was taken during their period of collaboration. A joint photographic portrait appears in the portfolio showing the two artists reclining in the identical setting with Dine wearing the same outfit.[3]

In 1970 the first volume of Friedlander's photographs, *Self Portrait*, was published, exploring the photographer as artist, person, and role-player. The photographic portraits, reflections, and shadows function on multiple levels as social documents and part of a psychological autobiography. Since then, several distinct bodies of work reflect Friedlander's multi-faceted range of concerns: *Gatherings* (1973), *Photographs of Flowers* (1975), and *The American Monument* (1976). The latter recalls in scope and ambition *American Photographs* by Walker Evans and *The Americans* by Robert Frank. In 1979, Friedlander scrutinized the factory system and worker in western Pennsylvania and eastern Ohio for a project commissioned by the Akron Art Museum. These photographs, published as *Factory Valleys*, ended up as self-contained works of art, rather than documents dealing with issues of daily industrial life. Friedlander's style has affected the ways in which a new generation of American photographers perceives the urban environment.

1. Lee Friedlander, *Self Portrait* (New York: Haywire Press, 1970), n. pag.
2. Jim Dine, quoted in Liz Glazebrook, "Jim Dine," *Album*, 1 (Feb. 1970), p. 43.
3. *Jim Dine Complete Graphics* (Berlin: Galerie Mikro, 1970), no. 55a.

Paul Caponigro
American, b. 1932

Inner Trilithon Through Circle Stones, Stonehenge, 1970.
Gelatin silver print, 49.0 x 34.0 cm on mount 61.1 x 55.9 cm.
Signed in pencil on mount lower right: *Paul Caponigro.*

Museum Purchase: Gift of Jeanette White Martz and William R.
Martz, by exchange, 1981.135.

Provenance: Images, Cincinnati (from Paul Caponigro).

Exhibitions: Images, Cincinnati, *Photographs by Paul Caponigro*,
1981; Cincinnati Art Museum, *The Cincinnati Art Museum
Photography Collection*, 1981-82.

My concern…is to maintain, within the inevitable limitations of
the medium, a freedom which alone could permit contact with
the greater dimension – the landscape behind the landscape.[1]

Throughout his photographic career, Paul Caponigro has
sought a personal vision, aspiring to capture on film "the elusive
image of nature's subtle realms."[2] Influenced by the work of Alfred
Stieglitz and Minor White, Caponigro's goal is to get behind the
physical appearance of things. Many of his prints have a lyrical
quality which stems from his musical background. Composing
music comes from within and, in Caponigro's mind, so should the
photographic image.

Paul Caponigro was born in 1932 in Boston, Massachusetts. He
began playing the piano at an early age but gradually became more
interested in the expressive qualities of photography. After
spending a year at the College of Music at Boston University,
Caponigro was drafted into the army where he worked in the base
photography lab under Benjamin Chin. A student of Ansel Adams
and Minor White, Chin introduced Caponigro to the teachings of
both men and taught him Adams' Zone System. He quickly
mastered the technical aspects of photography, but strove for
something deeper and more personal in his work.

Caponigro met Minor White in 1957 and studied with him for
six months. Although he learned a great deal from White, by 1959
he had become disenchanted with his teaching methods and turned
down an invitation to work with him the following year. His own
experimentations in photography led him back to music as well as
to a closer look at the ideas of G. I. Gurdjieff, a philosopher who
believed that one could recapture spiritual harmony through ancient
mysteries and Eastern teachings. Continuing his pictorial
investigations, Caponigro also enrolled in several drawing courses
in New York City.

In 1966 Caponigro received his first Guggenheim Fellowship.
Unable to visit Egypt because of the strained relations between this
Middle Eastern country and the United States, he followed the
suggestion of his wife Eleanor to investigate Ireland's landscape,
ancient churches, and high crosses. It was here that he ultimately
encountered the megaliths of the British Isles which led him to one
of his most challenging projects, photographing the Stonehenge
monument.

To me, the compelling quality of the stones is that they contain
one of the greatest of all mysteries: that which can never be
brought to physical manifestations, yet is discernible to our
innermost consciousness. Locked in the silence of these stone
complexes lies a link to the world of the unutterable.[3]

In *Inner Trilithon Through Circle Stones, Stonehenge,* the play of light
and dark and the receding post and lintel pattern draw one into the
composition, and conveys a sense of inner activity that Caponigro
himself must have felt.

Caponigro received a second Guggenheim Fellowship in 1975
and spent a year photographing Shinto shrines, Buddhist temples,
and gardens in Japan. He has been the recipient of numerous other
awards and has had many gallery and museum exhibitions,
including *The Wise Silence: Photographs by Paul Caponigro*. This
traveling exhibition, organized by the International Museum of
Photography at George Eastman House, traveled to the Cincinnati
Art Museum in 1985. In 1960 he began a long association with the
Polaroid Corporation as a consultant in photographic research. His
most recent project took him to France in the fall of 1987, to record
the Cistercian abbeys and cathedrals. Caponigro currently lives in
Santa Fe, New Mexico, where he continues to work and
photograph.

— D.K.

1. George Walsh, Colin Naylor, and Michael Held, eds., *Contemporary Photographers*
(New York: St. Martin's Press, 1982), p. 131.
2. Caponigro, p. 131.
3. Paul Caponigro, *Megaliths* (New York: Little, Brown, 1986), n. pag.

W. Eugene Smith

American, 1918-1978

Tomoko and Mother, Minamata, Japan (1972). Gelatin silver print, 19.8 x 32.7 cm on mount 38.3 x 50.5 cm. Signed with pencil on mount lower right: *W. Eugene Smith*; inscribed with pencil on verso mount: PRINT PROPERTY OF AILEEN M. SMITH / *Aileen M. Smith*.

Museum Purchase: Gift of Mrs. James M. Hutton and bequest of Charlotte H. Mackenzie, by exchange, 1981.136.

Provenance: Aileen M. Smith; Photograph Gallery, New York.

Exhibitions: Cincinnati Art Museum, *The Cincinnati Art Museum Photography Collection*, 1981-82.

Photography is a potent medium of expression. Properly used it is a great power for betterment and understanding; misused, it can kindle many troublesome fires. Photographic journalism, because of the tremendous audience reached by publications using it, has more influence on public thinking and opinion than any other branch of photography. For these reasons, it is important that the photographer-journalist has (beside the essential mastery of his tools) a strong sense of integrity and the intelligence to understand and present his subject-matter accordingly.[1]

W. Eugene Smith not only mastered but virtually invented the narrative photographic essay. Throughout his career, his strong sense of responsibility and compassion made him a legend as did his intense desire to control all aspects of the photo-story.

Born in Wichita, Kansas, in 1918, he began his career covering stories for his hometown paper. At the age of nineteen he moved to New York where he worked for *Newsweek* for a short time before beginning a highly productive period with the Black Star photographic agency between 1938 and 1943. As a war correspondent during World War II, Smith sought access to ground combat in the Pacific for Ziff-Davis Publications (1943-44) and *Life* magazine (1944-45). While covering combat, he found a powerful, mature photographic style. He intuitively grasped that human events captured during the emotionally charged sphere of action break down the barriers between the subject and viewer. Smith covered the assaults of Iwo Jima, Guam, and Okinawa where he was wounded on the front lines, terminating his war coverage.

After a two-year convalescence, he rebuilt his career by creating approximately fifty photo essays for *Life* between 1947 and 1955. *Country Doctor* (1948), *Spanish Village* (1951), *Nurse Midwife* (1951) and *Man of Mercy* (1954) were major essays from which individual images became famous. Smith believed that a sequence of pictures could accurately present the truth of his chosen subject and that its revelations would inspire social change. He constantly advocated the photographer's right to direct editorial control over layout, captions, and text. His battle with the "magazine factory" led to his resignation from *Life* in 1954, taking with him a reputation for social responsibility and craftsmanship which reverberated throughout the photojournalistic world.

For the balance of his life, Smith supported himself with commercial assignments, teaching appointments, and grants. He joined Magnum Photos in 1955 and undertook an assignment for the historian Stefan Lorant to illustrate his book on Pittsburgh. Smith transformed the original project into a megalomanic essay lasting two years, partially supported by Guggenheim Fellowships in 1957 and 1958. Only a small portion of his ten thousand images was published. In 1961 Smith went to Japan, commissioned by the industrial giant Hitachi Limited to report on its activities. In the mid-1960s he became involved in the field of medical photography as visual editor for *Visual Medicine* magazine and through his association with the Hospital for Special Surgery in New York.

He returned to Japan in 1971 accompanying *Let Truth Be the Prejudice*, a major retrospective organized by the Jewish Museum, New York. Smith's mature work found its final expression in *Minamata*, the last major project he finished before his death. In 1971 he and his wife, Aileen Smith, settled in the Japanese fishing village of Minamata to record the struggle to stop the mercury poisoning of the local food supply by the chemical industrial giant Chisso. *Minamata* documents the tragic story of victims and the efforts of ecologists to fight for compensation. Before her birth in 1956, Tomoko Uemura was poisoned by mercury in the womb of her outwardly healthy mother. Smith constructed this image of the mother bathing her deformed sixteen-year-old daughter as a Pietà. He insisted both on the crime of its cause and on the beauty of the image. Secondary details are reduced under a mantle of darkness, concentrating attention on the caring parental relationship. When published in 1975, *Minamata* – through its eloquent photographs and words – brought worldwide attention to the tragic potential of industrial pollution. Shortly before his death in 1978, Smith donated his archive to the Center for Photographic Studies in Arizona.

1. W. Eugene Smith in "W. Eugene Smith," *Album*, 2 (Mar. 1970), p. 39.

Richard Avedon
American, b. 1923

Jean Renoir, 1972. Gelatin silver print 1975, 88.8 x 88.0 cm. Warranty and copyright stamp in black on verso: *Copyright © 1975 by Richard Avedon / All Rights Reserved / neg. no. (pen) 248 edition of (pen) 10 number 5 / Jean Renoir, director / Beverly Hills, California, 4-11-72.*

The Albert P. Strietmann Collection, 1979.40.

Provenance: Stephen Wirtz Gallery, San Francisco.

Exhibitions: Cincinnati Art Museum, *The Cincinnati Art Museum Photography Collection,* 1981-82.

Over his forty-year career, Richard Avedon has developed two separate and seemingly contradictory bodies of work. Born in New York City on May 15, 1923, he grew up surrounded by fashion in his parents' dress shop, Avedon's Fifth Avenue. He received his first formal photographic training in the photo section of the United States Merchant Marines, where between 1942 and 1944 he was assigned to take identification photographs. In the post-war decade he became a student and protégé of Alexey Brodovitch, the influential art director of *Harper's Bazaar.* From his debut in 1945 until 1965, his innovative photographs celebrating the ephemeral shifts in fashion appeared first in *Harper's Bazaar* and then in *Vogue,* where he moved in 1965. His early fashion work was influenced by his admiration for the 1930s fashion photographs of the Hungarian Martin Munkacsi. His style evolved from an emphasis on movement and natural settings to his preference for indoor studio work where he advanced the outrageous fashions of the liberated age of sexuality of the 1960s and 1970s.

While he was fabricating a contemporary mythology of grace and elegance, eternal youth and beauty in his commercial work, he began to explore a more personal vision in his portraits of cultural and political figures. His confrontational style – the figures are frontal, centered, and staring directly at the viewer – mercilessly strips off their celebrity masks to reveal their human frailties. Dore Ashton points out:

> Avedon's exceptional artistic merit lies in his uncanny way of recognizing the deepest themes through their superficial reflection on the human visage. It is the surface, the mask, that most reveals – a paradox many artists in history have entertained. Avedon has often said that he sets up a drama first by posing his sitters, then by having an intense confrontation in which he puts his sitters into a psychological condition in which they become "symbolic of themselves." This instinctive strategy of Avedon's allows both him and his subject to become momentarily suspended selves – an indispensable condition, for the artist at least. . . .[1]

Avedon uses the 8 x 10-inch view camera as an engraver uses a burin, to accent and compose, while deleting all detracting background intrusions. His aggrandizing enlargements reveal the human condition etched on his subjects' countenances. The ravaged facade of the French film director, writer, and actor, Jean Renoir (1894-1979), details the physical flaws inherent in the aging process – bags, wrinkles, enlarged pores, and rheumy eyes. Avedon subtly orchestrates tonal gradations across the isolated eroded topography of his subject's iconic persona. The black film edges, with negative numbers and markings framing the portrait, call attention to the photographic process. The reductiveness and seriality of his portraits against his signature seamless white paper parallel minimalist tendencies in contemporary art.

In 1971 Avedon turned his back on the rich, powerful, and famous, and undertook a five-year project to photograph the faces of working-class people west of the Mississippi, under a commission from the Amon Carter Museum, Fort Worth. Mindful of the powerful myths residing in Western photography and painting, Avedon assembled a compelling collective image of miners, farmers, waitresses, cowboys, and drifters who survive in the post-industrial western wasteland. In the introduction to *In the American West,* he remarks:

> A portrait is not a likeness. The moment an emotion or fact is transformed into a photograph it is no longer a fact but an opinion. There is no such thing as inaccuracy in a photograph. All photographs are accurate. None of them is the truth.[2]

Avedon has had major one-man exhibitions at the Minneapolis Institute of Arts (1970), The Museum of Modern Art, New York (1974), the Metropolitan Museum of Art (1978), and the Amon Carter Museum, Fort Worth (1985). Pratt Institute, Brooklyn, awarded him its Citation of Dedication to Fashion Photography in 1976. He was named Photographer of the Year in 1985 by the American Society of Magazine Photographers. Avedon continues to work and live in New York.

1. Dore Ashton, "This Silent Theater: The Portrait Photographs of Richard Avedon's *In the American West,*" *Arts Magazine,* 60, No. 1 (Sept. 1985), 138.
2. Richard Avedon, *In the American West* (New York: Harry N. Abrams, 1985), n. pag.

Jerry N. Uelsmann
American, b. 1934

Untitled, 1975. Gelatin silver print, 48.8 x 37.3 cm on mount 71.1 x 55.7 cm. Initialed and dated on mount lower right *J.N.U. 1975;* artist's stamp in purple on verso: ORIGINAL PHOTOGRAPHY / JERRY N. UELSMANN / COPYRIGHT 1975; signed with black pentel lower right: *1975* / JERRY N. UELSMANN.

Museum Purchase: Gift of Mr. and Mrs. George Rentschler, by exchange, 1982.77.

Provenance: Images, Cincinnati.

> Let us not delude ourselves by the seemingly scientific nature of the darkroom ritual; it has been and always will be a form of alchemy. Our overly precious attitude toward the ritual has tended to conceal from us an innermost world of mystery, enigma, and insight. Once in the darkroom the venturesome mind and spirit should be set free − to search and hopefully discover.[1]

In the early 1960s Jerry Uelsmann played an influential role in expanding the philosophical approaches available to photographers. Like his nineteenth-century predecessors, Oscar G. Rejlander and Henry Peach Robinson, Uelsmann used multiple negatives to create his compositions. Their Victorian-era photographic tableaux used combination printing or photomontage to emulate painting, and thereby advance the medium's claims to be fine art. In the decades between the two World Wars, this approach was replaced by straight photography, which required that decisions be previsualized before the picture was taken and that the negative be printed without darkroom manipulations. The leading advocates and practitioners of this new photographic style were Paul Strand and Edward Weston. Uelsmann revolted against the empiricism of the camera, and its use as an instrument of factual recording. He advocated a process which coupled previsualization with "postvisualization," his term for creative reintegration in the darkroom. He wrote that "it is important that we maintain a continual open dialogue with our materials and process; that we are constantly questioning and in turn being questioned."[2]

Uelsmann is a master at creating new contexts for ordinary objects through unexpected and ambiguous juxtapositions. Although there are visual ties to surrealism in his work, it diverges from the surrealist faith in automatism. Uelsmann has described his experimental working method as a means of

> inventing a language at the same time you're using it. . . . I make proof sheets of everything. . . . The negatives are kept in numerical order, but I let the proof sheets get mixed up. . . . When I get ready to print, I sit down with a stack of proof sheets. Usually the things that are most recent are on top, but they get rapidly mixed with the others. I look at these proof sheets and try to find clues to things that might work together. Sometimes . . . I can make more little notes of things I want to try than I could possibly do in a week. . . .[3]

He is a wizard in the darkroom, producing visions from composite negatives, positive-negative reversals, and solarizations. Using up to seven enlargers, Uelsmann articulates fragments of the natural world. Among the recurring details he employs to convey his themes are rocks, water, clouds, eyes, hands, interiors, and vegetation. These are joined with iconographical elements, including sensual nudes, floating objects, metamorphosing forms, and historic references. By manipulating the space, perspective, and scale, he constructs romantic images laden with evocative poetry and visual mythology where the absurd is believable and the incongruous convincing.

Jerry Uelsmann was born in Detroit, Michigan, on June 11, 1934. He pursued his high school interest in photography at the Rochester Institute of Technology, New York (1953-57), where he was influenced by Ralph Hattersley and Minor White. He received a master of fine arts degree in 1960 from Indiana University, where he worked with Henry Holmes Smith. Since 1960, he has been an instructor in photography at the University of Florida, Gainesville, where he continues to teach. His photography was launched by a major touring exhibition organized by the The Museum of Modern Art in 1967, followed by critical praise in *Aperture* in 1970. He received a Guggenheim Fellowship in 1967 to continue his exploration of multiple printing. He has demonstrated and lectured throughout the United States, Europe, and Japan.

1. Peter C. Bunnell, intro., *Jerry N. Uelsmann* (Millerton, NY: Aperture, 1970), n. pag.

2. Jerry N. Uelsmann, "Some Humanistic Considerations of Photography," *The Photographic Journal* 3, No. 4 (Apr. 1971), 166, rpt. in James L. Enyeart, *Jerry N. Uelsmann: Twenty-five Years: A Retrospective* (Boston: Little, Brown, 1982), p. 42.

3. Jerry N. Uelsmann, "How Jerry Uelsmann Creates His Multiple Images," *Popular Photography*, 80, No. 1 (Jan. 1977), 80-82.

Eve Sonneman
American, b. 1946

Boboli Gardens, Florence, 1977. Two dye-bleach (Cibachrome) prints, each 15.4 x 23.3 cm on 20.1 x 25.1 cm. Inscribed with pencil on verso: *Boboli Gardens, Florence, 1977 4/10 Eve Sonneman.* Inscribed with pencil on mount lower center: *Boboli Gardens, Florence Eve Sonneman 1977.*

Gift of RSM Co., 1985.344:a-b.

Provenance: Castelli Graphics, New York; RSM Co., Cincinnati (purchased from Castelli Graphics 1978).

Exhibitions: The Contemporary Arts Center, Cincinnati, *The RSM Collection,* 1981, n. pag.; Herron School of Art Gallery, Indianapolis, *RSM: Selections from a Contemporary Collection,* 1983, n. pag.; Judith Russi Kirshner, "The RSM Company Collection of Contemporary Art" in *New Visions in Contemporary Art: The RSM Company Collection,* (Cincinnati Art Museum, 1986), pp. 13, 46, illus. color p. 43.

Andy Grundberg has tried to define the art of Eve Sonneman:

> Sonneman's photography straddles the line between the traditional practice of photography and a more Conceptual, art-world approach to the medium. Her pictures are traditionally photographic to the extent that they describe events and interactions that occur out in the world, employing a loosely organized, free-hand style associated with the 35-millimeter camera, but they violate both the norms of print quality and doctrine of the decisive moment. Miss Sonneman refuses to fetishize technique . . . ; her intentions, we are forced to conclude, lie elsewhere than on the surface. By presenting related pictures in pairs, as diptychs separated by a black line and as little as a fraction of a second of time, she suggests that all moments are created equal – that "decisiveness" is a convenient fiction.[1]

During the 1960s the purist aesthetics of modernism were reexamined and a variety of means was explored to extend the photographic image to express more subjective feelings about public and private realities. The 1970s became a decade of pluralism in which diverse photographic mediums, movements, and styles came to prominence in the hands of the artistic vanguard. Conceptual art's concerns with systematic inquiry, organizing idea, and perceptual curiosity generated a richly varying body of photography.

Eve Sonneman's photographic interest in vernacular situations makes her stand out among the conceptualists. She is concerned, writes Grundberg,

> with the configuration of the entire world, not just the world of art, and her responses are largely emotional, not ideational. . . . but the essential difficulty of her work is the dual nature of her subject: Miss Sonneman's paired photographs speak at once to the nature of seeing (as mediated by the camera) and to the nature of the world. They critically probe the limits of the camera's frame and shutter, exploring our perceptions of time and space, and they depict the visual world as a place of marvelous variety and vicissitude, infinitely malleable and fickle.
>
> In many respects Miss Sonneman functions as a dialectician. She juxtaposes and reexamines fundamental oppositions: nature versus civilization, accident versus order, the seen versus the experienced, the materiality of the visible world versus the immateriality of the spirit. . . .[2]

Sonneman's earliest black and white work from the late 1960s depends on adjacent frames to supply the contiguity of her chosen moments. Her transition to color came in 1974 with the "Coney Island" series. Her sets of photographs, with color above and black and white below, explored subtle shifts in visual chronology and perspective and their impact on the viewer. She abandoned sequential frames when she shifted to color transparency film for her diptychs in 1975. The pairs challenge the viewer's skills to reconcile the passage of time and the vicissitude of space. *Boboli Gardens, Florence* makes ominous implications by contrasting dualities of male and female, gesture and meaning, split by diverging tree-lined paths.

Eve Sonneman was born in Chicago, Illinois, on January 14, 1946. She studied painting at the University of Illinois, Urbana (1963-67), and photography with Van Deren Coke at the University of New Mexico, Albuquerque, where she earned her master of arts degree in 1969. From her New York studio, she has traveled in Europe and America since 1969 in search of her subject matter. She taught at the School of Visual Arts in New York (1975-81), Cooper Union, New York (1970-71, 1975-78), Rice University, Houston (1971-72), and City University of New York (1972-75). Sonneman received two National Endowment for the Arts awards for photography (1971, 1978) and a Polaroid Corporation grant for work in Polavision (1978). Since 1970 she has had over twenty-five one-woman exhibitions including The Contemporary Arts Center, Cincinnati (1979), Minneapolis Institute of Arts (1980) and Centre Georges Pompidou, Paris (1984). The artist currently lives and works in New York.

1. Andy Grundberg, "Eve Sonneman's Explorations," *New York Times,* 18 Apr. 1982, p. 29.
2. Grundberg, p. 29.

Lewis Baltz

American, b. 1945

Night Construction, Reno, 1977. Plate no. 7 from the portfolio *Nevada*, published by Castelli Graphics, New York, 1978. Gelatin silver print, 16.3 x 24.2 cm on 20.2 x 25.4 cm. Numbered, signed and dated with pencil on verso: *N-7 40/40 Lewis Baltz 1977.*

Museum Purchase: Gift of Harry G. Friedman, by exchange, 1981.221.

Provenance: Castelli Graphics, New York.

Exhibitions: Cincinnati Art Museum, *The Cincinnati Art Museum Photography Collection*, 1981-82.

Born in California on September 12, 1945, Lewis Baltz has witnessed in his own lifetime the desecration of the American West by real estate prospectors as the pursuit of the American dream leads to increasing urbanization. Baltz writes:

> Among the most subversive qualities of the still photograph is that at its best it so often confronts us with a world wholly alien to our aspirations, a world, or its parts, that we would prefer to disregard altogether.[1]

Cognizant of the desire to photograph by the age of fifteen, he attended the San Francisco Art Institute where he received his bachelor of fine arts degree in 1969 and completed his graduate studies in photography at Claremont Graduate School, California, where he was granted a master of fine arts degree in 1971. A freelance photographer since 1970, he has taught part-time in California at Pomona College, Claremont (1970-72), and California Institute of the Arts, Valencia (1972). His portfolio *The Tract Houses* was the first of a series of portfolios for which he used his camera as a documentary tool to record man's relationship to the urban landscape.

Between 1973 and 1974 he worked on the portfolio and book, *The New Industrial Parks near Irvine, California.* This extended study documents the conversion of barren southern California landscape into prefab industrial architecture. His stark, tightly cropped, frontal close-ups recall the grids and other serial patterns of the 1960s minimalists. Baltz's social reportage is balanced by controlled aesthetics and conceptual strategy. Baltz explains:

> There is something paradoxical in the way that documentary photographs interact with our notions of reality. To function as documents at all they must first persuade us that they describe their subject accurately and objectively; in fact, their initial task is to convince their audience that they are truly documents, that the photographer has fully exercised his powers of observation and description and has set aside his imaginings and prejudices. . . . [P]hotographs, despite their verisimilitude, are abstractions; their information is selective and incomplete. . . .[2]

In 1976 Baltz won a Guggenheim Fellowship to photograph Northwest Nevada. The resulting portfolio was selected from photographs taken in Washoe County in late 1976 and 1977 with a Linhof Technica camera often with long exposures in the early evening. The fifteen images for *Nevada* were selected to present an analytic vision seemingly free from ideological or aesthetic rhetoric. Topographic information emphasizes both fine detail and tonal concern. Panoramic vistas are divided by the horizon. It could have been taken almost anywhere in the western United States. As with earlier series, human presence and activity are implied by housing developments, highways, and industrial parks. In *Night Construction, Reno,* the skeleton of an eerily lit home under construction is nestled into the dark mountains: ironically the desolation and alienation are magnified.

Park City (1980) documents the conversion of an abandoned mining town into a ski resort and bedroom community east of Salt Lake City in Utah's Wasatch Mountains. Other series include *San Quentin Point* (1981-83) and his recent project, the development of Candlestick State Recreation area in South San Francisco. The artist currently lives in Sausalito, California, and Milan, Italy. In addition to his photographic activities, he has published criticism and curated exhibitions on photography.

1. Lewis Baltz, "Konsumerterror: Industrial Alienation," *Aperture*, 96 (Fall 1984), p. 4.
2. Robert Adams, rev. of *The New West*, by Lewis Baltz, *Art in America*, 63, No. 2 (Mar.-Apr. 1975), 41.

Richard Long
British, b. 1945

A Circle in Africa: Mulanje Mountain Malaŵi, 1978. Gelatin silver print, 40.2 x 58.7 cm on mount 85.5 x 121.0 cm. Title and date with red pencil on mount lower center: *CIRCLE IN AFRICA /* (pencil) MULANJE MOUNTAIN MALAŴI *1978*; pencil on verso mount upper center: *Richard Long 1978.*

Gift of RSM Co., 1985.340.

Provenance: Sperone Westwater Fischer, New York; RSM Co., Cincinnati (from Sperone Westwater Fischer, 1978).

Exhibitions: Gabrielle Jeppson, *Richard Long,* (Cambridge, MA: Fogg Art Museum, 1980), p. 10, illus. p. 4; The Contemporary Arts Center, Cincinnati, *The RSM Collection,* 1981, n. pag.; Cincinnati Art Museum, *New Visions in Contemporary Art: The RSM Company Collection,* 1986, p. 46, illus. p. 54.

Bibliography: *Made by Sculptors.* Amsterdam: Stedelijk Museum, 1978, illus. n. pag.

> The source of my work is nature. I use it with respect and freedom. I use materials, ideas, movement and time to express a whole view of my art in the world. I hope to make images and ideas which resonate in the imagination, which mark the earth and the mind.[1]

The primary source of inspiration for Richard Long's art is landscape, though he avoids conventional pictorial imagery. Long's aesthetic is abstracted from cultural and anthropological contexts and wedged between conceptual and minimalist art. Long's walks, markings, and documents form a language system to express a spiritual relationship to nature.

His walking projects began in 1967 with a piece titled *A Line Made by Walking* while he was still a student at St. Martin's School of Art in London (1966-68). The conceptually predetermined walk produced a straight trail of bent grass which he recorded photographically, thus stressing direct involvement with time, place, and distance. He writes:

> I like the idea of using the land without possessing it.
>
> A walk marks time with an accumulation of footsteps. It defines the form of the land. Walking the roads and paths is to trace a portrait of the country. I have become interested in using a walk to express original ideas about the land, art, and walking itself.
>
> A walk is also the means of discovering places in which to make sculpture in 'remote' areas, places of nature, places of great power and contemplation. These works are made of the place, they are a re-arrangement of it and in time will be re-absorbed by it. I hope to make work for the land, not against it.[2]

Characteristic of his work is the conscious use of the character and condition of the terrain to make the sensations of space, scale, or isolation tangible and accessible.

A spiritual descendent of the nineteenth century's great solitary travelers, Long has traversed a number of continents over the last twenty years. His walks are structured according to specific locations, distances, and durations. Using indigenous materials such as stones, sticks, chalk, slate, or wood, he erects configurations as evidence of his intrusion in remote places. He selects simple geometric forms including lines, circles, crosses, and spirals, which are universally recognizable and were used ritualistically by many ancient cultures. Text and maps as well as photographs each play a role in documenting Long's ephemeral art.

A Circle in Africa is as much a souvenir of a site sculpture as it is a metaphor of place. Richard Fuchs comments:

> Once, going up a mountain in Africa with the idea of making a circle of stones, Richard Long found that there were no stones lying around because there was no ice on that mountain to break up the slabs of rock. There were, however, regular lightning storms in which the tall standing cacti growing there were hit and scorched. So he made a circle with pieces of scorched cactus. . . .[3]

Long's dramatic design, suggestive of a giant crown of thorns, provides spatial articulation to an otherwise bleak and featureless landscape. This straight, uncropped photograph includes ominous, billowing clouds. The photograph and laconic caption are all that remain as permanent evidence of the entire experience. Although this image was not editioned, a variant was illustrated in the catalogue accompanying the retrospective organized by the Solomon R. Guggenheim Museum in 1986.[4] According to the artist, complementary works to this piece include *Circle in the Andes* (1972), *A Circle in Ireland* (1975), *A Circle in Alaska* (1977), and *Walking a Circle in Ladakh Northern India* (1984).[5]

1. Richard Long, "Words after the Fact 1982" in R. H. Fuchs, *Richard Long* (New York: The Solomon R. Guggenheim Museum, and London: Thames and Hudson, 1986), p. 236.
2. Fuchs, p. 236.
3. Fuchs, p. 101.
4. Fuchs, illus. p. 122.
5. Richard Long, Documentary questionnaire to KS, 5 July 1985.

Marie Cosindas
American, 20th century

The Cincinnati Art Museum Centennial Still Life, 1980. Dye-imbibition (Kodak Dye Transfer) reproduction print from dye diffusion-transfer (Polacolor II) print, 35.5 x 28.2 cm on 50.8 x 40.3 cm. Signed with black ballpoint in composition lower right: *Marie Cosindas*; signed and dated in margin lower right: *Marie Cosindas/1980.*

Cincinnati Art Museum Centennial Commission (Centennial Fund), 1980.165.

Exhibitions: Kristin L. Spangenberg, *Color Photographs by Marie Cosindas*, Cincinnati Art Museum, 1981, n. pag., illus. cover; Cincinnati Art Museum, *Cincinnati Art Museum Photography Collection*, 1981-82.

To celebrate the Cincinnati Art Museum's 100th Anniversary in 1981, the internationally known color portrait and still life photographer, Marie Cosindas, was commissioned to create an original image for the Centennial poster. The subject was left to the artist's determination.

Cosindas arrived on Thursday, July 17, 1980, with her equipment in one hand-held bag. She immediately set about familiarizing herself with the collection by touring the galleries and discussing important art objects with the professional staff. To study the quality of illumination in the galleries she spent the afternoon photographing individual works *en situ.* By noon the following day Cosindas had decided to construct a still life of art objects which would represent the breadth, strength, and diversity of periods, nationalities, and objects in the Museum's permanent collection. The natural light of the courtyard off the Terrace Room made it the ideal location to assemble the multi-million-dollar still life.

Beginning with an oriental carpet and paintings by Thomas Gainsborough, Frans Hals, and Marc Chagall, Cosindas directed the arrangement of the still life. Each piece, including a French twelfth-century wooden Virgin, a Persian ceramic seated lion, and the gold libation dish of Darius, was carefully selected for size, shape, pattern, and color that would have a special affinity with the Polacolor medium. Periodically, Cosindas would disappear beneath the black cloth placed over her old Linhof box camera supported by a tripod, insert a Polaroid Land film holder, click the shutter, pull the film, and watch the 60-second or more development time. Photographs of each stage were examined with a magnifying glass; then further adjustments, additions, or subtractions were requested.

On Saturday, July 19, Cosindas made her final tour through the galleries, selecting smaller pieces to embellish the still life. Among them were a French twelfth-century Limoges enamel crozier, a Rookwood ewer, and a Sioux knife sheath. By early afternoon all the objects were assembled and it became a matter of adjusting angles, rearranging positions, and trying different filters while waiting for the sun to drop low enough to provide a soft reflected light off the courtyard wall. By photographing her subject in soft, natural light and controlling exposure and developing time, she created deep tones and enhanced color contrasts. *The Cincinnati Art Museum Centennial Still Life* surveys one hundred years of collecting and reflects the specific tastes and aesthetic choices of donors, directors, and curators. As part of the commission contract, the Museum received a dye-imbibition print made from the original Polaroid.

A Boston-born painter-turned-photographer, Marie Cosindas attended the School of Fashion Design and studied painting and graphics at the Boston Museum School. Her early professional activities were as an illustrator, textile designer, and color coordinator. In 1959 she bought a camera to collect ideas for paintings while in Greece. Intrigued by the creative potential of the camera image she attended the Ansel Adams workshop in 1961. It was he who observed that she thought in color rather than in black and white.

In 1962 the Polaroid Corporation asked Cosindas to experiment with its first Polaroid material. Her first highly productive period began in 1965 with the use of the new large format 4 x 5-inch Polacolor film. By extending the exposure and development times, and controlling light and color filtration, she achieved her desired results. The artist's portraits of sitters from all walks of life span several generations, from the adolescent Nicole to the grande dame of photography, Imogen Cunningham. Each portrait reveals the force of their individuality and human dignity. In the late 1960s she received two major portrait commissions, *The Dandies* (1967) for *Camera* magazine and *The Grande Dames of Couture* (1969) for *Life.*

After a period of relative inactivity in the early 1970s, Cosindas turned to the new 8 x 10-inch Polacolor format in 1976, which resulted in a new body of complex still lifes and double portraits. In 1978, *Marie Cosindas: Color Photographs* was published with an essay by Tom Wolfe. Over the last two decades she has had numerous major one-woman exhibitions at the Museum of Fine Arts, Boston, The Museum of Modern Art, New York (1966), Festival of Two Worlds, Spoleto, Italy (1967), The International Center of Photography, New York (1978), the Cincinnati Art Museum (1981), and The Santa Barbara Museum of Art (1986). During the last several years, Cosindas, who lives and works in Boston, has turned her attention to even larger format Polaroid portraits.

Bernhard and Hilla Becher

German, b. 1931 and b. 1934

Water Tower Typology (1980). Nine gelatin silver prints, ea. approx. 40.5 x 30.8 cm on mounts 50.8 x 40.9 cm. Inscribed with pencil on verso ea. mount: *A(1-9)*; A 1: (layout diagram) / *Bernhard Becher / Hilla Becher.*

Gift of RSM Co., 1985.326:1-9.

Provenance: Sonnabend, New York; RSM Co., Cincinnati (from Sonnabend, 1981).

Exhibitions: The Contemporary Arts Center, Cincinnati, *The RSM Collection*, 1981, n.p., illus.; Herron School of Art Gallery, Indianapolis, *RSM: Selections from a Contemporary Collection*, 1983, n. pag., illus.; Judith Russi Kirshner, "The RSM Company Collection of Contemporary Art," in *New Visions in Contemporary Art: The RSM Company Collection* (Cincinnati Art Museum, 1986), pp. 13, 36, illus. p. 52.

Bernhard and Hilla Becher are cultural anthropologists, collecting domestic and industrial architecture sifted from shards of passing civilizations. Bernhard Becher was born in Siegen, West Germany, on August 20, 1931. He studied painting and lithography at the Staatliche Kunstakademie, Stuttgart (1953-56) and typography at the Staatliche Kunstakademie, Düsseldorf (1957-61). His collaborator, the photographer Hilla Becher, was born Hilla Wobeser in Potsdam, West Germany, on September 2, 1934. She studied photography in Potsdam and at the Staatlichen Kunstakademie, Düsseldorf. Hilla's strong background in photography and Bernhard's interest in photographing structures as studies for paintings drew the two art students together. They started working as a team about 1959 and were married in 1961. Bernhard was appointed professor of photography at the Düsseldorf Kunstakademie in 1976 when photography became part of the curriculum.

Impassioned collectors of industrial artifacts, the Bechers have systematically photographed comparative "typologies." Since 1959 they have catalogued lime kilns, cooling towers, blast furnaces, water towers, grain elevators, and timbered houses in Germany, Holland, France, Belgium, Great Britain, and the United States. They find photography an efficient means of transmitting the physical form of a structure to a two-dimensional medium with minimal intervention. Many aspects of their procedure are determined by their desire for structures to speak for themselves. The photographs are arranged in six-to-fifteen grid units, combining physical resemblance with individual identity, and contrasting universal accommodation to function with particularization according to locale, period, and material.

The nine photographs selected for *Water Tower Typology* represent structures in West Germany.[1] The towers are uniformly documented: each is full face, centered in the frame, and unobscured by such picturesque touches as clouds, shadows, sun, smoke, and people. The edifices take on an iconic presence silhouetted against a neutral sky. Purged of emotive content and stripped of artistic frills, this decontextualization makes each the perfect model of industrial and architectural photography. The intent is to record rather than interpret. Conforming to the Bechers' normative approach, *Water Tower Typology* is keyed to perception of programmatic differences in significant details. The serialization of these straightforward images of monuments – or ruins – of industrial capitalism is comparable to the intellectual pursuits of contemporary post-minimal conceptualists. Their interest in recycled architectural form celebrates the obsolescence of industrialism and the transience of the seemingly modern.

The compilation of such a programmatic catalogue is comparable to the documentary mission of the early French calotypists Baldus, Le Gray, and Le Secq, who were commissioned by the Commission des Monuments Historiques to record all significant architecture in France. Likewise the Bechers' enumerative vision parallels the atlas of types compiled by August Sander for *Menschen des 20. Jahrhunderts*. The Bechers' work has received solo exhibitions in Germany since 1963 and in America since 1968. In 1977 it appeared in the prestigious *Documenta 6*, Kassel, and *Bienal de San Paulo*.

1. Hilla Becher, Letter to KS, 20 Dec. 1986. The locations of the water towers left to right (row one): 1. Bonn, West Germany. 2. Koblenz, West Germany 3. Köln, West Germany. (row two): 4. Frankfurt, West Germany. 5. Sesen, West Germany. 6. Hagen, West Germany. (row three): 7. Oberhausen, West Germany. 8. Nienburg, West Germany. 9. Bielefeld, West Germany.

Cindy Sherman
American, b. 1954

Untitled #115, 1982. Chromogenic development (Ektacolor) print, 113.6 x 76.1 cm on 127.9 x 76.1 cm. Signed and dated with pencil on verso: *Cindy Sherman 1982 / 7/10.*

Gift of RSM Co., 1985.324.

Provenance: Metro Pictures, New York; RSM Co., Cincinnati, (from Metro Pictures, 1983).

Exhibitions: Cincinnati Art Museum, *New Visions in Contemporary Art: The RSM Company Collection,* 1986, p. 46, illus. color p. 43.

Andy Grundberg writes:

> The self-conscious awareness that we live in a camera-based and camera-bound culture is an essential feature of the photography that came to prominence in the art world of the early 1980s and has come to be called postmodernist. Generally speaking, postmodernist art accepts the world as an endless hall of mirrors, as a place where all we *are* is images and where all we *know* are images. There is little room in the postmodern world for a belief in the originality of one's experience, in the sanctity of the individual artist's vision. . . .[1]

Cindy Sherman comes from a generation of photographers who grew up in the late 1950s and 1960s and whose consciousness was largely formed by mass-media images. It is not surprising that she is concerned about the mechanisms and structures of photographic representation rather than traditional values of fine art photography. Her imagemaking strategy is appropriated from media sources – TV, films, newspapers, and pulp magazines.

Born in Glen Ridge, New Jersey, in 1954, Cindy Sherman received a bachelor of arts degree from the State University, Buffalo, New York, in 1976. A series of approximately seventy-five black and white photographs, referred to as "Untitled Film Stills" and executed between 1977 and 1980, was her first important work. As actress, designer, scenarist, director, and photographer, she distilled a visual lexicon of female cultural stereotypes in these one-woman, one-frame melodramas. These high contrast and grainy black and white images resembling promotional stills are instantly recognizable as being culled from a reservoir of mass-media imagery of the 1950s and 1960s. Sherman has a knack for projecting feminine vulnerability in her forgettable heroines – Hollywood film starlets, suburban housewives, and pubescent bobby-soxers – who perform vaguely dramatic things in ambiguous situations. She borrows make-up, costumes, and props for her wide array of personalities and situations from the prefeminist decades. Emotional content, she argues, is important:

> I want that choked-up feeling in your throat which maybe comes from despair or teary-eyed sentimentality: conveying intangible emotions. A photograph should transcend itself, the image its medium, in order to have its own presence. These are pictures of emotions personified, entirely of themselves with their own presence – not of me. The issue of the identity of the model is no more interesting than the possible symbolism of any other detail. . . . I'm trying to make other people recognize something of themselves rather than me.[2]

She invites speculative psychological interpretation of her characters by intentionally leaving the photographs untitled.

In 1980 Sherman shifted her content and style to further explore the extent to which she could project herself into a role. She began to use color photography and a progression of larger formats. Stimulated by a proposed project in 1981-82 to do takeoffs on centerfolds for *Artforum,* she experimented with an almost life-size format. She moved the camera closer, severely cropping the figure, thereby heightening the psychological drama, pictorial depth, and theatrical intensity. In *Untitled #115* she explores contemporary femininity. Props are reduced to tank top, hair band, and cigarette; she wears minimal make-up. Facial expression, body language, and positioning suggest greater intimacy and emotional content. Despite the appearance of reality, we know that the image is fictional, with Sherman disguised as a protagonist who acts, loves, and lives. The artifice of the subject is reinforced by the dramatic chiaroscuro lighting with theatrical tints.

Recently she has made larger-than-life prints. Commissioned by the Madison Avenue boutique Dianne B., she has explored the stereotypes of fashion, creating images with power, anger, and humor. She uses artful make-up, enigmatic expressions, and artificial poses to mock high fashion advertising. Engaged by *Vanity Fair* in 1985 to do a series of photographs about fairy tales, she further extended her investigations into the transformation and metamorphosis of the female self. Her disquieting and nightmarish images of witches, monsters, and victims delve into the sinister side of timeless folk legends and archetypes. This new work reaches into the collective unconscious, grabbing the viewer at the most visceral level.

Since her debut in 1980, she has had solo exhibitions in Houston (1980), New York (almost yearly since 1981), Cincinnati (1982), Akron, Ohio (1984), and Munster, West Germany (1985). Her meteoric presence has been felt at the *Biennale,* Venice (1982), *Documenta 7,* Kassel, West Germany (1982), and Biennial, Whitney Museum of American Art, New York (1985), where she had a major one-woman exhibition in 1987.

1. Andy Grundberg, "Camera Culture in a Postmodern Age," in Andy Grundberg and Kathleen McCarthy Gauss, *Photography and Art: Interactions since 1946* (New York: Abbeville Press, 1987), p. 207.
2. Cindy Sherman, Statement, in Rudi H. Fuchs, ed., *Documenta 7* (Kassel, West Germany: [1982]), I, p. 411.

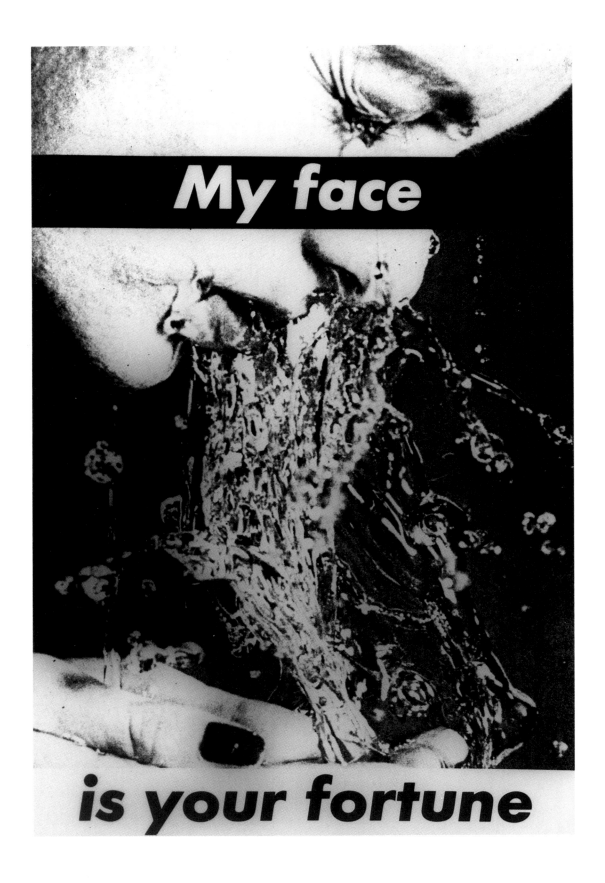

Barbara Kruger

American, b. 1945

Untitled (My face is your fortune), 1982. Gelatin silver print, 183.0 x 119.9 cm. Legend across upper center: *My face*; across bottom: *is your fortune.*

Gift of RSM Co., 1985.319.

Provenance: Annina Nosei Gallery, New York; RSM Co., Cincinnati (from Annina Nosei Gallery, 1983).

Exhibitions: Daniel Wolf, Inc., New York, *Photographs by/Photographs In*, 1982; Judith Russi Kirshner, "The RSM Company Collection of Contemporary Art," in *New Visions of Contemporary Art: The RSM Company Collection* (Cincinnati Art Museum, 1986), pp. 14, 39, illus. p. 54.

Barbara Kruger is a conceptual artist and film and television critic. She was born in Newark, New Jersey, on January 26, 1945. After only two years of advanced study at Syracuse University, New York (1967-68), and Parsons School of Design and the School of Visual Arts, New York (1968-69), Kruger became a graphic designer and picture editor for various Condé Nast publications. Her first artwork of the early 1970s gravitated to painting and stitching. By 1978 she transformed her labor as a designer into her work as an artist by turning to photographs and words. Her work resides at the crossroads of art and mass media image-making, and between image and language. She writes:

> I would rather say that I work with pictures and words because they have the ability to determine who we are, what we want to be, and what we become.[1]

Since the early 1980s Kruger has integrated appropriated photographs with provocative texts to expose and depose sexual stereotypes. From her experience in graphic design, Kruger derived a thorough understanding of the potential potency of prepackaged photographic material to create sexual roles and social mores which deliberately promote a product line. Kruger has discarded the traditional intentions and aspirations of art photography, and utilizes instead the strategies of public address appropriate to mass media advertising and image making. The interplay of figure and captions calls attention to the subliminal messages of camera-based popular culture. Kruger's pictures do not illustrate the words, and the words do not describe the images. She scavenges black and white images from old magazines, photo annuals, and how-to handbooks rather than taking her own images, a signature of postmodern technique. She radically crops, enlarges, and recontextualizes these selected pictures into theatrically compelling, seductive, or threatening images, as in the close-up facial shot of *My face is your fortune.* She sends her layouts to a photo studio for enlargement to her specifications and frames each in her signature red frame.

Kruger attacks the accepted order of gender relationships by overlying her own aggressive language of declarative or accusative one-line phrases. The classic gender-based code of power and passivity objectifies women, through the power of the media, female stereotypes, and occasionally art. This view is in keeping with contemporary feminist theory that sex is biologically defined while gender is socially constructed.[2]

By juxtaposing figures and figures of speech, Kruger intentionally confronts her viewers with the ongoing hypocrisy and disinformation of media imagery. Her compelling images invite women to identify with the mute female victim of exploitative consumerism controlled by men and in the process extricate herself from the exposed libidinal economy. The voice in *My face is your fortune* is given over to the victim. The male viewer is directed to gaze at the passive female whom he would have traditionally objectified and mastered by virtue of the power of his gaze. If he does not perceive the worship of false gods, who value appearance over human worth, he himself is now a victim of his own capitalism.

Since 1979 Kruger has had one-woman exhibitions in New York (almost yearly), Australia, Switzerland and France (1984). Selected group exhibitions include *19 Emergent Americans* at the Solomon R. Guggenheim Museum, New York (1981); *Biennale*, Venice; *Documenta 7*, Kassel, West Germany (1982); and *New Vision of Contemporary Art: The RSM Company Collection*, Cincinnati Art Museum (1986). The artist lives and works in New York.

1. Barbara Kruger in Jeanne Siegel, "Barbara Kruger: Pictures and Words," *Arts*, 61, No. 10 (June 1987), 19.
2. Barbara Kruger in Anders Stephanson, "Barbara Kruger," *Flash Art*, 136 (Oct. 1987), p. 55.

David Hockney
British, b. 1937

Graffiti Palace, New York, 1982. Photocollage of 129 chromogenic development (Ektacolor) prints, 101.6 x 127.9 cm on mount 121.0 x 144.8 cm. Inscribed with pen and white ink on mount lower center: *Graffiti Palace, N.Y. 4 Dec. 1982 David Hockney*.

John J. Emery Endowment, 1986.1027.

Provenance: Carl Solway Gallery, Cincinnati.

David Hockney is an internationally recognized photographer, painter, printmaker, draftsman, and stage designer. He was born in Bradford, Great Britain, in 1937. He studied at the Bradford College of Art from 1953 to 1957 and the Royal College of Art, London, from 1959 to 1962. Since 1968 he has used photography as an *aide mémoire* for his paintings. These amateur snap-shots chronicle his possessions, homes, and vacations, and form a diary of the friends, relatives, and lovers who have populated his paintings, prints, and drawings since the 1960s.

In 1982, in the wake of the preparations for his first exhibition drawn from his photo albums at the Centre Georges Pompidou, Paris, he realized the potential of the camera as a drawing medium rather than a mere recording device. He observed:

> It's neither an art, a technique, a craft, nor a hobby – it's a tool. It's an extraordinary drawing tool. It's as if I, like most ordinary photographers, had previously been taking part in some long-established culture in which pencils were used only for making dots – there's an obvious sense of liberation that comes when you realize you can make lines![1]

In just three months, starting in February 1982, he made more than 140 Polaroid grid collages using an instamatic Polaroid SX-70 camera. Between September 1982 and August 1986 he executed 231 additional photocollages using 35mm Nikon and Pentax 110 single-lens reflex cameras.

Hockney's concern is far from the monocular vision of "decisive moment" photography. He has remarked, "Photography is all right if you don't mind looking at the world from the point of view of a paralyzed cyclop – *for a split second*."[2] In his desire to move beyond traditional depictions of surface, time, and space he blithely rejects privileged moments of perception and conventional composition. His multifaceted, encyclopedic images of partial bits of intense looking reflect the control of subjective vision over the camera's mechanical limitations. Hockney's collages remind us that even in "normal" perception we do not seize a whole view instantaneously, but assemble it from an accumulation of glances over time which are continuously synthesized. He comments:

> I realized how much thinking goes into seeing – into ordering and reordering the endless sequence of details which our eyes deliver to our mind. Each of these squares assumes a different perspective, a different focal point around which the surroundings recede to background. The general perspective is built up from hundreds of micro-perspectives. Which is to say, memory plays a crucial role in perception.[3]

Hockney's conviction that visual experience is a composite of shifting views is clearly evident in his photocollage *Graffiti Palace* of Central Park, New York, made in December 1982. This middle-period landscape taken from one point of view shows his feet planted at the top of the stairway. One's eyes walk down the receding stairs toward the circular graffiti-covered edifice which looms in the mid-ground. The artist's play with conventions of illusionism and his choice of shifting focus, perspective, and vantage points wittily engage the eye and mind. The interactions, overlaps, and rhythmic articulations of the fractured images reinforce the sensual exploration of surface, time, and space.

Although Hockney decided not to sell any of his Polaroid collages, in mid-spring 1983 he undertook the publication of forty-two of his best photocollages. *Graffiti Palace* was executed in an edition of fifteen. The physical production of the collages was organized by Paul Cornwall-Jones of Petersburg Press, London, and managed by his assistant at that time, David Graves. New versions of the collages had to be composed to counter the unexpected variations in images and color as the result of the mass-produced one-hour printing used for the original photocollages. The artist selected a new Ektacolor print process guaranteed not to fade for at least fifty years. The prints were assembled on a lightly screen-printed diagram and framed with shapes which echo the forms they enclose. During the summer of 1983 simultaneous exhibitions of the entire series opened in New York, Chicago, Los Angeles, London, Zurich, and Tokyo.

1. Cited in Lawrence Weschler, "True to Life," *Cameraworks* (New York: Knopf, 1984), p. 13.
2. Cited in Anne Hoy, "David Hockney's Photo-Mosaics," *Art News*, 85, No. 8 (Oct. 1986), 91.
3. Weschler, p. 16.

(continued from page 91)

Stieglitz had been to Europe twice since 1890 and met with avant-garde painters. His new photographs reflected the influence of modern art. In strikingly modern subjects of skyscrapers, airplanes, and boats, he eliminated atmosphere and demonstrated a new concern for formal organization recorded with the clarity and directness of perception unknown to the pictorialists. With the exception of his own work, Stieglitz practically ceased to exhibit photography at "291." In a daring move he exhibited his own work at the time of the 1913 Armory Show as a way of testing its validity. In 1917, his final gesture as editor of *Camera Work* and director of "291" was to present the work of Paul Strand – demonstrating for the first time the abstract power of photography.

By 1917, as Stieglitz took up his own work again, it had become more objective, less iconic, and relatively subjectless. His use of space, form, and composition signaled his understanding of cubism. Three series dominate his work after 1917: photographs of Georgia O'Keeffe, New York skyscrapers, and clouds. In each series he tried to reconcile abstraction, inherent photographic characteristics, and his own vision. By the 1920s he succeeded in extracting the visual essence from his images which he termed "Equivalents." They were the culmination of his technical, formal, and expressive search for the understanding of "the idea photography." *Winter on Fifth Avenue* represents a first stage in his search for "idea photography" and charted the course for twentieth-century photography as a medium of integrity, independently capable of artistic expression.

1. Dorothy Norman, *Alfred Stieglitz: An American Seer* (Millerton, NY: Aperture, 1960), p. 36.

2. Edward Steichen, "50 Photographs by 50 Photographers," *Vogue*, 15 Aug. 1948, p. 186.

3. *Camera Work*, 12 (Oct. 1905), p. 2, Cincinnati Art Museum accession no. 1981.280.107.

4. Alfred Stieglitz, "The Hand Camera – Its Present Importance," *The American Annual of Photography* (1897), pp. 18-27, quoted in Nathan Lyons, ed., *Photographers on Photography* (Englewood Cliffs, NJ: Prentice-Hall, 1966), p. 110.

5. Beaumont Newhall, *The History of Photography from 1839 to the Present* (New York: The Museum of Modern Art, 1982), pp. 154-55. Newhall illustrated the comparison between a gelatin silver print from the entire negative in the George Eastman House collection with a cropped photogravure.

6. Weston J. Naef, *The Collection of Alfred Stieglitz: Fifty Pioneers of Modern Photography* (New York: Viking Press, 1978), p. 54.

7. Sarah Greenough, "Alfred Stieglitz and 'The Idea Photography'" in Sarah Greenough and Juan Hamilton, *Alfred Stieglitz: Photographs and Writings*, (Washington: National Gallery of Art and New York: Callaway Editions, 1983), p. 15. This recent book is the definitive analytical study on Stieglitz.

8. Greenough, p. 18.

(continued from page 109)

work received limited exposure until a 1971 retrospective organized by the Philadelphia Museum of Art which included this print of *Chair Abstraction*.[3] The artist died in Orgeval at the age of eighty-five.

1. Calvin Tomkins, *Paul Strand: Sixty Years of Photographs* (Millerton, NY: Aperture, 1976), p. 19.

2. Anthony Montoya, Letter to KS, 5 Aug. 1987.

3. Only one other print from this negative exists. This palladium print made in 1916 is in the collection of the San Francisco Museum of Modern Art (84.15). See Van Deren Coke, *Photography: A Facet of Modernism* (New York: Hudson Hills Press, 1986), pp. 26, 28, illus. p. 27.

(continued from page 189)

work has appeared in *The Journey of the Spirit After Death* (1971), *Take One and See Mount Fujiyama and Other Stories* (1976), and *Real Dreams* (1976). In the introduction of *Real Dreams*, Michals has recorded his feelings, perceptions, and philosophies:

> I use photography to help me explain my experience to myself. . . . I am the limits of my work. . . . I believe in the imagination. What I cannot see is infinitely more important than what I can see. . . . When you look at my photographs, you are looking at my thoughts. . . .[5]

1. Carter Ratcliff, "Review," *Artforum*, XI, No. 4 (Dec. 1972), 91.

2. Andy Grundberg, "Duane Michals at Light", *Art in America*, XI, No. 4 (May 1975), 79.

3. Duane Michals quoted in "Biographys," *Camera*, 51, No. 2 (Feb. 1971), 31.

4. Duane Michals, "Duane Michals," *Album*, 7 (Aug. 1970), p. 34.

5. Duane Michals, *Real Dreams* (Danbury, NH: Addison House, 1976), n. pag.

Glossary

This glossary is provided to aid in understanding photographic processes and terms cited in the catalogue. It is not intended to be comprehensive. A brief historical note introduces each process or term, citing principal originators and dates when known. Often a process evolved over a period of time – from suggestion through experimentation to practicable realization – through the work of one or more individuals. Only a general outline of the processes is given since they were often subject to modifications and variations. It is extremely difficult to set terminal dates for a particular process, since usage continued by some adherents and in various geographical areas long after it had fallen from general use. Today a few of the processes are now experiencing a revival for their artistic potential.

Additive color processes. Stimulation of the eye's receptors with combinations of pure red, green, and blue light will produce a range of color sensations including white. Because colored lights are added together to make white, this is known as additive color reproduction. In 1861, the fundamentals of the additive three-color process were demonstrated by the British scientist James Clerk Maxwell (1831-1879). He made color-separation negatives of a tartan ribbon by recording the subject separately using three primary color filters. Positive lantern slides formed from the negatives were separately projected to a common focal point through their corresponding color filters, thus recreating by additive synthesis the hues of the original tartan ribbon. Maxwell's emulsions were not panchromatic (see below), but were only sensitive to blue and ultraviolet radiation. The experiment succeeded because of differences in such reflectances and the transmittances of his filters of which he was unaware.

In 1904 the first practical color-screen process employing the additive principle was developed by the French scientists Auguste and Louis Lumière. Their Autochrome process was released commercially in 1907. A random color screen was formed on a glass plate by starch grains dyed red, green, and blue. Light was transmitted through the screen to expose the panchromatic black and white emulsion beneath (panchromatic means sensitive to all colors of the spectrum). Each dyed starch grain acted like a tiny red, green, or blue separation filter. The negative black and white image was developed, then reversal-processed by re-exposure and re-development to form a positive transparency. When the Autochrome plate was viewed by transmitted light, or projected, the positive silver image acted as a mask. Wherever the black and white image was thin, light was transmitted through the screen of adjacent colored starch grains; these were so small that they fused on the retina of the viewer into a continuous image which reproduced the color of the original subject. For thirty years until the advent of Kodachrome, the Autochrome and other additive color processes dominated the field of color photography. Although the additive process was used for early color photographs, the subtractive process (q.v.) proved to be more practical and has become the basis of modern color photography.

Albumen print. Egg white (albumen) was employed as a vehicle to coat glass plate negatives in the 1850s and to coat printing papers between 1850 and the 1890s. In 1848, Abel Niépce de Saint-Victor (1805-1870) developed the first practical albumen-on-glass process. His albumen negative, however, found little usage outside France because Archer's more sensitive collodion negative (q.v.) soon rendered it obsolete. In 1850, the French photographer Louis-Désiré Blanquart-Evrard (1802-1872) introduced albumen printing paper. The smooth, glossy albumen coating on the paper surface recorded fine detail more precisely and produced greater visual depth than the matte image impregnated in the paper fibers made by the salted-paper process. Although albumen prints in the early 1850s were produced from paper negatives, their excellent compatibility with Archer's collodion (wet plate) negatives, introduced in 1851, led to their exclusive use after 1855.

To make albumen printing paper, a thin, smooth paper stock was coated with a mixture of egg albumen and ammonium or sodium chloride, then dried. The user then sensitized the sheet by brushing it with or floating it on a dilute solution of silver nitrate, thus producing light-sensitive crystals of silver chloride in the albumen layer. Factory-coated albumenized papers were commercially available by the mid-1850s. After exposure, the latent image was printed-out by further exposure to bright sunlight in a printing frame until fully formed. It was then washed, toned, and fixed with hypo. Gold-toning became a universal practice, shortly after the introduction of albumen paper, to alter the image color from a reddish brown to the more desirable purplish brown.

Today it is rare to see albumen prints which retain their original rich depth of color and contrast. Despite gold-toning, albumen prints undergo two forms of age discoloration: overall yellow staining of the albumen coating, most apparent in the light areas such as the sky and skin tone; and changes in darker areas to a warmer brown tone. It is common to find an albumen print with a halo-like band of fading around the outer edge.

Ambrotype. Frederick Scott Archer (1813-1857) and Peter W. Fry devised the first collodion positive in 1851 as a variation on Archer's collodion negative. Ambrotype is the American name for a collodion positive on glass. The term was first used by the American James Ambrose Cutting (1814-1867) in 1854 in his British patent for a method of sealing the cover glass to the collodion positive with balsam of fir.

Although the ambrotype appears positive in reflected light it is actually a weakly exposed and developed collodion negative backed with either black varnish or dark fabric, or occasionally made on dark glass. Like the daguerreotype, for which it became a low-priced substitute, the ambrotype is a one-of-a-kind image. Ambrotypes were also hand-colored and generally sold in the same types of miniature cases or frames as daguerreotypes. Ambrotypes can be easily distinguished from daguerreotypes because they do not produce a fluctuating positive and negative mirror effect when held

at different angles, and their surface support is glass, not highly polished metal. The ambrotype was popular for portraits from the early 1850s through the 1860s.

Blanquart-Evrard process. Louis-Désiré Blanquart-Evrard, an amateur photographer and inventor, was the first major early French photographic publisher. In 1847, he introduced modifications of Talbot's calotype process which yielded more reliable prints. Blanquart-Evrard's introduction of the albumen developing-out paper in 1850 marked the beginning of a new era for the negative-positive process. Between 1851 and 1855 he produced twenty-four publications illustrated with about 550 photographs at his printing factory, Imprimerie Photographique, near Lille. Among the professional and amateur photographers involved in the publications were Charles Marville, Henri Le Secq, Auguste Salzmann, and John Bulkley Greene (see p. 40).

Unlike Talbot's calotype process, Blanquart-Evrard floated the paper on or immersed it in successive baths of potassium iodide and silver nitrate, allowing the solutions to permeate the paper. The dried paper could be stored until needed. Immediately before use it was floated on a sensitizing bath of silver nitrate and nitric acid. It was then exposed between two sheets of glass, wet, or, after 1850, dry, with the silver salts suspended on a layer of whey and egg albumen. Exposure times were reduced to about one-quarter that of the calotype.

Mass production at Blanquart-Evrard's Imprimerie Photographique was made possible by developing positive prints like negatives, thus shortening the exposure to a few seconds. The albumen printing paper which he introduced in 1850 contained gelatin, potassium bromide, and potassium iodide. It was sensitized in a bath of silver nitrate after fuming over dilute hydrochloric acid. Once dried, it was exposed to daylight under a paper negative in a printing frame until the image became slightly visible (three to twenty seconds). It was developed in a solution of gallic acid, then fixed in two baths of sodium thiosulphate (hypo), and gold-toned. After extended washing, the prints were dried in sunlight, which changed their color from reddish-brown to slate gray.

Cabinet cards and similar formats. In 1862, a large format card mount was introduced by C. W. Wilson for landscape photographs. The London photographer F. R. Window, of Window and Bridges, suggested in 1866 that this new size, suitably proportioned for group portraits and fashionable crinolines, might revitalize the dwindling market for cartes de visite. The cabinet card, measuring 16.5 x 10.8 cm (6½ x 4¼ inches), accommodated a print approximately 14.0 x 10.2 cm (5½ x 4 inches) made by a variety of photographic processes. These cabinet-size portraits, as well as topographical and genre subjects, were assembled in albums until the early twentieth century.

Within a decade of the introduction of the cabinet card, thicker mounts in various sizes and styles were introduced which could be displayed framed on the wall or standing upright on a piano. Among the new sizes were the "promenade mount," 21.0 x 10.2 cm (8¼ x 4

inches), introduced about 1875, and the "panel mount," 33.1 x 19.1 cm (13 x 7½ inches), in use by 1880. All of these mounts could be embossed or imprinted with the photographer's name, and the backs often carried elaborate designs advertising the studio. New York photographers like José Maria Mora and Napoleon Sarony (see p. 80) were famous for their elegantly presented portraits of famous personalities which were collected during the late nineteenth century.

Calotype process. The calotype process was the first practical negative-positive photographic process on paper. This process was an improvement by William Henry Fox Talbot on his earlier salted-paper process which he called "photogenic drawing." Talbot's discovery of the "latent image" and its chemical development in late September 1840 led to his February 8, 1841, patent of the calotype process. To form the calotype negative, he chemically developed the latent image rather than printing it out in light as he had done in his earlier photogenic drawing process. This new method required much shorter exposure time – around a minute – making portraiture possible.

The calotype negative was prepared by successively coating potassium iodide and silver nitrate on fine writing paper. The paper was then sensitized with a solution of gallo-nitrate of silver (Talbot's name for a solution of silver nitrate, gallic acid, and acetic acid). The light-sensitive paper was exposed in a camera for less than a minute until a latent image was formed. This was developed with the same gallo-nitrate of silver solution, washed and then fixed with sodium chloride or potassium bromide. In 1843, Talbot adopted hot sodium thiosulfate for fixing. The color of the calotype negative ranges from neutral gray to brownish black.

To obtain positive prints, Talbot printed his calotype negative in contact with a sheet of salted paper prepared by the method described in his earlier photogenic drawing process. Positives were printed out without development. To minimize the loss of detail through the paper fibers, the transparency of the calotype negative was often improved by waxing.

The invention of the calotype formed the basis of today's negative-positive photographic processes. To popularize his process, Talbot published two photographically illustrated books, *The Pencil of Nature* in 1844 and *Sun Pictures in Scotland* in 1845 (see p. 10). During the first decade, after the invention of the process, Talbot vigorously enforced his British patent rights and thus unfortunately prevented new developments. Outside England, the Scottish photographers Hill and Adamson (see p. 12) were the major exponents of the calotype process. The introduction of the collodion process in 1851 forced Talbot to relax his patent rights in 1852.

Camera obscura. The camera obscura was first described by a tenth-century Arabian scholar called Ibn Al-Haitham. As its Latin names implies, it was literally a dark room, with a tiny hole in the wall through which light passed to the opposite surface to form an inverted image of the exterior. High Renaissance artists such as Leonardo da Vinci used the camera obscura for accurate rendition of

perspective and scale. By the eighteenth century it had evolved into a portable box with a lens, mirror, and ground-glass screen, from which images could be traced. All early inventors of photographic processes used small portable variations of the camera obscura for camera design.

Carbon process. The early forms of the carbon method, a bichromate process, were invented by the Frenchman Alphonse Louis Poitevin (1819-1882) in 1855 and the Englishman John Pouncy (ca. 1820-1894) about 1857. In 1864 the Englishman Joseph Wilson Swan (1828-1914) patented the first practicable carbon transfer process and commercially released his perfected carbon tissue in 1866.

The tissue consisted of a layer of pigmented gelatin on a temporary support. Carbon black was a popular pigment (hence the name), but any pigment could be used. The carbon tissue was sensitized in a bath of potassium bichromate. It was then exposed to daylight through a negative in a printing frame. Light passing through the negative hardened the gelatin, rendering it water-insoluble in proportion to the amount of light which struck the carbon tissue. The carbon tissue remained soluble in those areas protected from light by the dense portions of the negative. Since the exposed areas were on top, development was most effective from the back. Before development, the issue was transferred face down to a new support. It was then immersed in hot water and the soluble gelatin washed away. The left to right reversal of the image produced by this method could be corrected by a second transfer to a final sheet. The advantage of carbon prints over albumen prints was that they were permanent and did not show signs of fading or deterioration. Carbon prints have a fine tonal range and sharp details, exemplified in the work of Thomas Annan.

Carte de visite. A mounted photograph the size of a visiting card became an extremely popular format for portraiture in the 1850s and 1860s. In 1854, the Frenchman André-Adolphe-Eugène Disderi (1819-1889) patented a method for exposing multiple carte de visite-sized images on a single wet-collodion negative, thus making it simpler and cheaper for photographers to produce this format. A four-lens camera with a shifting back plate soon became standard apparatus.

The craze for collecting celebrity and family carte de visite portraits, which were kept in albums, lasted from 1859 to 1866. Although mounted photographs were predominately albumen prints, carbon, collotype, and woodburytype prints were also found in this format. The cards measured approximately 10.2 x 6.4 cm (4 x 2½ inches) and carried a slightly smaller photograph. Mounts for these mass-produced photographs frequently displayed the name and address of the studio on the verso as part of an ornamental design. American cartes de visite made between September 1864 and August 1866 carry a tax stamp on the back. Although they were made until the 1880s, the larger cabinet card replaced them in popularity about 1866.

Cases and cased photographs. Daguerreotypes and ambrotypes were almost always presented in cases; tintypes were frequently cased as well. A cased photograph generally consists of the photographic plate (daguerreotype, ambrotype, or tintype), a decorative metal window mat, a covering sheet of glass, and a decorative metal frame (known as a preserver) which binds the other pieces together by folding around their edges. Frequently a gummed paper sealing tape was used to bind the layers together under the preserver. The glazed artifact was then placed in a hinged case constructed of thin wood, covered with embossed paper or leather. Papier mâché cases inlaid with mother-of-pearl were infrequently used. The cases opened like books, with the photograph on the right side and a satin or velvet lining on the left. Occasionally the lining was embossed or stamped with the photographer's or manufacturer's name.

In 1854 an American daguerreotypist, Samuel Peck, patented a case made from a thermoplastic composition of sawdust, shellac, and black or brown pigment. This was one of the earliest uses of a plastic. The elaborately designed plastic "union" cases were formed in dies or molds. Decorative motifs or scenes depicted popular historic, patriotic, religious, or landscape subjects.

Because of the interchangeability of mat, preserver, and case, it is almost impossible to date a cased photographic image without other external evidence. In general, the greater the simplicity of design and detail in the mat and case, the earlier the date of the example. Later mats and cases became extremely ornate. Fortunately there is usually some evidence if the glazed artifact has been taken apart and a mat changed. One must also bear in mind that a studio might be using old inventory to mat and frame.

Chromogenic development processes. The most revolutionary breakthrough in subtractive color photography came in 1935 when two Americans, Leopold Mannes (1899-1964) and Leopold Godowsky (1902-1983), in collaboration with Kodak Research Laboratory personnel, developed the first single-exposure, multilayer, three-color film and process. The inventors side-stepped the problem of wandering dyes in the multilayer tripack layers by introducing dye-forming couplers into the developer. In their process, a color developing agent encounters exposed silver halide. The latter is reduced to a silver image and the agent is oxidized. The oxidized developing agent then reacts with a dye-forming coupler to form image dye at the development site. This coupling reaction forms the basis for almost all of today's extant popular color photography.

The Eastman Kodak Company in Rochester, New York, released Kodachrome movie film in 1935 and 35mm slide film in 1936. That same year the Agfa Company in Wolfen, Germany, introduced Agfacolor Neu which incorporated dye-forming couplers into the separate layers of the integral tripack, thus successfully realizing the 1912 patented proposal of the German chemist, Rudolf Fischer (1881-1957). An advantage of incorporated couplers was that the user could develop the color transparency film, whereas the external

couplers in Kodachrome required that the user return the film for processing. At the end of the Second World War, the patents for Agfacolor's manufacturing process were seized and publicly released. Many firms used the Agfa technology for their first-generation color materials. Today, color slides, negatives, and the majority of color prints are made by chromogenic development.

To produce negatives, prints, and color slides involves a series of chemically complex development steps. When an integral tripack emulsion is exposed to light, it forms a multilayered latent image. The silver halides in each of the three tripack layers record one of the primary light colors, red, green, or blue, creating three separate latent images. In most chromogenic materials, the couplers are incorporated in the emulsons during manufacture; however, in the case of Kodachrome, the couplers are introduced in the developing solution. From this point, different development procedures are used for color negative film, color print material, and color slide (reversal) film.

Color reversal film: In reversal materials, the final color positive is formed in inverse proportion to the exposure of halides to colored light reflected from the photographed object. Color transparencies (slides) are produced by complex, multi-step development processes. In the first step, the latent images in each layer are developed to a black silver negative with a monochrome developer. The undeveloped black and white negative emulsion areas are then "re-exposed" and developed. During the second processing the dyes are formed. The re-exposed silver halide is reduced to silver and the developing agent is oxidized. The oxidized developing agent couples with a coupler to form dye. The developer either contains the couplers, e.g., in Kodachrome, or it uses the incorporated couplers to form a multilayer positive image. Three fully dyed layers are produced in the areas where no light was originally recorded, and lesser amounts of dye in areas of partial exposure. Once the positive and negative silver images are bleached and fixed, only the transparent dye image remains. Cyan dye formed in the red-sensitive layer, yellow in the blue-sensitive layer, and magenta in the green-sensitive layer together create the final image. Thus light projected through this color transparency forms the primary color red where the magenta and yellow dye layers subtract green and blue light respectively. The entire color spectrum is thus produced by various combinations of the superimposed dyes.

In 1936, Kodak introduced Kodachrome 35mm slide film, which was the first integral tripack subtractive color slide film. The dye-forming couplers were contained in the developer. In 1946 Kodachrome was joined by Kodak Ektachrome 35mm film with incorporated couplers, similar to Agfacolor Neu slide film introduced in 1936. Today there are many brands of transparency film available. All except Kodachromes use incorporated couplers, e.g., Agfachrome and Fujichrome. By convention, the suffix "chrome" designates reversal, i.e. transparency, films. These transparency films can be printed directly on special color print

material – a dye-destruct paper such as Cibachrome – or on reversal papers.

Color negative film: In color negatives, the dyes form during the development of the latent images. Incorporated couplers are activated by the oxidized developing agent to form cyan, magenta, and yellow dyes in the three superimposed emulsion layers. In the color negative, light areas of the original appear dark and colors are complementary hues to the original subject. The silver image is bleached away leaving the dye image and the remaining silver halide is fixed. The use of a negative permits color adjustments in the production of the final print.

By convention, the suffix "color" is applied to negative-positive material. In 1942, the Eastman Kodak Company released Kodacolor roll film and Kodacolor paper, which were the first modern negative-positive materials to use the dye-coupler process. The negative material was replaced in the late 1940s by a new Kodacolor roll film for amateurs and Kodak Ektacolor sheet film for professionals with residual colored couplers that act as a mask (hence the orange-brown color) to compensate for the color recording deficiencies of the cyan and magenta image dyes, greatly improving the color reproduction in the print.

Color print material: Most modern color print papers contain incorporated couplers, which combine with the oxidized developing agent to create the image dyes. The image development process is identical to the negative process. A color print made by chromogenic development is contact-printed or enlarged from a color negative onto a white paper or film base with a tripack emulsion sensitive to red, green, and blue. As with the negative, the primary colors are recorded by complementary dyes. Where the negative has a cyan image (red in the original subject), it exposes the green and blue light-sensitive emulsion layers of the paper and produces magenta and yellow dyes, respectively, during development. The superimposed magenta and yellow dyes appear red to the viewer on the final print. The print represents the product of the colors and amounts subtracted from white light by the superimposed dye images of the negative. Paper can also be coated with a reversal emulsion to print from color slide (reversal) films.

In 1953, Kodak introduced an improved version of the 1942 Kodacolor paper. Between 1955 and 1958, it marketed a paper process called Kodak Color Print Material, Type C, which was replaced by Kodak Ektacolor paper. "Type C" is the name for a specific paper process. It is often incorrectly used today to refer to contemporary prints produced by the chromogenic development process. In 1968, Kodak introduced Ektacolor RC paper. This "resin coated" paper does not absorb processing chemicals or water, thus shortening the processing and washing times.

External color coupler film, such as Kodachrome, has always had excellent color stability. Early film and print materials made with incorporated dye-forming couplers lacked color stability and were

susceptible to fading under normal display and storage conditions. Recent research and development have improved dye stability.

Chronophotography. Chronophotography recorded continuous action in a series of still images for the purpose of analyzing movement. Special apparatus was required to record the changes in position at regular intervals at a speed faster than the human eye can comprehend. In 1870 the French physiologist Étienne-Jules Marey (1830-1904) first attempted to document the mechanisms of movement scientifically. Eadweard Muybridge (1830-1904) produced the first true chronophotographs in 1877 when he successfully photographed a trotting horse with all its feet off the ground. As it passed a battery of twelve cameras, the horse broke a series of threads triggering the cameras shutters electrically. The sequence of images in the chronophotograph record a complete stride. To convince skeptics, Muybridge devised a projection device, the Zoöpraxiscope, which reconstituted the movements in still photographs.

Challenged by the work of Muybridge, in 1882 Marey built several cameras in an attempt to record chronophotographs on one negative. His invention, a "photographic gun," recorded twelve exposures on one plate as it followed a body in motion. The multiple exposures created the unprecedented illusion of movement, in spite of the fact that for large subjects the contours appeared blurred as the result of partially superimposed images. Both Marey and Muybridge benefited by the newly perfected highly sensitive gelatin dry-plate negative, which made detailed images with short exposures that were impossible with the slower wet-collodion negative. Muybridge used the dry-plate negative in 1884-85 for his major opus *Animal Locomotion*. In 1888, Marey devised a movable film camera which took rolls of paper, replaced in 1892 by celluloid film. Marey's film camera and Muybridge's Zoöpraxiscope were the precursors of cinematography in the 1890s.

Cliché-verre. A cameraless print which was the direct outgrowth of photographic experiments in the early nineteenth century. The term "cliché-verre" was popularized in the twentieth century by the major nineteenth- and twentieth-century French print cataloguer, Loys Delteil.

The "cliché-verre" negative (glass negative) was a hand-drawn or painted image on a glass support. Often the plate was coated with an opaque substance (such as black varnish); then the image lines were scratched in it with a sharp tool. The plate was contact-printed by the transmission of light through this negative onto salted or albumen paper. Between 1853 and 1875, a number of Barbizon painters, including Corot, Millet, and Rousseau (see p. 58), experimented with the creative possibilities of this technique.

Collodion positive (see ambrotype and tintype).

Collodion (wet plate) process. In March 1851, the British photographer Frederick Scott Archer (1813-1857) published in *The Chemist* his unpatented process for a collodion negative. It is often referred to as the "wet collodion" or "wet plate" process because the collodion emulsion needed to remain moist and tacky from preparation through development. A photographer working outdoors required a special darkroom tent (see p. 50), equipment, and chemicals. The light-sensitive emulsion had to be prepared immediately before use and the negative developed immediately after exposure.

The adhesive properties of collodion, a mixture of gun cotton (cellulose nitrate) dissolved in alcohol and ether, were first applied to medical uses in 1847. In spite of conflicting claims for invention of the process, Archer's perfected method was the first published account of the use of collodion as a vehicle for silver halides on glass. A solution of collodion and potassium iodide was coated onto a glass plate. It was placed in a sensitizing bath containing silver nitrate, then slipped into a light-tight plate holder and exposed in a camera while damp. The negative was developed in a solution of pyrogallic acid or ferrous sulfate, and then fixed with sodium thiosulfate (hypo), washed, dried, and varnished.

Compared to the calotype negative process, the collodion process had several important advantages which made it the favored negative process from the mid-1850s until the 1880s, when it was eclipsed by the gelatin dry-plate negative. Exposure times, the fastest achieved at the time by any process, were reduced from minutes to seconds. Because of its fine-grained silver structure and transparent, flat glass base, this negative process reproduced extremely sharp detail in a broad tonal range, unlike the diffuse image from the calotype negative which resulted from the paper fiber structure. Early prints from collodion negatives were printed on salted and albumen papers. In spite of the perils of broken glass and the difficulties of wet manipulation, the collodion negative was a major breakthrough for professional and amateur photographers.

Collotype. A planographic photomechanical printing method producing images with extremely fine detail which are difficult to distinguish from an original photographic print. The basic collotype process was patented in 1855 by the Frenchman Alphonse Louis Poitevin (1819-1882) and commercialized in Germany, in 1868, by Joseph Albert (1825-1886). A bichromated gelatin coating on a ground glass plate is dried under controlled conditions. After exposure under a continuous tone negative, and a second short exposure through the glass, the plate is washed and the printing surface treated with glycerine and water to give a fine wrinkled or reticulated pattern. The antipathy between water and greasy ink is proportional to the action of light on the bichromated gelatin. The light-hardened areas (shadows) reject water and consequently accept ink, while the unhardened, less-exposed areas (highlights) attract greater amounts of water, and thus, less ink. The collotype was used for high-quality book illustrations such as Muybridge's *Animal Locomotion*.

Color coupler. An organic compound which links with the oxidation products of a developer to form dye. The image-forming

couplers in incorporated photographic materials are colorless until the latent halide image is developed. Modern color negative films contain orange-colored couplers which act as masks during printing to correct for deficiencies in the cyan and magenta dyes. Only Kodachrome film introduced couplers in the developer. The oxidation products from the developing silver halide image link with couplers in proportion to the amount of silver reduced. Heavy deposits of silver, produced by exposure in negatives or by reversal development of silver, deposit heavy dyes.

Color processes. Color is a psycho-physical phenomenon produced by light. White light passed through a prism is broken up into its component colors which we see as a color spectrum or rainbow. Human eyes have receptors which react principally to three primary colors: red, green, and blue. When mixed in various proportions, these color light primaries give the viewer the sensation of seeing all colors. A light-sensitive silver halide emulsion can record only a monochrome range of light intensity from light to dark (white to black). To reproduce accurately the colors of a subject, three black and white images are recorded; one for each primary color, through a corresponding color filter. These are called color separation negatives. Red light reflected from a red apple is transmitted through a red filter and recorded on the film; blue and green light is absorbed by the apple. A green tree is recorded with a green filter; red and blue light is absorbed. A blue sky is recorded with a blue filter; the red and green light is absorbed. Reflected white light exposes all three, while nonreflective black is not recorded. Color-separation negatives are reversed or printed to make the color separation positives used to reconstitute the final image we see.

Color photographs can be produced by additive or subtractive color mixture. Additive and subtractive color process (q. v.) refers to the means by which the final image is obtained or viewed.

Cyanotype (blueprint). A non-silver process using light-sensitive iron salts, which was first published in 1842 by the British scientist Sir John Herschel (1792-1871), although he had developed the process in 1839. To produce a cyanotype print, paper is coated with a solution of ferric ammonium citrate and potassium ferricyanide which forms a deep Prussian blue pigment in response to light and air. After exposing the dry paper behind a negative, the print is washed in water to remove the unexposed iron salts. The process was extensively used for the reproduction of architectural and engineering drawings.

Daguerreotype. The French painter and dioramist Louis Jacques Mandé Daguerre (1787-1851) discovered the first practicable photography process. Francois Arago announced the discovery on January 7, 1839, to the French Académie des Sciences and it was publicly demonstrated on August 19 after the French government had purchased it. The discovery evolved from Daguerre's collaborative work with Joseph Nicéphore Niépce (1765-1833) who had recorded the first preserved photographic image in 1826.

The daguerreotype is a unique image made by a direct positive process. According to Daguerre's original method, a cleaned and polished silver-coated copper plate was sensitized to light with iodine fumes and exposed in a camera. The latent image was developed with mercury vapor, which formed a whitish amalgam on the exposed light-sensitive silver iodide. The unexposed shadow areas were formed by the unchanged smooth plate surface. Daguerre, at first, fixed the remaining light-sensitive salts with a strong solution of salt (sodium chloride). This procedure was soon replaced by a more effective fixing agent, sodium thiosulfate (called hypo) which Sir John Herschel proposed be used for this purpose in March 1839. The earliest images were limited to architectural and landscape views since camera exposure times required about 30 minutes.

By 1841, improvements in lens design and modifications in the sensitizing process reduced exposure time to less than a minute, making portraiture commercially feasible. The Viennese optician, Joseph Petzval, designed an improved lens with a large aperture and short focal length, which was produced by the Viennese manufacturer Frederich Voigtlander. In England, John Frederick Goddard used bromine, and Antoine Claudet chlorine, to increase sensitivity of the plates. A French physicist, Hippolyte Fizeau, invented a gold-toning process which enriched the tonal contrasts by bathing the fixed image in a solution of gold chloride.

To view the positive image on the mirror-like surface, it was necessary to tilt the image to an appropriate angle. Unless a correcting prism or mirror was used, the exposed image appeared reversed left to right. A copy of the daguerreotype could only be obtained by making another daguerreotype of it since there was no negative. To shield the fragile surface from abrasion and tarnish, the plate was protected by a mat and glass cover, sealed, then inserted into a case. A delicate metal frame was later added to protect the seal. In general, the more elaborate the case, the later the date. Sometimes, however, earlier daguerreotypes were recased. Daguerreotype plates were manufactured in rough standard sizes by which they were usually identified.

Whole plate	16.5 x 21.6 cm.	6½ x 8½ in.
Half plate	11.4 x 14.0 cm.	4½ x 5½ in.
Quarter plate	8.3 x 10.8 cm.	3¼ x 4¼ in.
Sixth plate	7.0 x 8.3 cm.	2¾ x 3¼ in.
Ninth plate	5.1 x 6.3 cm.	2 x 2½ in.

The daguerreotype, used primarily for portraits, was the prevailing photographic process in America from its introduction in 1840 through the 1850s. The precise detail and subtle midtone gradations in the daguerreotype image were unprecedented in the history of the arts. It was replaced in popularity by cheaper processes including ambrotypes, tintypes, and cartes de visite.

Development. A latent (invisible) image, formed in light-sensitive chemical compounds, is chemically altered to form a visible image, either negative or positive. The chemical aspects of development are covered under individual process entries.

Dye-bleach process. A subtractive color method using dye destruction to produce color prints or transparencies. The Hungarian chemist, Bela Gaspar, introduced the Gasparcolor process in 1933, but it never received substantial commercial use. Cibachrome, using the silver dye-bleach principle, was released in 1963 by the Swiss Ciba Company. It is widely used today to produce prints, usually enlargements, which have excellent color fidelity and stability.

In the silver dye-bleach process, tripack papers or transparency material already contain complete dyes (not couplers). The cyan, magenta, and yellow dyes in the emulsion layers are coated on an opaque white base or transparent film base. A positive image is formed from a color transparency or negative. The amount of light passing through a color transparency during exposure is proportional to the densities of its dye images. After development of the dye-bleach materials, a catalytic action by the silver image destroys the dyes selectively in proportion to the amount of silver image formed. Light passing through the highlight areas of the original transparency forms a full strength silver image. All of the dyes in these areas are bleached out, leaving highlight areas in the final print. In the dark shadow areas where little or no light is transmitted to create a silver image, proportional amounts of the dyes remain to form the color image. Processing is completed by bleaching out the negative silver image and removing the unexposed and underdeveloped silver halides in the positive image. What remains is a subtractive color positive image. If a print or transparency is made from a negative, the exposed material is reversal-processed, and the dyes are bleached after the second development.

Dye diffusion-transfer process. In 1948, the Polaroid Corporation, Cambridge, Massachusetts, revolutionized photography when it released one-step Polaroid black and white film for use in the Polaroid-Land camera invented by Edwin H. Land (b. 1909). Polacolor film for color prints was introduced in 1963. All Polaroid processes exploit the difference between exposed and unexposed silver halides to regulate the formation of the final print. Unlike black and white Polaroid materials, where the final image is comprised of silver, the final image in color pictures is made from dyes.

All Polaroid materials are multilayer films consisting of a negative, a positive receiving sheet, and a reagent in a sealed pod. Polacolor (1963), Polaroid SX-70 (1972), and Polacolor 2 (1975) films utilize the subtractive color principle. The negative comprises three primary light-sensitive emulsions (red, green, and blue) positioned immediately above their respective subtractive complementary dye-developers (cyan, magenta, and yellow). Dye-developers are dyes to which black and white developing agents are attached.

Pulling the Polacolor film tab after exposing the negative draws the negative and positive film unit between the camera rollers, rupturing the pod and spreading the alkaline reagent between the two surfaces. The alkali permeates the negative moving the now soluble dye-developers into contact with the silver halide emulsions. The exposed silver halide is reduced and the oxidized dye-developer is immobilized, halting its contribution to the positive image. In unexposed, or less-exposed areas, the soluble dye-developers migrate to the positive receiving sheet where they form one of the three color images which comprise the final Polacolor print. Once the sixty-second development in the light-tight film unit is complete, the negative sheet is peeled from the positive and discarded.

In the instant-ejection Polaroid SX-70 film, the negative and positive layers form a single integral unit. The film is exposed through the negative layers, which are situated beneath the positive layers. Once ejected, development of the film is similar to Polacolor. The final color print materializes as the image forming dyes migrate to the receiving layer. "Metalized" dyes used in Polaroid SX-70 and Polacolor 2 films have improved color stability of the prints.

Dye imbibition process. Since the 1870s, the subtractive color principle has been used to make dye imbibition prints. In dye imbibition processes, dye is absorbed or "imbibed" and held immobile in the final print or transparency. One imbibition process, the Kodak Dye Transfer method introduced in 1946, has been the most successful dye imbibition process for color prints. Adjustments can be made at different stages to control contrast and color balance to a greater extent than with other color methods.

Three black and white separation negatives are made from an original color transparency, using filters to record each of the primary color layers, red, green, and blue. These are then used to make positive black and white gelatin relief matrices. When these matrix films are developed in a tanning developer, the portions of emulsion exposed to light become hard and insoluble. The unexposed portions remain soluble and are washed away in hot water, leaving a relief image. In proportion to the remaining amount of gelatin relief, the matrices absorb dye from aqueous solutions containing their appropriate pre-manufactured dye: cyan, magenta, or yellow. Successively contact-printed in register on a white gelatin-coated paper support, the matrices produce the final positive dye image.

Today, the Kodak Dye Transfer process is one of the most stable color processes available. In addition, the three separation negatives can be archivally processed, thus making future prints possible even if the color original is lost.

Dye transfer (see dye imbibition process).

Emulsion. A suspension of image-forming light-sensitive silver halide crystals coated on the surface of paper, glass, or film. The size of the silver halide crystals affects the speed, granularity, and contrast of the emulsion. In general, the larger the crystals, the faster the emulsion and the lower the contrast. The smaller the halide crystals, the higher the contrast but the slower the emulsion. Most color

emulsions have added dye-forming couplers; full strength dyes, however, are used for the silver-dye bleach process.

Starting in the 1850s, albumen and collodion were used as binders (suspension media) for silver salts. In 1871, Richard Maddox discovered the advantages of gelatin as an emulsion binder, and gelatin has since become the basis of most modern photographic processes.

Exposure. The amount of radiant energy – light – falling on a light-sensitive emulsion. The effects of exposure depend on the time, intensity of light, and the sensitivity of the emulsion. Continued improvements in the sensitivity of materials have reduced typical exposure times from hours to thousandths of a second and greatly expanded the repertoire of possible subjects.

Fixing. The process of stabilizing an image by removing the unused light-sensitive silver halides from exposed and developed negatives and prints. Sodium thiosulfate (previously called hyposulphite of soda, and often shortened to hypo) was suggested by Sir John Herschel in 1839, and continues to be the standard fixing agent today.

Gelatin dry plate. The first workable gelatin silver halide emulsion was described in 1871 by the British doctor and amateur photographer Richard Leach Maddox (1816-1902). In 1873, John Burgess started the small-scale commercial production of a pre-sensitized gelatin-bromide emulsion and gelatin dry plates. By 1878 Great Britain had four firms actively manufacturing and marketing ready-made gelatin dry plates for photographers capitalizing on the improvements in processing of the gelatin emulsion. The Eastman Kodak Company had its beginnings when George Eastman started a business to produce gelatin dry plates in 1880.

This revolutionary invention of gelatin dry plates relieved the photographer of the cumbersome preparation of the collodion wet plate negative which chained him to a darkroom. The characteristics of emulsion permitted the light-sensitive negative to be manufactured in advance and stored until use. Development could be done some time after exposure, unlike the collodion process which required immediate use and development. Gelatin silver halide emulsions allowed greatly increased light sensitivity, permitting shorter exposures.

At first, prints from the gelatin dry plate were made on albumen paper. In the 1890s, it was displaced by gelatin and collodion printing-out papers. Beginning about 1905, gelatin developing-out papers were used. Without documentation or marginal evidence, it is difficult to distinguish between a print made from a gelatin dry plate and a print from a collodion wet plate negative.

Gelatin silver print. A photographic print in which the emulsion contains a silver compound as the light-sensitive salt. Gelatin silver print is a generic term adopted by photographic historians to refer to black and white gelatin silver halide papers. While this is correct, it is imprecise. These papers vary in the type of silver salts and can be chemically treated with toners which affect the final print color. When first introduced in the 1880s, gelatin silver papers were not readily accepted because they were unfamiliar and somewhat difficult to use. Most amateur and professional photographers preferred the slower collodion and gelatin printing-out papers.

This printing paper is made by coating the paper with light-sensitive silver halide crystals suspended in gelatin. After exposure to light through a negative, the latent image is chemically developed to make it visible. This type of paper is often referred to as developing-out paper (abbreviated D.O.P.). Gelatin silver prints range in color depending on the silver halides (bromide and/or chloride), developer formulations, and chemical toners. The papers were available in a variety of surface textures and a range of finishes from matte to gloss.

Gelatin bromide paper was invented and introduced in 1873 by Peter Mawdsley, founder of the Liverpool Dry Plate & Photographic Co., but it was not commercially successful until 1880 when two other British firms produced it. Bromide paper was the fastest (most light-sensitive) and therefore used for contact prints and enlargements. The neutral black print could be toned.

Silver chloride paper was invented by Joseph Maria Eder and Giuseppe Pizzighelli in 1881, but was not generally available until 1890. The silver chloride emulsion had a slow response to light restricting its use to contact prints, which have a distinctive blue-black color. It was popularly called "Velox" Gaslight paper after the brand name under which it was produced by the Nepera Chemical Co. in Yonkers, New York, in 1893.

Chlorobromide paper was invented by J.M. Eder in 1883. Its sensitivity and development time ranged between the two former papers since the gelatin emulsion contained roughly equal proportions of silver bromide and silver chloride. This enlarging and contact printing paper was favored by pictorialists during the early twentieth century for its warm brown-black tones and variety of surface textures and finishes.

Without documentation it is almost impossible to distinguish with certainty the various silver halide papers; thus they are generally called gelatin silver prints. Since the 1970s, many contemporary black and white papers have been manufactured with a resin-coated (RC) base to minimize water and chemical penetration of the paper base during development.

Gum bichromate process. Although the Frenchman Alphonse Louis Poitevin (1819-1882) laid the foundation for the bichromate process in 1855, it was the Englishman John Pouncy (ca. 1820-1894) who successfully produced prints by the gum bichromate process about 1857. A French amateur, A. Rouillé-Ladévéze, led the revival of the process by pictorial photographers in 1894.

The photographer could now select both pigment color and paper texture. The process involved hand-coating paper with a solution of gum arabic, potassium bichromate, and pigment. When exposed under a negative, the gum in those areas receiving light hardened and became water insoluble in proportion to the amount of light reaching it. The gum in unexposed areas remained soluble. When washed in warm water only the light-hardened pigment

remained. During this stage, considerable hand manipulation of the emulsion was possible with a brush or sponge. Gum prints rendered broad tonal effects rather than fine resolution of details. The ability to print multiple layers by recoating and reprinting to increase depth or alter color made the process a favorite of turn-of-the-century European and American pictorial photographers, such as Robert Demachy and Heinrich Kühn (see p. 98).

Hallmark. A stamped identification mark in the form of initials, names, or symbols used by daguerreotype plate manufacturers in one corner of each plate. French plates carry a number incorporated in the platemark specifying silver content. Marks can be useful in establishing approximate dates of daguerreotypes.

Hypo (see sodium thiosulfate).

Integral tripack (see tripack).

Kodachrome (see chromogenic development processes).

Latent image. An invisible change produced in a light sensitive emulsion by exposure to light. Chemical development converts the latent image into a visible image.

Negative. An image formed after exposure and development on a transparent base (paper, glass, or film). It may be used to produce an unlimited number of prints. The tones of the negative are the reverse of those in the final positive print. Dark tones of the original subject are recorded as light or thin areas on the negative; conversely, light tones are recorded as dark or opaque areas. In color negatives, the colors are complementary to those of the subject. However, they are masked by an overall orange cast which improves the printing characteristics, but makes it difficult to distinguish the negative color values.

Oil pigment process. Introduced by G.E.H. Rawlins in 1904, the permanent oil pigment process was popular in Europe during the first quarter of the twentieth century with art and salon photographers like Robert Demachy and Constant Puyo (see p. 96). An unpigmented gelatin, coated onto paper, was sensitized with a bichromate solution. After contact-exposure under a negative, the unexposed areas of unhardened gelatin readily swelled as the paper was soaked in water. While the paper was wet, oil base ink or pigment was applied with a brush to the wet gelatin image. The unexposed water-swollen areas rejected pigment, while the exposed areas accepted color in proportion to the amount of light which reached them. This hand manipulation gave the photographer control over the final result once the technique was mastered. Oil pigment prints generally have broad tonal effects and limited resolution of fine detail.

Panel mount (see cabinet cards and similar formats).

Photogalvanographic print. Photogalvanography was one of the first intaglio photomechanical processes capable of middle tones. It was patented in England in 1854 by the Austrian Paul Pretsch (1808-1873). A glass plate coated with a solution of gelatin, potassium bichromate, silver nitrate, and potassium iodide was exposed to daylight through a transparent positive. Because of the low sensitivity of the dried emulsion, the exposure time had to be greatly increased to harden the exposed gelatin. Rather than remove the unexposed soluble gelatin, as in the carbon or gum bichromate processes, water-swollen gelatin formed a relief image in direct proportion to the darkness of the tones. This relief was varnished, dried, then coated with gutta-percha (a rubber-like substance), which created an intaglio mold. From this mold, a copper relief matrix was formed by electrotyping. When backed, the copper matrix could be printed by the intaglio method. Although photogalvanography was used for *Photographic Art Treasures*, a series of portfolios illustrated by Fenton (see p. 48) and others, it did not become widely practiced due to faulty middle tones which required retouching by hand.

Photogenic drawing. The antecedent of contemporary positive-negative processes, photogenic drawings relied on the printing-out (q.v.) of both camera negatives and prints. In August 1835, the British chemist, linguist, and mathematician William Henry Fox Talbot (1800-1877) first successfully recorded the negative image of a "Latticed Window" at Lacock Abbey with a camera obscura. Alarmed that his work would be overshadowed by the announcement on January 7, 1839, of Daguerre's new process in France, he exhibited on January 25 a number of his photogenic drawings at the Royal Institution in London. It was not until February 21 that he publicly disclosed his method, a process, of course, quite different from Daguerre's. What Talbot termed "photogenic drawings" were negative views of Lacock Abbey taken with a camera obscura, photograms of flowers, leaves, and lace, and a couple of images obtained with a solar microscope which were probably taken in 1835.

Talbot's method, at the time he disclosed his process, was to sensitize a fine grade of writing paper by successively coating it with alternate solutions of common salt (sodium chloride) and silver nitrate. This method had provided maximum sensitivity experimentally. The negative image was printed-out in light, turning darker in those areas receiving more light. Chemical development was not used. The image was stabilized by a strong solution of common salt or potassium iodide. The use of salt as a stabilizing bath is what distinguished a photogenic drawing from other silver printing-out materials.

At the suggestion of Sir John Herschel, Talbot began fixing his images with sodium thiosulfate (hypo) at the beginning of February. Talbot's first positive prints from negative camera images are undocumented; however, he included a number in an exhibition in August 1839. Although he recognized the potential value of making "copies," i.e., positive prints, his immediate concerns in 1839-40 were more sensitive papers, better manipulation, and suitable apparatus to improve results. His landmark discovery in 1841 of the

calotype (paper negative) process made portraits possible and established the negative-positive system as a basic approach.

Photogram. A photographic technique rather than process. The photogram is made without a camera by placing objects of varying light-transmitting ability, such as leaves, lace, paper, or other objects directly on any light-sensitive material. Once exposed to light, the resulting shapes, textures, and outlines are determined by the translucency of the objects. The photogram can be used as a negative to produce prints with a tone reversal. Talbot's photogenic drawings using objects such as lace and leaves were the earliest experiments with the photogram. Twentieth-century artists such as Moholy-Nagy and Man Ray (who called his Rayographs) creatively utilized this technique.

Photogravure. Karel Klíč perfected a photomechanical method to faithfully reproduce photographs in 1879. A continuous tone printing plate is produced from a photographic image transferred to the printing plate which creates a barrier during the etching phase.

First, a layer of resin powder is affixed by heat to a polished copper plate. Then, carbon tissue coated on one side with gelatin and sensitized with potassium bichromate is contact-printed with a positive transparency. The moistened gelatin is transferred to the grained copper plate. Warm water is used to wash away the carbon tissue and dissolve the unexposed gelatin leaving the "resist" image. The plate is then etched with ferric chloride, pitting the surface in inverse proportion to the gelatin resist which corresponds to the tonal range of the image. Once the resist is removed, the plate is inked and hand-printed like an etching. Thin Japanese paper was frequently used for the high-quality photogravure prints of pictorialists and other photographers whose work appeared in publications such as *Camera Work,* published by Alfred Stieglitz.

Photomechanical processes. Processes in which the printing plates are prepared with the aid of a camera. Photomechanical processes utilize one of the four basic printmaking methods. In the intaglio process the inked image lies below the surface of the plate. In the relief process, the inked image is all that remains of the original surface. In the planographic process, the inked image and nonprinting areas are chemically separated on the surface. In the stencil process, the ink prints in the open areas of the stencil. A few photomechanical processes, grouped according to the printing method they employ, are: *Intaglio:* photoetching, photogalvanography, photogravure, woodburytype; *Relief:* halftone, photoengraving; *Planographic:* collotype, photolithography; *Stencil:* Photo screen printing.

Photomontage. Double-printed, composite, and manipulated photographs are as old as photography itself. Photomontage was coined after the First World War by the Berlin dadaists to describe their revolutionary technique of assembling separate ready-made photographic fragments, at times in combination with newspaper and magazine halftones, lettering, and drawing to create provocative and explosive new images. Photomontages were used for book and magazine illustrations, posters, and stage sets. By the 1930s, photomontage referred not only to cutting up, reassembling, and rephotographing images, but to printing multiple negatives to create a radically new entity. Artists such as Bayer (see p. 136) and Moholy-Nagy (see p. 116) manipulated photographs for artistic reasons; other photographers were motivated for commercial or political ends.

Platinum process. The platinum process, also known as platinotype, was patented in 1873 by the British photographer William Willis (1841-1923). His Platinotype Company began marketing pre-sensitized papers in 1880. As the price of platinum escalated before World War I, it was partially replaced by palladium which produced comparable results, and was eventually abandoned in 1937.

In this process, paper was coated with a solution of a light-sensitive iron salt (ferric oxalate) and a platinum compound (potassium chloroplatinite). During exposure, light changed ferric oxalate to ferrous oxalate. The ferrous oxalate dissolved during development in potassium oxalate, precipitating a metallic platinum to form the final image. Unused iron and platinum salts were then removed in baths of dilute hydrochloric acid, followed by water washing. Like salted-paper prints, platinum prints have no separate emulsion layer. The image is embedded in the paper fibers and has a matte appearance. Prepared platinum papers enjoyed great popularity for their permanence and extensive range of delicate silver gray tones. P. H. Emerson (see p. 86) and Frederick Evans (see p. 110) were renowned exponents of this process.

Polacolor (see dye diffusion-transfer process).

Polaroid (see dye diffusion-transfer process).

Positive. A positive image in which the light and dark tones or color areas correspond to the values of the original subject. The light areas of the print correspond to the dark, opaque areas of the negative and the dark areas correspond to the transparent areas. The complementary colors of a negative produce a color print corresponding to the original subject. Sir John Herschel first used the term "positive" in 1840.

Printing-out paper (P.O.P.). Printing-out papers are contact-printed by passing light through a negative until the image appears fully visible, or "printed-out." There is no additional chemical development, as is the case with negative materials. Processing consists of gold-toning, which alters the reddish color to a sepia or brown image, fixing, and washing.

Printing-out papers are a class of papers intended for this printing-out method and include salted and albumen papers. The term "P.O.P." refers to papers coated with an emulsion containing silver chloride in gelatin or collodion, which were introduced in the 1880s and succeeded albumen papers. These papers dominated the market from 1895 to 1905, roughly concurrent with the gelatin dry-

plate negative. The one remaining example of commercial printing-out paper was scheduled to be discontinued in 1987.

Promenade mount (see cabinet cards and similar formats).

Sabattier effect. In 1862, the French scientist Armand Sabattier (1834-1910) first described this partial tone reversal on film or paper caused by re-exposure to light during development. The partial reversal of black and white or color image is often more dramatic with negatives than with prints, although the principle is the same. The sooner the image is flashed and the stronger the light, the greater the reversal of the final image. If the image is momentarily flashed during development of the negative, less exposed and thus low density areas will build greater densities and reverse the visual appearance. Often characteristic of the Sabattier effect are narrow black bands called "Mackie lines" which represent the boundary between reversed and unreversed areas. In 1929, the Sabattier effect was accidentally rediscovered by Man Ray (see p. 142) who used it to alter his camera-made images. This partial reversal is often incorrectly termed solarization (q.v.).

Salted-paper print. A positive print made with a hand-coated silver chloride paper. This is the direct descendant of the earliest print process, Talbot's photogenic drawing paper in 1839. The paper was prepared with a solution of sodium chloride and/or ammonium chloride, then sensitized with a silver nitrate solution. Exposed under a negative to print-out the image, it was then washed and subsequently fixed in hypo. The resulting matte-surfaced image is contained in the paper surface rather than situated in a separate binder layer. Talbot preferred the warmer brown or sepia color of the positive salted-paper prints with occasional purple overtones, to the neutral black color of the paper negative. When printed from a calotype negative, the sharp definition of detail was lost as a result of the negative's fibrous structure, even when the paper negative had been waxed. Salted-paper prints were also made from collodion negatives which replaced paper negatives in the early 1850s. Although superseded by the albumen papers in the 1850s, salted-paper prints continued to be made until the 1860s, and were later utilized by the pictorialists in the 1890s.

Silver halide. Many compounds of the precious metal silver (Ag) are light-sensitive. Silver halide is a collective term for compounds of silver with halogens, such as silver chloride, silver bromide, and silver iodide. These halides, or mixtures of them, are the basis of most photographic materials. With relatively short exposure to light, they form a latent image which can be reduced to a visible silver image by suitable chemical developers. They will also reduce under prolonged exposure to light, darkening on their own. This phenomenon is utilized in printing-out papers.

Sodium thiosulfate. In 1819, Sir John Herschel noticed its property of dissolving silver salts and suggested its use as a photographic fixing agent in 1839. Until the last quarter of the nineteenth century,

it was known as hyposulphite of soda – hence the term "hypo" by which it is still referred to today.

Solarization. The complete reversal of an image on a plate or film as the result of an exorbitant amount of overexposure to light. This effect is frequently confused with a technique used to produce a partially reversed image known as Sabattier effect (q.v.). Solarization is no longer possible with many contemporary photographic materials because of chemical modification of the emulsion.

Subtractive color processes. The principle of subtractive color reproduction is to record with color filters or dyes the complementary colors in the light reflected from the subject which will form the desired color image. Color reproduction relies on the subtractive primaries cyan, magenta, and yellow; these are the complementary colors of the additive primaries red, green, and blue respectively. When present in varying proportions, the subtractive primaries form all of the colors of the spectrum. Black is produced when the combined subtractive primaries absorb all the colors from white light. The subtractive primaries allow the widest workable range of dye mixtures to approximate the original color subject by transmitted or reflected light from photographic material.

A positive dye image is formed in a tripack emulsion (q.v.), or by a more involved process called dye imbibition process (q.v.). The color negative image is the inverse of the original subject in tone and color. Light tones register as darks, and vice versa. The subject's primary colors – red, green, and blue – are recorded as their respective complementary (negative) colors: cyan (blue-green), magenta (blue-red), and yellow (red-green). Red light reflected from an apple forms a negative cyan image on the film. A green tree forms a magenta image and a blue sky forms a yellow image. Each of the dyes act as a subtractive filter blocking one third of the spectrum (its complementary color) while transmitting or reflecting two thirds (its component primary colors) to produce the dye image. Cyan (red subject) blocks red light while transmitting blue and green light, magenta (green subject) blocks green while transmitting red and blue, and yellow (blue subject) blocks blue while transmitting red and green. The primaries of the original subject are reconstituted when superimposed pairs of subtractive primaries are viewed with white light transmitted through a transparent base or reflected from a white base; yellow and magenta dye layers produce red, cyan and yellow produce green, and magenta and cyan produce blue. Colors obtained from mixing primaries will be recorded on more than one dye layer. The final dye image corresponds in tone and color to the original subject.

Almost all of today's color photographs are made by subtractive methods of color reproduction. The advantage of subtractive color processes over additive color processes is that bright and sharp full color prints on paper or film are feasible.

In 1869 the French scientist Louis Ducos de Hauron (1837-1920) published *Les Couleurs en Photographie: Solution du Problème* in which the principles of subtractive color formation were set forth. Dye

images were combined on paper, rather than by projection, to reproduce natural colors. As in the additive process, three color-separation negatives were made using primary color filters. These negatives were used to make carbon positives pigmented in complementary colors (cyan, magenta, and yellow), which when successively printed in register, recreate the initial color image.

Although several other subtractive color methods were introduced after 1870, none were widely used. It was not until the mid-1930s that additive color methods were superseded by the commercial introduction of Kodachrome and Agfacolor Neu 35mm films, which made color photographs practicable. Today the four major subtractive development processes used to produce color images are: dye imbibition, dye-bleach, chromogenic development, and dye diffusion-transfer (see individual entries). Trade names by which color prints are popularly known will be found under the generic development classifications.

Tintype. The tintype, as it became popularly known, was another use of the collodion process. On February 18, 1856, Hamilton L. Smith of Kenyon College, Gambier, Ohio, took out a patent for a collodion positive produced on a sheet of black lacquered iron. Smith turned his patent rights over to his colleague, Peter Neff, Jr., and William Neff, his father, who built a factory in Cincinnati at 239 West Third Street for manufacturing the coated plates which they called "melainotypes." A competing manufacturer and former Kenyon student, Victor M. Griswold, called his plates "ferrotypes."

The tintype, like the ambrotype, was a weak negative image backed with a black layer. Light scattered by the silver image appeared whitish, creating the highlights of the tintype. The black lacquered plate provided the shadows. Since the emulsion was coated directly on the coated base, the unique image was reversed left to right.

Tintypes are sometimes found in the same frames and cases as daguerreotypes and ambrotypes, but were typically sold in cheap paper mounts. They were also incorporated into jewelry and collected in family albums. Tintypes are easily identified by their metal plate supports or their attraction to a magnet if cased. The image itself appears dull and gray, without brilliant white highlights.

Since the tintype originated in the Midwest rather than in the East, it did not gain in popularity until the Civil War, and not until the 1870s in Europe. Itinerant street tintypers continued to sell their sturdy, instantaneous, and inexpensive portrait photographs of inferior quality to the public through the 1900s, well beyond the era of daguerreotype and ambrotype.

Toning. A chemical treatment to change the image color of a black and white photograph. Image color can be altered by three methods: by development, by substituting inorganic compounds for the silver image, and by dyeing the image. During normal development, papers with silver chloride emulsions yield warmer tones than those with silver bromide emulsions. A greater variety of image color is possible by using inorganic compounds containing gold or

selenium, to replace the silver of a fully developed and fixed image. Dye-toning is used for an even wider selection of colors.

Tripack. Light-sensitive material consisting of three emulsion layers coated onto a common base. Usually, the top emulsion layer is blue-sensitive, the second is green-sensitive, and the third is red-sensitive. A yellow filter protects the two underlying layers from blue light during exposure. In tripack materials the dyes are produced during development. In integral tripacks, the dyes are in the emulsion layers.

Waxed-paper process. In 1851 the French photographer Gustave Le Gray (q.v) published his improved paper negative process called the waxed-paper process. Le Gray waxed the paper before, instead of – as in the calotype process – after exposure, thus further increasing its transparency. The waxed paper was then immersed in a solution of rice water, milk sugar, potassium or ammonium iodide, and potassium bromide. When dry, it was sensitized in a solution of silver nitrate and acetic acid. Unlike the calotype negative, it could be prepared ten to fourteen days before exposure and could be processed several days after exposure. It was developed in a solution of alcohol, gallic acid, and silver nitrate. The convenience of dry materials, and the rendering of fine detail, made it popular with architectural and landscape photographers in Britain and France after the introduction of the wet-collodion negative.

Woodburytype. The Englishman Walter Bentley Woodbury (1834-1885) invented this intaglio photomechanical process in 1865 and patented it the following year. A bichromated gelatin-coated paper was exposed under a negative, then washed in warm water to remove the soluble unexposed gelatin. The remaining light-hardened gelatin relief image was pressed into a lead sheet, creating an intaglio mold. Pigmented gelatin cast in the mold was transferred to paper with pressure by a hand press and hardened with a solution of alum. Different densities of pigment created highlights and shadows which correspond to the tones of the original photographic image. Prints were trimmed flush in order to eliminate the excess marginal gelatin, and mounted. The grainless woodburytypes were most commonly printed in a reddish brown color which, unlike albumen prints, did not fade along the edges. Because of the prodigious amount of manual labor required, the process was not financially competitive with other direct photomechanical processes such as photogravure; consequently, it received limited use after its introduction. Photographic reproductions illustrating *Galerie Contemporaine* from 1876 to 1884 were woodburytype prints (see p. 76).

Index of Artists' Entries